The Photographer's Guide to
Professional-Quality Digital Photography

MASTERING

Digital

Photography

David D. Busch

Mastering Digital Photography

Senior Vice President, Professional, Trade, Reference Group: Andy Shafran

Publisher: Stacy L. Hiquet

Credits: Senior Marketing Manager, Sarah O'Donnell; Marketing Manager, Heather Hurley; Manager of Editorial Services, Heather Talbot; Senior Acquisitions Editor, Kevin Harreld; Senior Editor, Mark Garvey; Associate Marketing Manager, Kristin Eisenzopf; Retail Market Coordinator, Sarah Dubois; Production Editor, Jenny Davidson; Technical Editor, Michael D. Sullivan; Proofreader, Kate Shoup Welsh; Cover Designer, Chad Planner, *Pop Design Works*; Interior Design and Layout, Bill Hartman; Indexer, Sharon Shock.

Technology and the Internet are constantly changing, and by necessity of the lapse of time between the writing and distribution of this book, some aspects might be out of date. Accordingly, the author and publisher assume no responsibility for actions taken by readers based upon the contents of this book.

Library of Congress Catalog Number: 2003108389

ISBN: 1-59200-114-9

5 4 3 2

Educational facilities, companies, and organizations interested in multiple copies or licensing of this book should contact the publisher for quantity discount information. Training manuals, CD-ROMs, and portions of this book are also available individually or can be tailored for specific needs.

Muska & Lipman Publishing, a Division of Course Technology ■ 25 Thomson Place ■ Boston, MA 02210 ■ www.courseptr.com ■ publisher@muskalipman.com

About the Author

David D. Busch has been demystifying arcane computer and imaging technology since the early 1980s. However, he had a successful career as a professional photographer for a decade before he sat down at the keyboard of his first personal computer. Busch has worked as a newspaper photographer, done commercial studio and portrait work, shot weddings, and roved the United States and Europe as a photojournalist. His articles on photography and image editing have appeared in magazines as diverse as *Popular Photography and Imaging*, *Petersen's PhotoGraphic*, *The Rangefinder*, and *The Professional Photographer*, as well as computer magazines such as *Macworld* and *Computer Shopper*. He's currently reviewing digital cameras for CNet.

Busch has written more than 70 books since 1983, including the mega-bestsellers *Digital Photography All-In-One Desk Reference for Dummies* and *The Hewlett-Packard Scanner Handbook*. Other recent books include *Digital Photography Solutions* and *Mastering Digital Scanning with Slides, Film, and Transparencies*, both from Muska & Lipman/Course Technology. This is his seventh book on digital photography.

He earned top category honors in the Computer Press Awards the first two years they were given (for *Sorry About The Explosion*, Prentice-Hall, and *Secrets of MacWrite, MacPaint and MacDraw*, Little, Brown), and later served as Master of Ceremonies for the awards.

Contributor Bio:

Technical Editor **Michael D. Sullivan** added a great deal to this book in addition to checking all the text for technical accuracy. A veteran photographer (in the military sense of the word!), he contributed some of the best images in this book, and volunteered his expertise in Mac OS X for important behind-the-scenes testing of software and hardware.

Mike began his photo career in high school, where he first learned the craft and amazed his classmates by having Monday morning coverage of Saturday's big game pictured on the school bulletin board. Sullivan pursued his interest in photography into the U.S. Navy, graduating in the top ten of his photo-school class. Following Navy photo assignments in Bermuda and Arizona, he earned a B.A. degree from West Virginia Wesleyan College.

He became publicity coordinator for Eastman Kodak Company's largest division where he directed the press introduction of the company's major consumer products and guided their continuing promotion. Following a 25-year stint with Kodak, Sullivan pursued a second career with a PR agency as a writer-photographer covering technical imaging subjects and producing articles that appeared in leading trade publications. In recent years, Sullivan has used his imaging expertise as a technical editor, specializing in digital imaging and photographic subjects, for top-selling books.

Dedication

For Jonathan and Teryn.

Acknowledgments

Once again thanks to Andy Shafran, who realizes that a book about working with color images deserves nothing less than a full-color treatment, and knows how to publish such a book at a price that everyone can afford. It's refreshing to work for a publisher who has *actually written* best-selling books on imaging, too. Also, thanks to senior acquisitions editor Kevin Harreld, for valuable advice as the book progressed, as well as project editor, Jenny Davidson; book/cover designer, Chad Planner, *Pop Design Works*; interior designer, Bill Hartman; proofreader, Kate Shoup Welsh; and indexer, Sharon Shock.

Also thanks to my agent, Carole McClendon, who has the amazing ability to keep both publishers and authors happy.

Special thanks go out to Konica Minolta Photo Imaging U.S.A. for their extended loan of a top-of-the-line digital camera for the half-year it took to produce this book. I worked with more than a dozen digital cameras to produce the images you'll find in these pages, from teensy point-and-shoot snapshooters through 14-megapixel professional models. But time and again, when the chips were down, I kept returning to my Minolta DiMAGE. Why? I'm a photographer, and the DiMAGE operates like an honest-to-gosh *camera*. The results were great, too.

Contents

PART II : TECHNIQUES UNLIMITED

APPENDIX

Preface

This isn't a digital camera book. It's a book about digital *photography*: how to take great pictures and make great images using imaging technology, while taking into account the special needs of digital cameras. Whether you're a snap-shooting tyro or an experienced photographer moving into the digital realm, you'll find the knowledge you need here. Every word in this book was written from the viewpoint of the serious photographer.

This isn't just a photography book, either. It's a *digital* photography book. The focus is on the special capabilities and needs of computer imaging. You'll learn how to take close-up photographs with cameras that have optical viewfinders, and techniques for producing professional-looking portraits with cameras that aren't designed to work with multiple light sources. No fast shutter speeds? No problem! You'll learn a professional sports photographer's secret for stopping action with any camera. It's time you stopped taking snapshots and started taking photographs!

Introduction

All too often, digital photographs are taken with a "Ready, Fire, Aim!" approach. In an age when both "point and click" and "point and shoot" have come to represent no-brainer simplicity, there are many serious photographers who want their photos to reflect the serious thought they put into them.

That's not to say you need to sit for hours (or even minutes) contemplating each photo you take. "Serious thought" may take only a moment or two deciding what you want to accomplish with a photo, and another few seconds examining your composition in the viewfinder. The difference between casual snapshooting and serious photography is often nothing more than an awareness of the process gained through practice and experience.

Truman Capote was thinking of the process of writing, not photography, when he rebuffed the work of a hack author by remarking, "That's not writing—that's typing." Just as writing is more rewarding than mindless typing, you've already discovered that pointing your camera and pushing the button isn't photography, and it isn't particularly satisfying. Whether you're trying to capture an image that will hang in a gallery, grabbing a shot for publication, or attempting to create a digital treasure chest of vacation memories, you'll enjoy your digital camera a lot more if you put some thought into what you're doing.

It's time to move to the next level, and this book will help you. The first step is to know where you're going, and to understand the tools you'll be using. Then, you need to master the simple techniques that separate the amateurs from the pros. You'll find all that information between these covers.

Why Another Digital Photography Book?

There are easily one hundred books that purport to address the topic of digital photography. I've written seven of them myself. Do we really need another book on the topic?

In truth, I've been busy writing books on various aspects of digital photography because I think there is a serious shortage of books written from the photographer's viewpoint. Too many of the books on the shelves concentrate on the gee-whiz aspects of the technology and stuff that's only peripherally related to picture taking. I examined several dozen existing books before sitting down to write this one. They averaged about 16 chapters each, which broke down into, unfortunately, perhaps only three or four chapters that actually dealt with digital photography. These were prefaced by chatty chapters explaining the history of digital photography, the pros and cons of digital cameras, and acronym-hobbled discussions of CCD, CMOS, and CIS image sensors. There were thick sections on selecting storage media, and each had perhaps half a dozen chapters on image editing.

I dispense with most of the background "historical" stuff with a few pages in Chapter 1, "Digital Photography from 50,000 Feet." I suspect you don't need any convincing that digital imaging is cool, and you probably have little interest in ancient history. I figure that you don't really want to know much about amorphous semiconductors, you wouldn't bother to read separate chapters on digital camera peripheral devices, and if you want a Photoshop book, you'll buy a Photoshop book. (If you're serious about image editing, *Photoshop CS Photographers' Guide* from Muska & Lipman is a good choice.)

The manual that came with your camera probably has lots of great tips on how to turn it on, focus, and snap off a picture. I'm going to concentrate on what your camera's controls mean to your photographs, not how to access them. There are plenty of general-purpose photography guides that apply equally to point-and-shoot film cameras as to the average digital model. This book concentrates on creative techniques for the digital photographer. There are enough nuts and bolts in the first four chapters, and image editing is mentioned only in passing as it applies to particular techniques. The rest of the book deals with honest-to-gosh photography. If you have a Windows PC or Macintosh and a digital camera, you'll find what you need here. You'll learn:

- Creative posing for portraits
- How to capture close-up scenes on your desktop using the digital camera's special capabilities
- How to use this book's lighting diagrams to get professional portrait lighting the first time
- Ways to capture breathtaking scenic photographs
- Action photography techniques the professionals use to counter shutter lag problems
- Inside information on the latest digital sensors and emerging technologies
- Professional tips for removing defects *before* taking the picture
- Easy special effects that can transform any photograph

What is *not* contained in this book is as important as what you'll find here. The shrewd folks at Muska & Lipman/Course Technology recognize that digital photography is a huge topic, so all the things I don't address fully within these pages are covered in other books in the Photography line of books. These include:

Photoshop CS Photographers' Guide. This book serves as an introduction to intermediate and more advanced Photoshop techniques, specifically from the photographer's viewpoint.

Digital Retouching and Compositing Photographers' Guide. Here you'll find everything you need to know to turn your shoebox reject photos into triumphant prizewinners. It covers both eliminating defects and repairing pictures, and also more sophisticated techniques for combining two or more images into a realistic (or, if you choose, fantastic) composite.

Mastering Digital Scanning with Slides, Film, and Transparencies. Shooting pictures on negative films or slides doesn't lock you out of the digital-imaging realm. Low-cost film

scanners, as well as flatbed scanners with film-scanning capabilities and third-party scanning services make it easy for *anyone* to manipulate images captured by silver instead of silicon. This book is your introduction to a whole new world of digital imaging possibilities.

What You'll Find Here

I've tried to pack this book with exactly the kind of information you need to graduate from snapshooting to serious photography. It's divided into two parts. One part gives you the background you need to understand the special requirements of digital photography. You'll learn a little of how digital photography works, why so many options, features, and formats exist, and how you can use these to improve your pictures. The second part deals with professional techniques that anyone can use to take better action photos, portraits, scenics, close-ups, and other kinds of pictures. You'll find an outline of the chapters in Parts I and II at the end of this Introduction.

I'm especially proud of the hefty illustrated glossary I put together for this book. It's not just a word list, but, instead, a compendium of definitions of the key concepts of photography. You'll find all the most important terms from this book, plus many others you'll encounter while creating images. I've liberally sprinkled the glossary with illustrations that help clarify the definitions. If you're reading this book and find something confusing, check the glossary first before you head to the index. Between the two of them, everything you need to know should be at your fingertips.

Who Are You, Anyway?

Mastering Digital Photography is aimed squarely at digital camera buffs and business people who want to go beyond point-and-click snapshooting and explore the world of photography to enrich their lives or do their jobs better and smarter. If you've learned most of your digital camera's basic features and now wonder what you can do with them, this is your dream guide to pixel proficiency. If you fall into one of the following categories, you need this book:

- Individuals who want to get better pictures, or perhaps transform their growing interest in photography into a full-fledged hobby or artistic outlet.

- Those who want to produce more professional-looking images for their personal or business website.

- Small business owners with more advanced graphics capabilities who want to use photography to document or promote their business.

- Corporate workers who may or may not have photographic skills in their job descriptions, but who work regularly with graphics and need to learn how to use digital images for reports, presentations, or other applications.

- Professional webmasters with strong skills in programming (including Java, JavaScript, HTML, Perl, and so on) but little background in photography.

- Graphic artists and others who may be adept in image editing with Photoshop or another program, but who need to learn more about digital photography.

- Trainers who need a non-threatening textbook for digital photography classes.

Who Am I?

Perhaps introductions are in order, but maybe not. You may have seen my photography articles in *Popular Photography & Imaging* magazine. I've also written about 2,000 articles for *Petersen's PhotoGraphic*, *The Rangefinder*, *Professional Photographer*, and dozens of other photographic publications. You can find my opinions about digital photography on CNet, too (www.cnet.com). First, and foremost, I'm a photojournalist and made my living in the field until I began devoting most of my time to writing books.

Most digital photography books (I call them digital *camera* books) are not written by photographers. Certainly, the authors have some experience in taking pictures, if only for family vacations, but they have little knowledge of lighting, composition, techie things like the difference between depth-of-field and depth-of-focus, and other aspects of photography that can make or break a picture. The majority of these books are written by well-meaning folks who know more about Photoshop than they do about photons.

Mastering Digital Photography, on the other hand, was written by someone with an incurable photography bug. I've worked as a sports photographer for an Ohio newspaper and for an upstate New York college. I've operated my own commercial studio and photo lab, cranking out product shots on demand and then printing a few hundred glossy 8 × 10s on a tight deadline for a presskit. I've served as photoposing instructor for a modeling agency. People have actually paid me to shoot their weddings and immortalize them with portraits. I even prepared press kits and articles on photography as a PR consultant for a large Rochester, N.Y., imaging company. My trials and travails with imaging and computer technology have made their way into print in book form an alarming number of times, including nine tomes on scanners and seven on digital photography.

So, what does that mean? In practice, it means that, like you, I love photography for its own merits, and I view technology as just another tool to help me get the images I see in my mind's eye. It also means that, like you, when I peer through the viewfinder, I sometimes forget everything I know and take a real clunker of a picture. Unlike most, however, once I see the result, I can offer detailed technical reasons that explain exactly what I did wrong, although I usually keep this information to myself. (The flip side is that when a potential disaster actually looks good, I can say "I meant to do that!" and come up with some convincing, but bogus, explanation of how I accomplished the "miracle.")

This combination of experience—both good and bad—and expertise lets me help you avoid making the same mistakes I sometimes do, so that your picture taking can get better with a minimum of trial-and-error pain.

I hope this book will teach anyone with an interest in computers and/or photography how to spread his or her wings and move to the next level. This book will reveal the essentials of photography and the important aspects of digital technology without getting bogged down in complicated details. It's for those who would rather learn the difference between a digital and an optical zoom, and how it affects their picture taking than find out which type of image sensor is the best; although, I do briefly cover that topic, because I think it's possible to feed your technology curiosity without neglecting meaty photographic aspects.

What You Need

A few of you will be reading this book to satisfy your curiosity about digital photography before actually taking the plunge and buying a camera or scanner. The information here may help you decide just how much camera you need.

However, most of you already own a digital camera and want to know, "Is this book for me?" That's an excellent question, because books that try to do everything invariably provide too little information for each of its audiences. I'm going to target information for a broad range of the digital picture-taking public, but if you can satisfy a few prerequisites, you'll find this book will be much more useful to you.

I'm going to assume that your digital camera has certain minimal features common to the most widely used digital models, in terms of resolution, an LCD viewing screen, removable storage, and automated features. If you have a camera that exceeds the minimum specs, each chapter will offer additional suggestions of things you can do with your premium capabilities. If you happen to own a camera that doesn't quite meet the recommendations, I'll have suggestions on how to work around your limitations.

I'm not going to name specific models, for the simple reason that model names are irrelevant. One of the cameras I use regularly is an old Epson PhotoPC 600 dating from the latter years of the last millennium. Many of you will be using much newer basic cameras with similar features and capabilities, so the exact model you or I use doesn't matter. So, when I talk about an 11-megapixel camera, or a 6-megapixel device, or even something between 2 and 4 megapixels, I mean to refer to those kinds of cameras generically, not a specific model. The techniques in this book apply to all digital cameras within the rough groupings I'll outline in Chapter 2.

For most of the techniques in this book, I'll assume you have a digital camera with at least 2 to 3 megapixels of resolution. (If you don't understand resolution right now, don't panic; I'll explain what all these megapixels mean in Chapter 2.) A camera with a 2-megapixel sensor corresponds to about 1600 × 1200 pixels, which is enough detail to give you decent 6 × 8-inch prints at 200 dpi printer resolution. A 2-megapixel camera also can capture enough information to allow some cropping, especially if the image will be used on a web page, where high resolution isn't necessary.

If you have a camera with less resolution, that's okay, too. I'll show you how to get the most from your resolution, which is plenty for web pages and 4 × 5-inch prints. As I mentioned earlier, my trusty old 1024 × 768 max resolution Epson camera still gets plenty of use, particularly at its lowest 640 × 480 setting for eBay auction pictures that must be kept slim and trim for efficient downloading.

Should your digital camera have 6 megapixels of resolution or more, you'll have even more flexibility. You'll be able to make larger prints, as full-size 8 × 10-inch prints are possible even at the 2048 × 1536 resolution of a 3-megapixel camera. You can also crop small sections out of the center of your pictures, and create more subtle effects. I'll have some suggestions for those who have these more advanced cameras, too.

The other most important basic specification will be your lens. To get the most from the techniques in this book, you should have a zoom lens with a 2:1 or 3:1 (or better) zoom ratio and, preferably, a close-up focus setting. Some of the most interesting effects call for a wide-angle or telephoto look and a close viewpoint. However, even if you have a low-cost digital camera without a zoom or close-up ("macro") capability, I'll show you how to use what you have to get similar effects.

Most of the other components, such as amount and type of memory storage, manual/automatic exposure and focusing options, built-in flash capability, and so forth can vary widely. You'll learn how to make the most of each of these features.

Chapter Outline

Here's a breakdown of what you will find in this book:

Part I: Your Lean, Mean Pixel Machine

This part will provide both an overview and a detailed look at digital photography and digital cameras from a photographer's perspective. How has digital technology changed photography? How are cameras changing now, and what will they be like in the future? How can a digital photographer choose a camera that does what is needed today and tomorrow? How do camera controls differ between film and digital cameras?

Chapter 1: Digital Photography from 50,000 Feet

This chapter focuses on the rapid convergence of conventional photography and digital photography, in terms of features, capabilities, techniques, and price considerations. It outlines the skills film photographers already have that are directly transferable to digital photography, and shows how those skills actually become enhanced given the special features of digital cameras. The goal here is to create excitement among photographers who have worked with conventional cameras, showing them how they are well prepared to move smoothly into digital photography with the help of this book.

Chapter 2: Inside a Digital Camera

Serious photographers have always been gadget freaks, even before solid-state technology began to intertwine itself into the workings of conventional cameras in the 1980s, and gave birth to the all-electronic digital cameras of the 1990s and 2000s. This chapter provides an inside look at how digital cameras work now, and some information on how they will work in the very near future when breakthroughs like the Foveon sensor become more widely used. You'll learn about lenses, sensors, storage, and other topics.

Chapter 3: Mastering Camera Controls

Although every camera uses different buttons and menus to control key features, nearly every digital image-grabber includes some variation on the basic array of controls. This chapter provides an overview of the controls a digital photographer must master, and includes descriptions of how these controls differ between digital cameras and film cameras. You'll learn about the different exposure modes and how they can be used creatively. You'll master focusing tricks, use of shutter speeds, and choosing resolution and compression settings that best suit the kind of pictures you're taking.

Chapter 4: Dealing with Digital Camera File Formats

The average amateur photographer with a digital camera just points and clicks, without a thought about which file format, from among those offered by a particular camera, is the best. More serious photographers will want to know why optional formats are offered, and how to choose the right one for a particular shooting session. This chapter covers each of the major formats, why they exist, and how you can use them to your advantage.

Part II: Techniques Unlimited

This part is all photography, written from the viewpoint of someone who wants to take better photographs and who probably has some experience with a conventional film camera. Each chapter will jump into a different type of photography and explain exactly what special demands digital photography makes as well as the special capabilities of a digital camera. Although each chapter explains all the jargon used, and will be written so that even photography tyros can catch up quickly, the text will explore each topic in more depth than found in digital photography books written by computer guru/amateur photographers. Each chapter will be sprinkled with "Tips from the Pros," which are special tricks that pros use, and that amateurs would use if they knew about them.

Chapter 5: Action Photography

Action isn't limited to sports! Whether your subject matter is your kids' Little League or soccer teams, or the company picnic, bowling tournament, or company products in action, you'll need these tips on grabbing fast-moving subjects. You'll learn how to stop action, choose your shooting spots, and use flash. Some of the topics covered include stopping action, using motion blur, and coping with fast-moving events.

Chapter 6: People Photography

This chapter covers tips and tricks for photographing people for attractive portraits. Learn how to arrange and photograph people pictures. Among the Tips from the Pros in this chapter is a sure-fire way to know whether any of your subjects in a group photo had their eyes closed during the shot (without squinting at your digital camera's LCD). Topics covered include group and individual portraits, with lighting diagrams that let you reproduce lighting techniques of the masters, as well as candid portraits.

Chapter 7: Scenic Photography

The wide-open spaces provide wide-open opportunities for capturing great photos, whether you're on vacation or just want to document the natural wonders around your home. This chapter includes topics such as filter tricks for great scenics, creating panoramas, and selection of lens zoom settings to get stunning nature and scenic photos.

Chapter 8: Architectural Photography

Photographing buildings, monuments, and other structures offers some special challenges. This chapter shows how you don't need a view camera to correct perspective, and ways to enhance photos of architecture to lift an ordinary shot of your home, office, or other structure to a new level. Among the topics are ways to correct for perspective distortion, and solving the typical digital camera's wide-angle "problems."

Chapter 9: Macro Photography

This chapter covers making your hobby collections or business products look their best whether on location or in a "studio" you can set up and take down quickly. Learn how to set up this quick-and-dirty "studio" with effective backgrounds and lighting, and use close-up techniques. Topics in this chapter will include simple plans for creating a close-up studio, or taking your shooting on the road. You'll also learn about depth-of-field, in depth, and how to choose add-ons to enhance your digital camera's close-up capabilities.

Appendix A: Illustrated Glossary

This section explains all the photography and digital imaging terms in the book, illustrated by photographs that will help you understand the terms more easily.

This part will provide both an overview of and a detailed look at digital photography and digital cameras from a photographer's perspective. How has digital technology changed photography? How are cameras changing now, and what will they be like in the future? How can a digital photographer choose a camera that does what is needed today and tomorrow? How do camera controls differ between film and digital cameras? And, hey! What are all those digital camera file formats used for?

As you can see, Part I is the nuts-and-bolts portion of the book, with everything you need to know to make the transition from serious film-oriented photographer (or even just a snapshooter) to digital-imaging proficiency. The first part gets you started making great digital images with your camera. You'll learn how to choose your equipment and operate the basic controls.

Then, in Part II, we'll get into the digital photography techniques that will spark your imagination and get your creative juices working overtime.

PART I

Your Lean, Mean Pixel Machine

1

Digital Photography from 50,000 Feet

Some amazing things have happened to the digital-photography world in the past few months. If we were looking back from a vantage point 10 years in the future, I'd say the real revolution began when Canon introduced its Digital Rebel in late 2003, a fully featured 6 megapixel interchangeable lens single lens reflex that cost less than $1,000, lens included.

At a time when glorified point-and-shoot digital cameras with fixed lenses and electronic viewfinders could cost that much, Canon's innovation caused the entire industry to regroup. First, such a low price point suddenly made digital photography more attractive to the millions of serious photographers who would settle for nothing less than an SLR, but who couldn't afford the $1,500 tariff on even the least expensive models. Second, the presence of a $1,000 SLR on the market meant that everyone else's non-SLR models became much less attractive at that price. Vendors began dropping prices, packing their new cameras with more features, and digital photography immediately became even more of a booming mainstream consumer trend than ever before. At these prices and with these capabilities, ordinary film cameras are in deep trouble.

Even without the recent unexpected dramatic growth of digital photography over the past few years, I've watched in amazement as perfectly good photographers transformed themselves, one after another, into computer nerds. It's not hard to understand their motivation: successful photographers have an unusual combination of artistic eye, dedication to a demanding craft, a huckster's knack for self promotion, more than a smattering of good business sense, and an affinity for the mechanical and electronic gadgetry that make up our cameras and darkroom equipment. Digital photography is, on one level, just another outrageously powerful kind of

photo gadget. If you liked autofocus, can't live without automatic bracketing, and think databacks are cool, you'll love digital imaging.

In fact, if you're an avid photographer, your interest in digital photography probably predates practical digital photography itself, because affordable electronic models that could compete with traditional film cameras have been available for only five or six years. This is one technology in which all of us are getting in on the ground floor.

For photographers who have longed for decades for the kind of capabilities that digital photography brings to the table, this is the best of all times to be taking pictures. You're probably the happiest clam on the beach as you watch technology finally catch up to your needs.

And things are only going to get better.

However, it's been a long and strange trip. Only a photographer can truly appreciate how weird it is that the ability to correct, retouch, edit, and manipulate digital pictures with a computer became common a full decade before the technology to *originate* images in digital form became practical for the average picture taker. How is it that we had Photoshop back in the 1990s, but had to wait for practical digital cameras until the 21st century? Certainly, the ability to edit conventional photographs within image editors like Photoshop (after the photos are duly scanned and digitized) is valuable whether digital cameras are widely used or not. But doesn't it make more sense to eliminate that intermediate step? Doesn't digital image editing cry out for digital *photos*? Figure 1.1 shows what the Photoshop interface looked like roughly 10 years ago on a Macintosh Quadra 650. Figure 1.2 shows how far we've come, with a shot of the latest version running on a Pentium 4 that operates roughly 80 times faster.

Figure 1.1 *This version of Photoshop was introduced even before practical digital cameras were available.*

Figure 1.2 *Today, the latest version of Photoshop CS is ready for anything your digital camera can produce.*

Yet, while Photoshop is blossoming into its eighth edition, Photoshop CS, we're just now seeing affordable digital cameras that can truly do everything a serious photographer's film counterpart can handle. You're probably thinking "about time!" along with millions of other picture takers.

This book is going to delve a little deeper into digital *photography* than many of the books you might have read. Unlike most of the other books on the shelf, this is a *photographers' guide*, designed to leverage the things you already know about photography as you spread your wings in the digital realm. This first chapter is intended to be an overview of digital photography and technology—a glimpse from 50,000 feet that provides you with some perspective on where we are, where we're going, and how we got here.

You might not have seen background information like this in the digital camera books you've read—probably because the authors weren't photographers. A computer guru who understands microprocessors and software applications might have no clue as to what makes a great image. However, if you're serious about photography, you know that simple knowledge of the mechanics of taking pictures isn't enough. You must also have the right tools, know how they are best applied, and understand how to use them. That's what you'll be gleaning from this book.

You'll learn exactly how digital technology frees us to do things with images that could only be accomplished by tedious work and experimentation with conventional tools. Photographers who have darkroom experience might have combined images with double exposures, sandwiched two slides together, cross-processed chromes in color-negative developing

solutions, or pushed super-fast films to ridiculous exposure indexes to get a particular effect. These techniques usually involve more error than trial when you're working with conventional films. With a digital camera, you can instantly reshoot a picture until you get the results you want. The computer—both the one on your desktop and the one built into your camera—gives you the freedom to tweak, re-tweak, and start over if the final results don't please you. Indeed, there is a whole litany of tricks that couldn't be done at all before the introduction of digital imaging.

Individual image components can be isolated, combined with other components, reversed, rebalanced, or removed entirely with barely a trace of what has been done remaining for the casual eye to detect. We can relocate the Great Pyramid of Egypt, show Elvis shaking hands with aliens from space, or remove an intrusive mother-in-law from a bridal portrait.

More than anything else, digital photography is fun. Most of us, even though we're capable of doing good work with simple equipment, don't hesitate to take advantage of all the tools that are available. So, it was only a matter of time before digital imaging started seducing photographers who previously did not intend to use computers. As cameras became more electronic and computerized, it was a logical next step to incorporate scanned images, electronic retouching, and eventually digitally originated images into the average photographer's repertoire. That's why so many perfectly good photographers have found it necessary to become computer nerds.

How You Got Here

The path to digital photography has almost as many roads as those leading to Rome. Many of you probably first discovered the joys of film-based photography. Perhaps you yearned to transcend the ordinary vacation photograph and bring back pictures that would provide memories that would last a lifetime. Or, you might have discovered photography as an artistic outlet, either because you lacked skills with a brush or chisel or simply saw images in your head that could only be made tangible through creative picture taking.

In my case, photography first became a full-time occupation when I applied for a job as a reporter for our local newspaper and found that they needed my budding skills as a photographer more than they needed additional writers. The fit proved to be a good one, and after turning in a few well-crafted three- and four-page cutlines for some of my solo photography assignments, I earned my first hyphen, as a reporter-photographer. I spent almost 10 years as a photojournalist before I sat down in front of my first personal computer, so it's safe to say that conventional photography was ingrained in my system long before the first digital cameras impinged on my consciousness.

Photography also attracts adherents who never dreamed they'd one day love peering through a viewfinder. You might be an eager cog in some corporate wheel, who discovered that photos can spice up your PowerPoint presentations or enhance your résumé. What starts as a lark—maybe, snapshooting at company picnics—can easily develop into a reputation as the only staff member who really understands photography. You might be a webmaster looking to improve your personal site or that of your organization. Even the most dedicated computer nerd can

discover the joys of graphics processing, and from there, it is only a short step to photography and digital photography.

No matter how you got here, it's safe to say you're hooked.

How the Technology Got Here

For millennia, text and pictures were more or less equals: scribes illuminated or illustrated a manuscript at the same time the text was drawn. The only technology involved was, say, a quill pen and the tools used to sharpen it. When both text and graphics were hand-drawn, it took a little longer to create an illustration, but, as they say, a sketch is worth a thousand words. Until the invention of movable type, text and graphics merged seamlessly, with neither form of visual communication having a "technological" advantage over the other. Of course, manual methods sharply limited access to visual information, unless you were royalty, rich, or worked in a profession that required literacy.

That balance between text and graphics changed dramatically when movable type simplified the printing of books about 500 years ago. The distribution of text suddenly became several orders of magnitude easier than the reproduction of images. Movable type let text reach the masses, but pictures still had to be laboriously carved as woodcuts, engraved in steel, or converted to halftone dots before they could be printed. The transmission of words by telegraph predated wirephotos and fax machines by roughly a century, and the first 35 years of the Computer Age were dominated by text and numbers. Newspaper advertisements in the 1860s were better illustrated than accounts of the Civil War, and computer artists a century later sometimes created portraits by assembling ASCII characters into crude mosaics (if you've seen these, you'll know why they were considered crude).

It's only been in the past few years that digital imaging has provided the technology we need to meld text and pictures seamlessly with our documents, computer presentations, web pages, and other electronic media.

The advantages of digital imaging are simple: if you have a digital camera, computer, and printer, you can capture images, refine or retouch them, and distribute them though printouts, e-mail, or web pages. You can accomplish all these things in the span of a few minutes or hours without relying on film manufacturers, photofinishers, professional retouchers, or, in most cases, the postal system.

The disadvantages? Digital cameras still cost more than point-and-shoot film cameras of equivalent features and quality. Digital "film," while almost infinitely reusable, is expensive to buy. Computer-generated prints are still more costly than the drugstore kind. But, to be fair, you buy your camera and "film" once and then forget about it, and you print only the images you really want—not whole rolls of pictures that end up in a shoebox.

As recently as two centuries ago, unless you had met a relative personally or came from a family wealthy enough to have commissioned a portrait, you probably didn't even know what your ancestors looked like. Your own grandfather might have been a stranger to you. Today,

you can snap a picture of the old geezer with your digital camera and e-mail it to a long-lost relative who might never be able to drop by for a visit. The average computer owner today can do useful things with images that were beyond the imagination of the wealthiest royalty in the past.

Even though we're currently immersed in a transition from conventional film photography to digital photography, the two technologies actually have very little in common, except on an abstract level. Digital photography didn't evolve from film imaging any more than audio CDs evolved from phonograph records or magnetic tape cassettes. While the technologies serve the same needs, their origins are very different. Traditional photography has its roots in chemical technology, which gave us photosensitive films, plates, and papers. Digital imaging comes from a foundation of electronics (even though digital sensors are created chemically). The chief technological convergence between the two lies in the optical and exposure systems of cameras: both film and digital cameras use lenses, viewfinders, and lens apertures.

We can skip the history of conventional photography entirely, and jump ahead roughly 100 years to 1951, when Bing Crosby Laboratories (yes, *that* Bing Crosby) developed the first videotape recorder to convert live TV images to a format that could be stored onto magnetic tape. A few years later, Ampex marketed the first commercial VTR for a whopping $50,000. Although TV cameras had been available previously, the ability to *save* those images permanently really marks the beginnings of digital photography. Video cameras and digital cameras generally use a sensor called a CCD (charged coupled device), developed in 1970 (although other types of sensors will be important in the future). The early VTRs are truly the granddaddies of our present day digital cameras.

WHICH CAME FIRST?

A case can also be made for scanners, first developed by Kodak in the mid-20th century, as a progenitor of the digital camera. However, scanners capture information line-by-line over a period of time and are limited to objects that can be placed close to the scanner's sensor. Video systems also scan, but take only 1/30th of a second, and can grab anything the eye of the video camera can see.

True digital photography came later in stages, nudged along by your tax dollars at work. In the 1960s, NASA converted from analog to digital signals for the lunar missions that mapped the surface of the moon, because, as you probably know, analog signals can fade in and out, whereas digital information can be captured virtually error-free. The first heavy-duty image processing was developed in this era, as NASA put the power of computer technology to work, enhancing the images returned by its various space probes. The Cold War, replete with spy satellites and various super-secret imaging systems, also helped push the development of digital photography.

The first film-free electronic camera was patented by Texas Instruments in 1972. One of the patent drawings for this system is shown in Figure 1.3. The chief drawback of this system was that it would have required viewing the still photos on a television. TV viewing was also an

option for the Sony Mavica, introduced in August, 1981 as the first commercial electronic camera. However, the Mavica could also be attached to a color printer. Yet, even the Mavica wasn't a true digital camera; it was more of a video camera that was able to capture and display individual frames.

Figure 1.3 *The first filmless electronic camera was patented by Texas Instruments more than 30 years ago.*

The Mavica (for Magnetic Video Camera) recorded up to 50 images on two-inch floppy disks with a 570 × 490-pixel CCD sensor rated at the equivalent of ISO 200. It had a single shutter speed of 1/60th of a second, a manual aperture setting, and three interchangeable lenses in 25mm wide-angle, 50mm normal, and 16-65mm zoom focal lengths. The system might seem primitive today, but keep in mind that the original Mavica was developed almost 25 years ago!

The emergence of electronic photography in the 1980s was particularly exciting for me. I was doing work for Eastman Kodak Company (an early leader in digital photographic technology) as a technical writer and helped introduce products like the first megapixel sensor, the Kodak Photo CD system, and the Kodak DCS-100. Based on a Nikon F3 body and priced at $30,000, this was one of the first digital cameras I ever used. (Thanks to a Kodak loan; I certainly couldn't have afforded to *buy* one!) This pioneering system had a 1.3 megapixel sensor (about the same resolution as many $100 digital cameras today), and stored its images on an external 200MB hard drive. The total kit weighed 55 pounds, so only well-muscled and well-heeled photographers who needed to make prints no larger than 5 × 7 images could justify one of these babies.

WHO NEEDED A 1.3 MEGAPIXEL, $30,000 DIGITAL CAMERA?

Among the earliest users of digital cameras were news magazines and newspapers. They found the digital camera to be ideal for beaming spot news photos back to photo editors moments after they were taken. All the photographer needed was a digital camera, a telephone, and a device for sending the photo's bitstream over the phone lines. Before the advent of digital cameras, news organizations would set up makeshift darkrooms at sites where news was breaking, develop film, and then transmit images back using facsimile devices. Digital cameras were at least an hour faster, and well worth the $30,000 investment!

Other early adopters of expensive digital cameras were catalog photographers, who could create a lighting setup and then capture dozens (or hundreds) of electronic photos, one after the other, each ready for immediate placement into a computerized layout.

The whole decade of the 1990s was a tantalizing one, as vendors with their roots in conventional photography (such as Kodak and Fuji) vied with more electronics-oriented firms like Apple, Casio, and Sony to produce digital cameras that, at $500 to $1000, were actually affordable. Unfortunately, early models like the Apple QuikTake 100 (1994), the Casio QV-11 (introduced late in 1995 with an LCD monitor), and my own first Epson PhotoPC 600 (1997), were handicapped by what we today would consider to be extremely low resolution, ranging from 320×240 to 1024×768 pixels. Digital cameras of that era had just enough muscle to make them attractive, but not enough to make them useful, except for illustrating web pages or (in my case) for quick snapshots published as two-inch wide illustrations in books and magazines.

Digital photography really didn't start to take off until the new millennium, when sensors with two megapixels or more of resolution, built-in zoom lenses, and inexpensive removable storage devices like CompactFlash and SmartMedia began making digital cameras the functional equivalent of their film counterparts (in many ways) at prices that anyone who really needed digital imaging could afford.

The availability of $100-$200 inkjet printers that could produce inexpensive photo-quality prints didn't hurt either. Digital photographers might work with their images on-screen, but they still want to be able to create prints to pass around, send to relatives who don't have electronic mail, or paste into albums. In some respects, photo printers were the last piece of the puzzle needed to make digital photography popular to the masses.

Transferring Skills

As a photographer, you've accumulated a lot of useful knowledge and skills that help you take better pictures than the average snapshooter. For example, you know not to shoot into the sun (unless you're looking for a silhouette), and that the tiny built-in flash on a point-and-shoot camera isn't powerful enough to capture the lead singer at a concert when you're seated in the balcony.

You've instinctively learned to hold the camera steady when shooting in dim light, or to take multiple shots when photographing groups, because *somebody* in each photo is going to be making a face or have his eyes closed. You might not even be aware of all the photographic techniques you use automatically, but being photo savvy does offer an important edge when it comes to making outstanding pictures. The good news is that, despite the differences in technology, most of what you've learned can be transferred directly to digital photography. An experienced film photographer making the transition to digital photography always has an edge over a beginner.

The photographic skills you possess become even more useful when you begin editing your digital photos in Photoshop or another image editor. Terms like *lens flare*, *motion blur*, and *grain* are probably familiar to you. If you are a more advanced photographer, you might understand techniques like *solarization*, or perhaps even graphic reproduction concepts like *halftones*, *mezzotints*, or *unsharp masking*. Those whose perspective is more pixel- than photography-oriented must learn these terms the hard way. Photography can sometimes appear to be a highly technical enterprise to those who just want to take a picture.

Fortunately, serious photographers have always been a little gadget-freaky. Early photographers built their own cameras, and through the years photographers have continued to craft their own custom-built devices and accessories. Today, you'll still find that some of the coolest gadgets for photography are home-brewed contraptions. The first photographers also had to be something of a scientist, as they experimented with various processes for coating and sensitizing plates and film, exposing images by the illumination from electrical sparks.

Until electronic photography began making inroads, the avid photographer with a home darkroom still dabbled in photographic chemistry as a way to increase the sensitivity and improve the image quality of his film through refined darkroom technology. Now that many chemical tricks can be reproduced digitally, photo alchemy has become the exception rather than the rule. I still have a darkroom in my basement, but it's been gathering dust for the last decade. The joys of working with images in the darkroom have been supplanted by computerized image processing.

So, while many of the skills a digital photographer needs to acquire are the same, others are very different. You no longer need to know how to build a camera or mix chemicals. Instead, a basic familiarity with computer technology has become something of a prerequisite for using microprocessor-driven digital and conventional film cameras. But, while photography has become "easier," don't underestimate the wealth of knowledge and skills you've picked up. The things you already know will stand you in good stead when you advance to digital photography and computer-enhanced photo manipulation. The skills you can continue to refine and use fall into 10 broad categories. I'll run through them quickly in the next sections.

Basic Composition

Compositional skills, so necessary for lining up exactly the right shot in the camera, are equally important in conventional and digital photography. Your finished product should be well-composed regardless of how it was captured. The chief difference in the digital realm is that image editing can let you repair compositional errors after the fact. If you want your subjects

in a group shot to squeeze together for a tighter composition, Photoshop lets you rearrange your subjects. If you discover you've overlooked a tree that appears to be growing out of the head of one of your subjects, you can remove it. However, it's still important to be able to spot these photographic faux pas when they crop up. The ability to recognize good composition and put it into practice is an invaluable skill that not all photographic beginners have. Figure 1.4 shows the kind of compositional corrections a serious photographer makes almost instinctively.

Figure 1.4 *Ooops! What's growing out of the statue's head? Simply taking a step to one side improves the composition.*

Lens Selection

Beginners don't think about the choice of a lens or lens setting at all. The only thing they care about is that their camera can "zoom in" on something far away and make it appear closer or "zoom out" to let them include more of a scene in the photo. Photographers, on the other hand, understand that the choice of a particular lens or zoom setting can be an important part of the creative process. For example, telephoto settings compress the apparent distance between objects, making them appear to be closer together. Cinematographers use this telephoto trick when the hero of a flick runs in and out of traffic, apparently just missing vehicles that are actually dozens of feet apart. Wide-angle settings expand in the apparent distance, giving you vast areas of foreground while making distant objects appear to be farther away. Faces can seem to be broader or narrower depending on lens selection, too.

The perspective of different lenses and zoom settings operates in similar ways within both the conventional and digital photographic worlds. The chief difference you'll notice in digital photography is that your choice of settings is liable to be more limited. The typical digital wide-angle view isn't very wide at all, frequently no broader than you'd get with a 35mm lens on a film camera. The longest telephoto effect you might achieve can be no longer than the equivalent of 200mm with a film camera. Digital "zooming" can electronically enlarge a portion of your image to simulate a longer telephoto lens, but the quality often suffers. Even

so, if you know how to use your lens arsenal with a film camera, you can apply the same concepts to digital imaging.

Selective Focus

One thing that differentiates the knowledgeable photographer from the snapshooter is the ability to use focus to isolate or emphasize portions of a subject. When one thing is in focus and the rest of the image is blurry, our eye is automatically drawn to the sharp portion of the image. Whether you're using a conventional or digital camera, you need to make these decisions at the time you take the photo. Unfortunately, the process is complicated with most digital cameras, because virtually everything in a digital image might be sharp, regardless of what lens settings you use. I'll get into the reasons behind this in Chapter 3, "Mastering Camera Controls." On the plus side, those working with digital images have tools that are not available to the traditional photographer. An image editor can apply selective focus effects quickly, and in a much more precise, repeatable, and easily modified way.

Indeed, one of the key advantages of applying effects in an image editor is that you don't have to risk ruining an original piece of film every time you experiment.

Choosing the Right Film

Just as a painter chooses a palette of colors or a sculptor selects the right piece of marble or clay, traditional photographers have long been able to select a film with the characteristics they need for their images. Each variety and brand of film has a personality of its own, which, quite literally, colors your image with subtle nuances of contrast, texture, and hue. For example, some films are more sensitive than others, offering the ability to capture images in less light or with shorter shutter speeds to freeze action. Of course, these fast films tend to have higher contrast, more grain, and muted colors.

Other films manipulate the contrast/texture/hue triad in different ways. Some are known for their bright, vibrant colors or their ability to reproduce flesh tones realistically. Professional photographers often rely on an array of films formulated for these characteristics, selecting the film with bright colors and snappy contrast for product photography to make inanimate objects more attractive. An entirely different film might be the choice for portrait or wedding photography, when accurate skin tones and a softer, more flattering look are desired. These films tend to be lower in speed and have more compact grain, so the texture of the film becomes invisible.

Still other films are selected solely because of their sharpness or finer grain, which makes it possible to make bigger enlargements. Some films are chosen specifically because they will be used for some sort of darkroom manipulation, such as "cross-processing," when a color transparency film is processed in chemicals designed for color negative films (and vice versa). As you can see, film photographers have a rich set of film tools to choose from.

Digital photographers have fewer options when *taking* a photo, because most of the characteristics of the digital sensor are hardwired into the solid-state device. However, digital picture takers have many more options when *making* the picture within an image editor, as

contrast, texture, and color can all be modified to an extent much greater than is possible through selection of a conventional film alone.

However, you can make some adjustments that control how your digital "film" behaves. Most digital cameras let you change the sensitivity of the sensor by adjusting the ISO rating (which is roughly equivalent to the ISO film speed). If you opt for a higher rating to shoot in lower light or at faster shutter speeds, quality will suffer the same as with higher speed films. Instead of grain, you'll get electronic artifacts, a kind of fuzziness that does resemble film grain in many ways. Other digital camera controls might let you change the color sensitivity ("white balance"), image contrast, color saturation ("richness"), and other characteristics. In these cases, though, you're not really modifying your digital film (the sensor) as much as you're telling the camera's built-in computer chip what image processing changes to make to the raw data as an image is stored in memory.

The latest digital cameras let you adjust characteristics such as contrast and saturation before you take the picture, in effect, letting you choose the kind of digital film you're using. The two photos of some artificial flowers shown in Figure 1.5 were taken seconds apart with a digital camera mounted on a tripod.

Thanks to intelligent design by the camera manufacturer, switching from one saturation level to another required only pressing a single button and turning a control wheel. The top photo shows the cloth flowers as they actually appeared in the shade on an overcast day. The bottom version brings the fake blooms to life with a boost in saturation. I could have performed the transformation in Photoshop, but the ability to do the same thing in the camera is more in the spirit of digital photography's "shoot, review, re-shoot (if necessary)" capabilities.

Most of the time you'll still want to rely on your image editor to adjust colors, change contrast, blur, or sharpen images. Although digital photographers don't change their "film" much, in the final analysis, they have much the same capabili-ties as their film-shooting counter-parts, plus many more that can't be equaled outside a computer.

Figure 1.5 *Press a button and turn a control wheel to instantly change the color saturation of these flowers from blah (top) to vivid (bottom).*

Darkroom Techniques

Knowledge of darkroom techniques is becoming something of a lost art these days, but if you're the kind of photographer who is used to huddling under the dim illumination of a safelight while the acrid fumes of stop bath fill the air, your knowledge will prove to be invaluable in the digital realm. And, even if you don't have darkroom experience, you're likely to be more than a little familiar with what can be done in the darkroom. Even photographers who don't mess with processing and printing themselves tend to understand the techniques, if only so they can make intelligent decisions when ordering images from their own photolab.

Your darkroom savvy will prove useful when it comes time to edit your images within an application like Photoshop. After all, there's a good reason why Photoshop's predecessors had names like Digital Darkroom. The number of darkroom techniques that have been directly transferred to Photoshop is enormous. From the Dodging and Toning tools to the tremendous range of masking techniques, dozens of Photoshop capabilities have direct counterparts in the darkroom.

Remember, the phrase *camera obscura* (applied to the earliest imaging devices) comes from the Latin for "dark room."

IMAGE-EDITING FAST TRACK

This book doesn't delve deeply into image editing in Photoshop, but instead emphasizes digital *camera* techniques. If you want to learn more about mimicking darkroom and camera effects in Photoshop, or to master advanced image-editing skills, I recommend another book in this series, *Photoshop CS: Photographers' Guide*. If even more sophisticated image manipulation is your cup of tea, check out *Digital Retouching and Compositing: Photographers' Guide*. Like this book, these are written from a photographer's perspective and are available from Muska & Lipman/Course Technology.

Retouching

When I started in photography, retouchers were true artists who worked directly on film negatives, transparencies, or prints with brush and pigment. They applied their skills in a variety of ways. Some worked on assembly lines, improving the complexions in millions of high school senior portraits with a few deft dabs. Others were involved in more painstaking efforts, laboriously restoring treasured family photos or perfecting a high-ticket portrait. The most skilled artisans were employed in advertising, using both retouching and compositing skills (described next) to turn a product or fashion photo into a marketing masterpiece. Today, Photoshop enables those with artistic sentiments who lack an artist's physical skills the ability to retouch images. Even the most ham-fisted among us can remove or disguise blemishes, touch up dust spots, repair scratches, and perform many tasks that were once totally within the purview of the retouching artist.

Compositing

Compositing is no longer the exclusive domain of million-dollar advertising campaigns and supermarket tabloids. Those who want to combine several products into an exotic collage, or show Tony Blair shaking hands with a space alien, can now do it on their own. If you want to mock up a photo that seems to imply that you drove the family car to Samoa, the task is within your reach. Or, perhaps your goals are less lofty: all you want to do is excise that clod of an ex-brother-in-law from the family reunion snapshot. Compositing is the key. You can perform this magic in minutes using an image editor. Photographic masters of the past had to spend hours double-exposing images in the camera, or toil for days to meld negatives, transparencies, or prints. Today, the chore takes only a few minutes, as you can see in Figure 1.6, taken from my book *Digital Retouching and Compositing: Photographers' Guide*. It shows a castle on a cliff overlooking the sea. The castle, cliff, and clouds are from three different photos, yet on first glance, the composite is fairly convincing.

Figure 1.6 *This image combines three photos into one composite.*

Color Correction

As a digital photographer, you have more flexibility in getting accurate color in your images, but the techniques you used with film cameras provide valuable background for implementing digital techniques. In the film realm, color correction is often achieved using filters over the camera lens to compensate for slight color casts. Other filters correct for the unique requirements of fluorescent lighting. Color correction can also be done when making a print. If you understand all these methods, you'll know how to use your digital camera's white-balancing tools to provide the best color in your raw image. You'll certainly have a head start if more drastic corrections are required in an image editor. One advantage digital color correction has over conventional methods is that your corrections can be updated and refined as you work. If you snap a photo and the LCD view screen shows that the image is badly balanced, you can adjust your camera and reshoot the picture. Corrections made with your image editor are also fast, repeatable, and reversible. If you like, you can even make several changes to your image's color and decide which you like best.

Monochrome

Most of the digital black-and-white photos I've seen resulted when a tyro photographer pressed the wrong button and set his or her camera for monochrome capture. However, black-

and-white photography is alive and well, and widely practiced by professional photographers and some of the most avid amateurs. These days, black-and-white pictures are generally produced solely for creative reasons; color is routinely used for everything else. My local newspaper publishes two or three of my publicity photos each month, and I always provide them with a color 5 × 7 print from my inkjet, even though 90 percent of the time the photo is published in monochrome.

From a creative standpoint, though, black-and-white photography is a great tool, letting you strip an image down to its bare essentials, untinted by the mental images conjured up by full color photography. Tones can be more stark and mood-invoking in black and white. Images can also display a full range of subtle shades that are often ignored when color predominates. Serious photographers understand this, and can use the capabilities of digital photography to explore the artistic possibilities of the world of black and white.

Many of the latest digital cameras are sensitive to infrared illumination, so, equipped with the right filter, you can even explore the amazing world of black-and-white infrared photography. I'm going to include a section on infrared techniques later in this book.

Filters

You can never be too rich, too thin, or own too many filters. Slap a filter on the front of your lens and you can transform a boring image into a kaleidoscopic marvel. Filters let you apply split-field colorization (that is, blue on top and reddish on the bottom of an image, or vice versa) in the camera, or create a romantic blur in a glamour portrait. Conventional photography has long been rich with clever filter techniques that add star-points to highlights, apply serious color changes to images, and polarize sunlight to reduce reflections off shiny objects. If you've ever packed a stack of decamired (color correction) filters in your camera bag, or wondered which Cokin filter to buy next, you're already hooked on the optical effects you can get with glass or gelatin.

Filters are such an important part of serious photography that I'd never consider a new digital camera with a fixed lens that didn't have a screw mount on the front of the lens for the filters. I'd even give extra weight to a model that accepted (or could use an adapter for) my extensive collection of 37mm and 52mm diameter filters. Your knowledge of using filters can be transferred easily to digital photography, and will come in handy with image editors, which themselves are designed to use software "filters" to modulate images. The first thing a photographer notices when introduced to Photoshop is how many of the image editor's filters mimic traditional photographic filters and darkroom effects.

Key Uses for Digital Photography

One aspect of digital photography that we can easily examine from 50,000 feet is the broad range of areas in which digital technology has become important. This section looks at a few of the photography realms that have seen the most impact.

Photojournalism

You don't have to be a professional photojournalist to realize that news and digital photography were made for each other. You don't need to be a working press photographer to use the fast-working capabilities of digital photography in your own work, either. Figure 1.7 was taken on an "emergency" basis to publicize an art show at my kids' school. I was able to snap the picture, run home and make a print, and deliver it to the local newspaper an hour after the shooting session. Newspaper photographers work under tighter deadlines every day.

Indeed, digital imaging made strong inroads at newspapers and other news organizations quite early because the technology is such a good match for the needs of fast-breaking news events. However, several developments that preceded digital photography actually helped drive the transition.

First, newspapers began to see a real need for good quality editorial color in their pages, not necessarily as a service to their readers, but because color made good economic sense for them. Economics at newspapers usually involves advertising dollars more than circulation revenues so, as you might expect, the impetus came from the ad side of most publications. As advertisers began paying for more pages of spot color or full color as a way of making their ads stand out and catch reader attention, color in daily newspapers became the norm.

Figure 1.7 *From snapshot to newspaper in less than an hour. Digital photography is perfect when you need a photo quickly.*

Of course, an advertiser might need only a single page or corner of a page for a full-color ad, providing the opportunity for the editorial department to grab an almost-free ride with an editorial photo or two elsewhere on the same sheet. Before long, newspapers had found that editorial color pleased readers. Back in the days when more larger cities had competing dailies, color-using pioneers discovered that their street sales of issues featuring color on the front page topped those of their rivals. Circulation boosts help raise ad rates, and by the time *USA Today* helped make daily editorial color a standard feature, the question was no longer "Should we use color?" but "How many color pages can we get?"

Digital photography arrived at the perfect time to answer the newspapers' need for speed and growing appetite for color images. Electronic images don't have to be processed. A photographer can rush back to the newspaper, download images to a computer, and immediately select the best shots. Even when digital images are physically transported, just as

film must be, the electronic shoot saves half an hour or more over one that requires conventional processing. Digital pictures can be transmitted electronically, saving the drive time required to move film images.

Today, digital cameras are available built on the Canon and Nikon camera bodies favored by photojournalists. They can shoot color or black-and-white images using the full complement of lenses and aperture/shutter speed combinations available for conventional photography. With resolutions topping 14 megapixels, these cameras easily provide the quality needed for news applications, where images will be two, three, or four columns in most cases, and not ordinarily enlarged beyond that.

As a bonus, some digital cameras have the effect of extending the effective focal length of lenses, which gives sports photographers more telephoto for their buck. Most digital cameras can capture several frames per second to emulate motor drives, although the number of frames you can fire off is often limited to seven to ten.

Popping out a digital camera's memory disk can be much faster than changing a roll of film. An assistant or photo editor on site can be previewing pictures you took a minute ago while a shoot is still underway. As long as the removable media holds out, or can be downloaded/erased, digital photo sessions can be open-ended. Digital images are already in the right format to transmit them by conventional telephone modem, cell phone modem, satellite uplink, or other means back to the main office.

Portrait Photography

Portrait photography is something that appeals to professionals as well as amateurs. Perhaps you need a formal photo of a revered relative to hang over the fireplace. You might want to take your own passport photos to ensure that the traveler is recognizable. Or, you might simply need a quickie portrait like the one shown in Figure 1.8 for, say, a wanted poster. I'll tell you more about digital portraiture in Chapter 6, "People Photography."

Digital portraiture is attractive to serious photographers and professionals for similar reasons. Traditional portrait photography has always been something that took a bit of time, although the investment on the part of the photographer and sitter is somewhat less than that required for a painted portrait. Formal portrait sittings using conventional film technology were often followed some time later by a session at which proofs were reviewed, and the client made the final selection. Prints might be delivered at yet another session.

Figure 1.8 *Grab a digital portrait in minutes, whether it's for your passport or a wanted poster.*

While there is something to be said for the opportunities that can crop up when you get a client back to a studio three or more times, this procedure has its drawbacks from a

marketing standpoint. For one thing, enthusiasm is always highest at the original sitting, and has cooled off by the time the proofs are available. Clients might have other things they'd rather spend their money on, or had second thoughts about ordering that big print they originally planned on.

For the professional photographer, digital portraiture offers an immediacy not available with traditional film alone. Pros can snap off a series of poses, either captured 100-percent digitally, or using a system that grabs a digital version at the same time an image is also exposed onto film. Then, they can show the sitter the digital images immediately and write up the order. Big prints can be sold by displaying them on a large screen, or projecting images into a frame that shows how the image will look on the wall in the larger size. Photographers have been doing this with conventional proofs for a long time, and digital imaging just refines the technique.

The digital image also has some advantages when it comes time to retouch a portrait. You'll find that Photoshop can do all the corrections that you might have used dyes for in the past, plus many more. Removing bags under eyes, cleaning up a teenager's complexion, de-emphasizing Dumbo-sized ears, and softening of wrinkles are all child's play for an accomplished digital worker.

The chief disadvantage of digital portraiture is that your output options are a little more limited. Your inkjet printer probably handles paper no larger than 8.5 × 11 inches. Professional studios with some money to spend can equip themselves to print directly to dye-sublimation printers, but those capable of larger than 8 × 10 size are expensive, and you're still limited to only a few paper surfaces. If you want the full range of paper surfaces and texturizing effects that portrait photographers commonly sell, you might have to output to film and make conventional prints. These limitations are gradually vanishing as photographic/digital printing technologies converge.

Outdoor and in-home portraiture should lend itself to some kinds of digital photography much sooner, although I think that weddings are probably the most natural application for this technology. Some photographers like to select their own best shots and present them in an album the couple can use to make a final selection, but the problem with this approach is that the review often must take place long after the honeymoon. Digital images, on the other hand, can be reviewed as soon as the pair return, or right at the reception (if you think that photography holds a high enough priority at that special time—I personally don't think so).

Photoillustration

The third professional area that has seen a dramatic increase in the use of digital photography has been the related fields of photoillustration and corporate/industrial photography. Photoillustration can take many forms. For the amateur photographer, it often involves taking attractive photos of hobby collections, such as model ships or Lladró porcelain. Or, perhaps you're interested in photographing flowers or animals. Figure 1.9 was taken to provide an illustration for an eBay auction page. Professionals need to capture images of similar objects, plus a great deal more.

A converter, not an adapter!

Plug it in!

Plug this converter into your S-Video out port

Then connect to your TV's yellow RCA composite jack!

Figure 1.9 *Enhance your online auctions using photo illustrations you create yourself with a digital camera.*

In some commercial applications, such as catalog work, digital photography has become *the* way to go. It also lends itself to other kinds of illustration, too. Certainly, time can be an important consideration. One professional photographer told me about a client who came into his studio in the morning, helped set up a digital shot, and was on press with the image that same afternoon.

Today, digital cameras easily provide the quality needed to produce 11 × 17 and larger images. Some other features of digital cameras might be useful in these applications. For example, the ability to link a camera to a computer and preview images before they are taken can be helpful in fine-tuning a setup. In industrial photography, this capability, coupled with remote control, allow digital cameras to be used effectively in remote monitoring situations. An assembly line, product conveyor, or other factory scene can be photographed continuously at frame rates that are slower than those produced by video cameras—but with better resolution. Images can be fed to a computer located some distance from the monitoring point and stored on a large hard disk for review at any time.

Industrial photographers who must document processes for quality or certification studies also like the speed of digital cameras and the ease of converting images to computer format for use in desktop publishing or other applications. Medical photographers can also use digital images. Opthalmic photography, for example, uses special camera setups to photograph the fundus (back inside surface) of the eye. Fluorescein dye injected into the patient's blood stream glows when illuminated by ultraviolet light, and the resulting patterns of blood vessels in the fundus can be used to diagnose many illnesses.

Where We're Going

I'll be covering emerging and future technologies in later chapters, but the view from 50,000 feet looks bright. The "average" resolution of a mid-priced (say, $500) digital camera has been increasing dramatically. As I write this, just about anyone who is serious about photography can afford a 6 megapixel camera, and megapixel monsters from Kodak and others with (what seems to me) an astounding 14 megapixel scope cost less than a week at Disney World. Expect even more dramatic improvements when the innovative Foveon sensor (which is discussed in Chapter 2, "Inside a Digital Camera") becomes common.

Storage will get cheaper and more capacious, too. I expect 1GB CompactFlash cards and 4GB teensy hard disks to appear to be laughably small during the life of this book. (This comes from someone who paid $300 to upgrade to 32,768 *bytes* of memory in 1978, and paid $1,000 for a 200-*megabyte* hard drive roughly a decade later.)

Look for better zoom lenses, smaller cameras, more efficient viewing systems, faster transfer speeds, and dozens of features (such as motor-drive-like "sequence" photography) that we didn't even know we needed. The most interesting thing about looking to the future is knowing that much of what is headed our way are things that we didn't imagine could exist, used in ways we couldn't have predicted. Crystal balls make predicting technology simple, but the consequences are more difficult to foresee. After all, futurists of the 19th century and earlier had no trouble predicting the advent of the horseless carriage. But not one of them foresaw smog, traffic jams, or road rage.

In one sense, the chief value of predicting the future lies in the amusement it might provide our ancestors. Edward Bellamy, in his 1888 book, *Looking Backward: 2000-1887*, insisted that in the 20th century it would no longer be necessary to go to concert halls to enjoy music. Average citizens would be able to listen to musical selections of their choice from the comfort of their own homes. Of course, Bellamy wasn't predicting radio, phonograph records, or even audio CDs. Nor did he have a clue about how MP3s and peer-to-peer file sharing would affect music distribution. His idea was that we would use telephones (a relatively new invention in 1888) to call various symphony halls and listen to the live music in progress!

Predicting the future of digital photography is fraught with similar pitfalls. One part is easy. I can safely say that digital cameras in the very near future will have higher resolutions, greater sensitivity, and much lower cost than the cameras on the market today. In my first book on digital photography, written in 1995, I described "cameras with 3000 × 2000 pixel sensors that equal the resolution of ISO 100 film, yet contain enough fast static RAM to let you shoot 50 to 100 images at four to six frames per second." In writing this book, I used a $1,200 digital camera from Minolta with roughly those specifications.

Other predictions are not so easy. Will digital cameras replace film in all applications? Will new applications for digital photography be developed once sophisticated equipment becomes affordable? Will it still make sense to distribute digital images in the same old ways? What are the key issues we'll be facing as digital photography takes over (almost) completely from conventional photography?

Making Your Images Your Own

Copyright—extended in 1978 to the artist's lifetime, plus 75 years—has through recent court rulings been made almost perpetual if the copyright holder chooses to exercise all the options. But what good is a copyright in an age when copies of digital images can be made that are perfect, and pretty good duplicates can be made of analog versions by anyone with access to a scanner or color copier?

Photographers who want to protect their work must now face this problem. Every image you create in every format can be illegally copied and reused without payment. The process might be simple or difficult, depending on the format and expertise of the person doing the copying. Transparencies can't be easily duplicated without using a photolab, slide scanner, or some other technology. Prints, on the other hand, can be copied using any flatbed scanner, giving you a fairly good digital file, or taken to a photo kiosk at a department store and duplicated quickly and easily.

The most annoying possibility of all is that someone will gain access to your original digital image—essentially the same as a camera negative or transparency—and then be able to make exact duplicates at will.

Of course, the copyright law might let you collect from those who use images without permission after the fact, if you're lucky enough to discover the usage and can prove it's your image. Proof might not be as easy as you think. Pursuing copyright defense through the legal system is, in any case, very expensive, and the results are uncertain. Worse, the law is not clearly defined in many areas. Just because someone flagrantly uses your image does not automatically mean you have an enforceable claim.

For example, consider the image in Figure 1.10, a view of Toledo, Spain from a hilltop outside of town. The vantage point from this hill is perfect, and El Greco used it several times to create paintings that now hang in the Metropolitan Museum of Art in New York City, and the Museo del Greco in Toledo. This view is so popular, that I own no fewer than five books that use similar photographs on their covers. All the photographs are by different photographers, but are virtually identical except under very close examination. I discovered why this is so some years back when I drove up the hill myself and discovered a well-trod scenic overlook that must have been used by thousands of photographers, and perhaps the Greek painter himself, over the years.

Figure 1.10 *If someone steals this photo for their own use, how will the photographer know?*

Some types of images, particularly news photographs, scenics, and other pictures that don't contain unique subject matter, are difficult to prove as your own. However, even the most unusual image must be solidly established as belonging to you if you expect to recover damages. This is true if the image is reused in its entirety, and more difficult if parts of the

image were "sampled." I won't get into the differences between new works and derivative works, or things like "fair use." There are plenty of law-and-the-photographer books available that address these issues.

Instead, I'll tell you some of the ways digital photographers can "mark" their works much as they use an ink stamp, embossing, or some other device on conventional photographs.

One way to protect work is to include information in file headers within the digital file itself. A little expertise and the right disk-editing tools can let a photographer insert a code or text signature in the file in a place where it won't affect image quality. Of course, anyone with the same expertise and tools can take it right out.

Another method involves overprinting the digital image with a faint watermark, which (supposedly) doesn't interfere with evaluating the image, but makes it impossible to duplicate or use the file without reproducing the watermark as well. Of course, you still have to supply the unaltered digital file for reproduction, so this form of protection is far from complete.

A third method is to use encryption, and works particularly well with images distributed on Photo CD. Every Photo CD using the original format contains several copies of the image at five to six different resolutions. The low-res versions can be left unencrypted so they can be viewed on-screen. Some distributors even give permission to reproduce these images, with proper credit, since they are suitable only for basic desktop publishing applications anyway. Then, when a buyer wants to gain rights to a high-resolution version of an image, a decryption code can be purchased by paying the necessary fee.

Encryption is a good solution, but distributing images on Photo CDs is inefficient in some cases. You might have to send along a hundred different Photo CDs containing the ones the client wants to look at, whereas it might make more sense to burn a special CD-ROM with only the 100 images that fit the requirements. Moreover, even if you encrypted a bunch of TIFF files, you'd have to create a special low-res version of each so the client could view the images on a screen.

A company named Digimarc Corporation has developed a scheme that might solve most of the problems inherent in other image-identification methods. It involves embedding a random code pattern right in the digital file as a form of noise that is present at such a low level that it can't be detected with the eye. Yet, the code can be detected reliably even after the image has been subjected to the photomechanical reproduction process. That is, you can scan in a suspect image that has been printed in a book, magazine, newspaper, poster, or whatever, and find the embedded digital signature using the right software. The encoded information is holographic; the entire code can be read from any smaller portion of the reproduced image. Cropping your work drastically won't disguise the code one bit.

A lot of work remains to make this technology viable. It has been incorporated into a Photoshop plug-in, to add the codes to any images you want. It could even be included in a chip in copy print stations or photocopiers that would alert the machine that a copyrighted image was present. The code can include information on how to obtain permission, so if you

tried to copy a certain image, a dialog box would pop up saying, "call 800-xxx-xxxx, obtain a code, then key it in to proceed."

For photographers to recover damages, the reliability would have to be established in a court, much as radar gun manufacturers routinely send experts to testify about the accuracy of their devices the first time they are used in a given jurisdiction.

There are advantages to this method. The code can be supplied to an image when it is finished, or actually applied by the digital camera when the picture is first made. It will automatically be reproduced along with the file, and can't be removed without destroying the image, unless you have the original creator's code. As with common encryption schemes today, both public and private codes can be incorporated—one code that allows for verifying an image and can be freely distributed, and a second, private code known only to the photographer. That prevents others from falsely stamping other images with anyone else's code. Photographers who sell all rights to an image could remove their own code, and allow the new owner to embed one of their own.

The Digimarc system also bypasses having to encrypt the images themselves, so they can be freely distributed, viewed, and used. It doesn't stop unscrupulous people from stealing pictures, but does make it easier to prove their theft if you catch them. Since Digimarc works with any digital file, including video, audio, or text, its broad commercial applications are an incentive to work out the last few kinks in the system.

Is Film Dead?

Back in the 1970s, when newsfilm cameras began to be replaced in a few markets by electronic news gathering (ENG) equipment—portable videotape cameras and recorders—a trade paper rocked the industry by publishing an article with the headline, "Is Film Dead?" It was predicted that videotape would replace film in television news (which it eventually did, although film hung on quite a few years as the favored medium for local television documentaries), and, eventually, in the production of theatrical motion pictures. A decade later, pundits were saying the same things about film in all still photographic applications.

But don't hold your breath. Motion pictures today are still shot on color negative film, and most still photographs are still produced using negatives or transparencies exposed in a camera. The advantages and disadvantages of electronic image capture versus film will change over the next few years, but with the pros outweighing the cons for many film applications for quite a while.

Certainly, digital photography has already taken over some fields, such as catalog photography, completely and utterly. But there remain other worlds to conquer. There are artistic reasons for retaining film capabilities, too, as anyone who shoots a lot of black-and-white film will testify. The film "look" may someday have a cachet of its own in an age of digital imaging. If you want the lowest cost media, the broadest range of film speeds, spectrum sensitivity, and grain characteristics, film provides options that you needn't expect from electronic gear anytime soon.

Pricing

If you sell your photographs (or hope to!), digital photography is likely to cause some changes to how pictures are sold. Should they be adjusted because no processing is required? Can a photographer who works with an assistant or stylist hire a computer nerd instead, and bill higher rates because the nerd gets paid more?

Or, how about the cost of supplying images? Instead of circulating dupe slides and sending camera originals or prints only when absolutely necessary, can you use CD-ROMS with full resolution TIFF files? Will clients expect you to pass along the savings—if any—to them?

The problem is that photography has always been a difficult business to quantify. A shooting day you can bill for probably requires two days of preparation. That image shown earlier of Toledo, Spain might be worth quite a bit to someone who needs it taken at a certain day or time and doesn't want to fly to Spain to get it. But, if all you need is any old picture from that hillside, a stock house can provide it for a reasonable fee. My average-looking shot might be good enough, even when compared to one by, say, Ansel Adams, although Adams' will have a neat moon positioned in just the right spot and have a lot longer tonal scale.

Digital stock photography may revolutionize the industry in several ways, some good, some bad. Photographers will have many more outlets for distributing their photographs, and the availability to end-users will become much broader, but overall prices should come down significantly. I can remember when digital fonts used for desktop publishing cost $100 per typeface. Now you can buy a CD-ROM with 2,000 decent typefaces for $5, and even pro-quality fonts are selling for a tiny fraction of their original price. When buyers can purchase traditional stock fodder for a few dollars, your own seaside sunsets, Yellowstone Park scenics, cute kid and kitten photos, and other efforts must either be cheaper (not likely) or better than the alternatives. Unless you're a "name" photographer, or happen to grab a one-time shot of a news event, the days of collecting thousands of dollars for a single picture, year after year, might be over.

Look for new ways to bill for photography to emerge as digital photography becomes more mature.

Ethics

Anytime I interview a news organization about digital photography, one of the first things they emphasize—even if I never bring up the topic myself—is how they have measures in place to ensure that images are never, ever altered in a misleading way. Even something as innocuous as moving the pyramids around for a *National Geographic* cover, or placing Oprah Winfrey's head on Ann-Margret's body for *TV Guide* sends shivers of terror down the spines of journalists and their critics alike.

For thousands of years, "seeing is believing" was more or less true. Viewers of an early motion picture that showed a train heading straight at the audience fled the theater in terror, because they couldn't comprehend that this fuzzy, black-and-white image wasn't the real thing. Today, we're confronted with realistic photos of the President shaking hands with space aliens, or

Elvis attending the (most recent) wedding ceremony of his daughter. It's hard to know what to believe. Some images are obvious fakes, such as the one shown in Figure 1.11, but others are not. How do you know which photos are real?

As much fun as digital manipulation is, there are several areas in which it must be used with caution. The most obvious is in news photography. Picture editors have long worked with restrictions on what they could do and not do. Publishing a picture which shows a male politician hugging a lovely woman, but cropping out his smiling wife standing right behind him would be misleading, to say the least. News publications keep such situations in mind.

There are many ways to juxtapose images, crop, or otherwise present a photograph in a way that misrepresents the truth, even without digital manipulation, and newspapers are used to dealing with this. Even the NPPA (National Press Photographers Association) concedes that color correction, dodging, burning, contrast enhancement, and other techniques that have long been used to improve an image without altering the meaning of its content are acceptable in the digital realm.

Strict rules govern images collected for evidence or forensic purposes in legal applications. Pictures must portray a scene accurately, to the extent that crime scene photographers often provide many different views and wide-angle perspectives to show the overall picture before zeroing in on a specific piece of evidence. An unbroken chain of possession must be established, proving that these are, indeed, the photos taken at that time and place, rather than some others that might have been substituted intentionally or by accident.

Figure 1.11 *Some digital photos are obvious fakes, but others might be more believable.*

In this regard, digital photography has some advantages over conventional processes. Digital images don't have to change possession as many times, since a separate processing step isn't required. In addition, images stored in a vendor's proprietary, raw camera format have been accepted by courts as proof enough that they haven't been previously altered.

A third area in which photographers must be extremely careful is in advertising. Digital photography lends itself to the kind of manipulation that courts have frowned on as being

misleading. You can do what you like to make a product look good, but it must still accurately represent the product to the consumer.

Many years ago, there was a case in which a soup vendor put marbles in the bottom of a bowl of soup, to make all the vegetables rise to the top and make a photograph of the soup appear richer than it really was. Today, we'd probably just clone extra food chunks using Photoshop. However, any such manipulation could be done only to the extent that it didn't misrepresent the product, as the soup manufacturer found out. You can brighten a sweater, add drops of dew to a bowl of fruit, drizzle some digital juice down the front of a sandwich, but the final image must be representative.

The vagaries of the reproduction process can be compensated for, but not overcompensated. One camera manufacturer was allowed to include photos in an advertisement that were actually sharper than those typically produced by the camera in question. (They were shot with a 120 SLR rather than the 35mm camera being touted.) It proved that by the time the ad was printed, the sharpness of the photos was still less than similarly sized prints from the advertised camera. Lighting and other aspects of the images were all similar to what the camera could produce, even though a larger format was used.

Like journalistic and legal photography, advertising illustration is a field in which the pitfalls are well known, and most photographers, art directors, picture editors, and others know what to look out for. There are several other areas, such as medical photography, industrial documentation, and so forth, in which deceptive manipulation is also a potential problem, but there is little incentive to falsify information in these arenas, so digital photography presents few problems at present.

Next Up

I once visited photographer Maureen Lambray in her New York City studio soon after she completed work on *The American Film Directors*. She told me that she was fascinated with cinema because it is an art form that began not too long before she herself was born, and that many of its pioneers like Raoul Walsh, Howard Hawks, and Fritz Lang were still alive (then) for her to talk with and photograph.

Digital photography today is still very much in its infancy. Many of the pioneers who will be revered 20 years from now are still unknowns today. You have a remarkable opportunity to get in on the ground floor of a new and growing technology that will change the way we produce and use images. The Fritz Langs and Alfred Eisenstadts of digital imaging are out there working right now. (Actually, as I write this, immortal photographer Henri Cartier-Bresson, born in 1908, appears to *be* immortal, as he is still alive and working.) Don't miss this chance to pattern your work after these legends of the future, or perhaps even become one of those leading lights yourself.

If you think digital photography from 50,000 feet is interesting, consider the panorama visible from behind the viewfinder. We'll delve into digital cameras in the next chapter.

2

Inside a Digital Camera

Although digital cameras are a very recent innovation, the road to all electronic digital photography has been a gradual transition. Solid-state technology began to intertwine itself into the workings of conventional cameras more than 20 years ago, as electronic metering was joined by electronic shutters, programmed exposure modes, automatic focus, and other computer-oriented innovations.

Since motorized film transport became common, there has not been a lot of difference in operation between advanced film cameras and the most sophisticated digital models that followed. Indeed, some of the newest cameras with interchangeable lenses use electronics to set both the shutter speed and lens aperture. Nikon's G series lenses, for example, don't have an aperture ring at all. You set the f-stop with camera controls. Many of the early high-end digital cameras were little more than 35mm SLRs with a sensor located where the film plane ought to be. If you're comfortable using one of the latest film cameras, you'll be right at home using many of the current digital models.

Studio cameras have needed even less modification to enter the digital world. Electronic studio cameras have frequently been built through the simple expedient of designing a digital back that replaces the sheet-film holder of a conventional view camera or the rollfilm back of a medium format camera. (Mamiya has a particularly nice digital back for its 645 line.) Catalog photographers, in particular, favor solutions of this sort because they can alternate between capturing digital and film images seamlessly. Mitsubishi, Kodak, and Fuji are among the vendors of digital camera backs for Hasselblad, Mamiya, Bronica, and Contax, priced between $12,000 and $20,000.

Basing digital camera design on existing film cameras made a lot of sense when digital cameras were expensive to produce (the sensor of a professional digital camera sometimes cost as much as the rest of the camera) and sales of such an expensive device were low. Instead of designing

a new camera body, vendors patterned digital models on existing film camera systems, and used many of the same parts, such as lenses. When the cost of high-resolution sensors became reasonable, new cameras were designed from scratch to take advantage of their capabilities, and to sell at lower prices. Today, even expensive digital cameras and their accessories have less and less in common with their film counterparts.

This chapter will help you understand the differences between film and digital cameras, particularly the features that digital cameras have, and film cameras do not. You'll find this information especially useful when shopping for a new camera, because not every camera has every feature. But even if you already own the digital camera of your dreams, you'll still find this chapter helpful in sorting out the most useful features from those that are likely to be more trouble than they are worth.

Guided Tour of a Digital Camera

We're going to start with a generic tour of a typical digital camera. I've chosen for my example a medium-range model that has many features, even though it isn't one of those single-lens reflex models that have recently become available at amazingly low prices.

Your camera may not look exactly like my example. I used a fully featured Minolta camera as my model, but digitally changed its appearance a bit to genericize its shape. Digital cameras vary widely in appearance, but all of them share certain common components. Although the location for individual controls and features may differ slightly, and the camera body may be square, cubical, or rounded, virtually all digital cameras have a taking lens, an optical or electronic viewfinder, a color LCD display panel for previewing an image and showing menus, a shutter release, and a clutch of control buttons. You'll find the layouts in many cases are surprisingly similar to my Minolta example.

Most also have one or more slots for removable storage, such as Secure Digital or Compact-Flash cards; a built-in electronic flash unit; a top-mounted monochrome LCD panel for displaying the number of exposures left, current camera mode, and other status information; and a serial or USB port for connecting the camera to your computer when you want to download photos. You also might find a tripod socket, or an infrared port for wireless transmission of pictures.

We'll look at our example camera from four different views: the front, back, top plate, and the "control" side (which contains many of the important controls). The other two surfaces of the average digital camera are less interesting: the bottom side might contain a tripod socket and maybe a compartment for batteries, while the right side is gripped by the photographer and usually has little more than a cover that hides the digital memory card access slot.

It's possible that not all the terms in the following tour will be familiar to you. I'll explain about shutter speeds, f-stops, autofocusing, programmed exposures, single-lens reflexes, and other topics later in this chapter. Consider this a basic orientation tour, and feel free to come back and review once you are comfortable with all the components of a digital camera.

First up is the front view, shown in Figure 2.1. I've numbered the key features and listed their functions below.

1. **Control wheel/jog wheel.** This control is usually placed near the shutter release so it can be operated by the finger that presses the shutter. It is used to change settings when the camera is up to your eye just before the photo is taken. For example, one camera puts the control wheel to work changing both shutter speed and aperture settings (depending on whether the shutter speed or lens opening control buttons are pressed with the other hand). The same camera uses this wheel to change filters, flip between various white-balance settings, and to adjust other parameters. You'll learn more about each of these kinds of settings later in this chapter and in the next one.

2. **Shutter release.** Pressing the shutter release part way down locks the exposure and focus settings of most cameras, and may trigger a display of information about those settings in the viewfinder. Press the shutter release down all the way to take the photo.

3. **Microphone/speaker.** Many digital cameras have voice annotation capabilities that let you record comments about each photo as it's taken. The microphone can also record sound when the camera is used in motion picture mode. Cameras can also emit sounds, either during playback of annotations/movies, or to simulate the sound a mechanical shutter makes when the picture is taken.

4. **Handgrip.** The handgrip gives you something solid to hold, and helps position your fingers over the shutter release and other controls on the right side of the camera.

Figure 2.1 *Here's the front view of a typical digital camera.*

5. **Focus ring.** Digital cameras that allow manual focus may place the focusing ring around the lens, for convenience and for familiarity, because that's how focusing is done with a film camera, and for design reasons (when the ring physically moves lens elements to achieve sharp focus). Other cameras use the cursor keypad to focus manually.

6. **Zoom ring.** You'll find one of two common systems used to change the zoom setting of a digital camera. Some cameras have W (Wide) and T (Tele) buttons on the back surface of the camera, which operate a motorized zoom feature. Others operate more like traditional film cameras with manually operated zoom, often using a ring around the circumference of the lens.

7. **Lens.** Every digital camera has a lens of some sort, which will usually be marked with the actual focal length settings of the lens, plus the equivalent length for a 35mm camera. Our example camera has a 7.2mm to 50.8mm zoom lens, the equivalent of a 28mm to 200mm lens on a conventional camera. Because sensor size varies, the amount of magnification provided by a lens of a particular focal length varies from camera to camera, so equivalent focal lengths are used to make comparisons easier. I'll address this issue in more detail later in the chapter.

8. **Filter thread.** Most lens accessories attach via a screw-on thread on the front of the lens. These can range from close-up attachments to add-on wide-angle and telephoto converters that enhance the magnification range of your fixed lens. You can also attach various filters, lens hoods, and other accessories to the filter thread. The advantage of a standard screw thread on the front of your lens is that you can attach a wide variety of accessories, including inexpensive add-ons not made by your camera vendor. Note that not all cameras come with this convenient feature, and some require special adapters to attach even the simplest lens accessory.

Not shown:

The example camera uses an electronic viewfinder (EVF, an LCD screen viewed through an eyepiece), so this illustration does not show the window for an optical viewfinder, which is needed for any camera that doesn't have either an EVF or true through-the-lens viewing.

Next up is a back view of the example camera, shown in Figure 2.2.

1. **Eyepiece.** All digital cameras have an eyepiece for viewing the optical viewfinder, electronic viewfinder, or through-the-lens view. Most also have a control for adding plus or minus diopter correction so that those with vision problems can view without needing to wear their glasses. This particular camera model also has a sensor to the right of the eyepiece to turn the electronic viewfinder on and off as you move the camera to your eye.

2. **LCD view screen.** This screen can be used for previewing images, reviewing images, and for focusing (if your camera doesn't have an electronic viewfinder or SLR view). Some cameras also display status information, such as shutter speed or number of shots remaining, as well as setup menus on this screen.

3. **Battery compartment.** Most digital cameras use removable rechargeable battery cells or packs. The compartment may open on the back of the camera, the bottom, or one side, depending on your model.

Figure 2.2 *The back of a digital camera is the "business" end of a digital camera.*

4. **Viewfinder controls.** You may be able to adjust the type of information displayed in your camera's viewfinder. Options include a plain view, a view with focus area showing, or a complete view with all status information (such as focus, exposure, shooting mode) displayed. Choose a plain view to declutter your viewfinder, or opt for a full display to give you the most information as you shoot. Some cameras have a viewfinder control that sets whether the LCD or electronic viewfinders are used alone or in combination, while others rely on menu controls for these features.

5. **Spot meter/spot focus control.** Digital cameras sometimes have a button that switches metering or focusing into a "spot" mode that reads from a small section of the image shown in the viewfinder. You can use this control to fine-tune exposure or focus to a specific area.

6. **Menu button.** Pressing this button pops up various setup menus in your LCD display or electronic viewfinder. Many camera functions not controlled by specific buttons and dials can be set through menus.

7. **Cursor controls.** The cursor movement controls serve multiple functions in most cameras. You might use them to navigate menus, move from picture to picture in review mode, relocate the focusing "spot," or scroll around enlarged views of images. The button in the center selects the highlighted menu option, or performs some other Enter/Return key function.

8. **Quick view/Delete button.** Automatically trashes the most recent photo you shot, or lets you call the image back to the LCD screen for review.

9. **Ports and sockets.** Digital cameras bristle with various ports and sockets, ranging from DC power jacks to USB connections to audio/video OUT connectors.

The top view, shown in Figure 2.3, has a variety of camera controls.

1. **Hot shoe cover.** You may find a mount to hold a more powerful electronic flash unit on top of your digital camera. This "hot shoe" provides electrical contact with the camera, and is frequently protected by a plastic cover like the one shown in the illustration.

2. **Viewfinder swivel.** Your electronic or LCD viewfinder may swivel to let you point the camera in one direction and view from another angle. Some models, like our example camera, allow only a small amount of adjustment, from 0 to 90 degrees. Others let you swing the LCD out and twist it to many different angles. Several Nikon Coolpix models let you point both the LCD and lens at yourself (so you can shoot a self-portrait) and automatically invert the LCD display when you've turned the viewscreen 180 degrees (to avoid the need to look at an upside-down view of yourself).

Figure 2.3 *The top of the camera has key controls for camera operation and exposure modes.*

3. **Exposure program modes.** Choosing the right combination of shutter speed and lens opening can be tricky, so camera vendors have computerized the process. The example camera has five different program settings for (left to right) portraits, action photos, sunsets, night portraits, and text. These are chosen by pressing the button to the immediate right of the program mode strip. The button marked P at the far right resets the camera to normal program mode.

4. **Shutter release.** As mentioned earlier, pressing the shutter release part way down locks the exposure and focus settings of most cameras, and may display those settings in the viewfinder. Press the shutter release down all the way to take the photo.

5. **Control wheel/jog wheel.** Also described previously, this wheel is used to change settings just before the picture is snapped.

6. **Access cover for flash memory card.** You'll find one or more slots for solid-state memory cards underneath this hinged door.

7. **Main control dial.** This dial controls the camera's main functions, such as switching the camera on and off, changing from shooting mode to playback or movie modes, or setting up controls and transfer images from your camera to your computer.

8. **LCD status screen.** This monochrome display shows the number of pictures left, exposure program mode, and other status information. This data is sometimes repeated in the viewfinder.

WHAT ABOUT LEFTIES?

Left-handers will notice that all the controls described so far are laid out for the convenience of right-handed photographers. Those who are left-handed have probably learned to put up with abuse they suffer both in and out of the computer realm. Everything, from keyboards to mice to arrow-shaped cursors, is designed for right-handed users. (At least you can change the orientation of cursors in your control panel!) If you're left-handed (or even just left-eyed), digital cameras can be a pain to use in some cases. Many lefties report that they have no difficulties at all. Others, particularly those who don't have full (or any) use of their right hand, are up a creek with only one paddle.

The only advice I can offer you (other than experimenting to see if a particular camera is easy to use when held upside down) is to give any digital camera you plan to buy a rigorous workout to see if the controls are at least workable for a southpaw. Some digital cameras put most of the controls on the left side, but you still must hold the camera in the right hand and (preferably) view through the right eye. If you find a camera that is comfortable for left-handers, be sure to spread the word. There are many "sinister" web pages and mailing lists devoted to your needs, and you'll have an eager audience.

With many digital cameras, the left side is crowded with controls like those shown in Figure 2.4.

1. **Flip up electronic flash.** The best electronic flash on digital cameras flip up to raise them as far from the lens as possible, to better reduce red-eye effects (which are accentuated when the lens and flash are located close together). Usually, raising the flash also turns it on, unless you've explicitly disabled the flash using your camera's controls.

2. **Zoom ring.** Changing the magnification of a lens manually with a zoom ring is usually faster than the motorized zooms some cameras have. Generally, inexpensive cameras with 3:1 or less zoom ratios use motorized zoom, while more expensive cameras with much longer zoom ratios (like the 7:1 of our example camera) use manual zoom because it's faster for such long stretches.

3. **Macro button.** Digital cameras with close-up capabilities usually have a macro button to switch to close-focusing mode. The button may be on the lens (as in this case) or located elsewhere on the camera.

4. **Focus ring.** Manual focus is most convenient when a ring around the lens is used to adjust the focus position.

5. **Filter/color/contrast/exposure options.** Multifunction dials are the norm with digital cameras. This one can be set to four different positions. The user then presses the button in the center of the dial and chooses the option desired with the control/jog wheel. Options for this dial include colored filters, color saturation, contrast, and exposure compensation.

Figure 2.4 *Many frequently used controls are placed on the side for quick access during shooting.*

6. **Sensitivity/program mode/white balance/focus/sequence options.** In this case the options are MEM (store current camera settings for instant recall); metering mode (choose from segmented, spot, or center-weighted readings); PASM (select between programmed exposure, aperture or shutter priority, and manual); Drive (single or multiple exposures, plus self-timer and time-lapse); WB (white-balance options); or ISO (sensor "sensitivity" or "speed").

7. **Automatic focus/Manual focus button.** I won't use a digital camera that doesn't have this kind of focus control. Press the button to toggle between automatic and manual focus. That's it! Some digital cameras force you to switch to manual mode or use menu options to access manual focus. Ack!

8. **External flash terminal.** While many digital cameras accept detachable flash units, some of them are so sensitive to the voltage used to trip the flash that you must use only electronic flash offered by or recommended by the vendor. A better option is a standard external flash terminal like this one, which allows you to use virtually *any* third-party flash unit.

9. **Eyepiece diopter correction control.** If you wear glasses, use the diopter control to correct for some kinds of vision problems so you can view your subject without those spectacles.

How a Digital Camera Works

This section provides a quick look at how a digital camera works. You don't really need to understand quantum physics to operate a digital camera, but a basic comprehension of what's going on inside your picture box can help you troubleshoot vexing photographic challenges later on, plus, if you're the typical serious photographer, satisfy your curiosity. While this explanation will be greatly simplified, you'll find the concepts apply to virtually all the digital cameras on the market today.

Capturing the Image

The birth of a digital picture begins when illumination from a light source bounces off a subject (or is transmitted through a backlit translucent subject like a stained glass window). Each portion of the subject absorbs some of the wavelengths of light while allowing others to find their way to your camera's lens ([1] on the diagram shown in Figure 2.5). In the illustration, I show only two big fat "beams" of rainbow-colored light passing through the front of the lens, when in truth there are zillions, all composed of photons (light particles) that behave as if they were waves. (Wave/particle duality is one of those quantum physics puzzles we're going to steer clear of!)

The light strikes the lens's glass elements, represented by [2] in the diagram. I show just a single convex element in the illustration, but in real life lenses consist of 4 to 15 or 20 or more elements of varying shapes, which move in unison or individually, depending on how the lens is focused or zoomed.

Fixed-focus, non-zooming lenses are the simplest: They are designed to focus an image on the sensor in a single way, so no provision has to be made for moving the elements. As the lens' functions become more complex, additional elements are required to correct the image at particular magnifications or focus positions. The goal in all cases is to direct the light beams

Figure 2.5 *A lot goes on inside your digital camera when a picture is taken, as represented by this diagram.*

([3] in the diagram) to a sharply focused position on the camera's sensor, marked with a [4] in the illustration.

The sensor serves as the camera's "film" and, like film, contains substances that are sensitive to light. Although some cameras use CMOS (complementary metal oxide semiconductor) technology, most digital cameras today use CCD (charge coupled device) sensors. We'll look at sensor types in a little more detail shortly. For now, all you need to know is that a sensor is an array (a layout of rows and columns) of very tiny light-sensitive diodes. Electrons are created when enough photons strike one of the diodes. The greater the number of photons that reach a single photosite, the more electrons that accumulate and the brighter that pixel becomes in your final image.

The minimum number of photons required to register an image determines the "sensitivity" of the sensor; very sensitive sensors require fewer photons and thus can record an image with less light. When you crank up the ISO setting of your digital camera (say, from ISO 100 to ISO 800), you're effectively changing this threshold, and telling the sensor to require fewer photons before recording an image for a particular photosite or pixel. That's why you get a grainy "noise" effect at higher ISOs: The sensor may record electrical interference or other non-picture information as a pixel at these higher sensitivities. In general, the larger the sensor, the less noise produced.

Traditional CMOS chips are inherently less sensitive to light, and so more susceptible to noise. Yet, they require up to 100 times less power to operate (which translates into longer battery life) and are much cheaper to produce than CCD chips, which is why they have become

popular in low-end digital cameras (and scanners). More recently, CMOS sensors have become sophisticated enough that they're seeing use in more advanced cameras (costing $1000 or more) as well.

With a CCD sensor, the electrical charge is transported to a corner of the pixel array and converted from an analog signal to a digital value. CMOS chips include transistors at each position in the array to amplify the signal and conduct it to the analog-to-digital converter through tiny wires. Even though CCD chips predominate today, CMOS technology is improving all the time, and one very special CMOS sensor developed by Foveon offers some significant advantages.

Viewing the Image

Once the light from your subject reaches the sensor, a lot of things start happening. The most important event is your opportunity to view or preview the image, either through a color LCD display panel on the back of the camera, or through a viewfinder ([5] in the diagram). The electronic nature of a digital camera provides many viewing options. You may use one or more of the following viewing choices, depending on your camera model.

- *View on the LCD display.* These viewing panels, which operate like miniature laptop display screens, show virtually the exact image seen by the sensor. The LCDs measure roughly 1.6 to 2.0 inches diagonally, and generally display 98 percent or more of the picture view seen by the lens. An LCD may be difficult to view in bright light.

- *View through an optical viewfinder.* Many digital cameras have a glass direct-view system called an optical viewfinder that you can use to frame your photo. Optical viewfinders can be simple window-like devices (with low-end, fixed-magnification digital cameras) or more sophisticated systems that zoom in and out to roughly match the view that the sensor sees. The advantage of the optical viewfinder is that you can see the subject at all times (with other systems the view may be blanked out during the exposure). Optical systems may be brighter than electronic viewing, too. A big disadvantage is that an optical viewfinder does not see exactly what the sensor does, so you may end up cutting off someone's head or otherwise do some unintentional trimming of your subject.

- *View through an electronic viewfinder (EVF).* The EVF operates like a little television screen inside the digital camera. You can view an image that closely corresponds to what the sensor sees, but is easier to view than the LCD display. The EVF goes blank during exposures, however.

- *View an optical image through the camera lens (with single-lens reflex models).* Another kind of optical viewfinder is the through-the-lens viewing provided by the SLR camera. With such cameras, an additional component (not shown in the diagram) reflects light from the taking lens up through an optical system for direct viewing. Some kinds of cameras use a mirror system. The mirror reflects virtually all the light up to the viewfinder. Then, the mirror swings out of the way during an exposure to allow the light to reach the sensor instead. Sometimes, a beamsplitting device is used instead. A beamsplitter does what you expect: It splits the beam of light, reflecting part to the viewfinder and allowing the rest of the light to strike the sensor.

As you might guess, because a beamsplitter steals some of the illumination for the viewfinder, neither the sensor nor the viewfinder receives the full intensity of the light. However, the system does mean that the image needn't blank out during exposure.

WHEN IS AN LCD NOT AN LCD?

Kodak was the first to introduce a digital camera with an "LCD" display screen that isn't an LCD at all. The EasyShare LS633, introduced in mid-2003, featured an OLED (organic light emitting diode) display. Because an LED doesn't need backlighting, OLED displays use much less battery power. As a bonus, these displays look great from any viewing angle.

Taking the Picture

When you press the shutter release button ([6] in the diagram), the camera takes the photo. Some cameras have actual mechanical shutters that open and close for a specific period of time (representing the shutter speed), while others perform the same function electronically. Electronic shutters actually "dump" the image from the sensor just prior to the exposure, then make the sensor active again just for the interval when the picture is taken, providing a very good simulation of how a mechanical shutter works.

If you partially depress the shutter release before pushing it down all the way, most cameras carry out a few last-second tasks. Your automatic exposure and focus are locked in. If you like, you can reframe your image slightly and the camera will keep the same exposure and focus settings. With autofocus, the focus is adjusted by maximizing the contrast of the main subject, or by more sophisticated means. For example, Sony pioneered an autofocus system using a Class 1 laser that projects a grid of light on your subject. The camera then analyzes the contrast between the subject and the laser pattern. This system is particularly good in low light levels in which the subject's contrast under the existing illumination may not be enough to focus easily.

If the existing light is not sufficient, the electronic flash ([7] in the illustration) may fire. Most cameras interpret the amount of electronic flash light bouncing back from the subject to calculate the correct exposure. Some use a preflash a moment before the main flash to calculate exposure. The preflash also may cause the irises of living subjects to contract slightly, reducing the chance of red eye.

The shutter speed has no effect on exposure in most cases, because the electronic flash's duration (1/4,000th to 1/50,000th second or less) is much briefer than the typical shutter speed. While lens openings can adjust exposure within limits, most electronic flash provides additional exposure flexibility by emitting varying amounts of light, providing a shorter exposure at closer distances.

The electrical signals from the sensor, once converted to digital form within the electronics of the camera, are stored on digital media, such as CompactFlash, SmartMedia, SecureData cards

or some other media, such as the Hitachi Microdrive mini hard disk. The time needed to store an image can be as little as a few seconds to 30 seconds or longer, depending on the size of the image, the compression method and ratio you've selected, and the "speed" of the storage media. (Some memory cards take significantly longer to store an image than others.) I've located the electronics and storage at [8] on the diagram, but the actual position can vary widely by digital camera vendor and model. The most popular position seems to be the right side of the camera.

Making Sense of Sensors

Understanding how sensors operate can be important, because, ultimately, the resolution and quality of your digital image is largely determined by the solid-state capture array. Certainly, the lens that focuses the image on the sensor has an equal role, but optical technology is fairly mature, dating back to the invention of the first magnifying glasses (used for reading) in the 13th century. Even fairly recent developments, such as aspheric (non-spherical) lenses and optics created especially for digital cameras, involve little more than refined application of well-understood principles.

Digital sensors are a whole new ballgame. The first CCD sensors were created around 30 years ago, and Kodak introduced the first megapixel sensor (with an incredible 1.4 million pixels) in 1986. The technology has improved in several directions, the most important of which for digital photographers is the increase in resolution that has come hand in hand with a huge reduction in price. We now have sensors with 16 million pixels or more, and the cost to produce them has dropped enough that cameras that can capture 6 or more megapixels can be purchased in the $1,000 price range. During the life of this book, I fully expect the pixel counts to double while the cost is cut in half.

The most interesting developments seem to be coming in technology like that used with the Foveon X3 sensor, the first sensor capable of capturing any of the primary colors of light at any pixel position. As odd as it might seem, standard digital camera sensors only grab part of a picture with each exposure, using a mathematical process called *interpolation* to make some educated guesses about the missing pixels. This will all become clear after a bit of explanation.

Figure 2.6 shows a six-by-six pixel section of a CCD sensor. The full sensor for a 5 megapixel camera would have something like 2,560 columns and 1,920 rows of pixels, but the array would be essentially identical to the section in the illustration. For the figure, I've broken the sensor section apart into two layers. The gray layer on the bottom is the actual photosites that capture photons for each pixel's information. The colorful layer on top consists of colored filters that each pass red, green, or blue light and block the other colors. Because of the

Figure 2.6 *A typical CCD sensor consists of a sensor array overlaid with a series of filters arranged in a mosaic pattern.*

filters, each of the five million pixels in the sensor can register *only* the amount of one of these three colors at its position.

Of course, a pixel designated as green might not be lucky enough to receive green light. Perhaps that pixel should have registered red or blue instead. Fortunately, over a 5 million pixel range, enough green-filtered pixels will receive green light, red-filtered pixels red light, and blue-filtered pixels blue right that things average out with a fair degree of accuracy. Algorithms built into the camera can look at surrounding pixels and calculate with some precision what each pixel should be. Those are the pixels saved when an image is stored as a JPEG or TIFF file on your memory card. (Saving the uninterpolated RAW data is another option, which I'll explain in Chapter 4 "Dealing with Digital Camera Formats.")

For reasons shrouded in the mists of color science, the pixels in a sensor array are not arranged in a strict red-green-blue alternation, as you might expect to be the case. Instead, the pixels are laid out in what is called a Bayer pattern, which you can see in Figure 2.6: one row that alternates green and red pixels, followed by a row that alternates green and blue filters. Green is "over-represented" because of the way our eyes perceive light: we're most sensitive to green illumination. That's why monochrome monitors of the computer dark ages were most often green on black displays.

The arrangement used is called a *mosaic* or *Bayer pattern*, and one result is that a lot of the light reaching the sensor is wasted. Only about half of the green light reaching the sensor is captured, because each row consists of half green pixels and half red or blue. Worse, only 25 percent of the red and blue lights are registered. Figure 2.7 provides a representation of what is going on. In our 36-pixel array segment, there are just 18 green-filtered photosites and nine each of red and blue. Because so much light is not recorded, the sensitivity of the sensor is reduced (requiring that much more light to produce an image), and the true resolution is drastically reduced. Your digital camera, ostensibly with 5 megapixels of resolution, actually captures three separate images measuring 2.5 megapixels (of green), 1.25 megapixels (of blue), and 1.25 megapixels (of red).

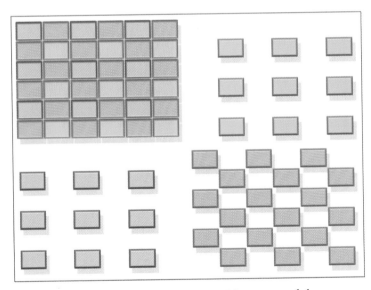

Figure 2.7 *A CCD's mosaic captures 50 percent of the green information, but only 25 percent of the red and blue.*

The Promise of Foveon Technology

The Foveon sensor is a CMOS device that works in a dramatically different way. It's long been known that the various colors of light penetrate silicon to varying depths. So, the Foveon device doesn't use a Bayer filter mosaic like that found in a CCD sensor. Instead, it uses three separate layers of photodetectors, which are shown in Figure 2.8 colored blue, green, and red. All three colors of light strike each pixel in the sensor at the appropriate strength as reflected by or transmitted through the subject. The blue light is absorbed by and registers in the top layer. The green and red light continue through the sensor to the green layer, which absorbs and registers the amount of green light. The remaining red light continues and is captured by the bottom layer.

So, no interpolation (called *demosaicing*) is required. Without the need for this complex processing step, a digital camera can potentially record an image much more quickly. Moreover, the Foveon sensor can have much higher resolution for its pixel dimensions, and, potentially, less light is wasted. Of course, as a CMOS sensor, the Foveon device is less sensitive than a CCD sensor, anyway, so photons are wasted in another, different way. Compare its coverage pattern, shown in Figure 2.9 with that of the CCD's mosaic in Figure 2.7.

Digital still cameras are going through the same process that changed the video camera world some time back. Early video cameras had a single CCD set up in a mosaic much like that used with digital cameras today. Eventually, video systems migrated to a tri-CCD sensor that uses three CCDs, one each for red, green, and blue.

The Downside of CMOS Technology

After reading the previous section, you might conclude that CCD sensors are headed for the dustbin and that, in the very near future, we'll all be using the next generation of Foveon-style imagers. In the real world, while Foveon technology has a lot of theoretical advantages, there are currently some disadvantages that need to be overcome. This next section discusses some of the techie issues. If you're not interested in nuts and bolts, you can skip ahead.

Figure 2.8 *The Foveon X3 sensor can record red, green, or blue light at each pixel position, with no interpolation needed.*

Figure 2.9 *The Foveon X3 sensor captures each color at every pixel position, using three layers of photodetectors.*

CCD and CMOS sensors have been duking it out for the past several years. Most digital cameras, especially the highest-quality models, use CCDs. As I mentioned earlier, CMOS devices have been most often used in lower-end cameras. Canon, which uses a type of CMOS sensor in its higher-end cameras, and Foveon, which produces the sensor used initially in the Sigma SLR, have mastered the art of coaxing high-quality images from CMOS sensors. So has Kodak, which uses a CMOS sensor in the Kodak DCS 14n full-frame digital camera.

The two types of sensors manipulate the light they capture in different ways. A CCD is an analog device. Each photosite is a photodiode that has the ability (called *capacitance*) to store an electrical charge that accumulates as photons strike the cell. The design is a simple one, requiring no logic circuits or transistors dedicated to each pixel. Instead, the accumulated image is read by applying voltages to the electrodes connected to the photosites, causing the charges to be "swept" to a readout amplifier at the corner of the sensor chip.

A CMOS sensor, on the other hand, includes transistors at each photosite, and every pixel can be read individually, much like a computer's random access memory (RAM) chip. It's not necessary to sweep all the pixels to one location, and, unlike CCD sensors, with which all information is processed externally to the sensor, each CMOS pixel can be processed individually and immediately. That allows the sensor to respond to specific lighting conditions as the picture is being taken. In other words, some image processing can be done within the CMOS sensor itself, something that is impossible with CCD devices.

However, the chief advantage of CMOS technology is that CMOS chips are less expensive to produce. They can be fabricated using the same kinds of processes used to create most other computer chips. CCDs require special, more expensive, production techniques. In most cases, the extra expense is worth it, because CMOS sensors generally produce more noise and artifacts (two kinds of non-image information that can creep into an image), are less uniform, and require larger sensors.

So, in the war between CCD and CMOS, there is quite an array of pros and cons facing each type of sensor. Things become even more interesting in the case of the Foveon chip, which has some additional limitations that I haven't mentioned yet.

First, you'll recall that light of all three primary colors strikes the Foveon chip, passing through the blue, green, and red layers. Some light is absorbed in each layer, so a much smaller amount reaches the bottom layer, providing reduced color information. In addition, a phenomenon called *blooming*, or the spreading of light from one layer to another, can occur. If one layer is overexposed, the excess light can "bleed" into the layer below. When you add these to the reduced sensitivity and extra noise of CMOS chips, you can see that, as promising as the Foveon sensor is, there is plenty of room for improvement before digital camera vendors abandon CCD technology.

There are other characteristics of sensors that are relevant and interesting, such as the infrared sensitivity that's inherent in CCD sensors. Indeed, camera vendors must install infrared blocking filters in front of sensors, or include a component called a *hot mirror* to reflect infrared to provide a more accurate color image. Luckily (for the serious photographer) enough

HOW SHUTTERS WORK

Digital cameras can have either a mechanical shutter, which opens and closes to expose the shutter, or an electronic shutter, which simulates the same process. The type of shutter your camera has depends a great deal on the kind of sensor that is built into your camera. In terms of the kind of shutter they can use, sensors fall into one of two categories, *interline* and *full frame*. Both terms deal with how the sensor captures an image.

The interline sensor, developed originally for video cameras, isolates an entire image in one instant, and then gradually shifts it off the chip into the camera electronics for processing and conversion from an analog signal to digital format. While this process is underway, a new image can be accumulating on the chip. That's because the interline sensor is, in effect, two sensors in one; while one sensor is exposed to light, the other is masked. The two sensors exchange places so that the previously masked sensor can then accept light while the sensor that was previously exposed is shielded so it can offload its image to the camera's electronics. This capability was important for video cameras, which expose their sensors at a rate of 30 frames per second. Because of this ability to isolate an image in a fraction of a second, interline sensors can function as an electronic, non-mechanical shutter.

A full-frame sensor, in contrast, is a single sensor that cannot isolate an image while it is still exposed to light. The sensor must be physically covered, uncovered to make the exposure, and then covered again while the image is transferred to the camera's electronics. If the sensor is still exposed to light when an image is moved from the chip, the image will be smeared by illumination that strikes the photosites while the old image is being shifted. That calls for a mechanical shutter.

infrared light sneaks through that it's possible to take some stunning infrared photos with many digital cameras. That's a capability we're going to have a lot of fun with in Chapter 7, "Scenic Photography."

A relatively recent development is the "4/3" standard proposed by Kodak and Olympus, which will establish a common 4:3 aspect ratio for sensors used in digital cameras, along with a standard size sensor and back focus distance. If adopted, it would mean that, among other things, lenses for digital cameras would perform similarly regardless of which camera they were used with.

Selecting a Digital Camera

For the serious photographer, buying a camera can be a major undertaking. The point-and-shoot set may purchase a camera based on one or two marginally relevant characteristics, such as whether the camera is small enough to tuck into a pocket, or whether it has 2 or 3 megapixels of resolution. You know the type: they want a camera that takes "sharp, clear" pictures and don't care about much else. Because they just want snapshots, evaluating camera features in depth is just not worth the time for them.

Those who see photography as something more than a tool to record vacation pictures have more at stake in their selection of a camera, especially when you consider that digital cameras still command a premium price. If you pay $800 to $1,000 (or a lot more) for a digital camera and find it won't do what you want, you might be stuck with your bad decision for a long time. Not all of us are as lucky as the friend of mine who can afford to buy a new digital camera every six months (nor even as fortunate as his close relatives, who receive the hand-me-down cameras on a schedule that they eagerly anticipate).

One way to choose a camera is to read the reviews found in magazines and websites. Unfortunately, such reviews will tell you how a particular camera is suitable for the kinds of photographs the reviewer takes, but may not have information that applies directly to you. The reviewer may not even be a photographer. How can you decide what to buy?

This next section should help you, because I'm not going to recommend specific camera models. Instead, I'll provide some perspective on what kind of features you can expect to find, and how (and why) they may be important to you.

You may have purchased your first digital camera before you bought this book. Or, perhaps you're the type who likes to learn everything he can before making a purchase. You may be reading this chapter to make sure that the digital camera selection you make is a wise one, and that your camera will suit your needs for a very long time. In either case, it's very likely that the digital camera you now own or plan to buy in the near future will not be the last one you ever purchase. No matter how feature-laden your current camera is, or how lengthy the feature list of the camera you have your eye on, there will be a better one with more features at a lower price in the future, whether it's a six months from now or two years from now.

For most of us, a digital camera isn't a lifetime investment. It's more of a purchase like a computer: a tool we buy now so we can enjoy the advantage of current technology, but with the full expectation of replacing it somewhere down the road with a smaller, better, more powerful, more flexible device—at a lower cost. No matter what type of digital camera buyer you are—veteran, beginner, or someone who hasn't dipped a toe into the digital waters yet—this section will assist you.

Defining Your Expectations

Among my many photography-oriented jobs, I was the manager of a camera store for two years. Saturday was the traditional day when the store was flooded with eager photography fans who poured in, cash in their feverish hands, all posing the same question: What's the best camera to buy? My response was always: What do you plan to do with it? The question "what's the best camera?" is a little like "what's the best car?" Depending on what you plan to do, your needs, like your mileage, may vary. Do you want basic transportation? Do you want an exotic machine that makes your friends drool with envy? Are you looking for a sports utility choice that does everything well once you master its demanding features? You'll find analogs for all these automobile types within the digital camera realm from the economy compact to the luxury model with everything from power steering to power zoom.

Not even the well-heeled with unlimited funds can escape the need to establish a list of needs. Digital photography is one area in which the most expensive equipment may not be the best. You can spend a lot, and still end up with a camera that won't do what you want, or, as is more likely, which is so complicated to use that you'll never figure out how to take the pictures you want to take.

I've owned one particular digital camera for more than 18 months. I still can't remember which menu I need to access to switch to manual focus, and even when I manage that, focusing requires pressing an odd combination of buttons. Changing from fully automatic exposure to shutter priority mode (necessary for shooting sports pictures when you want to use the highest shutter speed possible) is equally time consuming.

A newer camera I use makes manual focus a dream. I press a button labeled AF/MF until an MF (manual focus) indicator appears in the viewfinder, and then rotate a focus ring around the base of the lens. A reassuring readout in the viewfinder shows the current focus distance. If I want to change to aperture priority mode, all I need to do is twist a dial to the "exposure mode" position and turn a jog wheel next to the shutter release until "aperture priority" appears in the viewfinder. If a particular camera confuses someone who has used hundreds of different cameras over a span of many years, think how a model like that might confound someone trying to master their first digital camera!

There are many other factors to consider in addition to ease of use. Rather than buy the wrong camera, you'll want to think about this checklist before you go shopping.

Do You Plan to Edit Your Images?

For the avid photographer, image editing is usually part of the game plan. You may intend to spice up your digital photos with filters, correct colors, or by combining several images to create a whole new picture. For many, that sort of image editing is one of the main reasons for switching to digital photography. The photo shown in Figure 2.10 shows the kind of image editing you can do, although in this case the image is a misguided attempt to remove by retouching all the links that overlap a caged tiger. If you're going to be manipulating pictures that extensively, you'll want a camera with the most flexibility, easiest access to manual features, extra resolution, and many bonus capabilities that give you pictures worth editing.

However, other digital photographers are part of a second group that intends to do little or no editing. Maybe you're shooting home exteriors and interiors for a real estate firm. Or, you might need pictures of items for your eBay auctions, and will be doing nothing more than cropping your images. Perhaps you require some quickie product shots for an online catalog. In all these cases, the best camera for the job may be one with the widest-angle lens (for those home interiors) or the best close-up capabilities (for those eBay auctions). A less expensive camera may be in order, or, at least, one with *different* capabilities than the one a devoted Photoshop freak will be considering.

Figure 2.10 *Retouching can sometimes work miracles, as in this work in progress of removing the cage (upper left) around the captive tiger (lower right).*

TIP FROM THE PROS

Before choosing a lower-resolution camera, keep in mind that you'll be limiting yourself to low-resolution photography. Pro photographers know that if you need a feature, such as higher resolution, even 10 percent of the time, it makes sense to go for a more advanced camera that includes it. Those one-in-ten shots will soon easily pay for the extra expenditure. Should you take the low-res road, maximize your pixels by composing very, very carefully.

What Are Your Resolution Requirements?

Some types of photography demand higher resolutions. If you want to create large prints (anything larger than 8 × 10 inches), you'll need multimegapixels. If you want to crop out small sections of an image, you'll want a camera with 5 to 6 megapixels or more.

On the other hand, if your primary application will be taking pictures for display on a web page, or you need thumbnail-sized photos for ID cards or for a catalog with small illustrations, you may be get along just fine with a 3 to 4 megapixel camera. These models are still much less expensive than their mega-megapixel brethren.

When choosing a camera's resolution, remember to consider not only the *top* resolution, but all the optional resolution and compression options the camera provides. For example, a 5 megapixel camera that can capture 2560 × 1920 pixel images will also include controls that let you choose other resolutions, such as 1600 × 1200 or 1280 × 960. Compression ratios can also be user selected, and can range from ultra-high quality (and ultra-large) TIFF and RAW files to several levels of JPEG squeezing that trade some image quality for smaller file sizes. These options can come in handy when you need a lower resolution so you can shoot at a faster frame rate for "motor drive" picture sequences, need to cram more images onto a film card, or simply don't need the higher resolution.

We'll take a closer look at resolution and compression in Chapter 4.

Do You See Photography as a Creative Outlet?

Like those who plan to make Photoshop their second home, creative photographers will want cameras with the most convenient manual controls, accurate viewfinders, and other options. Perhaps you need a model that can be adapted for infrared photography. Would you like to take time-lapse photos of a flower opening or the moon setting? Are you interested in photography of fireworks? Do you have a special yen to specialize in black-and-white photography? There are cameras that are more suited to each of these pursuits than other models, so if creative flexibility is high on your list, you'll want to choose your camera carefully.

How Many Pictures Do You Take in One Session?

If you often find yourself shooting pictures far from easy access to your computer, you'll want a camera and accessories that cater to the needs of the high-volume photographer. Some kinds of digital media have limited maximum storage capacity, sometimes 128MB or less. Choose a camera that uses that kind of storage and you'll need to take *lots* of digital film with you on each shoot. Other types of media have capacities of a gigabyte or more. If you take many photos, or need to use the highest resolution settings and file formats of your camera, storage capabilities will be a major consideration.

Should your plans include taking lots of photos at one time, or over the course of a trip, buy a camera that uses high capacity media that's priced low enough so you can afford to stock up. Also consider buying one of those stand-alone hard disk drives that can download all the images from your digital camera. Another alternative is taking along a laptop to hold your images, or to serve as a gateway to upload images to your Internet web space. All you need is a PC Card adapter for your laptop, like the one shown in Figure 2.11. Some recent laptops include a digital film card reader, too!

Figure 2.11 *A laptop equipped with a PC Card slot and an adapter can serve as a home away from home for your digital photos.*

How Quickly Do You Need Access to Your Photos?

The camera you choose can make a difference in how quickly you can download and work with your pictures. Cameras with a USB link or removable storage card and matching card reader in your computer expedite images into your computer at high speed. FireWire (IEEE-1394) and USB 2.0 are faster than USB 1.1 (still found on some older cameras). Cameras that use an old-fashioned serial port can take a minute to download a single picture. That can seem like an eternity when you need to transfer a couple dozen photos to your computer.

Will Your Camera Be a Long-Term Investment?

Photography is one field populated by large numbers of technomaniacs who simply must have the latest and best equipment at all times. The digital photography realm rarely disappoints these gadget nuts, because newer, more sophisticated models are introduced every few months. Nikon, for example, made the transition from its (then) top-of-the-line CoolPix 900 to the 950, 990, and 995 in about 24 months. The company then introduced several more variations on the same basic swivel-lens scheme before jumping off in different directions with even newer models. If you wanted to own the most sophisticated non-SLR Nikon digital camera since 1998, you'd have to purchase eight or more models in less than five years.

If you want to remain on the bleeding edge of technology, a digital camera *can't* be a long-term investment. You'll have to count on buying a new camera at least once a year. Keep in mind that you'll be duplicating your investment in the near future, and your old camera will be worth more as a hand me down to another user than as a trade-in. Don't spend $2,000 for a 6 megapixel digital SLR today if you'll be unhappy and unable to afford the upgrade next year when 12 megapixel models cost $1,000.

On the other hand, many digital camera buyers aren't looking for a shiny new gadget: they want pictures. Once they acquire a camera that does the job for them, they're not likely to upgrade until they develop an important job their current model can't handle. My wife is still using a 1024 × 768 pixel digital camera for eBay pictures. I keep a 3.3 megapixel model on my desk for those times when I need a quick close-up to illustrate a point for a book. (For example, Figures 2.1 through 2.4 were captured on the spur of the moment simply by placing the camera illustrated on an 8.5 × 11 inch piece of paper and snapping away with that 3.3 megapixel antique.)

If you're in the anti-upgrade camp, you should get a camera that does the job for you at a price you can afford. If your desires are large but your pocketbook is limited, you may want to scale back your purchase to make those inevitable frequent upgrades feasible.

Is Size Important?

Some intermediate or advanced cameras are small enough to slip into a pocket so you can carry them everywhere. You can even find 4 and 5 megapixel models that verge on the tiny. Other cameras with roughly similar features and comparable price tags may be so chunky you'll need a camera bag, perhaps with wheels, to carry them around. On closer inspection, you'll find there are some differences (say, in storage media or zoom lens range), so you'll need to decide if the trade-offs are worth the smaller size.

Is the Camera Likely to Be Lost, Stolen, or Damaged?

Will you be taking your digital camera on your boat for some exciting regatta photos? Planning on toting along a camera during your next free climb up Terror Cliff? Will your 9 year old be taking the camera to school? Don't spend a lot for a digital camera that will be used under perilous conditions unless you can afford to write off the camera if it's lost, stolen, or damaged. Certainly, your homeowners or other insurance policy may pay for the camera—once—but it's always a good idea not to try to shift the responsibility off on the nice folks you may rely on to replace your home the next time it burns to the ground. It's more prudent to avoid that kind of exposure in the first place and purchase a less expensive camera for hazardous duty.

Do You Want to Share Lenses and Accessories with a Conventional Film Camera?

Do you already own a Nikon or Canon SLR camera with lots of lenses and other accessories? You may be able to justify a digital camera built around a camera body similar to the one used by your film camera. The camera need not come from Nikon or Canon, either. Other vendors, such as Kodak and Fuji, build cameras based on models from the two market leaders.

The list of compatible gadgets that can be shared is long, ranging from electronic flash units through filters, close-up attachments, tripods, and so forth. I have a zillion glass filters and accessories in 52mm size to fit my existing 35mm cameras. I was happy to discover a digital camera that used 49mm accessories, because a simple 49 to 52mm step-up ring let me use my existing accessories with the newer camera. Figure 2.12 shows a more drastic adaptation, from 28mm up to 52mm. Check compatibility now, before you purchase your digital camera.

Figure 2.12 *Adapter rings let you get double duty from your filters and other lens accessories.*

TIP FROM THE PROS

Buy yourself some step-up and step-down rings in common sizes, even if you don't need them now. In an emergency, you can always borrow a filter from a colleague, but an adapter ring may be more difficult to scrounge up. Try out the rings on your camera ahead of time, too. A large step-up may mean that the ring and accessory intrude on the optical viewport of your camera, obscuring part of the frame. In that case, be prepared to switch to the LCD viewfinder. Finally, these rings can vignette the corners at wide-angle settings. Buy "thin" rings if you can. Otherwise, you might need to take a step backwards and zoom in a tad to get the framing you want without clipping the corners.

Choosing a Camera Category

Until recently, digital cameras fell into a few neat categories, defined by the resolution of the sensor. Beginner cameras had about 1.3 megapixels; intermediate cameras were those with around 2 megapixels, while advanced cameras topped out in the neighborhood of 3.3 megapixels. For more resolution than that, you had to spend big bucks for a professional camera.

The reason for the neatly defined categories is that sensors were easily the most expensive component of the camera, accounting for a large percentage of the vendor's cost. So, you never saw a 6 megapixel model with nothing but point-and-shoot capabilities; the manufacturer would still have to charge $1,000 for the camera because of the sensor's cost, and who would pay $1,000 for a camera not loaded down with other features?

The prices for sensors have dropped dramatically, so today we're seeing compact, fully automated cameras at relatively low prices with 4 and 5 megapixel sensors. These are sold side by side with more fully featured cameras with longer zooms, electronic viewfinders, and other goodies, but basically the same 4 to 5 megapixel resolution. You'll see 6–8 megapixel SLRs selling for less than $1,000 from the same vendors who offer a $4,000 version with the same resolution but capabilities that have been beefed up in other areas. The lines between digital camera categories are blurring. Even so, it's useful to describe the various categories as they still exist, because your digital camera will probably fit into one of them, one way or another.

Basic Point-and-Shoot Models

Aside from webcams and a few "toy" digital cameras, any model that falls roughly into the $100–$150 price range is probably a point-and-shoot camera. These will have a top resolution in the 2 to 3.3 megapixel neighborhood, around 1600 × 1200 pixels. There will be a built-in flash good for shots from five to about 15 feet, and either a non-zooming, fixed focal length lens or a very modest 2:1 ratio zoom lens. Focusing may be fixed or limited, and there will be few, if any, manual controls. You'll frame your picture through a simple optical viewfinder and view it on a 1.6 to 1.8 inch LCD. In point-and-shoot tradition, you simply press the button and everything else is taken care of for you.

Intermediate Models

The largest number of digital camera models fall into the intermediate category, because cameras of this type appeal to casual snapshooters who want sharp, clear pictures and a bit of versatility in their pixel grabber. Most of these cameras have from 3 to 6 megapixels and cost $200 to $400. They have more powerful built-in flash units, automatic focus and exposure, and zoom lenses with 3:1 or greater ratios. There may even be a few manual settings, such as exposure compensation for backlight (such as photos taken toward the sun). Anyone who is not a photo buff can probably take any picture they care to create with a camera of this sort.

Advanced Models

While intermediate cameras are numerically more common, slightly more advanced models have become a hotbed of interest as prices have dropped. Your $500 to $600 can buy a 6 megapixel (or more) camera with a 4:1 or longer zoom range, more manual control options, and other bonus features. These cameras appeal to those who aren't yet photo hobbyists, but who realize they can take better and more interesting pictures with a digital camera that has a little more horsepower. These models are liberally studded with multifunction buttons and dials, lots of modes, dozens of menus, and thick manuals. They're often sold with a rich bundle of image-editing software. Those who need, or think they need, the features these cameras boast, should prepare to spend some time learning to use them. A whole new category of advanced models is likely to be spurred by the introduction of the Canon Digital Rebel, which boasts 6 megapixels of resolution but is a true SLR camera, even though it is aimed at consumers rather than the "prosumers" discussed in the next section.

Prosumer Models

What's a "prosumer" camera? This particular kind of camera has been around since before the digital age—a model with truly sophisticated features, offering a knowledgeable photographer

Prosumer Models

What's a "prosumer" camera? This particular kind of camera has been around since before the digital age—a model with truly sophisticated features, offering a knowledgeable photographer lots of control, but lacking in some of the features and ruggedness that a professional absolutely must have. These are the cameras that advanced amateur photographers favor, because their lower cost frees up money to purchase extra accessories. They are also the cameras that pros use on weekends for their personal photography, or which they purchase as cheap, extra cameras to supplement their "good" equipment.

For $1,000 to $4,000 (and prices are dropping all the time), you can buy a 6 to 14 megapixel camera with enough precision optical glass to detect life on Jupiter. Some of these are based on existing SLR models from Nikon or Canon, or are designed from the ground up as a digital camera.

What do you get for the extra cash? Prosumer cameras either have interchangeable lenses, or have zoom lenses with 7:1 to 10:1 ratios that practically eliminate the need for removable lenses in the first place. They'll have through-the-lens viewing or, at the low end, an electronic viewfinder. There will be enough built-in memory buffer to let you snap off five or six frames individually or in motor drive mode without pausing for breath.

What's the downside? Some of these cameras are a little like conversion vans, offering the disadvantages of both the conventional photographic worlds without all the advantages of the digital dominion. For example, they may be heavier than most digital cameras, yet not as flexible as a traditional film camera in some ways. Because the digital sensors are smaller than the 24 × 36 mm size of the standard 35mm film frame, a given lens's field of view may not be what you expect. Your 55mm normal lens becomes a short telephoto lens, and your 105mm portrait lens becomes a longer telephoto. The price of a prosumer camera is a lot to spend on a device that will certainly be obsolete (from a technological viewpoint; not in practice) alarmingly soon. However, if you've got the bucks and need the features, go for it.

Professional Models

For $5,000 to $30,000 or so, you can get yourself a camera, like the one shown in Figure 2.13, which is in virtually all respects the equal of a professional film camera. If you need one of these, you don't need me to tell you so. However, if you're not ready to venture into this territory, you may wonder exactly what all the fuss is about. Why does Nikon, for example, offer both pricey professional digital cameras as well as a seemingly similar "amateur" model with roughly the same resolution for one-third the price?

A few hours with these stablemates and you'll know the reason. Professional digital cameras are built with stronger, more rugged bodies, often made of titanium or some other metal, rather than the lighter polycarbonate frames found in prosumer models. Pro cameras may be quicker to start up, allow snapping longer sequences of photos at the camera's full resolution, use faster and more accurate automatic focus and exposure mechanisms, or have beefier power sources. They also have full-frame sensors so you don't have to calculate in your head the "true" focal length of the lens you are using. If your living depends on getting a photo, you'll want one of these (actually three of these) in your camera bag.

Figure 2.13 *Professional cameras like this Kodak DCS Pro14n with 14 megapixel sensors (or greater) are dropping below the $5,000 price level.*

TIP FROM THE PROS

A particular photo shoot may be important to you (say, it's your first trip to Europe and you don't want to go home empty-handed) or to someone else (a client is paying you for the pictures). It's always a good idea to have a backup for every important piece of equipment. If you're working professionally, *three* workable alternatives is probably the bare minimum. That means three cameras, three electronic flash units (if you're using external flash), three times as many batteries as you think you're going to need, and triple the number of digital memory cards that you believe a job requires. The equipment needn't be 100 percent identical in all cases; functional equivalency is often sufficient. So, you'll want to carry a backup digital camera of some sort along with your main camera, perhaps some alkaline batteries to supplement your heavy-duty rechargeables, and a clamp-style camera stand in case your tripod suddenly falls to pieces. When I was a traveling photojournalist, I insisted on having at least three of even the most expensive pieces of equipment: one to use, one as a backup, and one in the shop being repaired.

Choose Your Weapons

Narrowing down your choices to a specific camera category is only half the job. Because features can vary widely even within a category, you'll still need to decide which capabilities are "must haves" and which are "nice to haves if they don't cost an arm and a leg." This section will outline your chief options among lens requirements, resolution, storage options, exposure controls, and viewfinders.

Understanding Lens Requirements

The lens is the eye of your camera. It captures and focuses the light from your scene onto your sensor. Your digital camera's lens affects the quality of your images as well as the kinds of pictures you can take. What really counts is the quality of the lens, the amount of light it can transmit, its focusing range (how close you can be to your subject), and the amount of magnification (or zooming) that the lens provides. Here are some of the things you should consider.

Lens Aperture

The lens aperture is the size of the opening that admits light to the sensor, relative to the magnification or focal length of the lens. A wider aperture lets in more light, allowing you to take pictures in dimmer light. A narrower aperture limits the amount of light that can reach your sensor, which may be useful in very bright light. A good lens will have an ample range of lens openings (called "f-stops") to allow for many different picture-taking situations.

f-stops are actually the denominators of fractions rather than actual measurements, so an f2 opening is larger than an f4 opening, which is in turn larger than an f8 aperture, just as 1/2 is larger than 1/4, which is larger than 1/8. Each stop you open up (going from, say f8 to f5.6) doubles the amount of light reaching the sensor, as shown in Figure 2.14.

Figure 2.14 *Each time your lens opens up one f-stop, twice as much light is admitted to the sensor.*

You generally don't need to bother with f-stops when taking pictures in automatic mode, but we'll get into apertures from time to time in this book. For now, all you need to know is that for digital photography, a lens with a maximum (largest) aperture of f2.8 is "fast" while a lens with a maximum aperture of F8 is "slow." If you take many pictures in dim light, you'll want a camera that has a "fast" lens. The sensitivity of the sensor, discussed later, is also important for low-light pictures.

Digital camera lenses tend to be slower than their prime lens (non-zooming) counterparts. That's because digital optics are almost always zoom lenses, and zoom lenses tend to have smaller maximum apertures at a given focal length than a prime lens. For example, a 28mm non-zoom lens for a 35mm camera might have an f2 or f1.4 maximum aperture. Your digital

camera's zoom lens will probably admit only the equivalent of f2.8 to f3.5 when set for the comparable wide-angle field of view. The shorter actual focal length of digital camera lenses also makes it difficult to produce effectively large maximum apertures.

What about the minimum aperture? The smallest aperture determines how much light you can block from the sensor, which comes into play when photographing under very bright lighting conditions (such as at the beach or in snow). Digital cameras don't have as much flexibility in minimum aperture as film cameras, partly because of lens design considerations and partly because the ISO 100 speed of most sensors is slow enough that apertures smaller than f5.6 or f8 rarely are needed. A digital camera's shutter can generally reduce the amount of exposure enough that resorting to the f11, f16, or f22 minimum apertures found on film cameras isn't necessary. (If you're using a digital SLR that uses the same lenses as a film camera, you'll of course have access to these smaller apertures.)

Seasoned photographers will know that a second reason for using a smaller lens aperture is to increase depth-of-field. The smaller the lens opening, the more depth-of-field that is available. In practice, a phenomenon known as *diffraction* reduces the effective sharpness of lenses at smaller apertures. A particular lens set at f22 may offer significantly less overall resolution than the same lens set at f5.6, even though that sharpness is spread over a larger area. Depth-of-field is also tied to the absolute focal length of the lens, too, though, so digital cameras with those 7mm to 35mm zoom lenses already have enough depth-of-field, even at maximum aperture, that stopping down provides no additional benefit. So, unless you're using a digital SLR that accepts conventional lenses, the minimum aperture available isn't particularly important.

Manual Exposure Adjustments

Digital camera lenses that have a selection of f-stops adjust themselves for the proper exposure automatically. The only exceptions are the least expensive models with lenses that cannot be adjusted for exposure at all. Serious photo-hobbyists and professionals might also want the option found in higher-end cameras of setting the lens f-stop manually to provide special effects or more precise exposure. These controls come in several forms, and I'll discuss them in the exposure control section later in this chapter.

Zoom Lens

A zoom lens is a convenience for enlarging or reducing an image without the need to get closer or farther away. You'll find it an especially useful tool for sports and scenic photography or other situations where your movement is restricted. Only the least expensive digital cameras lack a zoom lens. Some offer only small enlargement ratios, such as 2:1 or 3:1, in which zooming in closer produces an image that is twice or three times as big as one produced when the camera is zoomed out. More expensive cameras have longer zoom ranges, from 4:1 to 10:1 and beyond.

In addition, there are two ways to zoom a lens. With so-called *optical zoom*, the relationships of the individual elements of the lens are changed to produce the changes in magnification. Because the lens elements can be fine-tuned, this produces the sharpest image at each lens magnification. For example, a typical zoom might be described as having 10 elements in eight groups. Each of the groups can be moved individually to provide the desired magnification and

the best image. The optical science behind these relationships is complex, and we should be thankful that our spanking new digital cameras have 50 years or more of research backing the optical component.

Digital cameras also feature *digital zoom*, in which the apparent magnification is actually produced by simply enlarging part of the center of the image. Your camera's viewfinder will probably have a frame or other indicator that shows just what portion of the viewed image will be magnified to simulate the zoom setting. Digital zoom is less sharp than optical zoom. Indeed, you can often do a better job by simply taking the picture at your camera's maximum optical zoom setting and enlarging the image in your image editor.

That's all you really must know about zoom lenses. However, here's a bit more detail for the technically inclined. It's easiest to think of zoom ranges in terms of magnification, but the magnification of an image is actually measured in something called "focal length." Focal length is a ratio between the size of the film or sensor image and the distance from a position in the lens to the plane of the film or sensor. Focal length is used to measure whether a lens provides a wide-angle, normal, or telephoto view with a particular size sensor or film.

So, a 6.5mm focal length lens or zoom setting would provide a wide-angle picture with a .5 inch sensor, while a 12mm focal length lens or zoom setting would provide a telephoto effect. Camera vendors often express the focal length of digital camera lenses in terms of how they are equivalent to the common lenses used with 35 mm cameras. They do this because most camera buffs already know that a 28mm lens is a wide-angle optic on a 35mm camera, a 50mm lens is a "normal" lens, and a 135mm lens is a particular kind of telephoto. Digital camera sensor size can vary from model to model, so the actual focal length of a digital camera lens means a lot less than its 35mm "equivalent."

Because the elements of a lens are moving around in strange and mysterious ways, the effective aperture and focus of a lens may vary as the magnification settings change. A lens that has an f2.8 maximum aperture at its wide-angle setting may provide only the amount of light admitted by an f3.5 lens at the tele position. Focus can change, too, so when you focus at, say, the wide-angle position and then zoom in to a telephoto view, the original subject might not technically still be in sharpest focus (although the huge amount of depth-of-field provided by digital camera lenses might make the difference impossible to detect). You'd notice the differences only when using the camera in manual exposure or focusing mode, anyway. When set to autofocus and autoexposure, your camera will provide the optimum setting regardless of zoom magnification.

Focus Range

The ability to focus close is an important feature for many digital camera owners. One of the basic rules of photography is to get as close as possible and crop out extraneous material. That's particularly important with digital cameras, because any wasted subject area translates into fewer pixels available when you start cropping and enlarging your image. So, if you like taking pictures of flowers or insects, plan to photograph your collection of Lladró porcelain on a tabletop, or just want some cool pictures of your model airplane or stamp collections, you'll want to be able to focus up close and personal.

What's considered close can vary from model to model; anything from 12 inches to less than an inch can be considered "close-up," depending on the vendor. Fortunately, those short focal length lenses found on digital cameras come to the rescue again. Close focusing is achieved by moving the lens farther away from the sensor (or film) and a 7.5mm lens doesn't have to be moved very far to produce an image of a tiny object that fills the viewfinder.

The closer you get, the more important an easily viewed LCD display (that screen on the back of your camera) becomes. You'll also want automatic focusing. Lower cost cameras with non-zooming lenses may not have focusing abilities at all; they provide sufficiently sharp focus at normal shooting distances (a few feet and farther) and, possibly, at a particular close-up distance (typically 18 to 24 inches). More expensive cameras have automatic focus that adjusts for the best setting at any distance. Higher-end cameras might also have manual focusing that can let you "zero" in on a portion of your image by making everything else seem blurry. Figure 2.15 shows a pair of close-ups taken with the same camera, at distances of 4 inches and less than an inch.

Figure 2.15 *Get as close as you like with a digital camera that has macro capabilities.*

Add-on Attachments

Photographers have been hanging stuff on the front of their lenses to create special effects for a hundred years or more. These include filters to correct colors or provide odd looks, diffraction gratings and prisms to split an image into pieces, pieces of glass with Vaseline smeared on them to provide a soft-focus effect, and dozens of other devices. These range from close-up lenses to microscope attachments, to infrared filters that let you take pictures beyond the visible spectrum. Add-on wide-angle and telephoto attachments are also available, along with slide

copy accessories and other goodies. If you're serious about photography, you'll want to explore these options.

Make sure your camera's lens has a standard screw thread size (usually from 28mm to 55mm or larger) so you can use standard accessories. Some cameras require special attachments for the front of the lens, which may lock you into accessories from that particular vendor. Fortunately, enterprising third-parties are quick to create adapters that work with the most popular digital models. A few notorious models have lens elements that move *forward* through what would be the front of the lens, making attachment of any sort of filter rather difficult. Check out your intended camera model carefully before buying.

The Myth of Resolution

True or false: you can never be too rich, too thin, or have too much resolution in your digital camera.

Bill Gates and most fashion models would probably agree with the first two points, but the third assertion is open for discussion, even though most buyers of digital cameras seem obsessed with the number of pixels they can capture. Can you actually have too much resolution?

I'd amend the statement to say something along the lines of, "buy and use as much actual resolution as you really need for your photography, unless the extra pixels won't cost you much." The salient points are that, first, you don't need to pay a huge extra amount for resolution that you won't really use, and, second, resolution overkill can actually hamper your creativity and provide a productivity bottleneck. Someone who could get along just fine with a medium resolution $400 camera would be crazy to pay $1,000 or more for a much higher-resolution model if they won't be using that resolution now. After all, next year, when they might actually need that much pixel-grabbing power, cameras that offer that much resolution will probably cost only $400. In this case, waiting until you really need the resolution would save $200, and you'd end up with two usable cameras!

Even if the pixels are available, you shouldn't always use every last bit of resolution in any case. Consider these examples:

■ *Most of your photos are posted on the web in sizes that rarely exceed 600 × 400 pixels.* You often crop your photos, and want to start with a nice, sharp original before reducing it to the size you'll display on your web page. A 3.3 or 4 megapixel camera will do a great job, and provide enough resolution for general photography and reasonably sized prints. You might even be able to get away with a 2 megapixel model.

■ *You love sports photography.* A digital camera with 6 megapixels will certainly let you grab some great sports shots, and even give you enough resolution that you can enlarge portions of the image to simulate having a longer telephoto lens than you really have. Yet, it's not always a good idea to take sports pictures at the max res setting. When action is fast moving, you may lose some great shots while you wait six or ten seconds for a high-resolution photo to be stored so you can take the next one. In this particular case, the

amount of *buffer* memory built into your camera can be crucial. Some 6 megapixel cameras can take only one or two pictures at a time. Others can fire off a half dozen or more before the buffer fills up. When rapid fire or photo sequences are important, you may get better overall pictures by dialing back to a lower resolution, say, 1600×1200 pixels, if you gain the ability to shoot faster and smarter.

- *You're documenting your vacation, and want to snap off 100 photos a day.* You don't have access to a laptop, nor any other means of emptying your digital film cards on a regular basis. If you want to shoot everything using your camera's 5 megapixel top resolution, you'd better count on having one 256MB memory card for each day of your trip. Of course, you can review your photos as you take them, or at the end of the day, and delete the real clunkers. But even so, your costs for digital "film" can really add up, and you really only need that much storage once or twice a year. Who says digital cameras are cheaper to operate than film cameras? The answer may be to shoot tighter and scale back the resolution of most of your shots to a smaller size or use a higher compression ratio that costs you a bit of sharpness. Can you really see the difference in a 5×7 print of you standing atop Mount Everest taken at the 5 megapixel setting from one taken at 3 megapixels?

Keep in mind that resolution is largely a myth, anyway. Pictures taken with a high-quality 3.3 megapixel camera can easily look better and sharper than those grabbed with a model touting 6 megapixels of resolution. How so? Consider all these factors that can affect the quality of the finished image.

- *True resolution.* As mentioned earlier in this chapter, your 6 megapixel camera isn't really capturing 6 million pixels of information in the first place. If it uses a CCD Bayer matrix sensor, it's grabbing a *maximum* of 50 percent of the green pixels, and a *maximum* of 25 percent of the red and blue pixels. The other pixels are created through interpolation, a scheme that has a high degree of accuracy (because adjacent pixels are a very good indicator of what a particular pixel *should* be), but is far from perfect.

- *Shutter speed/camera motion/subject motion.* Your subject might be moving. The photographer might not know how to hold a camera steady and might be a little jittery. You may be taking a picture at a long telephoto setting, which automatically *magnifies* camera or subject motion. The camera's shutter speed may be too slow to freeze the subject while all this movement is going on. As a result, a "high-resolution" photo may be less sharp than one taken at a lower resolution at a higher shutter speed, with a steadier photographic hand or an unmoving subject. Something as simple as a tripod might magically transform your medium-resolution camera into one that can thoroughly thrash the results of a handheld high-res model.

- *Lighting/contrast.* An image of a higher-contrast subject, or one taken with higher-contrast lighting, can look sharper than a low-contrast picture of similar subject matter.

- *Focus.* A sensor can only capture a sharp image if it's sharply focused. A poor autofocus system or inept use of manual focus can reduce the sharpness of even the highest-resolution image.

- *Optics.* Even the highest-resolution sensor will be only as good as the lens used to capture the image. Fortunately, lenses designed for digital cameras are capable of producing many times the resolution that a typical sensor can resolve, so a stellar optic doesn't necessarily have much of an advantage over a poor one from a resolution standpoint. However, lenses, particularly zoom lenses, can have other problems. Perhaps you've left a big thumbprint on the front of the lens. Maybe you neglected to use a lens hood, or the lens hood is poorly designed, so extraneous light enters the optical system and reduces contrast and detail. A really cheap lens might not focus all three colors of light at the same point, producing color fringing. A poor lens or one badly used can reduce the final resolution of an image far more than the lack of a few million pixels.

Image resolution (the number of picture elements, or pixels your camera can capture), can determine (along with the quality of your lens and sensor) how sharp your images will be. Resolution is measured by the number of pixels wide by the number of pixels high that can be captured by your camera's sensor. The number may not be strictly true, as some cameras "manufacture" pixels by a mathematical process called interpolation, but it generally provides a good measure of a camera's relative sharpness. You can establish how much resolution you require by estimating how many of your photos will fall into one of these categories:

- *Low-resolution requirements*: Most pictures for web pages or online auctions; photos that won't be cropped very much; pictures that won't be printed in large sizes. If all your photos are of this type, you'll probably be able to get away with a camera with as little as 1280×960 pixel resolution. In the long run, though, if you're serious about photography, you'll probably want a camera with a little more resolution muscle.

- *Medium-resolution requirements:* If you often need to trim out unwanted portions of your pictures or will be making somewhat larger prints, you'll need a higher-resolution camera with resolution of 1600×1200 pixels to 2048×1536 pixels as a bare minimum. Because the actual measurements of the area of the sensor vary greatly, these cameras are most often referred to by the total number of pixels. A sensor with 1600×1200 pixels, or a similar combination that produces two-million pixels, is called a 2 megapixel camera; one with 2048×1536 resolution is in the 3.3 megapixel range. At the time I write this, anything 5 megapixels or less is considered a medium-resolution camera. Add a megapixel or so for every year after the original publication date of this book.

- *High resolution requirements:* If you like to do lots of cropping or make prints that are 5×7 to 8×10 inches or larger, you'll need a high-resolution camera. Today, these are considered models with 6 to 14 megapixels or more. In the future, you can expect the number of pixels to increase and the prices to come down, so that even the highest-resolution models will be easily affordable by serious digital photographers.

You'll probably want a choice of resolutions within a given camera, so you can select the best resolution for the job at hand. For example, if you're shooting a large batch of pictures for a web page or online auction, you'll want to have a relatively low resolution, so you can take more pictures, more quickly, with a minimum amount of resizing required in your image editor. You'll also want to be able to quickly switch to maximum resolution to snap a picture you know you'll want to print out.

Your camera's storage format options can also have a bearing on sharpness. Digital cameras usually store photos in a compressed, space-saving format known as JPEG (Joint Photographic Experts Group). JPEG format achieves smaller file sizes by discarding some information that may not be needed in most cases. The JPEG format has various "quality" levels. If sharpness is very important to you, look for a camera that lets you choose the highest quality JPEG mode when you need it, or which has an optional mode for storing in a higher-quality format such as TIFF (Tagged Image File Format).

One of the first things you'll want to do when you get a new digital camera is set it up on a tripod and take a series of pictures at your camera's Standard, Fine, SuperFine, Ultrafine, and TIFF modes. Then compare the shots to see just how big the difference is. With several cameras that I use, it's difficult to see any difference between the default Fine setting, which yields relatively compact 1MB image files, and its SuperFine mode, which creates files that are four times as large (and which take four times as long to store and transfer). We'll look at file formats in a little more detail in Chapter 4.

Storage Options

Few people select a digital camera based on the kind of storage it provides and, in any case, your storage is usually very open-ended. Virtually all digital cameras have removable storage of some type. Those that don't make you connect your camera to your computer from time to time to download existing pictures to make room for more. In most cases, however, if you need to take more pictures in a session, just buy an additional digital "film" card (usually called CompactFlash, SmartMedia, Secure Digital, Sony Memory Stick or some other trade name). It's unfortunate that vendors seem so intent on introducing more and more memory card formats, because that makes it difficult to swap cards among different cameras and devices.

There are even differences between media that are otherwise compatible. For example, CompactFlash cards come in both Type I and Type II varieties. The chief difference between them is that Type I cards are 3.3mm thick, whereas Type II cards are 5.5mm thick (and thus can have higher capacities). Hitachi's Microdrives are actually miniature hard disks in a CompactFlash Type II configuration. Not all digital cameras can accept both Type I and Type II cards, and not all that are compatible with Type II memory cards work with the more power-hungry IBM Microdrives.

Capacity should be your main concern. Try not to get locked into a type of media that has relatively limited capacity. For example, Sony somehow managed to design its Memory Stick device with a built-in upper limit of 128MB, which is clearly not sufficient in an age when 8 to 14 megapixel cameras are becoming more common. The company developed a clumsy workaround called Memory Select, which includes several 128MB sticks on a single card, and a provision to allow the user to switch between them. The company had to start from scratch and introduce an entirely new format, Memory Stick PRO, to reach beyond the 128MB limitation. The new format requires new equipment designed for it, so purchasers of earlier Sony gear are stuck with the 128MB ceiling (or stacked Memory Select sticks) for now.

Today, CompactFlash and Secure Digital (SD) cards are the most common memory devices in use. CompactFlash has been vying for the capacity championship, with cards holding 4GB.

Secure Digital and the similar MultiMediaCard (MMC) formats have made some especially strong in-roads in recent months. (You can use a MultiMediaCard in a camera that accepts SD Card memory; the camera will write more quickly to the SD Card.) There is even a miniSD card, about two-thirds the size of a regular SD Card. Some Fujifilm and Olympus cameras use the tiny xD-Picture Card. If you were hoping that camera makers would standardize on a single digital film format, we're definitely moving in the wrong direction! The good news is that as formats proliferate, the prices for digital memory cards have plummeted.

Some kinds of memory cards claim to have faster writing speeds than others, even within the same format. I've never found the speed of my digital film to be much of a constraint, but if you shoot many action photos, sequences, or high-resolution (TIFF or RAW) pictures, you might want to compare write speeds before you buy. A card that's been tested to write more quickly can come in handy when you don't have time to wait for your photos to be written from your camera's buffer to the memory card.

Sony currently offers the most options, with cameras that use its Memory Stick, floppy disks, or even a built-in mini-CD-ROM writer. Removable storage devices can be inserted directly into a PC Card adapter, floppy disk drive, or other compatible device in your computer. You can also attach an external reader (many of these accept multiple memory card types). Your camera can also link to your computer though a serial, FireWire, or USB (Universal Serial Bus) cable. Although I own a CompactFlash reader for my computer, I end up simply linking my camera to the computer directly with a USB cable: it's faster and more automatic. I also have a PC Card slot in my computer, and in a pinch I can pop a card into an adapter and retrieve the photos that way. The adapter is shown in Figure 2.16.

Figure 2.16 *Adapters let you read digital camera memory cards in computers that have PC Card slots.*

Exposure Controls

Although I mentioned exposure controls under the lens section earlier, exposure involves more than lens settings, of course. Exposure is also determined by the amount of time the sensor is exposed to light (the equivalent of a film camera's shutter speed) and the intensity of the light (which can vary greatly when you're using an external source, such as an electronic flash unit). Digital cameras all have automatic exposure features for both flash and non-flash photography, but some are more flexible than others. Here are some of the options to look for:

- *Programmed exposure.* Digital cameras take advantage of their computer technology by offering a variety of programmed exposure modes. In addition to standard automatic exposures, you'll find program modes especially for action pictures, scenics, night

photography, portraits, or other common types of situations. These modes take into account the need for specific ranges of shutter speeds (as with sports pictures) or exposure weightings (described next).

■ *Exposure weightings*. A sophisticated digital camera doesn't simply look at how much light is passing through the lens to calculate correct exposure. Instead, the viewing area is divided into segments and individual segments can be given greater or lesser weight, depending on the shooting situation. For example, readings may be center-weighted, on the assumption that the most important subject matter will be in the center of the frame. Or, exposures can be calculated from a *spot* reading of a very small section of the frame. *Averaged* readings may work best for evenly illuminated scenes. I'll explain about various exposure modes in the next chapter.

■ *Plus/Minus or Over/Under exposure controls*. With these, you can dial in a little more or a little less exposure than the amount determined by your camera's built-in light measuring device.

■ *Aperture-preferred/Shutter-preferred exposure*. With this option, you can set the lens opening you prefer and the camera will choose the correct shutter speed. Or, you can select the shutter speed you want, and the camera will choose an appropriate lens opening. As you'll learn later in this book, these controls can be used effectively to ensure that the camera will select the aperture/shutter speed combination that works best in low light or, perhaps, to stop action.

■ *Full manual control*. With this option, you can set any shutter speed or aperture combination you like, giving you complete control over the exposure of your photo. There are many times when you don't want what the camera considers to be "perfect" exposure. Manual control lets you shoot photos that are "too dark" or "too light" but have the artistic appearance you want.

With these features in mind, ask yourself the following questions:

Can your digital camera take low-light pictures without flash? Low-light pictures call for an extra-sensitive sensor. Camera specs often provide the equivalents to conventional film speeds, measured in ISO (International Standards Organization) ratings such as ISO 100, ISO 200, and ISO 400. The higher the number, the more sensitive the sensor. Many cameras let you vary the ISO rating, making your camera more "sensitive" under particular situations. Later in this book I'll show you why changing the sensitivity setting is sometimes a good idea, and why it is sometimes not a good idea. As you select a camera, however, look for the stated ISO rating, and see if it can be changed by the user.

Can your camera compensate for backlit or frontlit pictures? Intermediate and advanced cameras may have a simple provision for departing from the "best" exposure determined by the camera's sensor. For example, you might want to adjust the exposure to compensate for subjects that are strongly backlit (that is, an unimportant background is very bright in comparison to your subject matter) or frontlit (the background is very dark), so the exposure is determined by your actual subject, rather than an overall average of the scene. I'll provide some examples of backlit and frontlit pictures later in the book, like the ones shown in Figure 2.17.

Figure 2.17 *Backlit (left) and frontlit (right) pictures call for different exposure modes.*

Does your camera have various exposure modes fine-tuned for particular kinds of picture-taking sessions, such as sports, portrait, and landscape photography? If so, you can dial in one of these and improve the quality of your pictures effortlessly.

How is the light measured? As I mentioned earlier, digital cameras may have a particular way of measuring light, or may offer several different light-measuring schemes that you can select. For example, your camera may have a "spot" meter that zeroes in on a particular, small area of the image and determines the exposure from that, ignoring the rest of the picture. This feature can be handy when you take many pictures in difficult lighting conditions and would like to specify which area of the picture is used to determine exposure. Or, a camera might measure corners or other specific areas of an image. For the most flexibility, you'll want a camera with several different exposure modes. I'll show you how to use these later in the book.

Can exposure be set manually? I mentioned earlier that cameras that allow manual setting of the lens f-stop might also let you choose either shutter priority or aperture priority (you set one, the camera sets the other) or full manual control over both aperture and shutter speed.

How flexible are the flash features? Some cameras might have a fixed flash range so that you are limited to shooting only in the range between 2 and 12 feet from your subject. Others have special settings for telephoto pictures (in which you are likely to be much

farther from your subject) or for wide-angle shots (in which you are likely to be much closer). You'll also be able to choose whether your flash fires automatically as required, flashes always (useful in some situations), or is always off. With one of my digital cameras, these flash settings apply only when the flash has been popped up from the camera body; you must remember to flip up the flash when it's needed.

It's also useful to be able to use an external flash unit not built into your camera, particularly when you want to use multiple flash for sophisticated lighting, as with portraits. Some digital cameras have a special connector for an auxiliary flash. Keep in mind that those cameras may require that you use only a particular brand of flash, too. (If you don't, the electronic triggering mechanisms may not match and you can "fry" your camera's flash circuitry!)

Viewfinders

Viewfinders have come a long way in the last 20 or 30 years in terms of the amount of information they provide the photographer. Figure 2.18 shows the display found in a traditional film camera's viewfinder when I started as a photographer, compared to the view today through a typical digital camera's viewfinder.

Today, virtually all digital cameras have both an optical viewfinder or electronic viewfinder, which can be used to quickly frame an image, as well as an LCD display screen on the back of the camera for more precise composition and picture review.

The only things you need to check when selecting a camera is to see how visible your camera's LCD display is in bright daylight, whether it is large enough to view easily (most digital cameras use a standardized 1.8 inch LCD component), and the amount of power it consumes. The LCDs on some cameras consume so much power that, if left on all the time, you may find yourself with dead batteries after only a dozen or so shots. (Organic Light Emitting Diode (OLED) displays may help provide lower-power displays in the future.) Active-matrix displays are among the brightest and most power efficient. Some cameras let you turn on the LCD display only when it is required to compose a picture. One camera I

Figure 2.18 *In ancient times, shutter speed, f-stop, and an exposure indicator were the only data displayed in the viewfinder (top). Digital cameras provide a lot more information! (bottom)*

use has a sensor that turns the electronic viewfinder display on only when your eye is pressed against the viewing window. It can also be set to automatically switch between the LCD and electronic viewfinder.

Most of the time, you'll be using your digital camera's optical or electronic viewfinders. The location can be important. A window-type viewfinder (non-electronic, non-SLR) provides a slightly different view from what the lens sees, which means part of the image you see may be clipped off when you're taking a close-up. Placing the viewfinder as near as possible to the taking lens reduces the tendency to chop off the tops or sides of heads or other subject matter. Many optical viewfinders have compensation (called parallax compensation) that clearly shows the limits of your image. Remember, you can also use the LCD display when framing is important. We'll look at these factors more in later chapters.

Of course, if you have a high-end single lens reflex (SLR) digital camera, you will view your subject through the same lens used by the sensor, giving you a much more accurate preview.

If you wear glasses, you'll want to make sure your optical viewfinder has built-in diopter correction (like that found in binoculars) that you can use to adjust the view for nearsightedness and farsightedness. With such an adjustment, you won't need your glasses at all to see the viewfinder image clearly. If you must wear your glasses while you shoot, make sure you can see the entire field of view. Sometimes a ridge or bezel around the viewfinder may prevent someone wearing glasses from seeing the entire subject area.

Other Features

Once you've chosen your "must have" features for your digital camera, you can also work on those bonus features that are nice to have, but not essential. Here's a list of some of the most common bonus features.

- *Voice recording*. Some digital cameras let you add a voice message to annotate your images with a few seconds of sound. Vacation snapshooters will find this capability valuable for keeping track of what photo was taken in what city (or foreign country). Photo hobbyists can record shooting conditions and other information about how the picture was taken (thankfully, digital cameras can record data like shutter speed and aperture used right in the digital file). Photojournalists can keep track of the people in the photo ("left to right are…"). This is a handy feature.

- *Video recording*. Most digital cameras let you record short video clips at low resolution, usually about 30 seconds worth of motion at 640 × 480 pixel resolution (or more). This capability will never replace a camcorder, but short movies can be interesting. If you want clips to put on a website, these digicam videos may be exactly what you need.

- *Video output*. Many digital cameras have video outputs so you can view your pictures on a TV screen without transferring them to a computer first. This is great for previews, and can turn your camera into a portable slide projector! If you're shooting tabletop setups, model train layouts, portraits, or other pictures with a relatively fixed camera position, using a TV as a monitor can be a great way to fine-tune your compositions, or let your portrait subjects see how they look before you snap the shutter.

■ *Power options.* The available power options a camera offers can be important. Some models use only proprietary battery packs, which can cost $40 or more, and may not be easy to replace in a hurry if your battery goes bad unexpectedly. Other models accept standard AA-sized batteries, so you can use cheap alkaline cells, which you can pick up anywhere in a pinch. Alkalines won't last very long in a power-hungry digital camera with flash, LCD display, and perhaps a mini hard disk all vying for juice, but they'll work in an emergency. The ideal situation is to have a digital camera with power-saving features (most can be set to power down after a minute or two and some switch on the electronic viewfinder only when your eye is placed up to the eyepiece), and powerful nickel-metal hydride batteries. Opt for a compact fast charger that can revitalize your cells in an hour or less, as shown in Figure 2.19, and be sure to purchase an extra set (or two) of batteries. Digital cameras also can use an AC adapter, which is often an optional accessory, and not very practical, anyway, unless you're shooting near an outlet.

Figure 2.19 *A compact, ultra-portable fast charger for your nickel-metal hydride batteries is a must-have accessory.*

Bonus features like these are seldom factors in choosing a camera, but all other things being equal, they are gravy on the cake (to mix a metaphor).

You should, however, consider ease of use to be a feature. Some digital cameras have logical layouts, a minimum of buttons and modes, and are very easy to learn. Place a premium on being able to access the most commonly used features without wading through a series of menus. The most frequently accessed features vary from person to person: you may use manual focus or exposure compensation frequently. Someone else may live or die by their ability to adjust shutter speed on a whim.

For that reason, I recommend that you try out any digital camera you are considering buying before you purchase it. You may have bought your DVD drive over the web, but a device like a digital camera, with so many controls and features, is not something to buy through mail order, unless you've had a chance to borrow the same or similar camera from a friend or colleague. Give it a real test-drive, using the typical features that you will need. No matter how ideal the specifications may be, until a camera has passed your own ease-of-use test, don't consider purchasing it.

Next Up

In this chapter you've learned just about all the nuts and bolts you need to understand how digital cameras work. I also introduced you to the key controls available with most digital boxes. In the next chapter, we're going to look at those controls a little more closely. Now that you know what they do, it's useful to understand what they can do for you.

3

Mastering Camera Controls

For more than 150 years, photography has become faster, easier, and less complicated. Once a pursuit of artists and craftspeople who had to be part mechanic and part alchemist, photography first reached the masses in 1888, when George Eastman introduced the first handheld Kodak camera. His goal was to make the camera as convenient to use as the pencil, and promised the world, "You press the button, we do the rest."

Of course, in those days, "the rest" involved mailing your camera back to Kodak for processing and waiting until the camera returned, loaded with fresh film, accompanied by a set of prints. Everything that happened between the release of the shutter and the return of the film was quite literally out of the amateur photographer's control.

Today, the digital camera puts all the control back into your hands in a most versatile way. You still need to compose the photo, but you can allow the camera to set the focus, exposure, and even color balance and other parameters for you automatically. Or, if you like, you can make these adjustments yourself. Once the picture is taken, you can review it and decide whether to discard the photo, reshoot, or simply take another picture. Serious photographers now have the choice of taking pictures in "point-and-shoot" or "point-and-think" modes.

The term "point and shoot" is often applied to the most basic cameras, because they ask nothing more of the photographer than the ability to aim the camera and press the shutter release. Many of these cameras don't even require remembering to remove the lens cap: the lens appears automatically from behind a protective door or flap as soon as you turn the power on. If you can find the power switch and shutter button, a point-and-shoot camera will take care of everything else, including focus, exposure, and flash (if you need it) automatically.

When I started in photography, the distinction between point-and-shoot cameras and more advanced amateur and professional models was clear. The point-and-shoot cameras were

automatic, and offered few, if any manual adjustments (other than focus, before autofocus became prevalent). All other cameras were fully manual. The photographer had to focus, select a shutter speed, and specify a lens opening by matching a needle with an indicator in the viewfinder (or by using a handheld light meter).

Today, even $6,000 professional/prosumer cameras have point-and-shoot functionality. If you like, virtually every digital camera can analyze your scene, determine the correct exposure from a complex set of alternatives, set focus for the main subject of the photo, and snap off a picture or sequence for you. You don't even have to press the shutter release: an infrared remote control or a built-in self-timer can select the decisive moment for you. Computer technology is so precise today that, in full automatic mode, you can get excellent pictures without giving the mechanics of the photo a second thought.

Even so, there are times when you'll want to take total control of the process. Other times, you'll need to use your knowledge of how your camera's automated features work to make sure your camera's brains aren't fooled by an unusual situation.

Although every camera uses different buttons and menus to control key features, nearly every digital image grabber includes some variation on the basic array of controls. This chapter provides an overview of the controls a digital photographer must master, and includes descriptions of how these controls differ between digital cameras and film cameras. I'm not going to explain how to operate your camera's controls. Your user's manual is your best guide to the nuts and bolts. Instead, we're going to concentrate on how these controls can affect your photographs, and what you can do to optimize their use.

Taking Control

If digital cameras do such a good job selecting settings, why would you want to interfere? There are lots of situations in which an experienced photographer can do a better job of selecting settings than even the most sophisticated digital camera. Here are a few:

- You're looking for a special exposure effect, such as a silhouette. When faced with strong backlighting, your camera may correctly expose your subject anyway, allowing the background to wash out. Using override or manual controls, you can adjust the exposure to produce a true silhouette.

- You'd like to use a particular shutter speed to produce a certain look. Perhaps you've mounted your camera on a tripod and want to shoot a mountain stream at a slow shutter speed to provide the popular fluid blurry look in the water. Or, you want to use the absolute fastest shutter speed to freeze action.

- You want to isolate your subject using selective focus, making the main subject sharp while blurring objects in front of or behind it. Selecting a combination of large f-stop, telephoto zoom setting, and manual focus, you can do this even with digital cameras that are noted for their generous depth-of-field.

■ You need a special color effect, and therefore would like to manipulate the white balance of your camera.

You might not need to switch from full automatic mode to manual mode to take pictures in these situations. Many cameras let you partially override their settings by pressing a button or turning a jog wheel. The most important thing is to understand exactly what each control can do, and how it affects your photo.

TIP FROM THE PROS

Don't get caught in an important picture-taking situation with no inkling of how to use a seldom-accessed feature. Don't count on taking your camera's manual along and taking the time to hunt through it when you're in a rush. Each time I get a new digital camera, I put together a "cheat sheet" like the one shown in Figure 3.1, which lists all the functions I use most, and clear, simple directions on how to use them. After a few days, I've mastered most of the controls, but I still keep my cheat sheet handy as an aid to using the more obscure functions.

Manual Focus Press AF/MF button on left side. Rotate inner ring.	**Spot Focus** controller button until plus sign appears in viewfinder cursor keys move point of spot focus	**Self Timer** *Function dial set to Drive* Press button in center of Function Dial Use control dial next to shutter release to choose Self Timer	**Set ISO** *Function dial set to ISO* Press button in center of Function Dial Use control dial to choose 100, 200, 400, 800
Auto Display Dial to right of viewfinder EVF (Only) Auto (Either) Monitor (Only)	**Display Content** Press I+ button to cycle All information Focus frame only All information + histogram Image only	**Flash/Exposure compensation** Set Digital Effects Switch to +/- AV Press digital effects button in center of switch Adjust with controller dial for exposure compensation Adjust with up/down controller keys for flash copensation Release the button. Cancel changes by pressing P on top of camera.	**White Balance** *Function dial set to WB* Press button in center of Function Dial Use control dial to choose: Auto Daylight Tungsten Fluorescent Cloudy Custom Custom calibration
Spot Metering Press Spot button under main dial Locks exposure while pressed	**Change Metering Mode** *Function dial, left side of viewfinder* Change to metering icons, use control dial next to shutter release Multisegment - frame with dot inside Center Weighted - empty frame Spot - spot		
Exposure Mode *Function dial, left side of viewfinder* Change to PASM function, use control dial next to shutter release Program Aperture Priority Shutter Priority Manual exposure.	**Setting Exposure Manually** *In manual mode:* Shutter speed: Turn control dial next to shutter release Aperture: Set digital effects switch (left side) to +/-AV Press button on the switch, then use control dial. Flash compensation set with up/down controller keys.	**Contrast/Color saturation** copensation/Filter Set Digital Effects switch to contrast icon, COL, or FIL Press button and use controller dial to adjust	**Delete Image** Press QV/delete button. left/right control keys to Yes/No Press control button to execute
		Subject Mode Press button to right of top LCD Portrait Sports Sunset Night Portrait Text **Format CF Card** Playback menu BASIC	**Digital Zoom** Press square magnification button. Viewfinder is shaded to show area (1280 x 960) **Macro Mode** Align zoom ring to wide angle or telephoto position Push Macro switch on lens outward
Bulb Exposure *In manual mode:* Use control dial next to shutter release to set to Bulb. Set aperture with +/-AV button and control dial Hold shutter release for length of exposure. **Locking** Hold shutter-release part way down. **Image Size/Quality** Main Dial set to Recording Press Menu button In Basic menu choose Image Size or Quality **Color Mode** Main Dial set to Recording Advanced 2, Color Mode	**Motor Drive** *Function dial set to Drive* Press button in center of Function Dial Use control dial next to shutter release to choose Continuous advance (multiple overlapping frame icon) Hi Speed (multiple with HI showing) Ultra High Speed (multiple with UHS showing) Self timer (dial) Time lapse (dial with dots) Continuous: 2 fps full-size, manual focus/manual exposure, up to 10 shots in Fine mode High Speed: 3 fps fullsize, manual focus/manual exposure, up to 10 shots in Fine mode UHS: 7 fps 1280 x 960 images, up to 62 frames in fine mode		
		View Images Press QV/delete button or Main dial to Play (Green triangle) left/right to scroll up for histogram/down to resume Menu button above controller to exit Quick view	
		Zoom Playback Press square magnification button under controller up/down to adjust magnification controller button to toggle zoom and scroll show/hide scroll guides with I+ button.	

Figure 3.1 *A "cheat sheet" can help you master your camera's controls.*

Understanding Exposure

Correct exposure is not the most important aspect of taking a picture. How well you frame or compose the image really makes or breaks a photograph. The exposure can be a little off and the picture can still look good, but if the composition is awry, there's not a lot you can do to save it. Fortunately, compositions are not chosen by the camera. In most cases, however, exposure settings *are*. You can do a great deal to ensure that your exposure settings mirror what you want to get out of your image.

As you recall from Chapter 2, "Inside a Digital Camera," exposure is defined as the amount of light striking the sensor. Think of each photosite or pixel on the sensor as a little bucket that catches photons of light as they pass through the lens. The photons must fill the bucket to a particular point (called a threshold) before that pixel will register its part of the image. Raising or lowering the threshold mark on the bucket decreases or increases the working sensitivity of the sensor. It doesn't make any difference whether the photons fill the bucket slowly or quickly, or whether they arrive in large streams or in a trickle. A pixel won't register an image until the threshold point is reached.

Figure 3.2 shows a fanciful representation of those buckets. The yellow drops at top represent sunlight, which contains red, green, and blue light, until all but one of those hues are removed by the colored filter mosaic placed atop a standard CCD sensor. The red, green, and blue photons continue past their respective filters to collect in the "bucket." If the bucket is filled at least to the threshold point (shown as a gray band around the bucket), that photosite registers that color. The amount of photons collected past the threshold point represents the density of the image for that photosite for that color. Once the bucket is completely filled, it can collect no more photons.

Figure 3.2 *Photons (shown as drops) must fill the sensor's "buckets" to the threshold mark for an image to register.*

The camera's shutter speed determines the interval used to flood the buckets with photons. A short shutter speed (such as 1/500th second) lets photons flow only for a brief period of time. A longer shutter speed (such as 1/60th second) lets the photons reach the sensor for a longer period. Figure 3.3 represents an exposure that is relatively short, so that photons can collect in the bucket for only a brief period.

Figure 3.3 *A short shutter speed lets photons reach the sensor for only a brief period.*

The lens's aperture size, or f-stop, controls how many photons are admitted at once. A small f-stop (on a digital camera, the smallest stop will be around f8) restricts the number of photons. A larger f-stop (such as f2.8) lets a larger number of the available photons through at once.

Figure 3.4 shows how a smaller f-stop restricts the number of photons that can reach the bucket.

Your sensor's photosite buckets can be filled quickly (with a short shutter speed and a large lens opening), or slowly (with a longer shutter speed and a smaller lens opening). Each faster shutter speed increment or f-stop lets in one-half the amount of light as the previous setting, so you can produce exactly the same exposure by switching to a smaller f-stop if you make the shutter speed twice as long (and vice versa).

Figure 3.4 *Choosing a smaller f-stop reduces the number of photons that can reach the sensor, too.*

These equivalent values are called exposure values, or EVs for short, and are consistent for any particular ISO setting on your camera. For example, a value of EV14 might represent 1/250th at f8 with a particular film. It would also represent all the other combinations of shutter speed and f-stop that would produce the same equivalent exposure, as shown in Table 3.1.

Table 3.1 Equivalent Exposures

Shutter Speed	f-Stop
1/30th second	f22
1/60th second	f16
1/125th second	f11
1/250th second	f8
1/500th second	f5.6
1/1000th second	f4
1/2000th second	f2.8
1/4000th second	f2

Your digital camera might have EV values that you can set. It might also have an EV+ or EV-dial, which lets you correct the automatic exposure by an amount you specify. For example, choosing EV+0.5 will add half an EV to your exposure, which would be the same as *either* opening the aperture by half an f-stop or making the shutter speed 50 percent longer. (It's easy for a digital camera to deal with fractions of an f-stop or fractional shutter speeds, because everything is done electronically.)

If you need to adjust your exposure manually or override your camera's settings to produce a darker or lighter image, it's easy to do by adjusting the EV+/EV- dial. If you're making the correction manually using the shutter speed or aperture controls, just remember:

- Opening the lens aperture one stop (to a smaller f-stop number, such as going from f8 to f5.6) doubles the amount of light reaching the sensor.

- Closing the lens aperture one stop (to a larger f-stop number, such as going from f5.6 to f8) halves the amount of light.

- Choosing a shorter shutter speed (from 1/250th to 1/500th second, for example) cuts the amount of light reaching the sensor in half.

- Choosing a longer shutter speed (from 1/500th to 1/250th second) doubles the amount of light.

- Cutting the exposure in half with either aperture or shutter speed while doubling the exposure with the other control keeps the exposure exactly the same.

When an Exposure Isn't

Because you can halve or double an exposure by changing either the f-stop or shutter speed, these equivalent exposures are said to be *reciprocal*. It shouldn't make any difference which control you or your camera use to change exposure; the result should be the same whether you choose a smaller f-stop or a shorter shutter speed to reduce exposure (or opt for a larger f-stop and longer shutter speed to increase exposure). Unfortunately, both the film and digital worlds have to contend with a phenomenon known as *reciprocity failure*. Film and sensors react to very, very short and very, very long exposures in a non-linear way so that, say, an exposure of 60 seconds at f16 will not necessarily be exactly equal to an exposure of one second at f2. If you're experimenting with long time exposures at night, say, to capture a dim city street scene, you might find that you've seriously underexposed your image.

Reciprocity failure can happen at the other end of the time scale, too, with very brief exposures, although even the 1/4,000th second speed of some cameras is not likely to produce the effect. However, some electronic flash units can produce very brief exposures of 1/50,000th second or shorter in automatic mode at close distances.

In either case, if you're using your camera's automatic exposure features, you should use the exposure compensation control to allow extra exposure. Or, you can switch to manual mode and make additional exposures for a longer period using slower shutter speeds, or using a larger f-stop.

How Exposure Is Calculated

Until you start thinking about it, calculating a correct exposure doesn't seem to be all that complicated. Just measure the amount of light reaching the sensor and figure out what combination of shutter speed and f-stop is required to allow exactly the optimal amount of light for the exposure.

Unfortunately, that sort of calculation won't work. It doesn't take into account the fact that subjects reflect different amounts of light. Imagine, for a moment, that you're taking a photo that contains a white cat and a dark gray cat. In the finished photo, you want the white cat to appear white and the dark gray cat to appear to be dark gray. Yet, the white cat might reflect five times (or more) as much light as the gray cat. Any exposure based on the white cat will cause the gray cat to appear to be much darker, almost black. Conversely, any exposure based only on the gray cat will make the white cat completely washed out, with no detail whatsoever. The proper exposure in this case is an *average* of the tones in the scene, a happy medium in which both the white cat and gray cat are properly exposed.

Light-measuring devices achieve this average by assuming that all the objects being measured average a standard value of 18 percent gray. The 18 percent figure was arrived at as a value that represents a gray tone that's halfway between black and white as perceived by film and, later, digital sensors (although not necessarily by human vision; there is still some controversy over this point). The assumption is an important one, because the camera or light meter has no way of knowing whether it is pointed at an object that is highly reflective, or one that doesn't reflect much light at all. Instead, calculations are made *as if* the object were reflecting 18 percent gray. It's the job of the photographer or automatic exposure system to make adjustments when that is not the case, using some sort of programming or compensation. Figure 3.5 shows a continuous gray scale with the approximate 18 percent reflectance point marked.

Figure 3.5 *A reflectance of 18 percent approximates a middle gray tone in most scenes.*

In most cases, your camera's light meter will do a good job of calculating the right exposure, especially if you use the exposure tips in the next section. But if you want to double-check, or feel that exposure is especially critical, take the light reading off an object of known reflectance. Photographers sometimes carry around an 18 percent gray card (available from any camera store) and, for critical exposures, actually use that card, placed in the subject area, to measure exposure.

THE 18 PERCENT MYTH

In practice, light meters for most digital cameras are not calibrated for exactly 18 percent reflectance. Each camera company modifies the middle tone point a bit to produce the "best" exposure for its particular equipment. Even so, it's useful to keep the (approximately) 18 percent figure in mind when you're thinking about how cameras calculate exposures.

TIP FROM THE PROS: HUMAN GRAY CARD

Don't have a gray card handy and want to check your exposure? Take a light reading from the palm of a hand (yours or someone elses) held in the same light as your main subject. Then increase the exposure by one f-stop (or use a shutter speed that is twice as long), because the palm of a hand is about twice as reflective as a gray card. This trick works with just about any palm, regardless of ethnic background or how much of a suntan your human gray card has (don't try metering the *back* of a hand).

Bracketing

Bracketing is the practice of taking several photos using different exposures to ensure that at least one will be optimal for your image. For example, you might take one picture at the "correct" exposure (as determined by your camera's exposure meter), plus one with half as much exposure, and one with twice as much exposure (change either the f-stop or shutter speed as appropriate). At least, that's how it was done in the old days before cameras had as many automatic features as they do now. Today, many electronic cameras (both film and digital) have a setting for automatic bracketing. The camera will snap off several exposures for you at different settings.

Indeed, digital cameras can bracket parameters other than exposure, such as white balance, to improve your chances of getting a photo that is fine-tuned for your specific light source.

Working with Autoexposure

Thanks to the tiny computers built into modern film and digital cameras, exposure can be determined accurately in a variety of situations. Most cameras have multiple metering modes which measure light in any of several different ways. This next section explains the most common modes and how they work.

Exposure Zones

Sophisticated electronic cameras divide the subject area into as many as a few dozen different zones, and can measure the light for each of these zones separately. Then, your camera's programming can make decisions about how the differing illumination in the zones affects your photo and calculate an exposure based on those decisions. You can choose how the exposure is calculated yourself, too, if you understand how these zones work. Here are the most common metering schemes:

- *Averaging*. In this mode, the camera's exposure meter figures the exposure based on the average of all the illumination falling on the entire sensor. This scheme works best with scenes that have a mixture of light and dark subjects. You might select the averaging mode when shooting photos that involve a variety of subjects, and feel that the other exposure modes aren't suitable. For example, if you're taking pictures at an indoor soccer game, your

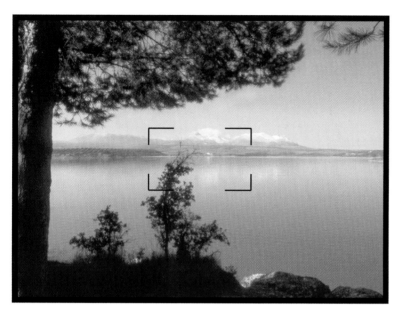

Figure 3.6 *An averaged exposure reading takes into account the illumination of the entire scene.*

main subjects might be scattered all over the frame, so an exposure based on the average of the frame can work for you. (Actually, because the lighting doesn't vary much, a *manual* exposure setting might be even better, but we'll explore that approach in the chapter on action photography later in this book.) With the camera set for averaging exposure, the entire subject area, shown in Figure 3.6, is used to calculate the exposure.

■ *Center-weighting.* In this mode, the exposure meter emphasizes a zone in the center of the frame to calculate exposure, on the theory that, for most pictures, the main subject will be located there. Center-weighting works best for portraits, architectural photos, and other pictures in which the most important subject is located in the middle of the frame. (No surprise there!) As the name suggests, the light reading is *weighted* towards the central portion, but information is also used from the rest of the frame. If your main subject is surrounded by very bright or very dark areas, the exposure might not be exactly right. However, this scheme works well in most situations. In Figure 3.7, most of the exposure would be calculated from the mountains and the lake, but the darker trees and foreground would also be taken into account.

■ *Corner-weighting.* The exposure meter places the emphasis on the corners of the frame. One way of doing this is shown in Figure 3.8. If corner-weighted exposure were calculated for the example photo, the trees and foreground would receive more exposure. This scheme works well when there is a very bright or very dark object in the center of the frame.

■ *Top- or bottom-weighting.* These schemes weight the top or bottom of the frame, or both. Bottom-weighting can help you ignore, say, a very bright sky area that would fool the

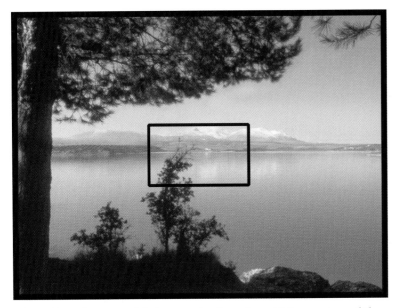

Figure 3.7 *Center-weighting emphasizes the middle portion of the frame to calculate exposure.*

Figure 3.8 *Corner-weighting de-emphasizes the center of the frame when calculating exposure.*

meter or cause underexposure. Top-weighting can be used when you *want* to expose for an area in the upper part of the frame. Using both top- and bottom-weighting lets you de-emphasize the middle of the frame. In the sample picture, shown in Figure 3.9, these modes would measure the foreground or trees (or both) in calculating the main exposure.

■ *Matrix-metering.* This is a sophisticated metering technique (also called *evaluative metering*) in which many different zones of the image are metered separately. Then, the camera evaluates the results to make an educated guess about what kind of picture you're taking, based on examination of thousands of different real-world photos. Eastman Kodak Company developed this sort of exposure control for its automated printing machines many years ago, when it found it was possible to determine whether a photo was a portrait, landscape, or other type of picture simply from the exposure matrix. For example, if the top sections of a picture are much lighter than the bottom portions, the algorithm can assume that the scene is a landscape photo with lots of sky. Figure 3.10 shows typical zones that a matrix metering system might consider in calculating exposure.

■ *Spot metering.* This mode confines the reading to a limited area, indicated in the center of the viewfinder. Some digital cameras let you *move* the meter spot to any location you like in the frame. If you're lucky, the process will be simple enough to use easily. One camera I use switches to spot metering when the Spot button is pressed; moving the spot to a different location is accomplished by continuing to hold the Spot button while pressing the cursor keys. Spot metering is a great tool when your subject is relatively small and surrounded by dark or light areas that would confuse any other metering method. Figure 3.11 shows the spot metering zone of a typical digital camera.

Figure 3.9 *Top- and bottom-weighted metering emphasizes the upper and lower edges of the frame.*

Figure 3.10 *Matrix metering tries to guess what kind of photo you're taking by metering separate zones and evaluating the results.*

Figure 3.11 *Spot metering can be used to calculate exposure from a limited area of the frame.*

Aperture Priority

Sometimes you want to use a particular lens opening to achieve a desired effect. Perhaps you'd like to use the smallest f-stop possible to maximize depth-of-field in a close-up picture. Or, you might want to use a large f-stop to throw everything except your main subject out of focus. That's what I did in Figure 3.12, in which I wanted to emphasize the tips of the cables.

There's no need to switch to full manual exposure if all you want to do is specify a particular aperture. Most digital cameras can be set for Aperture Priority mode. In that mode, you select the f-stop and your camera's automatic exposure system will determine the correct shutter speed. This mode is a good compromise between fully automatic and manual exposure when you really need to use a particular aperture. It's fast to use, too, because you don't have to worry about selecting the shutter speed.

Figure 3.12 *Choose your own aperture for maximum (or minimum) depth-of-field.*

One pitfall to keep in mind is that you might select an f-stop that is too small or too large to allow an optimal exposure with the available shutter speeds. For example, if you choose f2.8 as your aperture and the illumination is quite bright (say, at the beach or in snow), even your camera's fastest shutter speed might not be able to cut down the amount of light reaching the sensor to provide the right exposure. Or, if you select f8 in a dimly lit room, you might find yourself shooting with a very slow shutter speed that can cause blurring from subject movement or camera shake. Aperture priority is best used by those with a bit of experience in choosing settings.

Shutter Priority

Shutter priority is the inverse of aperture priority: you choose the shutter speed you'd like to use, and the camera's metering system selects the appropriate f-stop. Perhaps you're shooting action photos and you want to use the absolute fastest shutter speed available with your camera, as was the case for Figure 3.13. Or, you might want to use a slow shutter speed to add some blur to an otherwise static photograph.

Shutter-priority mode gives you some control over how much action-freezing capability your digital camera brings to bear in a particular situation. Keep in mind that your camera might have a more flexible program mode (described in the next section) that does an even better job. You'll also encounter the same problem as with aperture priority when you select a shutter speed that's too long or too short for correct exposure under some conditions. I've shot outdoor soccer games on sunny Fall evenings and used shutter priority mode to lock in a 1/1,000th second shutter speed, only to find my camera "locked" when the sun dipped behind some trees and there was no longer enough light to shoot at that speed, even with the lens wide open.

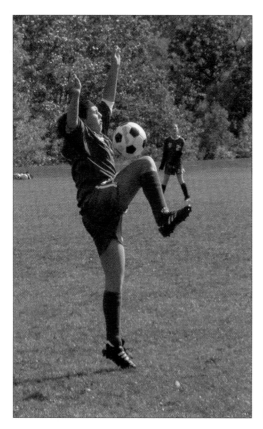

Figure 3.13 *Choose your own shutter speed for maximum action-freezing capability.*

Program Modes

Many digital cameras have specific user-selectable exposure programs specifically designed for certain kinds of picture-taking situations. These can do an even better job than semiautomatic modes like shutter- and aperture-priority, and can even do as well as an experienced photographer selecting settings manually.

For example, a Minolta digital camera I use has an Action program setting. In that mode, it will try to use the highest shutter speed possible appropriate for the lighting conditions. However (unlike shutter priority mode), if there simply isn't enough light, rather than lock you out, the camera will drop down to the next slowest shutter speed. The process is much like the one a veteran shooter will use to choose the optimal settings, but is much faster.

Your digital camera might have other program modes, such as for taking close-ups (when small f-stops are important for increased depth-of-field) or for making telephoto zoom shots, in which both high shutter speeds (to counter the magnification of camera shake that occurs at long zoom settings), and smaller f-stops (to improve on the reduced depth-of-field at telephoto settings) are used. Additional modes might include those for portraiture, night portraiture, sunsets, and other common shooting situations.

Manual Exposure

Part of being an experienced photographer comes from knowing when to rely on your camera's automation, when to go semiautomatic, and when to set exposure manually. With all the automated features built into modern cameras, you should find that you'd rarely need to set an exposure manually. After all, built-in bracketing can create several shots at different settings for you, or you can use shutter- or aperture-priority when a particular shutter speed or f-stop is required.

Manual exposure can come in handy in some situations. You might be taking a silhouette photo and find that none of the exposure modes or exposure correction features give you exactly the effect you want. Set the exposure manually to use the exact shutter speed and f-stop you need. Or, you might be working in a studio environment using multiple flash units. The additional flash are triggered by slave devices (gadgets that set off the flash when they sense the light from another flash, or, perhaps from a radio or infrared remote control). Your camera's exposure meter doesn't compensate for the extra illumination, so you need to set the aperture manually.

Because you might not need to set exposure manually very often, you should make sure you understand how it works. Some cameras force you to switch to full manual mode, or wend your way through menus to activate manual exposure. I like my Minolta camera's procedure: choose manual exposure, then set shutter speed or aperture with a jog dial next to the shutter release button while holding down either a shutter speed or f-stop control button.

Manual exposure lets you apply special effects, such as the one shown in Figure 3.14. For that photo, I used a slow shutter speed, but still froze the action by panning the camera in the direction of the movement during the exposure. Because the background is blurred, the emphasis is on the soccer players, who are relatively sharp. You'll learn how to pan action photos later in this book.

Figure 3.14 *Even slow shutter speeds work if you pan in direction of the movement.*

Locking Exposure

Another control to master is your camera's *exposure lock* control. As the subject matter seen through your viewfinder changes, the correct exposure might change, too. That's fine and dandy in most cases, because you want the camera to base its exposure on what's actually in the frame. Other times, however, you'll want to lock the exposure at a certain point. For example, you're shooting a portrait of someone outdoors; the sky behind her is very, very bright; the subject is located to one side of the frame; and you *don't* want a silhouette. Rather than switch to another exposure mode for just that one picture, compose the photo so the main subject is in the center of the picture. Then lock in the exposure (usually by pressing the shutter release button down part way). Then, reframe the picture with the subject located as you please. The photo will be taken using the exposure you locked in.

Some cameras have a spot exposure lock, too. Press the Spot button to switch to spot metering, keep holding the button down to lock the exposure, then reframe to take the picture. Using the exposure lock capabilities is generally a lot faster than switching to a special mode or specifying which exposure zone(s) to use.

Manipulating Focus

Beginner photographers typically say that they want their photos to be "sharp and clear," like the photo shown in Figure 3.16, in which the entire widget is reasonably sharp. However, experienced photographers know that a bit of blurriness, used intelligently, can turn an ordinary photograph into one that's special—a subject that appears to merge with its background. Selective focus, choosing exactly what parts of the image are in sharp focus, and which are not, is a powerful creative tool. Blur can also make other portions of an image appear to be sharper, by comparison. Figure 3.15 shows some flowers (at left) photographed with abundant depth-of-field, so the blooms merge with the background. At right, the reduced depth-of-field makes the flowers stand out from their background.

Unfortunately, the tool of selective focus is not as readily accessible to digital photographers as to those using film cameras, because the short focal lengths used for digital camera lenses render virtually *everything* in most photos razor sharp. Shorter focal lengths inherently have much more depth-of-field than longer focal lengths, so that 35mm (actual focal length) "telephoto" setting of your digital camera might provide the same field of view as a 135mm telephoto on a film camera, but the depth-of-field produced is closer to what the film photographer gets with a wide-angle lens.

Depth-of-field is also reduced at wider lens openings, and here, too, the digital camera's characteristics work against those who want to use selective focus. Most digital cameras don't boast a really large lens aperture, such as f1.4 or f2.0. The largest opening might well be f2.8, so you can't always count on shooting wide open to minimize depth-of-field. If you have your heart set on using selective focus, you can try two approaches (or combine them).

- *Use the longest telephoto setting your camera offers.* A camera with a long zoom range might offer the equivalent of 28mm to 200mm (with a film camera) that corresponds to true focal lengths of 7.2 to 50.8mm. That 50.8mm setting does have depth-of-field that is limited enough to allow selective focus, especially at wider apertures.

- *Get in close.* Depth-of-field is limited at close distances, too. If your subject matter lends itself to using your camera's macro capabilities, you might be able to reduce depth-of-field, as shown on the right in Figure 3.15.

Figure 3.15 *In some cases, you'll want to bring the main subject into focus and allow the background to blur.*

If you're shooting up close and want to maximize depth-of-field, you can do that too. Check out Figure 3.16, which was taken with lots of bright light, with a small f-stop, and a wide-angle zoom position. You'll learn more about close-up photography in Chapter 9 "Macro Photography.".

Figure 3.16 *A small f-stop made it possible to bring the entire subject into sharp focus.*

Using Autofocus

As I mentioned in Chapter 2, digital cameras use various ways of determining correct focus automatically. Most work quite well; some, such as laser-based systems, work better under certain circumstances (low light, for example) than others. All have to be used intelligently.

Digital cameras often use a zone focusing scheme, similar to the zone metering offered by automatic exposure systems, in which the frame is divided into segments. You might be able to choose autofocus based on the center portion of the frame, or corners, as shown in Figure 3.17, which roughly represents the focusing zones of a Nikon CoolPix camera I use. Cameras like my Nikon let you choose whether focus is based on the center autofocus area, or the center and the four corners. In manual mode, that same camera allows you to select just one of the five autofocus target areas, which can be useful when your subject matter is concentrated in one of the corners of the frame.

Figure 3.17 *Five or more "target" areas can be used to calculate the correct focus for an image.*

In addition, most digital cameras have several automatic focusing modes to choose from. The most common modes include:

- *Continuous autofocus.* In this mode, the camera continually focuses the image (you'll know because you'll hear the autofocus motor constantly moving the elements of the lens) so you can frame and reframe the image, and count on the picture always being (more or less) in focus when you're ready to take the picture. I say "more or less" because there is always a small amount of lag when you reframe the image on an object that is closer or farther away than the previous view. Some find this constant refocusing annoying. This mode can cause your camera's batteries to run down sooner, too, and can slow you down as you constantly wait for the camera to refocus each time you adjust the image. Continuous autofocus "locks" when you press the shutter release button down partway (or press a focus lock button, if available).

- *Single autofocus.* In this mode, the autofocus feature is activated only when the shutter release button is pressed partway. Once the image is sharp, focus is locked and you can continue to press the shutter release button to take the photo. This mode is easier on batteries and causes fewer delays when you're finally ready to take the photo. However, like continuous autofocus, this mode can contribute to a significant delay between the time you begin to press the shutter release and when the picture is taken. It's easy to miss that perfect expression or the peak action in a sports photo when using either type of autofocus.

■ *Manual focus.* With manual focus activated, your digital camera lets you set the focus yourself. There are some advantages and disadvantages to this approach. While your batteries will last longer in manual focus mode, it will take you longer to focus the camera for each photo, a process that can be difficult given the generous depth-of-field digital cameras provide at most zoom and aperture settings. On the one hand, the extra depth-of-field makes the need for precise focus less necessary, but, on the other hand, when you *want* exact focus to ensure best results, you might find it difficult to achieve.

TIP FROM THE PROS: CHANGING FOCUS

You'll find it easier to manually focus at the longest zoom setting and widest lens opening, because they provide the least amount of depth-of-field, making it simpler to zero in on exact focus. Unfortunately, many lenses *change* focus slightly at different zoom settings (indeed, so-called *varifocal* lenses require refocusing at every setting and aren't, strictly speaking, zoom lenses at all). So, when you zoom in to focus and then zoom back out to a wider setting, your manual focus might not be exactly right. If you're really having difficulty focusing, go ahead and zoom in and focus manually, but take notice of the distance setting shown in the viewfinder (or other status display). Then, when you zoom back out, you can make sure that the same distance is set at the new zoom setting. That should be close enough to exact focus for most purposes.

In addition, most cameras have focus *ranges* that can be set. These include:

■ *Autofocus.* This range provides normal autofocus operation for the full automatic range of the camera, typically infinity down to a foot or less. Some cameras provide autofocus at even closer distances; if you'll be doing a lot of close-up work, you'll want to check this specification before you buy.

■ *Infinity range.* This setting locks the focus setting for distant objects, such as landscape scenes or buildings. The advantage of this range is that the camera's autofocus feature is disabled, so there is less lag when you press the shutter release to take the picture.

■ *Macro/close-up range.* This setting moves the lens elements so that the camera focuses much closer than in autofocus mode, frequently to less than one inch. With some cameras, autofocus still functions at these close distances, and you might be able to adjust the magnification of your image by zooming in and out. Other cameras function only in manual focus mode when set to the macro position. My Minolta camera, for example, can be locked into macro mode at either the widest or longest zoom settings. At the wide-angle macro mode, the field of view is fixed, but focus can be adjusted with a focus ring around the lens. At the tele macro setting, the focus ring is still used, but the zoom ring can also be adjusted to provide small changes in magnification.

Sequencing

The first accessory I purchased when I worked as a sports photographer some time ago was a motor drive for my Nikon SLR. It enabled me to snap off a series of shots in rapid succession, which came in very handy when a fullback broke through the line and headed for the end zone. Even a seasoned action photographer can miss the decisive instant when a crucial block is made, or a baseball superstar's bat shatters and pieces of cork fly out. Sequence-shooting simplifies taking a series of pictures, either to ensure that one has more or less the exact moment you want to capture or to capture a sequence that is interesting as a collection of successive images.

Digital cameras provide "motor drive" capabilities that are, in some ways, better than what you get with film cameras. For one thing, a motor-driven film camera can eat up film at an incredible pace, which is why many of them are used with cassettes that hold hundreds of feet of film stock. At eight frames per second, a short burst of a second or two can burn up as much as half of an ordinary 36 exposure roll of film. Digital cameras, in contrast, have reusable film, so if you waste a few dozen shots on non-decisive moments you can erase them and shoot more.

The increased capacity of digital film cards gives you a generous number of frames to work with. A 5 megapixel camera that I use for sports photography can record almost 100 frames in the default Fine mode on a single 256MB CompactFlash card. Even at four or five frames per second for short bursts, I can take quite a few pictures before it's time to change cards.

One drawback to shooting sequences with some digital cameras is that the number of frames you can take in a row might be limited by the amount of buffer memory in your camera, and the speed with which the camera can write the images to the memory card. You might be able to snap off five or six pictures, then be forced to wait a second or two before you can take more photos. That limitation can be frustrating when you realize your first burst of images didn't capture the most important action and you watch the fullback scampering past you while you stare helplessly at the flashing red light on your camera that indicates your previous photos are still being written to the memory card.

Even so, a digital camera with any sequencing capabilities at all can come in very handy, as I discovered recently at an amusement park. I was having trouble capturing my kids as they zoomed by on a chair swing ride. I set the camera on its multiple-shot mode, and then pressed the shutter release when they came into view, snapping off several pictures like those shown in Figure 3.18. It still took me several tries to get the photos I wanted, because even at three or four frames per second many of the pictures captured "in-between" moments when one or more kids were partially in or out of the frame.

Figure 3.18 *You might need to take several sequences to capture the exact photos you want.*

Many models have several different sequence or *continuous advance* modes. Here's a list of the most common options:

■ *Single frame advance.* This is the default mode of most digital cameras. A single picture is taken each time the shutter release is pressed. With less expensive cameras that have little buffer memory built in, you might actually have to wait until the picture is stored on the memory card before you can snap off another one. Fortunately, most cameras are fast enough to let you take one picture after another almost as quickly as you can press the button.

■ *Continuous advance.* In this mode, if you press and hold the shutter release button, the camera will take pictures in sequence for as long as the button is held (within limits). The number of pictures taken per second, and the number of photos you can take in one burst are limited by the buffer memory of your camera, which in turn is filled up more quickly at higher resolutions and lower compression rates. Whether you're using automatic or manual focus can also affect your speed of capture. In general, using manual focus and lower

resolutions will let you capture more pictures, more quickly. Continuous advance might allow grabbing photos at 2 to 3 pictures per second, with a limit of around 7 to 20 photos before you must stop and wait for the burst to be stored on the memory card. One camera I use will let you capture 42 lower-resolution pictures in a row at 1280 × 960 resolution, or 84 really low resolution pictures in a row at 640 × 480.

■ *High-speed continuous*. This mode is similar to continuous advance, but at a higher frame rate, perhaps 3 to 4 frames per second, with the same kinds of limitations on the number of pictures in a single burst.

■ *Ultra high-speed continuous*. In this mode, the camera sacrifices resolution for more frames per second. My 5 megapixel camera drops down to producing 1.3 megapixel images in ultra high-speed mode, but can crank off seven frames per second. If you're analyzing your golf swing, or want to capture images at a high rate of speed, 1280 × 960 pixels should be plenty.

■ *Motion picture*. Many digital cameras offer a "movie" mode that grabs 30 seconds or more of motion (and audio) and stores all the frames as a video file on your memory card. The resolution might be only 640 × 480 pixels, or less, but this mode is a handy way of capturing some film clips.

■ *Time-lapse/interval*. This mode lets the camera take pictures at intervals you specify, creating a series of still images, say, either of the setting sun, or a time-lapse movie of a flower opening. For best results, your camera should be locked down on a tripod.

■ *Bracketing*. This mode also captures a sequence of pictures, but the intent is not to freeze moments in time but, instead, to grab a series of pictures (usually three) at several different settings: a default setting and a pair that adds or subtracts a little from the parameter being bracketed. For example, if you choose exposure bracketing, the camera will grab one photo at the metered exposure, plus one that gives more exposure and one that gives less exposure. You can set the bracket increment (for example, +/− 0.5 EV or +/− 1.0 EV) before you shoot. If your camera is versatile, you might be able to switch to shutter priority mode to activate bracketing using shutter speeds only, or to aperture priority mode to bracket using apertures only.

Depending on your camera model, you might also be able to create bracketed sets of pictures that provide more/less contrast, more/less color saturation, or more/less of a particular filter control. Generally, you can only bracket one factor at a time.

Other Kinds of Exposures

You might have even more exposure options available with your digital camera. Among your choices:

■ *Bulb/long exposure*. Long exposures are anything longer than 1/8th second; many cameras can produce exposures of several seconds automatically. When the exposure exceeds one full second, and is created by holding down the shutter button manually, it becomes a *bulb exposure* (so called because the photographer used an air bulb that was squeezed to hold

the shutter open). In either case, you'll want to have the camera mounted on a tripod, because hand-holding a camera for such a long exposure will invariably produce blur from camera shake. Figure 3.19 shows a long exposure. Traditionally, a bulb exposure is one that lasts as long as the shutter release button is pressed; when you release the button, the exposure ends.

- *Time exposure.* This setting is used to produce even longer exposures, as the shutter remains open even after the shutter button is released. You must press the button again (some cameras can also be activated/deactivated using a cable or electronic release or even a remote control) to stop the exposure.

- *Self-timer.* With this option, the camera waits a few seconds before taking the picture, usually with a flashing light that lets you know just before the exposure is made. Self-timers have several uses. The most obvious is that a self-timed picture taken with the camera on a tripod or other support gives the photographer enough time to rush into a photo, say, for a group shot or self-portrait. However, the self-timer is a great way of triggering the camera for longer exposures when you don't want to risk shaking it by pressing the shutter release. Forget to bring along your tripod, but still want to take a close-up picture with a precise focus setting? Set your digital camera to the self-timer function, then put the camera on any reasonably steady support, such as a fence post or a rock. When you're ready to take the picture, press the shutter release. The camera might rock back and forth for a second or two, but it will settle back to its original position before the self-timer activates the shutter.

Figure 3.19 *A longer than normal exposure with the camera on a tripod created this photo in which the rock star is relatively sharp, but his fast-moving fingers are blurry.*

Next Up

These first three chapters gave you most of what you need to know about your camera and its features, so you're ready to jump in and begin snapping masterpieces using the tips in Part II. However, if you want to know a little more about the file format choices your digital camera offers, hold off the photo frenzy a while and read Chapter 4.

4

Dealing with Digital Camera File Formats

File formats for digital cameras can be needlessly complex and confusing. Part of the problem is that you have three different formats to choose from, JPEG, TIFF, and RAW, and several variations on the formats. Vendors complicate things by not calling various formats and options by the same names. For example, a file saved in the highest quality JPEG format might be called Fine by one vendor, and Super Fine by another. Worse, Super Fine might actually indicate a file saved in TIFF format by a third vendor. What's a poor digital photographer to do?

Of course, compared to the hundreds of film options in the conventional photographic world, things aren't so bad for the digital picture taker after all. This chapter will help you sort out your digital file format alternatives. You'll learn about JPEG and TIFF, as well as RAW file formats, and when you should use each. You'll also find out a little about image compression, and what it does to your digital photos.

Why So Many Formats?

The gods who rule the imaging world must love different file formats, because they have created so many of them. There are dozens of graphics formats supported by image editors like Photoshop that are so far off the radar that simply mentioning them is an exercise in trivial pursuits. Who reading this book has used IFF (Amiga), TGA (Targa), PXR (Pixar), PX1 (PixelPaint), PIC (SoftImage), or RLA (Wavefront) formats?

Of course, the main reason digital cameras offer more than one file format in the first place is to limit the size of the file stored on your memory card. If a digital camera had unlimited memory capacity and file transfers from the camera to your computer were instantaneous, all images would probably be stored in RAW or TIFF format, with TIFF gaining the nod for convenience and ease of use, and because not all applications can interpret the unprocessed information in RAW files. (I'll explain the difference between RAW, TIFF, and JPEG later in this chapter.) Both RAW and TIFF store the image as you took it, with no noticeable loss in quality.

JPEG exists because a more compact file format is needed that can store most of the information in a digital image, but in a much smaller size. Unfortunately, JPEG provides smaller files by compressing the information in a way that loses some information. JPEG is a viable alternative because it offers several different quality levels. At the highest quality level, you might not be able to tell the difference between the original TIFF file and the JPEG version, even though the TIFF occupies, say, 14MB on your memory card, whereas the high-quality JPEG takes up only 4MB of space. You've squeezed the image 3.5× without losing much visual information at all. If you don't mind losing some quality, you can use more aggressive compression with JPEG to store 14 times as many images in the same space as one TIFF file.

RAW exists because sometimes we want to have access to all the information captured by the camera before the camera's internal logic has processed it and converted the image to a standard file format. RAW doesn't save space, nor does it provide intrinsic higher quality than, say, a TIFF version. Think of your camera's RAW format as a photographic negative, ready to be converted by your camera or, at your option, by your RAW-compatible image-editing/processing software.

Image Size, File Size, and File Compression

You can adjust the image size, file size, and image quality of your digital camera images. The guidebooks and manuals don't always make it clear that these adjustments are three entirely different things. However, image size affects file size and image quality, and image quality affects file size. File size, while it's dependent on the other two, has no direct effect on image size or quality. No wonder it's confusing! It's a good idea to get these three terms sorted out before we move on, so that we're all talking about exactly the same thing. Here's a quick summary:

■ Image size is the dimensions, in pixels, of the image you capture. For example, if you have a 5MP camera, it might offer a choice of 2560 × 1920, 1600 × 1200, 1280 × 960, and 640 × 480 resolutions. Each reduction in resolution reduces the size of the file stored on your memory card. A TIFF file at 2560 × 1920 pixels might occupy 4MB; a 1600 × 1200 pixel image, 1.7MB; a 1280 × 960 pixel image, 1.3MB; and a 640 × 480 pixel image, less than 1MB.

■ File size is the actual space occupied on your memory card, hard disk, or other storage medium, measured in megabytes. The size of the file depends on both the image size (resolution) and quality/compression level. You can reduce the file size by reducing the image size or using a lower-quality/higher-compression setting.

■ Image quality is the apparent resolution of the image after it's been compressed and then restored in your image editor. The TIFF format can compress the image, somewhat, with no loss of image quality, but JPEG compression does reduce the image quality, for reasons that will become clear shortly.

Keep the difference between image size, file size, and image quality in mind as we continue our discussion.

What's Image Compression?

The next thing to clear up is the idea of compression. Compression comes in two varieties: *lossless* compression, like that provided with the RAW and TIFF formats, and *lossy* compression, like that afforded by the JPEG format. Understanding a little about how compression works makes these terms a little more understandable.

Images, like all other computer code, are stored as a series of binary numbers, which are the only values a computer can handle. A string of 64 bits might (but probably wouldn't) look like this:

0000000000000001110000000000000000001111110000000000000000000000000001

Ordinarily, the computer would need 8 full bytes to store that string of 64 binary numbers. A lossless compression scheme, like that used to squeeze a TIFF file, could instead record a value that would designate how many times a particular value is repeated, so, instead of storing all 64 bits, a code that translates to "14 zeroes, followed by 3 ones, followed by 16 zeroes, followed by 6 ones…" would be used. Moreover, as the compression algorithm worked, it would notice that certain strings of numbers begin to repeat. Instead of enumerating only the number of runs of ones and zeroes, the code would indicate where to find a string of numbers identical to the one that needed to be recorded next. The second time the line of numbers above turned up, a short code representing where that line is stored in the file would be substituted. The larger the file becomes, the fewer actual numbers the compression scheme has to record. More and more of the code consists of pointers to strings of numbers. This method, called Huffman encoding, builds a frequency table of the number strings in a file, and assigns the shortest codes to the strings of numbers that occur most often.

Even though all the redundant numbers are eliminated from the file, the decompression algorithm can use the information to reconstruct the original file precisely. Today, more advanced algorithms, such as the Lempel-Ziv Welch (LZW) algorithm used to compress TIFF files, are very efficient.

LZW was originally developed by Israeli researchers Abraham Lempel and Jacob Ziv in 1977 and 1978. Their work was further developed by a Unisys researcher named Terry Welch, who in 1984 published and patented the LZW compression technique.

The Next Step in Compression

Although the compression scheme used with TIFF files works well, TIFF files can still be massive. As transfer of image files over telecommunications lines became popular (this was

even before the public Internet), a consortium called the Joint Photographic Experts Group (JPEG) developed a compression scheme particularly for continuous tone images that is efficient, and still retains the most valuable image information. JPEG uses three different algorithms: discrete cosine transformation (DCT), a quantization routine, and a numeric compression method like Huffman encoding.

JPEG first divides an image into larger cells, say 8 × 8 pixels, and separates the image into a special color space that separates the luminance values (brightness) from the chrominance (color) values. In that mode, the JPEG algorithm can provide separate compression of each type of data. Because luminance is more important to our eyes, more compression can be applied to the color values. The human eye finds it easier to detect small changes in brightness than equally small changes in color.

Next, the algorithm performs a discrete cosine transformation on the information. This mathematical mumbo jumbo simply analyzes the pixels in the 64 pixel cell and looks for similarities. Redundant pixels—those that have the same value as those around them—are discarded.

Next, quantization occurs, which causes some of the pixels that are nearly white to be represented as all white. Then the grayscale and color information is compressed by recording the differences in tone from one pixel to the next, and the resulting string of numbers is encoded using a combination of math routines. In that way, an 8 × 8 block with 24 bits of information per pixel (192 bytes) can often be squeezed down to 10 to 13 or fewer bytes. JPEG allows specifying various compression ratios, in which case larger amounts of information are discarded to produce higher compression ratios.

Finally, the codes that remain are subjected to a numeric compression process, which can be similar to the Huffman encoding described earlier. This final step is lossless, as all the information that is going to be discarded from the image has already been shed.

Because it discards data, the JPEG algorithm is referred to as "lossy." This means that once an image has been compressed and then decompressed, it will not be identical to the original image. In many cases, the differences between the original and compressed version of the image are difficult to see.

Compressed JPEG images are squeezed down by a factor of between 5:1 and 15:1. The kinds of details in an image affect the compression ratio. Large featureless areas such as areas of sky, blank walls, and so forth compress much better than images with a lot of detail.

This kind of compression is particularly useful for files that will be viewed on web pages and sent as e-mail files. It's also used to squeeze down digital camera files. However, more quality is lost every time the JPEG file is compressed and saved again, so you won't want to keep editing your JPEG files. Instead, save the original file as a TIFF file, and edit that, reserving the original as just that, an original version you can return to when necessary.

Key File Formats

This section will list each of the important file formats available for use with both digital cameras and image editors, including a few that you should *avoid* when working with images. I'll discuss their advantages, disadvantages, and the types of image compression used.

JPEG

JPEG is the most common format used by digital cameras to store images, as it was designed specifically to reduce the file sizes of photographic-type images. JPEG allows dialing in a continuous range of quality/compression factors. In image editors, you'll find this range shown as a quality spectrum from, say 0 to 10 or 0 to 15. Sometimes, editors let you choose from Low, Medium, or High quality. Those are just different ways of telling the algorithm how much information to discard.

Digital cameras, on the other hand, usually lock you into a limited number of quality settings with names like Standard, Fine, Extra Fine, or Super Fine, and don't tell you exactly which JPEG quality settings those correspond to. The names for the quality settings aren't standardized, and a particular setting for one camera doesn't necessary correspond to the same quality level with another camera. For example, Super Fine might be the highest lossy JPEG setting with one model, and the lossless TIFF setting with another vendor's camera.

If you're concerned about image quality, you should probably use the best JPEG setting all the time, or alternate between that and the TIFF setting. Your choice might hinge on how much storage space you have. When I'm photographing around the home where I have easy access to a computer, I use TIFF or RAW. When I travel away from home, I switch to JPEG if I think I'm going to be taking a lot of pictures. If quality isn't critical, then use lower-quality JPEG settings with your camera. Figure 4.1 shows close-up views of two JPEG files, one with mild compression and the other with extremely high JPEG compression.

Figure 4.1 *Mild compression (top) doesn't reduce image quality by much, but heavier compression (bottom) introduces visible artifacts.*

JPEG 2000

JPEG 2000 is a relatively new file format, supported by Photoshop CS and some other image editors but not universally supported by the applications that we'd find the most useful: web browsers. At this time, no digital cameras produce files in this format. JPEG 2000 uses a compression scheme called wavelet compression (for roughly 20 percent smaller files), which provides better image quality, but still discards some information. JPEG 2000 files have extensions like .jpx, jpc, or .jp2.

JPEG 2000 offers the ability to download a lower resolution image first, so you can preview the image in your web browser and decide whether to continue to download the page. Whereas conventional JPEG works only with RGB images, this new version is compatible with RGB, L*a*b color, and CMYK (cyan, magenta, yellow, black) color models. It can also include color profile information, as well as informational tags such as the owner of the image. JPEG 2000 also offers a lossless compression mode, which reduces the file size by roughly 50 percent, while not discarding any information.

JPEG 2000 has a very cool feature called Region of Interest, which you can use to designate the most important parts of an image. When you've done that, image compression will be concentrated in other areas of the photo, preserving more detail in your Region of Interest. This feature is very easy to use. In Photoshop, just select the region you want to protect (Quick Mask mode works well) and use Selection > Save Selection to store the selection as an alpha channel. Then when you use Save As and choose the JPEG 2000 format, the dialog box that appears has an option for selecting which, if any, of the alpha channels you've stored should be used as the ROI (see Figure 4.2).

Figure 4.2 *Choose any of the alpha channels in your image as a Region of Interest when you save in JPEG 2000 format.*

GIF

GIF, or Graphics Interchange Format, was developed back in the online dark ages (1987—before the public Internet) to exchange compressed graphics between different computer platforms. That's a bigger deal than you might think. In those days, it was tricky to create image files on one computer that could be readily viewed on another computer, and with 300 to 1200 baud modems, even small image files could take many minutes to upload or download. The online service CompuServe was the first big user of the GIF format.

The GIF format converts images into files with a maximum of 256 colors. Few video cards could display more than 256 colors, anyway, in those days, so that sufficed. GIF achieves its small file size by first reducing the colors available in an image to 1 to 256 different hues, then squeezing the file further by applying LZW compression to the indexed color tables that remain. So, GIF can be considered both a lossy and lossless file format. It loses picture information when the number of colors is reduced (but if the number of colors in an image is already 256 hues or fewer, no colors are discarded), but the remaining information is preserved 100 percent.

GIF has some other features that are useful chiefly for web display, such as interlacing (which allows an image to be displayed progressively as it downloads), transparency (which makes it possible for a GIF image to show the page background in its transparent parts), and animation (several images embedded in one file and shown consecutively, like an animated cartoon).

Because it can handle no more than 256 colors, GIF is a poor choice for digital camera images (which look posterized when converted to 256 tones), and is best used for logos, dialog boxes, line art, charts, and other graphics that don't involve continuous tones. Its compression scheme works great with images that have few colors, producing files that can be even smaller than those afforded by JPEG. Figure 4.3 shows a full-color image that has been reduced to 256 colors.

Figure 4.3 *Full-color images look posterized when reduced to 256 colors.*

PNG

The PNG (Portable Network Graphics) format was designed as a replacement for GIF, because the compression algorithm used in GIF was patented by Unisys, and developers supporting the GIF format were theoretically required to pay Unisys a royalty. The patent expired in June, 2003 in the United States, and in Canada, Japan, and Europe in 2004, so royalties will be charged only in countries in which the patent has not fizzled out (in other words, virtually nowhere).

That leaves PNG, a format that never saw much favor, even further in limbo than it was before. Even though PNG has some advantages over GIF or even JPEG, it's unlikely to flourish in the future. PNG uses optimized preprocessing filters that improve lossless compression efficiency, particularly in 24-bit images. Unlike GIF, PNG can specify any combination of 256 colors for transparency, embed gamma values so the image displays well on both Macs and PCs (which use different gamma settings), and beat both GIF and TIFF for compressing images.

PCX

PCX is an early graphics file format established by Zsoft for its PC Paintbrush software. It supports 24-bit color, and provides decent lossless file compression, but is now used only as a backup format. I sometimes save files in PCX format when the recipient is having trouble reading my TIFF files. Unlike TIFF, PCX doesn't have a wide variety of options and is thus more "standardized" and compatible with a wider variety of software on Mac, PC, and Linux platforms.

No digital cameras use PCX, but most image-editing software supports it.

TIFF

TIFF, or Tagged Image File Format, was designed in 1987 by Aldus (later acquired by Adobe along with Aldus' flagship product PageMaker) to be a standard format for exchange of image files. It's become that, and is supported by virtually all digital cameras as a lossless file option. However, because TIFF supports many different configurations, you might find that one application can't read a TIFF file created by another. The name itself comes from the *tags*, or descriptors, that can be included in the header of the file, listing the kinds of data in the image.

TIFF can store files in black/white, grayscale, 24-bit, or 48-bit color modes, and a variety of color models, including RGB, L*a*b, and CMYK. If you've used Photoshop, you know that TIFF can store your levels and selections (alpha channels) just like Photoshop's native PSD format. It uses a variety of compression schemes, including no compression at all, Huffman encoding, LZW, and something called Pack Bits. Most applications can read TIFF files stored in any of these compression formats.

PICT

PICT is a file format that was developed in 1984 by Apple Computer as the native format for Macintosh graphics. PICT can include both bitmap images and vector (line-oriented) graphics. Although PICT is used primarily to exchange graphics between Mac applications, many PC programs, such as Photoshop, support it. Apple elected to replace PICT with PDF, beginning with Mac OS X.

PICT supports grayscale images as well as up to 24-bit color images. (It also can use 32-bit images, but the extra 8 bits are used for selections as an alpha channel.) PICT uses a Huffman-like run-length encoding (RLE) compression scheme.

PDF

PDF (Portable Document Format) is a format originally developed by Adobe to store PostScript files for printing on PostScript printers. Its advantage is that it preserves the original layout, fonts, and appearance of the file. PDF is often used with Adobe Acrobat Reader or with browser plug-ins to display documents. I download instruction manuals, IRS tax forms, and other documents in PDF format.

More recently, PDF has gained some favor in the pre-press environment as a way of prepping documents for printing, and in the Macintosh world as a replacement for the PICT format. Because PDF files consist of PostScript text instructions, they can be highly compressed using any lossless compression method.

BMP

BMP was developed by Microsoft as a standard bitmap file format for computers running the Windows operating system. The intent was to produce device-independent bitmaps (DIB) that Windows can display on any type of device. BMP files can include color depths up to 24 bits.

RAW

As applied to digital cameras, RAW is not a standardized file format. RAW is a proprietary format unique to each camera vendor, and, as such, requires special software written for each particular camera. Each RAW format stores the original information captured by the camera, so you can process it externally to arrive at an optimized image. You'll learn more about RAW in the next section.

JPEG, TIFF, and RAW

As we've seen, digital cameras produce files in three kinds of formats. JPEG files are the most efficient in terms of use of space, and can be stored in various quality levels that depend on the amount of compression you elect to use. You can opt for tiny files that sacrifice detail or larger files that preserve most of the information in your original image.

Most cameras can also save in TIFF format, which, although compressed, discards none of the information in the final image file. However, both JPEG and TIFF files have been processed by the camera before they are created. The settings you have made in your camera in terms of white balance, color, sharpening, and so forth, are all applied to the image. You can make some adjustments to the image later in an image editor, but you are always working with an image that has *already been processed*, sometimes heavily.

The information captured at the moment of exposure can also be stored in a proprietary, native format designed by your camera's manufacturer. These formats differ from camera to camera, but are called Camera RAW, or just RAW for convenience. You might think of RAW as a generic designation rather than a specific format, just as the trade name Heinz applies to all 57 varieties instead of just one.

A RAW file can also be likened to a digital camera's negative. It contains all the information, stored in 12-bit or 16-bit channels (depending on your camera), with no compression, no sharpening, and no application of any special filters or processing. In essence, a RAW file gives you access to the same information the camera works with in producing a 24-bit JPEG or TIFF file. You can load the RAW file into a viewer or image editor, and then apply essentially the same changes there that you might have specified in your camera's picture-taking options.

Some RAW formats, such as those deployed by Nikon and Canon for their high-end cameras, are actually TIFF files with some proprietary extensions. That doesn't mean that an application that can read standard TIFF files can interpret them, unfortunately. Usually, special software is required to manipulate RAW files. If you're lucky, your camera vendor supplies a special RAW processing application that is easy to use and powerful. For example, Nikon offers Nikon View to read and manipulate its NEF files, Canon provides a viewer for its CRW format, and Minolta includes a DiMAGE Viewer for its RAW files.

If you're not so lucky, you'll get a less capable utility, be asked to pay extra for it, or find that none at all is available. Photoshop CS now includes a Camera RAW plug-in (which was formerly an extra-cost option with Photoshop 7) that works quite well. It can be used only with the particular digital cameras that Adobe has elected to support. The list is long, and

includes many popular cameras from Nikon, Canon, and Minolta. You'll find that third parties also provide RAW decoders for specific camera models, such as YarcPlus and BreezeBrowser for Canon, and Bibble for the Nikon line. The great freeware utility IrfanView can handle RAW files such as Canon's CRW format. Mac users can work with programs like Lemke Software's GraphicConverter.

Many digital photographers shoot nothing but RAW images, preferring to do all their image processing later in their computer. Such photographers have several things in common: they're extremely fussy about their images, they have a ton of memory cards and almost unlimited storage space, and they're willing to spend a great deal of time working on their images. Be prepared to spend more time shooting the images, too, because RAW files can take a bit longer to store on your filmcard than your average JPEG file.

For most of us, TIFF or JPEG is fine most of the time. RAW is a good choice for exceptional photographs or exceptional needs.

Browsing the RAW Browsers

This section provides an overview of the range of RAW file viewers, so you can get a better idea of the kinds of information available with particular applications. I'm going to include both high-end and low-end RAW browsers so you can see just what is available, and then move on to Photoshop's Camera RAW plug-in.

Kodak Professional DCS Photo Desk

This is the viewer used with Kodak's 14 MP DCS Pro 14N. As you might guess, the amount of information at your fingertips is astounding. For example, look at the sorts of data you can discover in the Image Info dialog box, shown in Figure 4.4. It includes things like the camera serial number (useful if you're working with several digital cameras and want to know which was used to produce the image), resolution, file size, ISO setting, type of metering used, flash sync mode, the focal length of the lens, and the exact time and date the photo was taken. If you annotated the image with a sound bite at the time you took the picture, you can play that back through your computer's speakers.

Professionals will love the Job Tracker dialog box, which lets you enter more information, including caption and credits, in an approved International Press and Telecommunications (IPTC) format. Anyone shooting digital pictures for publication will find this capability useful. The dialog box is shown in Figure 4.5.

Figure 4.4 *A wealth of information is available in the Image Info dialog box.*

Figure 4.5 *Embed job information right in your TIFF file.*

Other controls, shown in Figure 4.6, allow you to compensate for exposure, change the white balance and lighting, add noise reduction, or improve sharpness, exactly as you could with the camera.

Figure 4.6 *Adjust other camera settings using the Photo Desk controls.*

IrfanView

At the low (free) end of the scale is IrfanView, a freeware program you can download at www.irfanview.com. It can read many common RAW photo formats, like the Minolta format shown in Figure 4.7. It's a quick way to view RAW files (just drag and drop to the IrfanView window) and make fast changes to the unprocessed file. You can crop, rotate, or correct your image, and do some cool things like swapping the colors around (red for blue, blue for green, and so forth) to create false color pictures.

The price is right, and IrfanView has some valuable capabilities.

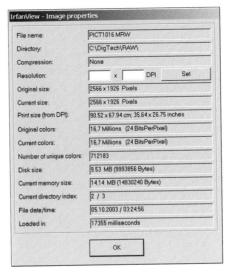

Figure 4.7 *IrfanView is a freeware program that can read many RAW file formats.*

Manipulating RAW Files in Photoshop CS

The latest version of Photoshop includes a built-in RAW plug-in that is compatible with the proprietary formats of a growing number of digital cameras, both new and old, including the positively ancient image file from the Kodak DCS 460, shown in Figure 4.8.

The list of supported cameras at the time this book was published is a long one, as shown in Table 4.1.

Table 4.1 RAW Camera Formats Supported by Photoshop CS

Camera Vendor	Models Supported
Canon	EOS-1Ds, EOS-1Ds, EOS-10D, EOS-D30, EOS-D60, PowerShot 600, PowerShot A5, PowerShot A50, PowerShot S30, PowerShot S40, PowerShot S45, PowerShot S50, PowerShot G1, PowerShot G2, PowerShot G3, PowerShot G5, PowerShot Pro70, PowerShot Pro90 IS
Nikon	D1, D1H, D1X, D100, Coolpix 5700, Coolpix 5000
Konica Minolta	DiMAGE 5, DiMAGE 7, DiMAGE 7i, DiMAGE 7Hi, DiMAGE A1, DiMAGE A2
Fujifilm	Fujifilm, FinePix S2 Pro
Olympus	E-10, E-20, C-5050 Zoom
Leaf	Valeo 6, Valeo 11

Figure 4.8 *Photoshop CS's Camera RAW plug-in accommodates a variety of proprietary RAW file formats.*

To open a RAW image in Photoshop CS, just follow these steps:

1. Transfer the RAW images from your camera to your hard drive.
2. Choose Open from the File menu, or use Photoshop's File Browser.
3. Select a RAW image file. The Camera RAW plug-in will pop up, showing a preview of the image, like the one shown in Figure 4.9.
4. Rotate the preview image using the Rotate Preview buttons.
5. Zoom in and out using the Zoom tool.
6. Adjust the RGB levels using the Histogram and RGB Levels facilities.
7. Make other adjustments (described in more detail below).
8. Click OK to load the image into Photoshop using the settings you've made.

Photoshop's Camera RAW plug-in lets you manipulate many of the settings you can control within your camera. I'm using the Minolta DiMAGE 7Hi as an example here. Your camera probably has similar RAW file settings that can be worked with. Here are some of the most common attributes you can change. This is an overview only. Check your Photoshop Help files for more detailed information on using these controls.

■ *Color space.* It's possible your digital camera lets you choose from among several different color space profiles, such as Adobe RGB or sRGB. The RAW file will be saved by the camera using the camera's native color space. You can change to another color space using the Space drop-down list shown at lower left in Figure 4.9.

Figure 4.9 *A preview of the image shows in the RAW plug-in.*

- *Depth.* Here you'll choose 8 bits or 16 bits per color channel. Photoshop CS now supports more functions using 16-bit channels, so you might want to preserve the full depth of information available.

- *Pixel size.* Usually, you'll choose to open the image at the same resolution it was recorded at. If you plan to resample to a larger or smaller size, you might find that carrying out this step on the RAW file yields better results because of the new algorithm incorporated in this version of the plug-in.

- *Resolution.* This is the resolution that will be used to *print* the image. You can change the printing resolution to 300 or 600 pixels per inch (or some other value) to match your printer.

- *White balance.* You can change this to a value such as Daylight, Cloudy, Shade, Tungsten, Fluorescent, or Flash, or leave it at As Shot, which would be whatever white balance was set by your camera (either automatically or manually). If you like, you can set a custom white balance using the Temperature and Tint sliders.

- *Exposure.* This slider adjusts the overall brightness and darkness of the image. Watch the histogram display at the top of the column change as you make this adjustment, as well as those for the four sliders that follow.

- *Shadows.* This slider adjusts the shadows of your image. Adobe says this control is equivalent to using the black point slider in the Photoshop Levels command.

- *Brightness.* This slider adjusts the brightness and darkness of the image similarly to the Exposure slider, except that the lightest and darkest areas are clipped off, based on your Exposure and Shadow settings, as you move the control.

- *Contrast.* This control manipulates the contrast of the midtones of your image. Adobe recommends using this control after adjusting the Exposure, Shadows, and Brightness settings.

- *Saturation.* Here you can manipulate the richness of the color, from zero saturation (gray, no color) at the -100 setting, to double the usual saturation at the +100 setting.

Additional controls are available on the Detail, Lens, and Calibrate tabs, shown in Figures 4.10, 4.11, and 4.12.

- *Sharpness.* This slider applies a type of unsharp masking using a sophisticated algorithm that takes into account the camera you're using, the ISO rating you used, and other factors. If you're planning to edit the image in Photoshop, Adobe recommends not applying sharpening to the RAW image.

- *Luminance Smoothing/Color Noise Reduction.* Both these sliders reduce the noise that often results from using higher ISO ratings. Each control works with a different kind of noise. Luminance noise is the noise caused by differences in brightness, whereas color noise results from variations in chroma.

Figure 4.10 *The Detail tab lets you adjust sharpness and noise attributes of your image.*

Figure 4.11 *The Lens tab has settings for technical lens corrections.*

Figure 4.12 *The Calibrate tab provides a way for calibrating the color corrections made in the Camera RAW plug-in.*

- *Lens Tab settings.* These are technical adjustments you can use to compensate for weaknesses in your lens' design. Most of us don't have the slightest idea what these are, and can safely ignore them.

- *Calibrate Tab settings.* These settings let you make calibrations in the way the Camera RAW plug-in adjusts hues, saturation, or shadow tints. If you consistently find that your images end up too red, blue, or green, or have a color cast in the shadows, you can make an adjustment here.

Next Up

This concludes the nuts and bolts section of the book. Part II, which follows, consists of down-and-dirty, technique-laden chapters that lead you through the ins and outs of the most popular types of digital shooting. Chapter 5 concentrates on action photography, which, as you'll learn, is not limited to sports.

In this section, the focus will be entirely on photography, looking at techniques you can use to get great action photos, people pictures, close-ups, scenics, and architectural shots. You'll learn pro tips that will separate your images from the pack.

If you find that most digital photography books offer more about digital technology than they do about photography, you'll enjoy the chapters that follow.

PART II

Techniques Unlimited

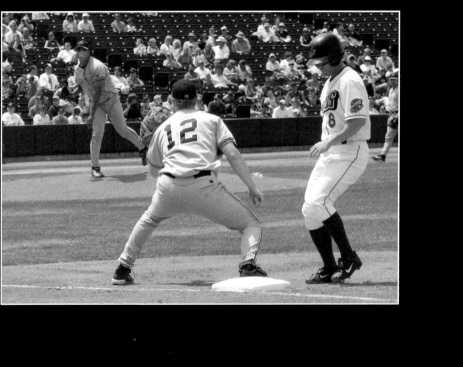

5

Action Photography

Lights! Camera! Action!

Those are the keys to exciting photography. And, given today's technology, you might not even need the lights. A digital camera, some fast-moving action, and a bit of knowledge about how to take the best pictures of moving subjects will start you on the road to some of the most interesting photographs you've ever taken. You've got the camera, the action is all around you, and this chapter provides the knowledge you need.

Action photography is by no means limited to spectator sports, of course. Certainly, you can grab some great shots at football or baseball games, soccer and tennis matches, or even those semi-organized bouts of mayhem they call rugby and hockey. You can also capture some fast-moving subjects at amusement parks, the beach, or while mountain climbing. Action photography is a great tool for capturing the excitement of participatory events, from skydiving to golf, and non-events that involve moving objects, such as juggling or driving your favorite car around a tight mountain curve. If it's moving, you might well want to photograph it. Action photography, on any level, is not a spectator sport.

My first full-time job that didn't involve tossing rolled-up newspapers on my neighbors' front porches was as a sports photographer for a daily newspaper. I didn't officially become a writer until the paper's sports editor began publishing the two- and three-page cutlines I was turning in with each photo, each written in inverted pyramid style, complete with quotes from the coaches. Later, I photographed college sports while working as a sports information director for a small upstate New York college. More recently, I've been taking a lot of photographs of high-school sports and professional baseball (the former for my kids' sports teams, and the latter purely because I love baseball and photography). So, I've got a lot of advice to pass along to you in this chapter.

Although the focus of this chapter is on sports photography, most of the lessons here apply to taking pictures of anything that won't sit still and pose for you.

The Two Most Important Things

As you'll learn from this chapter, the most difficult thing about action photography is not mastering your camera's controls well enough to freeze motion (or to allow it to blur in creative ways). Getting the right exposure isn't difficult, either. Nor, once you've had a bit of practice, is knowing how to shoot an action picture a particularly insurmountable obstacle.

The two most important things about capturing an exciting photograph are knowing *what* to photograph, and *when*. If you stop to think about it, action is a continuous series of moments, each a little different from the last, all leading up to *the* moment. It's the instant when a shooting guard releases the basketball at the apex of a jump shot, and you *know* that it's going to sail over the arms of a defender and swish through the net of the basket. Or, the moment might come from the look on a goalie's face as a soccer ball sails past her outstretched hands into the goal. The moment might involve almost no motion at all, as when a field goal kicker lowers his head in shame when he sees his boot is tumbling wide of the goalposts. Capturing the right moment is important.

However, the heart of sports photography lies in capturing not only the right moment, but also the right subject, in the right circumstances. My first lesson as a fledging professional came when the newspaper's picture editor rejected the shot I'd tentatively circled on my contact sheet. The shot was a thrilling moment, frozen in time.

"It's a great action picture," Danny, the photo editor, admitted, "but you've captured one of the scrubs making a meaningless play after the game was already in the bag. His parents would love this picture, but the fans would wonder why we published it. Even a so-so shot of a key player at the turning point in the third quarter would have been better." Choosing the right subject goes hand-in-hand with choosing the right moment.

TIP FROM THE PROS: SCOUTING REPORTS

If you want your action photo to have the most meaning, learn a little about the teams you'll be photographing. Who are the star athletes, the players who will make the big plays? What are their uniform numbers? Does the quarterback like to throw long, and to whom? Does the pitcher rarely catch anyone stealing? If so, you might want to pay special attention to the action at first base. Is that battered-looking player who just took to the ice the team's enforcer, so some teeth-chattering body checking is in the offing? It might be worth your while to work up an informal scouting report so you'll know what to look for.

The Decisive Moment is more than the title of a 1952 book by photojournalist Henri Cartier-Bresson, an enduring master of exquisite timing. The crucial instant can be seen in photojournalist Robert Capa's chilling 1936 photograph of a Spanish Loyalist militiaman at the moment of his death, or the Pulitzer Prize-winning photograph of a woman leaping to her death to escape a hotel fire in Atlanta in 1946. (If you want to talk about timing, the famous picture was taken by a Georgia Tech student, using his *last* flashbulb.)

In short, the two most important things to keep in mind when shooting action are

- *The right subject.* Know who to photograph, why they are important, what they might do that's photo-worthy, and where to stand to capture them. (As Capa once said, "If your pictures aren't good enough, you're not close enough.")

- *The right moment.* Snap a photo a fraction of a second too late (and that's easy to do with a slow-responding digital camera) or too early, and you'll capture the immortal instants that happen just *after* or just *before* the decisive moment. There were lots of photographs of the Hindenberg as it started its descent in Lakehurst, New Jersey on May 6, 1937, and quite a few of the charred rubble on the ground afterwards, but none of them made the cover of a Led Zeppelin album. Figure 5.1 shows the decisive moment in a professional baseball game.

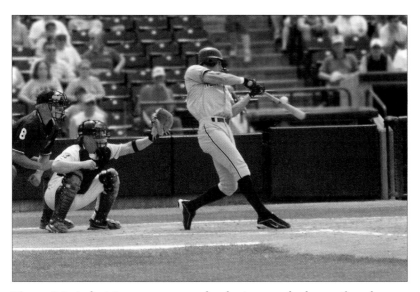

Figure 5.1 *A decisive moment can be the instant the bat strikes the ball to send a game-winning home run over the fence.*

Digital Cameras and Shutter Lag

When my last book on digital photography was published, I gave a few lectures on the topic at bookstores, computerfests, and photography shows, and followed each of them with a Q & A session. After the first few sessions, I could predict what one of the first questions would be. I heard it everywhere I went:

> *"How can I take action pictures? When I press the shutter button on my digital camera, nothing happens for a couple seconds, and by then I've missed the picture!"*

It's a universal problem. Although the lag is rarely actually as long as a few seconds, it might seem so when you're trying to take a picture of something that's happening *right now.* The actual time span is called an *ohnosecond,* which is the interval between the time you press the shutter release, realize that the decisive moment has passed, and when your camera belatedly takes a picture of nothing in particular. I've experienced delays so long that I've actually given up on the photo because the action is over and snapped a picture of my feet. Not limited to action photography, "shutter lag" is one of the most annoying things about digital photography. Fortunately, I have several full and partial solutions for you. First, it helps to understand why this happens. As you learned in Chapter 2, "Inside a Digital Camera," lots of things take place when you press the shutter release on your digital camera. To review, here's the sequence of events.

1. When you first depress the shutter button part way, a digital camera set in programmed or autoexposure mode probably locks in the correct exposure. Depending on the complexity of your camera's exposure system, this might take a significant fraction of a second.

2. Next, the autofocus system will seek the sharpest focus for the subject matter currently being framed. If your camera has been set to Continuous Autofocus, it might have been focusing and refocusing all the time you were framing the picture. If your camera has been set for Single Autofocus, it might have waited until you pressed the shutter button to focus the image.

3. Press the shutter button the rest of the way, and the exposure is made. Some electronic and mechanical things might be happening at this step. In the electronic realm, your sensor might be drained of its current image so it can capture an image for the precise length of time determined by the electronic shutter programming of your camera. Or, if your camera uses a mechanical shutter, that device might open and close. Should you be using a digital SLR with a mirror used for viewing, the mirror will fold up to allow the light to reach the sensor, instead. All this takes time, which ranges from a lot (with a digital camera having a slow autofocus mechanism) to virtually no time at all (with a digital SLR).

4. The captured image is stored in your camera's built-in RAM (almost instantly), then transferred to your digital film card (a bit more slowly, as you'll note from the red-flashing LED that marks the progress).

You might end up with a photograph like the one shown in Figure 5.2. I carefully composed a shot, waited until I could see my kids just entering the frame, and then pressed the shutter release. Unfortunately, by the time the camera snapped the picture, one of them was already out of the picture. All the stuff going on prior to exposure adds up to a delay significant enough to spoil many action photos, and other types as well. It's easy to spoil a candid portrait when you say, "Smile!" and the subject follows the smile with a frown when the picture isn't taken when expected.

Testing for Shutter Lag

Although the delay you experience when taking a photo might seem like an eternity, it probably isn't as long as you think. There are several ways to test for the lag time, and I'm going to show you three of them. First's an easy way to test just how much shutter lag you're really experiencing that you can do anywhere you can find a clock. Just follow these steps.

Figure 5.2 *The picture was snapped prior to the kids entering the frame, but this is the picture that resulted.*

1. Find a stopwatch (preferred) or an analog clock with a sweep second hand. A stopwatch will enable you to time your shutter lag more precisely.
2. With your digital camera set on automatic focus/automatic exposure, frame the clock in the viewfinder. There's no need to take a close-up photo. All you need is to be able to read the hands on the clock/watch. (Indeed, a close-up might slow down the focus mechanism of your digital camera.)
3. Start the stopwatch or begin watching the second hand of the clock.
4. When the second hand reaches some benchmark point (such as the beginning of a minute), press the shutter button and hold it down until the photo is taken.
5. Examine the picture, like the one shown at top in Figure 5.3. The time difference between when you pressed the shutter button and the actual time imaged in the photograph is your shutter lag.

Repeat each of these steps using various camera settings. Try the experiment both with and without flash. Set exposure or focus manually. Use shutter priority and aperture priority modes. See what the difference is in shutter lag during each of these modes, and use that information when taking your photos.

If you have an online connection and can test your camera while seated at your computer, there's a web page that provides a shutter lag test. As of this writing, the page can be found at www.shooting-digital.com/columns/schwartz/shutter_release_test/default.asp. It's located at the

web site of Mikkel Aaland, author of some great books on digital photography and image editing. The useful shutter lag test on the site merits Mikkel a free plug. Thanks!

A third method, which also involves a computer, is to use an on-screen stopwatch, like the Windows program that can be found at www.xnotestopwatch.com. To use XNote Stopwatch, shown at the bottom of Figure 5.3, you should mount your camera on a tripod and point it at your computer screen. Then, use both hands to click the Start button on the utility at the same time you press the shutter release on your digital camera. The quality of the picture doesn't matter, only the results, so don't worry about correct exposure or even precise focus.

Figure 5.3 *Photograph a clock, stopwatch, or computer timer to see just how bad your camera's shutter lag is.*

Here are some solutions for you:

- Use a digital SLR. This suggestion isn't entirely facetious. If you plan on taking many sports and action photographs, the near-instant response of the average digital SLR might be worth a few extra dollars to you, prompting the upgrade to a camera in this category. Most snapshooters don't want or need a digital SLR, but for serious photographers, the reduction in shutter lag might be just the extra push needed to justify the purchase of one.

- Anticipate the decisive moment. Press the shutter button a fraction of a second before the action peak. If you understand a sport or activity well, you'll be able to predict a key play often enough to improve your odds of capturing one in pixels.

- Use your camera's sequence mode to grab a series of photos, starting just prior to the big moment, and ending after it has passed, as shown in Figure 5.4. This method has some drawbacks that I'll discuss later.

- Use the manual exposure and focus settings. Preset the exposure (lighting doesn't change rapidly in most action situations) and set the focus distance to a point where you anticipate the action will take place. With the automatic features turned off, you should find your shutter lag problems dramatically reduced.

- If you must use automatic mode, aim the camera at the point where you expect the action to happen, partially depress the shutter button, and hold it until the big moment arrives. If your camera is set to lock in exposure and focus when the button is partially depressed, pushing it down the rest of the way should trigger the actual exposure without much further delay.

- Use the lulls between exciting moments to review the images you've shot so far. Learn from your mistakes on the spot, and delete the bad pictures immediately to provide more room on your memory cards for the stellar images to follow.

Figure 5.4 *Taking a sequence of shots can improve your chances of capturing a big moment.*

- Take as many photos as possible. The more pictures you take, the better your chances of overcoming shutter lag and ending up with a picture that truly captures the action.

- Be aware of the time it takes to offload images from your camera's internal memory to your memory card. If your camera's memory is sparse, you might have to wait a few seconds between shots or a series of shots before you can start shooting again. Good pictures can be lost in the interim, so you might want to limit the number of pictures you take in one sequence if you think you might want to shoot another photo during the time your camera is downloading to the memory card.

Your Action Arsenal

You don't need an expensive camera to take action photos. I once wrote an article for *Petersen's PhotoGraphic Magazine*, which I illustrated with sports photos taken with both a $100 point-and-shoot amateur camera and a $2,000 professional SLR. Reproduced in the magazine at a small size, and subjected to halftone screening, it was difficult to tell which photos were taken with which camera.

Any digital camera can do the job, assuming you can work your way around the shutter lag problem described. That's not to say you won't need to compensate for other limitations, too. If your camera has a modest zoom range, you might have to limit your photography to action that's close to the sidelines. Puny electronic flashes have a limited range, so you won't be taking photos dozens of feet from the camera at night. Some digital cameras offer shutter speeds as fast as 1/16,000th of a second; if yours can slice time into slivers no thinner than 1/250th second, you'll have to use other techniques to freeze the action (or learn to use blur creatively).

This section explains the key features to look for in a camera used for action photography. I explained most of these features briefly in Chapter 2. Now it's time to see how they relate to capturing fast-moving subjects.

Lens

Most of the readers of this book will be using zoom lenses rather than fixed focal length lenses. Non-SLR cameras are furnished with a zoom lens, and even DSLRs with interchangeable lenses are usually used with a zoom of some type. However, action images are one type of photographic pursuit that benefits from the use of specialized lenses.

The three things to consider about a lens used for action photography are the focal length, aperture, and whether the camera uses optical or digital magnification.

Focal Length

Your best bet is a camera equipped with a zoom lens that lets you adjust your field of view as the action moves around. I recommend a lens with at least a 3:1 zoom ratio. In addition to zoom ratio, you can compare the effective focal length of your lens with that of a 35mm camera, because the field of view provided by an actual focal length varies from camera to camera. A true focal length of 25mm might be a telephoto setting on one digital camera, or a wide-angle setting on another, depending on the camera's magnification ratio caused by the sensor size.

All digital camera vendors supply the equivalency information. For example, one camera I use has a 7.2 to 50.8mm zoom lens; that provides roughly the same field of view as a 28mm to 200mm zoom lens on a 35mm camera. You can see the difference in viewpoint between a wide-angle lens and a telephoto setting in Figures 5.5 and 5.6.

For most action photos, the longest zoom setting is more important than the shortest. Few sports require a really wide-angle lens. Most of the time you can't get as close to the action as you'd like. Many benefit from the equivalent of a 135mm to 150mm telephoto optic, particularly if you're unable to patrol the sidelines and must shoot from the stands. Sports like basketball and volleyball do call for shorter focal lengths and wider angles, because you might be literally on top of the action.

Those using some digital SLR cameras can benefit from using lenses designed for 35mm cameras with a sensor that's smaller than the 24mm × 36mm film frame. Mounted on such cameras, the focal length of a lens is effectively multiplied, so a 200mm tele actually produces the same field of view as a 320mm long lens (when used with one particular digital camera

Figure 5.5 *A wide-angle shot shows you the big picture.*

Figure 5.6 *A telephoto lets you zoom in on the action.*

with a 1.6X "multiplier" factor). Note that some newer digital cameras have "full frame" sensors, and don't produce this magnification effect.

Owners of fixed-lens digital cameras aren't left out in the cold when it comes to longer or shorter effective focal lengths. Many models can be fitted with attachments that provide telephoto or wide-angle effects. The best avenue is to choose one of these accessories offered by the manufacturer of your camera; they are designed specifically for your camera's lens and provide the best results. However, third-party vendors also produce generic attachments that can be fitted to a variety of cameras. The cost savings can be significant: a 3× tele converter

offered by a major camera manufacturer might cost $250, whereas a generic third-party attachment (possibly with 6× to 8× magnification) can be purchased for $100 or so.

Aperture

The maximum aperture of your lens can be important when shooting action in low light situations. A "slow" lens can limit the maximum shutter speed you can use, thus affecting your ability to freeze action. For example, if your lens opens no wider than f8 (a common limitation for longer lenses and zoom settings), the best you can do with your camera set to ISO 100 in full daylight is 1/500th second at f8. Your camera might have 1/1,000th or briefer setting, but you can't use it without increasing the ISO setting to 200 or higher, thus increasing your chances of detail-robbing noise in your photos. If daylight is waning or you're shooting indoors, an f8 lens might limit you to sluggish 1/250th or 1/125th second speeds.

So, a larger maximum aperture is better, assuming that the lens performs well wide open; an optic that is a bit fuzzy at its maximum aperture is no bargain. Keep in mind that the maximum opening of some zoom lenses varies, depending on the focal length setting. That is, a lens that rates an f4.5 aperture at the 28mm setting might provide only the equivalent of f6.3 or slower when zoomed all the way to the telephoto position.

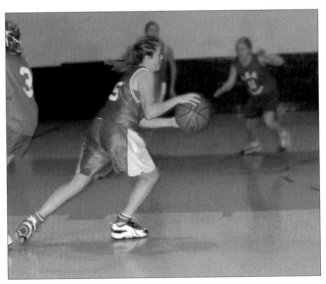

Use of larger maximum apertures can improve action photos by isolating your subjects, particularly at longer focal lengths. The reduced depth-of-field afforded by a lens with a wide-open aperture set at the maximum zoom setting can be used creatively, if you're able to focus accurately enough to apply the depth-of-field that remains to the subject. Figure 5.7 shows how reduced depth-of-field can emphasize a subject.

Figure 5.7 *Use depth-of-field to concentrate attention on a subject.*

Optical vs. Digital Zoom

In the quest for longer zoom ratios that can be posted in large letters on the outside of the box, camera manufacturers came up with an amazing and partially useful feature: the digital zoom. Digital zoom is a way of providing the illusion of a longer focal length lens: instead of the 135mm equivalent maximum optical setting your camera provides, the field of view can be magically magnified by 2× (or more) giving you an ersatz 270mm lens. Maybe.

Digital zoom doesn't capture any more information. Instead, it simply fills the photo frame with the pixels captured in the center of the image, using interpolation to enlarge the pixels and provide a magnified image. With some cameras, the results are terrible. You might get better results taking a straight shot and cropping in Photoshop or another image editor, as you can see in Figures 5.8 and 5.9, which show a photo taken with digital zoom and another that's a straight telephoto shot, both captured with the same camera. Other cameras do a fairly good job of interpolation, so the digitally zoomed images are acceptable. I use digital zoom occasionally. Your best bet is not to purchase a camera based on the reach of its digital zoom, and then to test your camera thoroughly to see how well it performs in digital zoom mode before relying on this feature for any important photos.

Figure 5.8 *This photo was taken using digital zoom.*

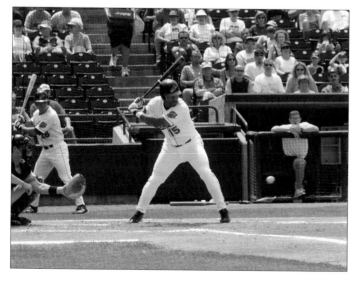

Figure 5.9 *This picture was taken with the same camera as a normal telephoto shot, then enlarged.*

If you do use digital zoom, learn how it operates with your camera so you can apply it quickly. The most common control for digital zoom is a magnification button on the back of the camera. Press it, and the lens zooms in, with either a magnified view in the viewfinder or, perhaps, a cropped image showing how much of the original view is being captured. The magnified view is preferred, because it allows you to evaluate your image at full size.

Exposure Controls

Exposure controls help determine whether your image has a pleasing tonal range, and whether there is sufficient detail in both the highlights and shadows. (The quality and quantities of the light are other factors.) Even the best action photograph can be ruined if it's not exposed properly. I'll show you what to look for in exposure controls in this section.

Exposure Modes

Your digital camera probably offers a variety of exposure modes, and might even include one especially for action photography. When choosing an exposure mode, keep in mind the shutter lag problems discussed previously. Here are the most common exposure modes, and how they relate to action pictures.

■ *Fully automatic.* The least expensive digital cameras might have only a basic full-auto exposure mode. In such cases, the camera's logic chooses both shutter speed and aperture using simple rules. For example, the camera might shoot at f8 using whatever shutter speed provides the correct exposure until the exposure becomes long enough to encourage handheld blurring (at, say 1/30th second). Then it will switch to a wider f-stop, as necessary. This is not the best mode for action photography.

■ *Programmed automatic.* Most digital cameras have more sophisticated programming that takes into account the shooting environment when deciding exposure settings. For example, if photographs are being taken in dim light, the camera assumes that you're indoors; in bright light, it assumes that you're outdoors. Lens openings and shutter speeds are selected based on typical shooting situations in these environments.

■ *Programmed selective.* If you're lucky, your digital camera has selective programs you can choose for automatic exposure under specific conditions. The one you want to opt for is the action/sports setting. In such cases, the camera will try to use the shortest shutter speed possible. It might even automatically boost the ISO rating (if you've set ISO to auto) or use other tricks to optimize your exposure for fast-moving subjects. If you must use automatic exposure, this is your best choice.

■ *Aperture priority.* In this mode, you set the lens opening, and the camera automatically chooses a shutter speed to suit. Use this if you want to select a specific f-stop, say to increase/decrease depth-of-field. Because aperture priority offers little control over shutter speed, you probably won't use it frequently for sports photos.

■ *Shutter priority.* In this mode, you choose a preferred shutter speed, and the camera selects the lens opening. That lets you select 1/500th or 1/1,000th second or shorter to stop action, yet retain the advantages (barring shutter lag) of automatic exposure. This is the mode to use if you're taking photos under rapidly changing light conditions. I use it for outdoor

sports on partly cloudy days in which a playing field might alternate between bright sunlight and overcast within the space of a few minutes, depending on how the clouds move. It's also a good choice for photos taken as the sun is setting, because the camera automatically compensates for the decreasing illumination as the sun dips below the horizon.

- *Manual exposure.* I end up using manual exposure for many of my action photographs. Indoors, the illumination doesn't change much. Most sports arenas, gymnasiums, and other sites have strong overhead illumination that allows taking pictures at 1/250th second at f2.8 using ISO 400 or 800 settings. I might also use flash indoors. Outside, I carefully watch the lighting and change exposure to suit.

Monitoring Exposure

Your camera's built-in light meter might do the job for you, especially if it has a readout that shows exactly how much over- or under-exposure you're working with at any given moment. Unfortunately, a modern camera might be equipped with nothing more than a red LED that blinks when the camera decides there isn't enough light to take a picture. In the worst case, you'll be blocked from actually taking the picture.

Working on the theory that the photographer should know best whether the picture is worth taking or not, I use only cameras that give me the freedom to goof in manual mode, should I want to intentionally take a severely backlit photograph or exercise some other creative license. In manual exposure mode, I sometimes use a handheld light meter and transfer the settings to my digital camera. I tend to use a handheld light meter more than the average amateur photographer—a habit that extends back to my days when people paid me lots of money to know exactly what lighting conditions I was shooting under.

Handheld meters are available in several varieties, including "spot" meters that zero in on a specific point you aim them at, and "incident" meters, which measure the light that falls on their sensors (usually a dome shape, like that shown in Figure 5.10). The disadvantage of the incident meter, of course, is that it only works when the light at the camera position is substantially the same as the light falling on the subject, assuming you don't want to run out onto the field and measure from there.

Better cameras let you choose the area being monitored for correct exposure. For action photography, it's handy to have a spot meter option that's easily accessible. With one of my digital cameras, all I need to do is press the Spot button and hold it down to meter the light at any point I choose.

Figure 5.10 *A handheld light meter can come in handy at sports events to confirm the correct exposure*

Focus Controls

Action photography is one field that can benefit from automatic focus, as long as the focus feature operates quickly enough to avoid delaying the exposure. As described before, many cameras take so long to focus that pictures can be lost waiting for the camera to zero in on the sharpest point.

For that reason, you'll want to test your camera's automatic focus features carefully in real action photography situations before switching to manual focus. With players racing around your field of view at a furious pace, the ability to allow your camera to determine the correct focus is a valuable capability. You have enough to think about!

Even so, manual focus can be a useful tool. Here's how to decide which mode to use.

- Avoid automatic focus if it introduces massive shutter lag problems to your action photography experience.

- Use automatic focus if you're able to prefocus on a specific point by partially depressing the shutter button. If your camera allows you to lock in focus, and then take a photograph quickly by depressing the shutter button the rest of the way, autofocus might work for you.

- Experiment with automatic focus if the action changes quickly from one point to another. You might not be able to focus manually fast enough. I've lost as many pictures to poor focus as I have to shutter lag.

- Manual focus is a good choice when you know in advance where the action will be taking place (for example, around the hoop) and can help your camera operate more quickly than in autofocus mode.

- Manual focus works when your shooting is limited by other factors. At baseball games, for example, if I'm working with a camera with a limited zoom range, I find that from my usual position by the first base dugout, my only realistic subjects are the batter, pitcher, and first base positions. I can prefocus on one of those spots and be ready for action at that position.

- Manual focus is best when you need to control your depth-of-field. For example, you might want to shoot a photo of spectators watching a game. In that case, you wouldn't mind if the game itself is a little out of focus. Your digital camera's autofocus might focus on the playing field in the center of the image rather than the spectators at the edges of the frame.

- Manual focus is practical only when you're able to accurately set focus manually. Distance guesstimates work sometimes. I use this method at football games, where I can use the yardline markers as a gauge, and at baseball games, because the distance between bases, or from home plate to the pitcher's mound is a standard increment. If you're focusing using your camera's viewfinder, remember that some viewfinders display sharp focus better than others, and that your ability to focus visually might suffer when the illumination wanes.

TIP FROM THE PROS: FOCUS PRESETS

Several of my digital cameras use a focus ring around the camera lens (as opposed to Plus and Minus buttons or some other means of setting focus manually). If you're lucky enough to have a focus ring available, you might be able to pre-mark the correct focus setting for specific playing positions on the barrel of the lens (use a sharpened white grease pencil). Then, you can switch (fairly) rapidly from one setting to another by aligning the mark with another reference mark on your camera.

Electronic Flash

All of us photography cognoscenti have smiled at sports events when an amateur photographer high in the stands attempted to snap a flash photograph of the game from 50 yards away. Everyone knows that a point-and-shoot camera's built-in flash produces its best results from no more than 10-12 feet away from the subject. Of course, I never mention this to the hapless amateurs, because they invariably reach into a pocket and pull out an abominable photo (which they nevertheless find perfectly acceptable) taken at the previous game under identical conditions. In virtually all cases, they had lucked out and used a film that was fast enough to produce a picture under the available light. The flash had little or nothing to do with the exposure.

Pros and Cons

Even so, we big-time photographers who understand electronic flash find some use for it, because there are advantages as well as disadvantages to sports flash photography. The advantages are well-known:

- The brief duration of electronic flash can often freeze fast action even more effectively than your camera's shortest shutter speed.

- Electronic flash can provide enough light to illuminate sports venues that are far too dim for good available light photographs.

- Electronic flash works just fine in close confines, so it works indoors for basketball photos, or outdoors for football pictures taken close to the sidelines.

Electronic flash also has some disadvantages, like these:

- Flash pictures often look like flash pictures, with very bright foregrounds and pitch-black backgrounds. Figure 5.11 is an example of the traditional "basketball instead of a head" shot that every sports photographer strives for, made to seem as if it were taken outdoors at night thanks to the overpowering glare of an electronic flash. Such photos can look dated, because many sports pictures taken today with faster films and faster digital sensors have no such look. Or, you can use the effect artistically to isolate your main subjects from the rest of the playing field.

■ Electronic flash can produce a "ghosting" effect, which occurs when the main exposure is made by the flash, and a secondary, blurry exposure is produced when the available light is strong enough.

■ Some cameras won't synchronize with the electronic flash at particular shutter speeds, particularly if your digital camera uses a mechanical shutter. Because the electronic flash exposure is over in as little as 1/50,000th of a second, the flash needs to be triggered at a point when the entire sensor is exposed to the light. For some cameras, that happens only when shutter speeds of 1/125th of a second or slower are used. For faster shutter speeds, a smaller opening is passed vertically or horizontally in front of the sensor, and only the portion exposed when the flash is triggered will show up in your photo. The slower the shutter speed you must use to synch with your flash, the more likely you're to get ghosting effects. Figure 5.12 shows a typical image with ghosting problems.

■ Some venues won't let you use flash. I've never had a problem at the high-school, college, or pro levels, but have been chastised sharply by the refs when attempting to use flash at middle-school basketball games. Although personally I feel that these young stars need to get used to playing under the glare of electronic flash illumination, I always abide by the officials' rulings.

■ Electronic flash eats up your camera's internal batteries quickly, and drains the cells in an external flash unit almost as quickly. I recently photographed a football game and took along six sets of 2000 mAh nickel metal-hydride batteries for my camera and external flash unit. By the end of the game, I had a few hundred exposures and six sets of dead batteries.

Figure 5.11 *You can never mistake a sports photo taken with flash for an existing light picture. This one has had some special texture effects applied in Photoshop.*

Figure 5.12 *This picture is actually two exposures, one made by flash and one, a ghost image, which resulted from the existing light.*

Flash Sync and You

Your digital camera probably has several flash synchronization settings that can help you work with the ghosting effect, either to reduce it or enhance it. Ghosting is such a common occurrence that photographers can even use it as a special effect, producing a photo that combines a sharp photo with a trailing blurry ghost that follows behind. All you need to do is use flash at an f-stop and shutter speed that will also allow a conventional image.

Unfortunately, your digital camera might work against you. That happens when the flash is triggered at the *end* of the exposure rather than at the beginning of it. You'll end up with a ghost image preceding the subject, followed by a sharp flash image at the end of the exposure, when you want the reverse. Your digital camera might have a setting to let you control exactly when the flash is fired. Set properly, the flash will fire immediately, but your electronic/mechanical shutter will remain open long enough to produce the ghost image as the main subject continues on its path.

Here are the most common synchronization options found on digital cameras:

- *Front-sync.* In this mode, the flash fires at the beginning of the exposure. If the exposure is long enough to allow an image to register by existing light as well as the flash, and if your subject is moving, you'll end up with a streak that's in front of the subject, as if the subject were preceded by a ghost. Usually, that's an undesirable effect.

- *Rear-sync.* In this mode, the flash doesn't fire until the *end* of the exposure, so the ghost image is registered first, and terminates with a sharp image at your subject's end position, with the well-known streak (like that which followed The Flash everywhere) trailing behind. That can be a bad thing or a good thing, depending on whether you want the ghost image.

- *Slow-sync.* This mode sets your camera to use a slow shutter speed automatically, to record background detail that the flash, used to expose a subject closer to the camera, fails to illuminate. This mode can improve your flash images if you hold the camera steady and the subject is not moving. So, slow-sync is best reserved for non-sports images, or photographs in which the subject is approaching the camera. Otherwise, you can almost guarantee ghost images.

Compatibility

If you're using flash, consider working with a more powerful external flash unit that's compatible with your digital camera. Such a flash might not be easy to find. Some digital cameras are only able to use dedicated flash units made specifically for them. One reason for this is that often the triggering voltage of the vendor's own flash units is low, and electronic flash that use higher voltages might fry the electronics. Another reason is that only a dedicated flash unit might be compatible with the flash autoexposure mechanism of your camera. Unless you want to set flash exposure manually, you're better off with the recommended units.

My favorite digital camera has a standard PC synch connector that's compatible with any electronic flash I care to use. It works happily with my studio flash units, and is equally at home with the "potato masher" flashgun I use at night football and soccer games when the field lighting isn't strong enough.

TIP FROM THE PROS: FLASH POWER

The more powerful an external flash unit is, the more power it requires. Avoid units that have only internal rechargeable batteries. You need a flash with replaceable battery packs, or which can use standard AA, C, or D-sized rechargeable batteries. (In a pinch, you can even use alkaline cells.) The best external flash units can use special external powerpacks, which can be built as belt-packs that fasten around your waist, or auxiliary cases you carry around with a strap. Some enterprising vendors make a "one size fits all" battery pack that can be used with several vendors' flash units.

Don't bother with multiple flash units. Pros relied on these extensively before the fast color films and more sensitive digital cameras of today became prevalent. I used to watch these folks spend hours suspending their radio-controlled strobes from the rafters of sports arenas before an important event. Is all that work worth it just to make the cover of *Sports Illustrated*? You should be able to get by with a single flash unit or no flash at all.

Flash Exposure

Learn to use your digital camera's various flash exposure modes. You can usually control how the flash fires, as well as the system used to measure the exposure. The most common exposure modes are these:

- *TTL (through the lens) metering.* With this type of exposure, the camera measures the flash illumination that reaches the sensor and adjusts the exposure to suit. If you're photographing a subject that reflects or absorbs a lot of light, the exposure setting might not be accurate.

- *Pre-flash metering.* The camera fires a pre-flash and uses that information only to calculate exposure. This is the best mode to use when your exposure is "non-standard" in some way, as when you put a diffuser on the flash, a darkening filter on your lens, or use an external flash unit.

- *Integrated metering.* The camera triggers a pre-flash just before the exposure, measures the light that reflects back, and then integrates that information with distance data supplied by your camera's focus mechanism. The camera knows roughly how far away the subject is and how much light it reflects, and can calculate a more accurate exposure from that.

- *Manual control.* In this mode, the flash fires at whatever power setting you specify for the flash (full power, half power, and so forth) and you calculate the exposure yourself, using a flash meter or various formulas using guide numbers (values that can be used to calculate exposure by dividing them by the distance to the subject).

Electronic flash units have firing modes in addition to exposure modes. The most common modes you'll encounter are these (not all are available with every digital camera):

- *Always flash*. Any time you flip up the electronic flash on your camera, or connect an external flash, the flash will fire as the exposure is made.

- *Autoflash*. The flash fires only when there isn't enough light for an exposure by available light.

- *Fill flash*. The flash fires in low light levels to provide the main source of illumination, and in brighter conditions, such as full sunlight or backlighting, to fill in dark shadows.

- *Red-eye flash*. A pre-flash fires before the main flash, contracting the pupils of your human or animal subjects, and reducing the chance of red-eye effects.

- *Rear-sync*. Controls whether the flash fires at the beginning or end of an exposure.

- *Wireless/remote sync*. In this mode, the camera triggers an external flash unit using a wireless sync unit. As with all such remote controls, a selection of perhaps four or more channels are available so you can choose one that's not in use by another nearby photographer who also happens to be using wireless control. Unless you're covering a major event, you probably won't experience many conflicts when using wireless control. Some remote control/slave flash setups trigger by optical means: the camera's flash is detected and sets off the remote flash. You might be able to set the camera flash to low power so the main illumination comes from the remote.

Tripod/Monopod

A tripod, or its single-legged counterpart the monopod, supports your camera during exposures, providing a steadying influence that is most apparent when shooting with long lenses or slow shutter speeds. By steadying the camera, a tripod/monopod reduces the camera shake that can contribute to blurry photos. I rarely use them for sports any more, but these supports are an important accessory.

I'd never use a tripod at all at any event at which I needed to move my shooting position frequently. Tripods take up too much space and are clumsy to move about. To use one along the sidelines of any field game would be insane, probably prohibited, and sure to incur the derision of your would-be colleagues. A tripod is most useful when the camera must remain *absolutely steady*, such as for an exposure of more than 1/15th second. A monopod doesn't provide quite as much support, but is sufficient for action photography. I saw plenty of monopods at the last football game I covered, and more than a few chestpods, which brace against your chest to steady the camera.

A monopod sharply reduces camera shake, which can be obvious even at shutter speeds as fast as 1/125th second (or even faster). A longer lens might be physically large enough to cause some camera shake of its own, and even a modestly sized tele on a digital camera magnifies any camera shake enough to provide more blurring than the movement of your subjects.

Tripods are most useful for sports like baseball, where the action happens in some predictable places, and you're not forced to run around to chase it down.

TIP FROM THE PROS: HOW STEADY ARE YOU?

If you think your hands are steady enough at faster shutter speeds, you might want to conduct a simple test. You'll probably be surprised to discover that camera shake might be noticeable at fairly brief shutter speeds. Even veteran photographers who pride themselves at being able to squeeze off sharp photos at 1/30th or 1/15th second are surprised at the results of this test.

Although there are several ways to conduct the test, my favorite is to use a large piece of aluminum foil, mounted vertically at eye-level and backlit. Poke some tiny holes in the aluminum foil so that little pin pricks of light are visible from the back illumination.

Then, position yourself 10 to 20 feet from the foil, rack your zoom lens out to its maximum magnification, and fire off some shots at various shutter speeds. You might have to use your camera's manual exposure or shutter preferred modes to select the speeds. For best results, focus carefully on the foil. Then dump all the images from your camera to your computer and view them in your image editor. If your hand is steady, each pin prick will appear to be round and sharp in the image. As you reduce the shutter speed, you'll probably notice that the pin circles become elongated in the vertical, horizontal, or diagonal directions, depending on the bias of your shakiness. At worst, you might notice little wavering trails of light that show you're not merely shaking a bit, but positively quivering, as you can see in Figure 5.13.

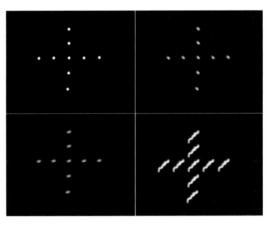

Figure 5.13 *Backlit test pattern photographed at 1/1,000th second (upper left); 1/30th second (upper right); 1/4 second (lower left); and 1 second (lower right).*

After you've reviewed the results, either practice hand-holding your camera more steadily, switch to a higher shutter speed, or get yourself a tripod/monopod camera support.

Your Digital Film

I covered most of what you need to know about digital film in Chapter 2, but the topic deserves a revisit, because action photography poses some special demands. There are two key things about this kind of picture taking that affects your choice of memory card:

- You'll probably be using your digital camera's sequence, or "motor drive" capabilities more heavily when shooting action pictures. Even a short sequence can eat up six or eight exposures. At that rate, you can run through your average digital film card in a few minutes. You'll need lots of film cards.

■ Even if you're firing off single frames, it's common to take one picture after another. As I mentioned before, the number of sequential photos you can take is limited both by the amount of internal RAM your digital camera has and how quickly it can be offloaded to your film card. In practice, the transfer speed of a digital memory card rarely makes much difference, but action photography is one of those exceptions. You don't want to wait for endless seconds as your previous pictures are transferred, particularly when new action is unfolding in front of you. If you do a great deal of action photography, you'll want to find and purchase memory cards with the fastest transfer speeds. Speeds can range from 1MB to 20MB per second (depending on how the manufacturer measures transfer speed) or even much higher.

When I photographed a professional baseball game last summer, I took along both a Kodak 14-megapixel pro camera and a more consumer-oriented 5MP Minolta model. The Kodak camera had a 1GB Hitachi/IBM mini hard disk, and the Minolta was outfitted with an array of CompactFlash cards in sizes from 64 to 256MB. I barely made it through the game! If you can't afford to buy more memory cards than you possibly can use, here are some tips for stretching your available removable storage as far as it will go.

■ Choose compact file formats. I routinely use either my digital camera's RAW format or the high-resolution TIFF format for everyday photography, because storage space isn't an issue and maximum sharpness is. As you learned in Chapter 4, "Dealing with Digital Camera File Formats," modest JPEG compression can squeeze down photos to a fraction of their TIFF equivalents without really costing your too much in sharpness. Use JPEG when you can, and select a compression/quality ratio that's compatible with your image quality expectations.

■ Reduce your resolution. Do you really need to shoot at 4500 × 3000 pixels? Switch to 1280 × 960 pixels, and you can store 10 times as many images in the same storage space. Perhaps the solution is as simple as moving closer so the full 1280 × 960 or 1600 × 1200 pixel image can be used instead of a cropped version of a higher resolution version. Some digital cameras automatically switch to a lower-resolution mode anyway when you're using high-speed sequence modes.

■ Use sequence mode only when you really feel you need to, and reduce the number of in-between photos that you didn't really want.

■ Review your shots after taking them (you'll want to do that to correct your mistakes on future shots, anyway) and press the Quick Erase button to remove the real dogs. Even if you're an above-average shooter, you might discover that half your original photos are clunkers that don't deserve to be saved, anyway. Deleting them now saves space on your film card for better photos later.

■ Investigate carrying along one of those portable hard drives that can transfer your pictures from the film card, freeing the space on the card. What else do you have to do during halftime?

Taking a Position

One of the keys to taking great action photos is getting a favorable vantage point. Some locations just lend themselves to better viewpoints and improved photographic opportunities. Gain access to the pit at an auto race, and you'll not only get incredible photos of cars on the track, but will be able to capture the excitement of the crew servicing a dusty, steaming hot vehicle that pauses just long enough for a picture or two before peeling back out to the competition. (This assumes you know how to stay out of the way of the professionals!)

Of course, at professional sports events you probably won't have much choice about where you position yourself unless you have press credentials. College games are big business, too, so you might run into restrictions there, as well. (An amateur photographer doesn't have a prayer of getting down on the field at a Big 10 football game.) However, once you lower your expectations a notch, you'll be amazed at how easy it is to gain a prime location (again, remembering to stay out of the way of the press photographers who are covering the event professionally). I've taken pictures at women's professional fast-pitch softball games, grabbed next-to-dugout seats at AA-class minor league baseball contests, shot lower-division college football, basketball, and soccer, and the whole range of high school sports with nary a problem.

TIP FROM THE PROS: GETTING CREDENTIALS

Forget about the Super Bowl or the World Series. But if you want a prime location at a second- or third-tier event, you might find a temporary press pass is easier to obtain than you thought. I've had good luck calling ahead to the organization's PR representative or talking to a college's sports information director or, at smaller schools, the athletic director's secretary. It helps that I worked in PR, and was a college sports information director, but you might be successful even without those slim credentials. Perhaps your local newspaper doesn't cover a particular sport and would be willing to take you on as an unpaid stringer.

Or, show up early, find the right person, and ask for permission to take pictures up-close and intimate. You just might get a temporary press pass. I shamefully admit to gaining admittance to several contests where I had no rightful place by the simple expedient of stringing three battered Nikon cameras around my neck and looking like I belonged.

Here are some sports-specific tips for gaining position:

Are You Ready for Some Football?

Football games are a lot of fun to shoot, but they're typically full of fans who are eager to beat you up if you obscure their view. In smaller stadiums, the impatient folks are likely to be close enough to do some damage, too. Your best bet is to keep moving, which is a good idea anyway because there is no telling when a 200-pound receiver might head for the sidelines after a catch in order to stop the clock.

My recommendation for football is to get down on the sidelines and take your pictures 10 to 20 yards from the line of scrimmage. It doesn't really matter if you're in front of the line of scrimmage or behind it. You can get great pictures of a quarterback dropping back for a pass, as in Figure 5.14, handing off, or taking a tumble into the turf when he's sacked. Or, downfield, you can grab some shots of a finger-tip reception, or, if you're lucky, a back breaking through for a long run. Move to the end zones when appropriate, to catch the fullback bulling over from the one-yard line, or the kicker lining up for a field goal.

Figure 5.14 *The sidelines are the best place to capture exciting football action.*

Soccer to Me

Soccer is a lot like football, at least photographically. The fans are less belligerent too, except in Europe or at elementary/middle schools. As with football, you can follow the action up and down the sidelines, or position yourself behind the goal. At that end of the field, you'll be concentrating on one team's fullbacks and goalie and the other team's wings and strikers. If the game is a bit one-sided, you might even find yourself spending most of your time in a single position, then changing to the other end of the field after halftime. Well-played soccer can range all over the field, but a really dominant team might spend most of the game on offense. The most exciting action typically takes place around the goal, as you can see in Figure 5.15.

Figure 5.15 *A lot of soccer action is clustered around the goal.*

Take Me Out to the Ball Game

It's fun to watch a baseball game from behind home plate, but that's not always the best place to shoot, unless the pitcher is a personal friend of yours. The netting typically used as a backstop can diffuse your photos a bit, (although with a long lens, the barrier will largely be out of focus). A better position is to find a niche at the ends of the dugouts. I prefer the first-base side, because much of the action takes place at home plate, at first base, or in right field. From that position you can swivel quickly to grab a shot of a runner sliding home, show the pitcher winding up (or eyeing the runner on first), or snap a picture of a steal at second base.

On the first-base side, right-handed pitchers will have their backs to you as they wind up, but will be more visible during/after their delivery. With southpaws, the situation is reversed. Figure 5.16 shows a pitcher trying to pick off a runner at first base.

Figure 5.16 *Keep your eye on the pitcher and grab a shot of him trying to pick off the runner on first base.*

You can also get interesting pictures from the upper stands at a professional baseball game, if you're willing to settle for human interest shots of the fans, or have a really, really long telephoto lens.

Nothing but Net

You won't spend a lot of time racing up and down the sidelines at a basketball game. While many interesting things can happen in the backcourt (particularly on defense), most of the attention focuses on a single spot, the basket. So, the best locations are clustered behind or next to the backboard, or from the sides near the baselines, as shown in Figure 5.17.

The biggest challenge of shooting basketball is avoiding clichéd photographs of guys and gals with their arms up in the air. Remain at eye-level. Most high angles make your photographs resemble screen shots from an NBA-themed video game, whereas low angles can give you photographs that are 90 percent legs, given the height of most basketball players. If you're stuck in the stands, look for a seat in the second or third row. However, if you're blessed with a long lens, feel free to move up high and shoot down on the rim of the hoop. All the players will be looking

Figure 5.17 *Either the basket or sidelines are the best locations to capture basketball action.*

up at the hoop and stretching their arms toward you. You can get great pictures from a high angle if you've got a lens that can capture the action.

Goony Golf

Golf is probably the most unsports-like of sports this side of bowling. In what other sport are the athletes almost totally surrounded by a gallery of spectators, yet insist on absolute silence from the thronging multitudes as they work? My earliest golf photography involved following Arnold Palmer around the course at Firestone Country Club in Akron, trying to capture human interest shots while not riling Arnie's Army. My best picture was of a woman struck by one of Palmer's shots. She remained in place, frozen, afraid to move and ruin his lie.

For certain, you should disable your digital camera's phony shutter click sound, and hunt down and destroy any autofocus or autoexposure beeps. Don't even think about shooting a picture during a golfer's swing. My Minolta camera plays a cheerful musical chime when switched on that has earned me sharp glances from time to time.

Cameras with a swiveling lens (like my Nikon CoolPix) are great for stealth photography at golf matches, because you can hold the camera at waist level (or lower, as in Figure 5.18) and innocently glance down at the LCD display to frame your photograph. In less sensitive situations, you can hold the camera over your head and gain a whole new viewpoint.

> **TIP**
>
> If you can't disable your camera's "boot" sounds, configure the camera so the automatic shutoff doesn't occur for 30 minutes or so, minimizing the number of times you'll need to turn it on. At the same time, turn the LCD preview off to increase your battery life. Your power will be taxed by leaving the camera on for 30 minutes a time, and the LCD is the big juice glutton.

Figure 5.18 *Don't take pictures during a golfer's swing, but a cordial duffer might let you take a picture as he or she lines up for a putt.*

Other Sports

Apply a little common sense and you can find the right position for every sport imaginable, from lacrosse to curling. Here are some quick tips for a few of the more popular activities (which do not include lacrosse or curling):

- *Hockey.* It's a good idea to photograph hockey from a high vantage point, because an elevated view lets you shoot over the glass, and the action contrasts well with the ice.

- *Skating.* Although figure skating also takes place on the ice, you'll find low angles and up-close perspectives work best. For speed skating, try to position yourself to catch the skaters going around a turn when they're at their most dramatic.

- *Wrestling.* Unless you have a ring-side seat and are prepared to dodge flying chairs, wrestling is often best photographed from a high, hockey-like perspective.

- *Gymnastics.* Look for shots of the athlete approaching a jump or particularly difficult maneuver, or perhaps attempting a challenging move on the parallel bars or rings.

- *Swimming.* With the athletes immersed in water most of the time, the best position is either from one side or another so you can shoot several swimmers across the lanes, or head on as they approach the finish or a turn.

- *Track and field.* These events are all different, and all exciting. You might want to be under the bar at the pole vault; right in the path of a long jumper (but a few yards behind the sand pit and out of the jumper's field of vision); next to the starting blocks of the 100-meter dash; and not even in the same ZIP code as a discus hurler. Exactly how close you can be and where you will be allowed to stand will depend on the nature of the event and the level of the competition. (For example, at middle-school events, you might be able to get quite close to the action as long as you assure the officials that you're not a parent.)

- *Motor sports.* If you're up to the task, try photographing automobile racing, in which the vehicles can move at 100 miles per hour—when they're slowing down to pull into the pit! Or, try motorcycle racing, in which adults recklessly propel their bodies around in close proximity to each other and hot metal at frightening speeds amid clouds of dust and dirt. Your only hope is to capture these machines as they're coming straight at you, or as they round a turn.

- *Horseracing.* If you've tried motor sports, photographing horse racing will seem calm. The same advice goes, however: photograph the animals head on or making a turn for the most exciting photos.

- *Skiing.* For a long course, the finish line might be your only option. Stay near a warm place so you can keep your camera and sensor at a decent temperature. Or, tuck the camera inside your coat. Watch out for condensation when a warm camera meets cold air suddenly.

Here's the Drill

Now you know the basics. It's time to set up some real-life scenarios and see just how you'd tackle them with a digital camera. This section will take you through a few typical action photography assignments.

Preparation and Setup

Before you go out on the shoot, it's a good idea to make sure you're well-prepared. You'll never get good pictures of any type if you don't do the right prep and setup beforehand, but action photography is particularly unforgiving. If you goof, forget an important accessory, or neglect to take care of a crucial detail, you probably won't be able to go home and get what you need, nor find a substitute. So, following a checklist like this is a good idea:

- *Three of everything.* If you're working professionally, an excuse like "My camera/flash/batteries didn't work" won't fly. Amateurs working a once-in-a-lifetime (or once-in-a-season) event won't want their style cramped by an equipment failure, either. That's why I try to own at least three or four of every important piece of equipment, and take at least two of them along on every shooting expedition. In my case, that includes having a backup digital camera, but that might not be practical for you. However, you'll want to include extra sets of batteries, more digital film than you think you'll need, and maybe a backup flash unit. If you have problems with one item, just switch to your alternate and you're back in business.

- *Charge your batteries.* Nickel-metal hydride batteries can be recharged at any time without causing any detrimental side effects, so you'll want to give all your batteries a fresh jolt just before embarking on any important photo journey. Your camera and electronic flash batteries should be freshly charged. Have a spare battery if you think you might be taking more pictures than your original set will handle. Remember that flash pictures take more juice.

- *Erase or format your film.* It's not enough to have memory cards. Your cards must have room on them for new pictures. Take some time to copy any pictures you want to keep to your computer, erase your card, or, perhaps reformat it so it's fresh and ready to use.

- *Learn your controls.* If you don't use a particular feature regularly, now is the time to check yourself out and make sure you remember how to use it. How do you set your camera for continuous sequences? Can you switch to shutter priority exposure mode quickly? I created a little cheat sheet I tuck in my camera bag so I can look up the most obscure feature in a few seconds, on location.

- *Make your basic camera settings now.* Don't wait until you're ready to begin taking pictures to set your camera's ISO rating, exposure mode, or focusing method. You can make changes later, but it's best to start off with all your basic settings locked in and ready to go.

■ *Clean and protect your equipment.* Few good pictures (other than soft-focus portraits) can be taken with a dirty lens. Carefully clean your lens. If it's going to rain or snow, put a skylight filter on the lens. You can wipe the filter off quickly, and if it should become scratched, throw it away and install a new one. If necessary, make a "raincoat" for your camera out of a resealable sandwich bag with a hole cut in it for the lens to stick out.

What ISO Speed Should I Use?

The lowest ISO speed your camera offers usually provides the best overall quality, but might not have enough sensitivity to allow a useful range of shutter speeds and f-stops. Of course, as you increase the ISO rating of your digital camera, your pictures will begin to display noise, as you can see in Figure 5.19. You should use the lowest ISO setting that will let you shoot at the shutter speeds you want to use.

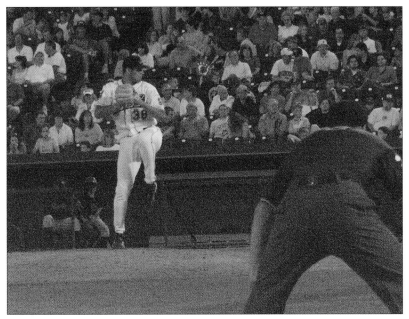

Figure 5.19 *Higher ISO ratings produce more noise, which shows up as multi-colored grain, in your photographs.*

Although digital ISO ratings don't exactly correspond to film ISO speeds, they are close enough that you can use them to estimate what setting to use. In bright sunlight, the reciprocal of an ISO rating will usually equal the shutter speed called for at an f-stop of f16. The numbers are rounded to the nearest traditional shutter speed to make the calculation easier. So, at f16, you can use a shutter speed of 1/100th-1/125th second at ISO 100; 1/200-1/250th second with an ISO rating of 200; 1/400-1/500th second at ISO 400; and perhaps up to 1/1,000th second at ISO 800.

Use this rule of thumb to help you determine which ISO rating is appropriate. If you're shooting racing cars going 200 mph across the frame, you might want a shutter speed of 1/1,000th second. If you can live with an f-stop of f8, that means you'll need to use an ISO rating of 200. (ISO 200 translates to 1/250th second at f16, which is the exposure equivalent of 1/1,000th second at f8. This is the sort of translation photographers can do in their head without thinking.)

Of course, in bright sunlight, such as on the beach or in the snow, you can cut the ISO rating in half to get the same exposure. ISO 200 will get you 1/1,000th second at f11 on a ski slope, for example.

Instead, use this rule of thumb to estimate how much action-stopping power you have in a particular situation. For example, if the sun is truly bright, you might want to set your camera's shutter speed to 1/2,000th second (if it's available) either manually or through the camera's shutter priority mode, and let the autoexposure system choose the correct aperture. The faster the shutter speed you want to use, the higher the ISO rating you'll need to use.

In darker surroundings, such as indoors, or at night, the ISO rating will be correspondingly higher if you want to use a particular shutter speed. However, you can expect to use the higher end of your digital camera's sensitivity scale. Unless the non-daylight location is remarkably bright, you'll probably always be using ISO 400 or higher for action photography. Over the years, I've discovered you can usually expect enough light to shoot at 1/125th second at f2.8 with an ISO setting of 400, and 1/250th second at f2.8 with an ISO setting for 800. In modern facilities, you'll probably encounter quite a bit more light than that, but even twice as much illumination is no picnic when you can use only 1/500th second at an f-stop like f2.8 with a noisy ISO rating like 800. Many digital cameras don't even *offer* an f-stop as large as f2.8. One of my favorite digital cameras has a maximum aperture of f2.6 to f5.1, depending on the zoom setting used.

What Exposure Do I Use?

Whether you're specifying the shutter speed and letting the camera determine the exposure, or making settings completely manually, you can't always simply set the shortest possible shutter speed and then forget about it. There are some other factors to take into account:

- ■ You'll need a smaller f-stop (the larger numbers) with longer lenses/greater zoom settings, to provide adequate depth-of-field.

- ■ Digital cameras offer more depth-of-field at a given magnification, so you don't have to be afraid of what is considered a wide lens opening in the film camera world: f5.6 might be entirely usable even at a telephoto setting.

- ■ Digital camera images can get dramatically noisy at higher ISO ratings, such as ISO 800, so you might want to choose the highest rating only when you want to use the very fastest shutter speeds and the smallest possible lens opening.

■ Bright sunlight can change significantly when a cloud moves in front of the sun. You can quickly lose half your available light. Your camera's autoexposure system can compensate, of course, but you might not like the results. You can end up with a lens opening that's too wide, or your camera might refuse to take a picture at all. When that happens, choose a slower shutter speed or, as a last resort, bump your camera's ISO rating up a notch.

Planning Your Shot

If you've taken my advice on where to position yourself, you'll still need to plan your shot before you shoot. Try to anticipate the action as much as you can. What's coming next? It might be a serve, a shot on goal, some sidelines action, an impending dunk, or some other bit of action. Sports moves so rapidly that you can spend an entire event incessantly chasing the current hot action, missing it every time. Don't waste time constantly zooming in and out. Instead of constantly reframing, concentrate on a point where the action you expect is likely to take place.

Rather than trying to reframe your picture as the event unfolds around you, it's often best to point your lens at the approximate point where the action you hope for will take place. Plan for a particular kind of shot and then wait for it. If you're at a football game and it's third down with 22 yards to go, choose a receiver near you and follow him on his route. If you're lucky, a pass will come his way and you'll get a great shot. With only a few yards to go, plan for a running play, like the one shown in Figure 5.20.

Figure 5.20 *Watch for a hole your runner can run through.*

At a tennis match, look for a smash to a far corner when a hapless opponent has been lured too close to the net. If your hockey team is on the attack, watch for a cross-rink pass to an open man who has a shot at the goal. Prefocus on the spot, watch your participants both inside and outside the frame (I tend to peer through the viewfinder with one eye, and keep the other eye open to take in the big picture), and be ready to snap.

Freezing the Action

Freezing a fast-moving subject in its tracks seems to be the primary goal of action photographers. However, a moment frozen in time might not be the best or most interesting way to capture your subject. Frequently, a little motion blur adds to the feeling of motion.

(As in Figure 5.21, in which the blurriness of the softball player's arm and back leg help convey the action.)

In fact, including a little blur in your pictures is more difficult and challenging than simply stopping your subjects in their tracks. Some of the best action pictures combine blur with sharpness to create a powerful effect. Now that you understand that, I'll explain a little about how to freeze and semi-freeze the action.

Figure 5.21 *The blur of the pitcher's arm and leg add to the feeling of motion.*

The first thing to understand is that motion looks different to the camera, depending on the direction, speed, and distance of the subject. You can use this information as you plan your image. Here are the basics:

- Motion that's parallel to the plane of the sensor (that is, across the width or height of an image in a horizontal, vertical, or diagonal direction) appears to move the fastest and will cause the most blur. So, an automobile passing in front of your camera at 200 mph is likely to be blurry, no matter how short your shutter speed.

- Motion coming toward the camera appears to move much slower, and will cause a much lesser amount of blur. That same race car headed directly toward you can be successfully photographed at a much longer shutter speed. Figure 5.22 shows several soccer players in action; the girl who is headed toward the camera is relatively sharp, while the girls who are moving across the frame are partially blurred.

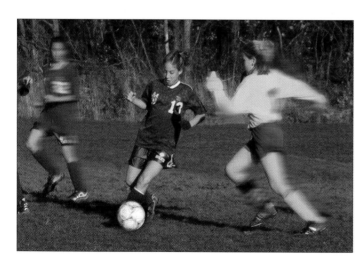

Figure 5.22 *Motion headed toward the camera is easier to freeze than motion across the width of the frame.*

- Motion coming toward the camera on a slant (perhaps a runner dashing from the upper-left background of your frame to the lower-right foreground) will display blur somewhere between the two extremes.

- Subjects that are closer to the camera blur more easily than subjects that are farther away, even though they're moving at the same speed. That's because the motion across the camera frame appears to be more rapid with a subject that is closer to the camera because the amount of movement in a given time period is greater.

- Blur is relative to the camera's motion, so if you pan the camera to follow a fast moving object, the amount of blur of the object you're following will be less than if the camera remained stationary and the object darted across the frame.

- There are two different kinds of blur to contend with: subject motion and camera motion. The former happens because your subject is moving faster than the selected shutter speed can stop. The latter occurs when the camera isn't held steady during an exposure. With *panning*, described next, you might get both kinds of blur in one photo.

Stopping Action with Panning

The term "panning" derives from the motion picture industry, from a camera's swiveling motion used to follow action as it progresses from one side of the frame to the other. (You can also pan vertically, of course, as when the camera follows the take-off of a rocket into space; it's just that horizontal panning is more common.)

So, a marathon runner is racing across your field of view. If she's close enough and moving fast enough, even your highest shutter speed might not be able to stop the action. So, instead, you move the camera in the same direction that the runner is moving. Her apparent speed is much slower, relative to the camera, so a given shutter speed will be able to freeze the action more readily. Blur from subject motion is reduced. Yet, the background will display more blur, due to camera motion. Your photograph might have a tack sharp runner surrounded by a blurry background. That's probably a more exciting and dramatic photograph.

Panning can be done with a handheld camera, or with a camera mounted on a tripod that has a swiveling panorama (pan) head. The more you practice panning, the better you'll get at following the action. You might find that if your panning speed closely matches the subject's actual speed, a shutter speed as slow as 1/60th to 1/125th second can produce surprisingly sharp images. Use of a lower shutter speed causes the background to appear more blurry, too.

To pan effectively, you should try to move smoothly in the direction of the subject's movement. If your movement is jerky, or you don't pan in a motion that's parallel to the subject's motion, you'll get more blurriness than you anticipate or want. Take a step back, if you can. The farther the subject is from the camera, the longer you'll have to make your pan movement, improving potential sharpness.

Panning is a very cool effect because of the sharpness of the subject, the blurriness of the background, and some interesting side effects that can result. For example, parts of the subject not moving in the direction of the overall pan will be blurry, so your marathon runner's body might be sharp, but her pumping arms and legs will blur in an interesting way.

Panning is interesting even when you don't use it to totally stop the action. Figure 5.23 shows a soccer action shot frozen using a fast shutter speed. Figure 5.24 was taken at the same game, but using a slower shutter speed and panning to create a more interesting semi-blurred look. The second photo actually is a bit more dynamic.

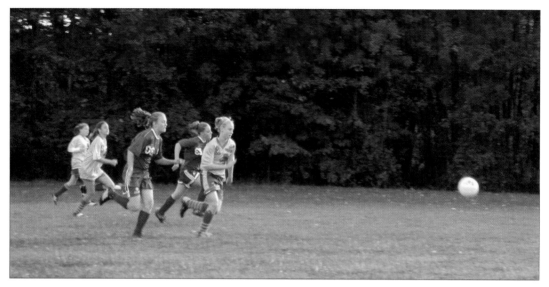

Figure 5.23 *Action stopped by a fast shutter speed looks frozen.*

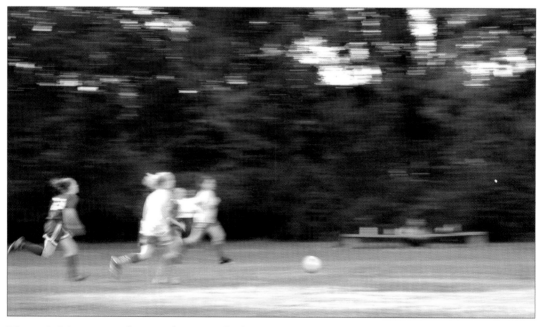

Figure 5.24 *Panning doesn't eliminate the blur, but it creates a more dynamic-looking photo.*

Freezing Action Head On

Another way to stop action is to photograph the subject as it heads toward or away from you. A runner who is dashing toward the camera can be effectively frozen at 1/250th or 1/125th second, but would appear hopelessly blurred when crossing the frame (if you're not panning). Head-on shots can be interesting, too, so you might want to use this angle even if you're not trying to boost your effective shutter speed. Figure 5.25 was exposed under the stadium lights at a paltry 1/250th second, but because everyone in the shot is running toward the camera, the action is effectively frozen.

Figure 5.25 *Everybody is headed toward the camera, so even 1/250th of a second shutter speed can stop the action.*

Freezing Action with Your Shutter

A third way to stop motion is to use the tiny time slice your shutter can nip off. A fast shutter speed can stop action effectively, no matter what the direction of the motion. The trick is to select the shutter speed you really need. A speed is that is too high can rob you of a little sharpness because you've had to open the lens aperture a bit to compensate, or use a higher ISO rating that introduces noise. There are no real rules of thumb for selecting the "minimum" fastest shutter speed. As you've seen, action-stopping depends on how fast the subject is moving, its distance from the camera, its direction, and whether you're panning or not.

Many cameras include shutter speeds that, in practice, you really can't use. The highest practical speed tops out at around 1/2,000th second. With a fast lens and a higher ISO rating, you might be able to work with 1/4,000th second under bright illumination. Yet, there are digital cameras available that offer shutter speeds as brief as 1/16,000th of a second. So, the

bottom line is usually that, to freeze action with your shutter speed alone, you'll probably be using a speed from 1/500th second to 1/2,000th second, depending on the illumination and what your camera offers.

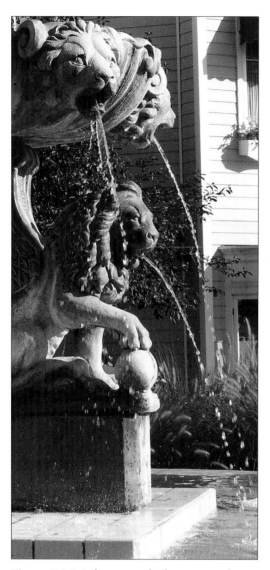

Figure 5.26 *A fast enough shutter speed can freeze things that seem a blur to our eyes, such as droplets of falling water, here captured with a 1/1000th second shutter speed.*

A shutter speed that's fast enough can freeze even the fastest-moving objects, such as the droplets of water shown in Figure 5.26 (which is also a reminder that action photographs don't have to involve sports, or even humans).

Freezing Action with Electronic Flash

Electronic flash units, originally called "strobes" or "speedlights," are more than a great accessory for artificial illumination. The duration of an electronic flash is extremely brief, and if the flash provides the bulk of the illumination for a photograph, some great action stopping results. One of the earliest applications of electronic flash was by Dr. Harold Edgerton at MIT, who perfected the use of stroboscopic lights in both ultra-high-speed motion and still (stop-motion) photography capable of revealing bullets in flight, light bulbs shattering, and other phenomena.

Some flash units have a duration of 1/50,000th second or less, which is very brief, indeed. One way of controlling an automated flash unit is to vary the duration of the flash by using only part of the stored energy that's accumulated in the unit's capacitors.

If the subject is relatively far away, the entire charge is fed to the flash tube, producing the longest and most intense amount of illumination. If the subject is relatively close, only part of the charge is required for the photograph, and only that much is supplied to the flash tube, producing an even briefer flash. Yet, even the longest flash exposure is likely to be

shorter than your camera's shutter speed, so electronic flash is an excellent tool for stopping action.

The chief problem with electronic flash is that, like all illumination, it obeys that pesky inverse-square law. Light diminishes relative to the inverse of the square of the distance. So, if you're photographing a subject that's 12 feet away, you'll need *four* times as much light when the subject is twice as far away at 24 feet, not twice as much. Worse, if an athlete in your photograph is 12 feet away when you snap a picture, anything in the background 24 feet away will receive only one quarter as much light, giving you a dark background.

That generally means that a digital camera's built-in electronic flash is probably not powerful enough to illuminate anything two-dozen feet from the camera. You might be able to use your camera's flash at a basketball game, but not at a football game where the distances are much greater. A more powerful external flash unit, like the ones discussed earlier in this chapter, might be called for.

Figure 5.27 is a flash picture all the way (see the reflection off the runner's eyeballs?), but the electronic flash has frozen the action crisply.

Figure 5.27 *Electronic flash stops fast-moving subjects in their tracks, even if the linebackers can't.*

Freezing Peak Action

The final method for freezing fast motion is simple: wait for the motion to stop. Some kinds of action include a peak moment when motion stops for an instant before resuming. That's your cue to snap a picture. Even a relatively slow shutter speed can stop action during one of these peak moments or pauses.

The end of a batter's swing, a quarterback cocking his arm to throw a pass, a tennis player pausing before bringing a racket down in a smash. These are all peak moments you can freeze easily. Other peaks are trickier to catch, such as the moment when a basketball player reaches the apex of a leap before unleashing a jump shot. If you time your photograph for that split second before the shooter starts to come down, you can freeze the action easily.

Non-sports action sequences also have peak moments. An amusement park ride, like the one shown in Figure 5.28, might pause for as long as a second between hair-raising swings. Your child leaping about on a trampoline reaches the top of a jump (just like that basketball player) and can be captured in mid-flight. A bird in flight, like the stork in Figure 5.29, flaps its wings furiously to gain altitude, then stretches out to glide leisurely for minutes at a time. If you study the motion of your action subjects, you'll often be able to predict when these peak moments will occur. Remember to factor in your camera's shutter lag problems!

Figure 5.29 *A stork's wings are motionless as it glides silently through the air, so freezing this moment is easy.*

Figure 5.28 *At the top of its arc, this amusement park ride pauses, and can be captured with ease.*

Shooting Sequences

Whether you call it sequence shooting, continuous advance, or "motor drive" mode, the ability to take multiple shots of fast-moving action is a valuable capability found in an increasing number of digital cameras. On the plus side, ripping off five or ten shots as the action unfolds can increase your chances of catching the peak moment(s) in one or more of them. Unfortunately, you can also end up with the best shot of all occurring *between* frames. Sequence shooting is a valuable tool, but it's not a panacea.

Back when I was shooting sports professionally, a motor drive for my Nikon was the first accessory I purchased after a 400mm lens. Digital "motor drives" are way cooler than the

mechanical variety. The biggest problem with motor transport on a conventional camera was that, at, say, six frames per second, you could eat up an entire 36 exposure roll of film with fewer than half a dozen action sequences. Remember, film can't be erased and re-used if you point the camera and shoot a busted play. For the big-time pros traveling around the world to cover a major sports event, film is likely to be the least expensive part of the cost equation, so special camera backs that could hold 100 feet of film and expose 750 images in one shoot became common.

Digital cameras bring sequence photography to the rest of us. There's no need to buy an expensive camera, special film back, or burn up hundreds of feet of film. Action sequences can be captured digitally, and if a particular sequence doesn't bear photographic fruit, it can be erased and the memory card re-used.

Sequence photography is no substitute for good timing, however. Once you've solved the shutter lag problem, so your camera cooperates by exposing a photograph reasonably soon after you press the shutter button, you'll find your best photographs come from your instincts. Clicking off a picture at exactly the right moment will almost always yield better results than blindly capturing a series of frames at random. Use your camera's sequence mode as a supplement to your customary techniques to grab a few pictures you might not have gotten otherwise, or to create sequences that are interesting in themselves, as shown in Figure 5.30.

You can see from the changing background that this series wasn't a simple motor-drive sequence of images taken a split second apart. Instead, I used the digital camera's multi-shot capabilities to take a series of photos as the athlete rounded the bases. Each of these photos

Figure 5.30 *The best sequence shots are those in which the series itself tells a story.*

were probably taken a few seconds apart, much more closely spaced than I'd have been able to shoot if I'd elected to whack the shutter button individually for each picture. Instead, I elected to let the camera take full-frame shots at a two-per-second rate while I panned and zoomed to follow the runner's progress. Each image tells something about the play, and you can almost see the excitement build on the player's face as he rounds third and heads for home.

Selecting Sequence Modes

Your digital camera probably has five or six "drive" modes, not all of which are useful for action photography. Some are better suited for special applications like time-lapse photography or making mini-movies, but here's a list of the most common modes:

- *Single frame advance*. In this mode, you can take one picture each time the shutter release is pressed. Your camera probably has enough internal memory that you can take another picture immediately, even if the camera has not offloaded the picture you've just taken to the film card. If not, you'll have to wait until the blinking light (or other indicator) stops to shoot the next picture.

- *Continuous advance*. The camera continues to take photographs, one after another, for as long as you hold down the shutter button. Depending on your camera, the effective frame rate might be anywhere from one frame per second or slower to two or more frames per second. The number of frames you can take might be limited by the amount of internal memory your camera has, and certainly will be limited by the number of available exposures on your memory card. When the internal memory is full, you'll have to stop taking continuous shots and wait until some room opens up. This is the mode I used for Figure 5.30.

- *High-speed continuous advance*. The camera takes pictures continuously as you hold down the shutter release, at a frame rate from three to five frames per second or more. As with ordinary continuous advance, once your camera's internal memory is full, your sequence is over until some of the images are offloaded to your memory card.

- *Ultra high-speed continuous advance*. This mode usually supplies your camera's fastest frame rate, from five to seven or more frames per second. Usually, the camera must use a reduced image size in this mode that's smaller than the maximum size your camera can produce. For example, you might have to shoot at 1600×1200 or 1280×960 pixel resolution in this extra-fast mode.

- *Multi-shot*. A few cameras can produce a quick blast of 16 tiny pictures on a single frame. Such images might be okay for analyzing your golf stroke, but can be too small for other applications.

- *Mini-movie*. Most digital cameras have the ability to shoot short video clips (typically 20-30 seconds) at 320×200 to 640×480 resolution (or higher). You can use the movies as is, or save and edit individual frames.

- *Time lapse/interval*. Although this is a sequence mode, it operates over a period that can extend for many, many seconds, and is best used for taking pictures of slow-moving events, such as the opening of a flower.

■ *Bracketing*. In this mode, your camera takes several pictures in sequence, but uses different settings for each picture, improving your chances of getting one shot that has a better combination of settings. The most common bracketing procedure is to take several pictures at different exposures, with some underexposed and some overexposed (based on the meter reading). Many digital cameras can bracket other features, such as color correction, color saturation, contrast, white balance, or special filters.

Of all the sequence modes, I prefer the basic continuous mode, and frequently trigger the sequence just before I expect some action to take place, as shown in Figure 5.31. This technique is still a hit-or-miss procedure, because a lot can happen between frames. It's very likely that you'll still miss the decisive moment, but I had that happen to me when I was using

Figure 5.31 *A sequence photo like this one has a lot more excitement than any single frame of the set taken alone.*

a six-frames-per-second motor drive, too. As with all sports photography, the more pictures you take, the more you increase your odds of getting some great ones.

Shooting Sequences

Each particular sequence mode has its own advantages and disadvantages. The more frames you capture per second, the quicker your digital film will fill up with images, so high frame rates must be balanced with how much storage space you have available. In addition, the resolution and compression ratio of the image can affect how quickly you can shoot and how many images will be captured in a sequence.

For example, with a typical 5MP camera like my Minolta, the number of photographs that can be taken in a single burst looks like the results in Table 5.1.

Table 5.1 Typical Number of Images at Various Compression Ratios

Compression Ratio Size (in Pixels)	2560 × 1920	1600 × 1200	1280 × 960	640 × 480
RAW	5	0	0	0
Super Fine	3	3	3	3
Extra Fine	7	12	15	33
Fine	10	19	27	61
Standard	17	29	42	84

As you can see, bursts might be limited to as few as three to five in the uncompressed TIFF (Super Fine) and RAW modes, while you can get as many as 84 images if you use 640 × 480 resolution and high compression (Standard). I usually use full resolution and Extra Fine compression, because seven pictures in one burst is usually plenty for my sequences.

Your camera's ultra high-speed mode provides more frames per second, but might provide an automatic reduction in resolution. For example, some cameras switch to 1600 × 1200 or 1280 × 960 resolution for extra high frame rates, which can range from seven to 10 fps or more. You probably won't be able to use RAW or uncompressed TIFF formats in this mode.

Another limitation of sequence shooting is that you won't be able to use your electronic flash in most cases. A flash must be specially designed for rapid-fire to work in this mode. Even then, you'll be limited to close-ups, because such flash operate on the principle that because close-up photos don't require the full charge of the flash, several briefer exposures are possible at faster intervals.

Once you've set up your camera, shooting sequences is relatively painless. Set focus and exposure as described earlier in this chapter. Frame your subject, and when the action that you want to capture begins, press the shutter release and hold it down. Usually you'll have to follow the subject by panning the camera, which can be tricky if your viewfinder doesn't provide a steady image to watch during the sequence. After you've finished shooting, review your sequence with an eye toward improving your shots on the next take.

Testing Your Camera's Sequence Capabilities

You might want to measure exactly how many frames your digital camera can shoot using its continuous advance feature. That XNote Stopwatch utility I mentioned earlier in this chapter is a perfect tool for measuring frame rates, both for individual, continuous shots, and in burst mode. You can test your camera using various file formats and compression ratios to see which is most suitable for your action photography. Follow the steps for the two methodologies that follow, and record your results.

To Measure Maximum Individual Shot Rate

To measure how quickly you can take individual photos, follow these steps:

1. Set your digital camera for minimal shutter lag using the recommendations from earlier in this chapter.
2. Load the stopwatch software, and start running it. The actual time setting when you begin shooting doesn't matter, so let it operate.
3. Focus the camera on the stopwatch on your computer screen.
4. Press the shutter release to take a picture of the stopwatch.
5. Keep pressing the shutter button to take multiple pictures.
6. Load all the photos into your computer and examine them in your image editor.
7. Subtract the stopwatch time shown in each shot from the one in the previous shot to determine the interval between shots.
8. Average the intervals to arrive at the number of shots you can take individually.

To Measure Continuous Sequences.

You can also accurately measure the true frame rate of your camera when set in automatic continuous picture-taking mode. Just follow these steps, and repeat at each image size your camera offers for sequence photography:

1. Set your digital camera to minimize shutter lag, as before.
2. Set the camera to shoot continuously when you hold down the shutter release.
3. Load the stopwatch software and focus your camera on the stopwatch image on the screen.
4. Start the stopwatch timer and press the shutter release at the same time.
5. Hold down the shutter release to take as many frames as possible.
6. Load the pictures you've taken into an image editor and calculate the elapsed time for the entire sequence.
7. Tabulate your results to learn the length of time you can cover with a single sequence of images, and the approximate number of frames per second. For instance, if your camera takes 14 images in 1.8 seconds before the internal memory fills, you'll know you can capture about 2 seconds worth of action at a rate of roughly 7.7 frames per second.

Project for Individual Study: Stop a Bullet

If you're at all serious about photography, you've seen and, perhaps, studied those stroboscopic pictures of bullets stopped in mid-air, lightbulbs captured in the act of breaking, or droplets of milk frozen as they erupt from a bowl. Your project for this chapter is to explore the world of high-speed motion stopping. Your digital camera and a little ingenuity may be all you need. I'll give you some tips to get started in this section.

Strobe photography takes advantage of the very brief exposure times afforded by electronic flashes. As I mentioned earlier in this chapter, the closer an automatic flash is to the subject, the shorter its exposure is likely to be. You might be amazed at the range of fast-moving objects that can be captured by a single exposure. Here are the key ingredients of your project:

- A tripod-mounted digital camera capable of long or time exposures, and which accepts an external flash unit.

- A darkened room, so that the only exposure comes from the flash itself, not any ambient illumination.

- A dark background. A piece of common black felt fabric should work fine.

- An electronic flashgun with user-settable power levels and a removable flash cord. Some flash units can be adjusted from full power down to 1/64th power or less. A flash with less power and a briefer flash duration would be preferred over a heavy-duty flash unit that's hard to scale down for close-up photos, and which has a longer flash duration.

- Optionally, a second electronic flash equipped with a slave unit so it can be triggered by the main flash, and also with low power/brief duration options.

- A subject to photograph. Some prefer hummingbirds, others like to break balloons or light bulbs, or capture coronas of liquid droplets arising from a smooth surface. Choosing an ingenious subject is part of your assignment. Use your imagination.

- If you're planning to destroy something for your photographic art, you'll need a triggering device that can set off the flash at the moment of destruction. I'll give you some hints on how to construct one.

The Basic Steps (Oversimplified to the Extreme)

Once you've assembled all the components, you'll need to plan your photograph carefully. The following is a checklist of how you might take such a high-speed photograph.

1. Set up your camera in a room that can be darkened, facing the black background. You're going to use a time exposure to make the picture, so you don't want any existing light to spoil the image.
2. Put the digital camera on a tripod, facing the dark background.

3. Place your subject between the camera and the background.

4. Arrange your electronic flash unit (or two) so they are on one or both sides of the camera, facing the subject. The second flash can also be used from the side to provide more interesting illumination. In fact, you can use one flash as a main light and one as a fill light, if you like. See Chapter 6, "People Photography," for instructions on this kind of lighting.

5. Set the electronic flash for its briefest exposure.

6. Set the camera's aperture so the image will be properly exposed by the flash. You might have to calculate the correct f-stop through a little experimentation.

7. Darken the room. You should plan the next few steps so you can handle them in the dark.

8. Open the shutter of the digital camera for the time exposure.

9. At the right moment (more on **that** in a moment!), trigger the flash.

10. After the exposure, close the shutter of your camera and turn the room lights back on. You're done!

Indeed, the whole process seems fairly easy, *except for step* 9. How in the heck is that managed? My list above is a little like providing a recipe for broiled unicorn, and listing step 1 as "find a unicorn."

The Hard Part

I didn't mean to throw you by making everything seem easy up until step 9. In practice, triggering the flash at the right moment *is* the real killer roadblock of high-speed photography. Sophisticated triggering mechanisms have been built, using sound, light, or other things to set off the flash. I'm assuming you don't have a degree in electrical engineering and want to try something similar.

For some types of phenomena, you might be able to trigger the flash manually, simply by pressing the Open Flash button on your electronic flash. If the movement is something that just happens to be very fast, but is consistent in its motion, you can trigger the flash at any time. Say you wanted to freeze the blades of an electric fan, or stop the wings of a hummingbird—it would be fairly simple to do. Just wait until the fan or hummingbird are positioned in front of your camera lens, and trigger the flash manually. Of course, convincing a hummingbird to hover just where you want it to is about as difficult as finding a unicorn, so your subject matter is likely to be something else.

More frequently, you'll want the flash to go off in synchronization with some other event. If you're inventive, you can come up with a solution. I'll give you some hints. Electronic flash units are triggered by closing a circuit. Usually that circuit is inside your digital camera. In the case of slave units, the circuit can be closed by a sensing mechanism that detects light (from another flash) or a radio signal. In any case, a switch is closed and the flash goes off. You can create the switch yourself.

Understand that the high voltage of the flash itself is separated from the electronic circuit that triggers that voltage, so you won't be in any danger of electrocuting yourself as long as you don't open your flash unit and start fooling around inside. The standard maximum triggering voltage for electronic flash is 24V, although many flash units use a lower voltage, and some digital cameras are able to handle only those lower voltages (which is why some cameras can't use just any flashgun).

All you need to do is build a switch that can be activated by the event you want to use to trigger the flash. If you have a flash unit that has a detachable cord, it's likely that the cord is a standard one that can be purchased at a camera store. That's good, because I'm going to suggest you cut off the end of the cord to gain access to the two wires inside. Separate the wires and connect them to two pieces of metal (even aluminum foil works). Then, arrange the metal terminals so that the event you want to photograph causes them to come into contact, completing the circuit, and triggering your flash at the right instant.

For example, you could tape the two terminals to the outside of a lightbulb, slightly separated. Strike the bulb at the point of the terminals with a hammer, and just as the hammer breaks the bulb, the two contacts are forced together triggering the flash. You can place your switch under an object, so another object striking it makes the contact. Some experimenters have shot a bullet *through* their makeshift switch so the force of the impact closes the circuit. (I can't recommend experimenting with bullets; the experiment might work just as well with a paintgun or ping-pong gun.) I'll leave the design and construction of your switch up to you. Would a squirt gun work? Can you build a mercury switch so when an object is tilted, suddenly the flash is triggered?

There are dozens of different ways to set off your flash. This can be an interesting individual project, indeed. I hope you have fun with it.

Next Up

Now that you've tackled moving subjects, it's time to master that most difficult of photographic endeavors: people pictures. Whether you're shooting candid photos of friends and loved ones, formal portraits, group pictures, or publicity photos of your organization, you'll find everything you need in the next chapter.

6

People Photography

People pictures are the one photographic outlet that every digital photographer enjoys. You may hate sports, find scenics boring, and think of close-ups only in terms of Norma Desmond's famous quote in "Sunset Boulevard." However, it's very likely that you love photographing your friends, family, colleagues, and even perfect strangers, because human beings are the most fascinating subjects of all.

Indeed, photographs like the lively celebrity photography of Richard Avedon, or Yousuf Karsh's powerful portrait of Winston Churchill are some of the greatest images ever captured. The value we place on photographs we take of each other can be measured by the number of people who say the one object they'd grab on their way out of a burning home would be the family photo album. After all, photographs of our friends and family are a way of documenting our personal histories, and the best way we have of preserving memories. The fact that there are so many different categories of people-oriented pictures, from fashion photography to portraiture, demonstrates the depth of this particular photographic field.

Each individual brand of people picture deserves an entire book of its own. You'll find lots of good books on family photography, group portraiture, wedding photography, photojournalism, or figure photography. Most of the digital photography books you see try to cram little snippets of information about a broad range of these categories into a single chapter or two. I'm going to take a different approach. This chapter will concentrate on just one variety of people picture, the individual portrait, and will cover it in a bit more depth. I'm going to give you some guidelines on lighting that are glossed over by most other books. What you learn here about posing and lighting applies broadly to other kinds of photography, so my goal is to get you interested enough that you try some other brands, whether you opt for weddings or Little League team photos.

Playing the Game Home or Away

For many years, most portraits were created in a studio of some sort. This custom pre-dates photography by a handful of centuries, because, unless you were royalty and were able to do exactly as you pleased, it was more common to venture to the artist's studio, where the lighting, background, props, and other elements could be easily controlled. That soft and flattering "north light" used to illuminate portraits could be best guaranteed by painting in a space designed for that purpose.

Studio portrait sittings remained the norm after the invention of photography, because photos often took minutes to create. Traveling photographers sometimes carried along tents that could be used as portable darkrooms or studios. Even after more portable cameras and faster films and lenses freed photographers to capture documentary images and insightful candid pictures anywhere, portraits were still most often confined to studio settings.

The social unrest and anti-establishment feelings of the late 60s and early 70s placed a new premium on natural, less formal photography that emphasized realism. Suddenly, "candid" wedding photography was sought after. Professional photographers became eager to set up lights in your living room to create family portraits in your own habitat. Before long, what was labeled as "environmental" portraiture became common, posed photographs with scenic backgrounds, such as the one shown in Figure 6.1. Enterprising pros either set up "natural" settings in their own studio backyards, or compiled a list of parks, seashores, and other sites that could be used for these informal portraits.

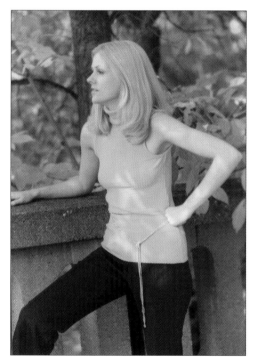

Figure 6.1 *Portraits needn't be confined to the studio.*

The most interesting part of the whole phenomenon was that this new kind of portraiture didn't change much, except the setting for the photograph. Consumers didn't want quick-and-dirty snapshots. They expected their professional photographers to provide them with well-posed portraits, using flattering lighting, attractive backgrounds, and the other qualities they came to expect from formal studio portraiture. What consumers wanted was a studio portrait taken in a less formal setting, with casual dress and less rigid posing. Environmental and home portraits still had to incorporate the professional's skills, even if they weren't taken in a studio.

While the portraiture industry hasn't come full circle, an updated version of time-honored portrait photographic techniques has returned to favor, and studio work commands the respect it traditionally has had. Portraits are still taken outdoors, but many are captured indoors in the studio. There may be more props, more latitude in dress, and variety in poses now, as anyone who's seen the kind of pictures high-school seniors covet for their yearbooks knows. So, as a digital photographer, you'll probably find yourself taking people pictures in both kinds of settings. It's helpful to be comfortable with both.

Studio portraits are usually more formal. With a professional-looking backdrop or a "serious" background, such as those omnipresent shelves of professional journals you see in so many executive portraits, a studio portrait can have a formal or official appearance. Even the crazy Mylar backgrounds and wacky props they're using for high-school portraits these days retain a sense of "this is a professional portrait" in the finished product.

Location portraits, on the other hand, end up having a casual air no matter how hard you try to formalize them. The most carefully staged photo of the Speaker of the House posed on the steps of the U.S. Capitol will still look less formal than a relaxed portrait of the same legislator seated in a studio with only the American flag in the background.

My feeling is that you should master both studio and location portraiture. You'll want a studio-style picture for a newspaper head shot or for mounting over the mantel, but will probably prefer an environmental picture to hang above the couch in the family room or use for your holiday greeting cards. It's great to have an option.

It's probably best to learn studio work first, because all the lighting and posing techniques you learn for your home studio can be applied elsewhere. You might be using reflectors rather than flash units for your portraits out in the park, but the principles of putting light to work for you are the same. The following section will get you started working in your own home studio.

Getting Set Up

Any handy space can be transformed into a mini-studio, as you'll discover in Chapter 9, "Macro Photography." A key difference is that close-up photos usually involve small subjects, taken from a few inches away. People pictures require more room than photographs of your ceramic collection, and few homes have space that can be devoted to studio use on a full-time basis. Two of my last three homes had large semi-finished attic space that I was able to commandeer as a studio, and when I had an office addition built for my current residence, I had the choice of having a crawl space underneath or a full basement. I opted for the basement and high ceilings, so I ended up with a 24 × 16-foot multipurpose room that can be used as a studio, darkroom, and storage space.

Those of you with newer homes *sans* attic, or who live in parts of the country where basements are not common, probably don't have an extra room for a studio. Even so, I'll bet you have space that can be pressed into service from time to time. A garage makes a good location, especially if you live in warmer climes or are willing to confine your studio work to warmer weather. Just back your vehicle out of the garage and you have space to shoot. I know several

part-time professional photographers who work exclusively from rooms that were originally the garage. Their studios don't much resemble a garage today, but that's how they started off.

Of course, a garage studio is impractical in California, and a few other places where the denizens pay more for living space than the rest of us make. Instead, the space is used permanently for storage, practice space for your kid's band, or maybe even as living quarters. In big cities like New York, many people don't even own cars, let alone garages.

See if enough space can be cleared in your family room, living room, or other indoor location to set up a few lights, a background, and perhaps a tripod. You want a place that can be used without disrupting family activities (which is why even the largest kitchen is probably a poor choice) and where you can set up and tear down your studio as quickly as possible.

What You Need

Much of the gear you need for home portraits is the same as what I'm going to outline in Chapter 9, too. The next section will list the basic items you need to have on hand.

Your Portrait Camera

There are few special requirements for a digital camera that will be used for portraiture. Here's a list of the key things to look for in a digital camera that's ideal for portraiture.

- *Lots of megapixels.* Portraiture is one type of photography that places a premium on resolution. Even if you plan on making prints no larger than 5 × 7 inches, you'll find a 5 to 8 megapixel (or more) camera useful, because those extra pixels come in handy when you start retouching your portraits to make your subjects look their best. However, I think you'll find it hard to resist making 8 × 10 and larger prints of your best efforts, so you'll be glad you sprung for a few million more pixels when you bought your camera.

- *A modest zoom lens (at least).* Digital cameras with no zoom lens, or which have only a 2:1 zoom, may not be your best choice for shooting portraits. That's because for the most flattering head-and-shoulders pictures, you'll want a lens that has a zoom setting in the 80mm to 105mm (35mm camera equivalent) range. Shorter focal lengths often produce a kind of distortion, with facial features that are closer to the camera (such as noses) appearing much larger in proportion than features that are farther away from the camera (such as ears), as you can see in Figure 6.2. By the time you

Figure 6.2 *The wide-angle setting (left) emphasizes subject matter (such as noses) that is closer to the camera. A more natural look comes from a telephoto setting (right).*

zoom in to the 135mm to 200mm (or longer) telephoto settings, the reverse effect happens: The camera's perspective tends to flatten and widen the face, bringing the nose and ears into the same plane. The 80 to 105mm settings are just about perfect.

■ *An external flash connection.* If you want the most control over your lighting, you'll want to use several light sources. Electronic flash is often the best option, so your digital camera should have a way of connecting an external flash. This may be a special connector, a standard PC connector (the PC is said to stand for Prontor-Compur, two early shutter manufacturers, not "personal computer"), or a hot shoe connector that can accommodate either an external flash or an adapter you can plug an external flash into.

■ *Filter thread.* Although not an essential feature, having a camera with a thread that will accept screw-on filters and other accessories can be very useful. There are some off-beat things you can do with filters, such as put petroleum jelly on the edges of a skylight filter to provide blurry edges that are a lot harder to duplicate in Photoshop than you might think.

If your camera meets these minimum specifications, you're all set.

Backgrounds

Backgrounds are an important consideration for more formal portraits. You can get great casual pictures with the gang posed on the couch in the living room, and, in fact, you should try some of the lighting techniques discussed later in this chapter in that sort of an environment. Good lighting can elevate the family room portrait well above the snapshot category. However, if you want a true studio portrait, you're going to have to arrange for a more formal background. Luckily, that's easy to do.

Seamless paper, available in 9- and 12-foot widths and around 36 feet long, is another good choice. A paper backdrop can be easily damaged, becoming wrinkled with handling and dirty as people walk on it. When a piece becomes soiled, you just rip it off and roll off some more. If you can, avoid using seamless paper on thick carpets. They don't provide enough support for the paper, so it rips more easily. A wood floor may be a better choice.

TIP FROM THE PROS: HOW WIDE IS A YARD OF CLOTH?

If you answered "36 inches," you lose and don't get to advance to Final Jeopardy. A yard of cloth is 36 inches *long*, but the width of the bolt can vary. Some are as narrow as 18 inches. Other types of cloth come in 45 inch or larger widths. I've had great luck with the velour cloth backdrops I mention from time to time in this book. For portraiture, the key is to purchase cloth that is wide enough and long enough to allow posing one or more people full-length. Find a bolt that is 54 to 60 inches wide. Purchase a piece that is a lot longer than you think you need. Six yards isn't too much when you want to stretch the cloth up to the ceiling, then drape it down on the floor. Make sure your fabric is easily washable, because it will get soiled from people walking on it. Buy as many different colors as you can afford.

You've probably admired those abstract backgrounds with, perhaps, a cloud effect, or stippled blotches of paint, like the one shown in Figure 6.3. Painted backdrop canvases are available for big bucks from professional photography supply houses, but you can easily make your own, as I did.

While professional photographers won't blink an eye at purchasing backdrops they can use repeatedly, most don't hesitate to create their own props and backgrounds to give their photography a customized, personal flavor.

When my studio was in operation professionally, I used the reverse side of 4×8 sheets of paneling to create dozens of backgrounds for individual portraits. Of course, I had a permanent studio to store them in. You're probably better off using sheets of awning canvas. The secret is to use a sponge to paint them with colors. You'll be surprised at the results, even if you're not the artistic type. Start painting using lighter colors in the center and work your way toward the edges with darker pigments. The sponge will give the surface an arty splotchy effect that will look great, especially when it's out of focus. Browns and earth colors are recommended for men; brighter colors, especially blues, work well for women and children. Remember, if you make any mistakes or don't like your initial results, you can always paint over them.

Figure 6.3 *Dabbing with a sponge and paint on a piece of canvas can create a workable backdrop for portraits.*

Visible Means of Support

The same kind of supports you will be collecting for close-up photography in Chapter 9 will serve you in good stead for people pictures, too. You'll need stands for your background, lighting, and camera, although there are many portrait situations in which you'll want to dispense with a tripod. Unlike macro photographs, portraits are often taken from a variety of angles and distances.

Whether you're using cloth backdrops, seamless paper, or another background, you'll need some sort of framework to support it. I prefer sturdy light stands for lightweight backgrounds, and ceiling supports for heavier paper rolls. You may not be able or willing to nail anything to your ceiling (this is one instance when having a basement or attic is great), but you can still build some sort of easily disassembled framework to hold your backdrop.

Light stands make good supports, and are a once-in-a-lifetime investment. Unless you manage to lose one, they'll last forever. You'll need to add clamps or other fasteners to fix your lights and, perhaps, umbrellas to the stands.

A tripod is not essential for people photography, particularly if you're using motion-stopping electronic flash, and in many cases can be detrimental. You'll want to be able to roam around a little to get various angles, move in and out to change from full-length or three-quarters portrait to close-up.

TIP FROM THE PROS: RIGHT OF SPRINGS

You can purchase spring-loaded vertical supports that fit tightly between your floor and ceiling, but can be released and stored when not in use. These work well with sturdy ceilings, or those with overhead beams. You can try making your own: cut a 2 × 4 a few inches shorter than your ceiling height. Pad one end of the 2 × 4 so it won't damage your ceiling, then put the end that rests on the floor in a coffee can with a spring mechanism of your choice. Press the 2 × 4 down to get enough slack to slide it in place, then release to allow your spring to hold it firmly in a vertical position. The spring must be strong enough to resist the downward pull of your backdrop material.

The only time you'll really need a tripod for portraits is when you need to lock down the camera to get a precise composition, or when you're working with relatively low light levels and need the tripod to steady the camera. For example, you might be shooting a series of head shots for your company and would like each photo to be taken from the exact same distance and angle. Or, you may be taking pictures using diffused window light or with household lamps as your illumination. In both cases a tripod can be useful as a camera support.

Make Light Work for You

Lighting is one of the most important tools for creative portraiture. The way you arrange your illumination can have a dramatic effect on the mood of a photo. Lighting can focus interest on your subject. You can even use lighting techniques to improve the looks of a subject with less-than-perfect features. You'll find that portrait lighting is a great deal more complex than the lighting you might use for many other types of subjects. Close-ups need to be lit carefully, and your scenic and architectural pictures will look better if the illumination is just so. For sports photography, much of the time you won't even have much control over the kind of light you use. Portraiture, on the other hand, looks best when the lighting is carefully crafted.

As a result, while very good portraits can be taken with just one light source, you'll find that mastering multiple light sources opens new creative avenues. But note that I said multiple light *sources*. You don't have to encumber your home or office studio with dozens of different lighting fixtures. Often, a skylight, window, or reflector can serve as an effective light source. Outdoors, you may work with the light from the sun, supplemented by reflectors or electronic flash. You'll learn how to use these light sources later in this chapter.

Here are your choices:

Existing Light

The existing light indoors or outdoors can be perfect for good people pictures. Rembrandt reportedly cut a trapdoor in the ceiling of his studio and used that to illuminate many of his portraits. If you have a room with a skylight, you may find that suitable for portraits at certain times of day. Some memorable pictures have been taken using only the soft light that suffuses

from a window. Indeed, you'll find references to "north light" (a window orientation that produces diffuse light from dawn to dusk) throughout painting and photographic literature.

Just because the lighting is already there doesn't mean you can't modify it to your advantage. You can lower the blinds part way to reduce or soften window light. You can use reflectors to bounce light around in interesting ways.

Electronic Flash

Electronic flash is often the best choice for indoor portraiture. The short duration of flash captures a moment in a fraction of a second, without danger of blur from a slow shutter speed. The high intensity of flash means you can use small f-stops if you want, so all of your subject will be in sharp focus. Flash can be reduced in intensity, as well, giving you the option of using selective focus, too. Flash can be harsh and direct, or soft and diffuse.

The chief problem with electronic flash is that it is difficult to preview how flash illumination will appear in the final picture. Fortunately, there are ways to overcome this limitation, as I'll show you later in this section. A second problem is that many digital cameras don't have a connector that lets you plug in an external flash, as I mentioned earlier.

Electronic flash comes in many forms, from the built-in flash on your digital camera, to external battery-powered units, to "studio" flash that operate from AC power or large battery packs. Unless you're moving into portraiture in a big way, you don't need studio flash units. However, investigate external battery-powered flash that are compatible with your digital camera. Many digital cameras cannot use electronic flash intended for film cameras, because conventional flash units use a voltage to trigger the flash (through a switch in the camera) that is too high, and likely to fry the electronics of a digital model. Digital cameras may also work only with dedicated external flash units that integrate with the camera's exposure system. Unless you have such a dedicated flash, you'll want a digital camera that has manual exposure settings that can be used with any external flash unit.

Some add-on flash units have a built-in device called a slave sensor that triggers the flash when the sensor detects another unit firing. These can be safely used with any camera, as they have no direct connection to the camera. You can also purchase detectors that attach to any flash unit, turning it into a slave flash.

If you're using an external flash, make sure you turn off your digital camera's internal flash unit, especially if you don't want it to trigger a slave unit. Some digital camera models require you to have the internal flash flipped up, even if disabled, to activate the external flash connector. Check your camera's instruction manual carefully to see exactly what you need to do to use an external flash unit.

If you use your electronic flash on stands, you may be able to rig an incandescent light along each side to give you some indication of what your lighting looks like. These "modeling" lights work especially well if your electronic flash is pointed at a reflector such as an umbrella. That's because the softening effect of the umbrella reduces the variation in illumination that results when the flash and incandescent lamp aren't in precisely the same position.

The ability to see the exact light you're going to get can be very important. For Figure 6.4, I carefully manipulated the lights so the model's hat fell into shadow, and most of the right side of her face was in shadow as well, except for the dangling earring. You can't achieve lighting effects like this on a hit or miss guesstimate basis.

Incandescent Lights

You'll find that incandescent lights are inexpensive, easy to set up, and make it simple to preview your lighting effects. You never have to worry about what your lighting will look like if you use incandescent lamps.

Unfortunately, lamps are not as intense as flash and may not provide enough illumination for good handheld exposures at short shutter speeds. Or, if the lamps are intense enough, they may be too hot to pose under for long periods of time. In addition, incandescent lamps are much redder than the illumination provided by daylight or electronic flash, so you may have to change your camera's white-balance control to compensate. (Many digital models have automatic white-balance control, but it's not foolproof.)

Figure 6.4 *Careful lighting can produce effects like this, in which the earring stands out sharply from the shadows.*

While you can use just about any light, you might want to investigate incandescent lamps made especially for photography. They aren't overly expensive, and are easier to buy hardware for, such as mounting clamps, umbrella adapters, and so forth.

Gadgets

There are dozens of different gadgets and accessories associated with portraiture. The best news is that you can make many of them yourself, so you don't have to pay a lot of money to spice up your portrait-shooting arsenal. Here are some versatile gadgets you might want to consider.

Flat Reflectors

Reflectors bounce some of the illumination from other light sources onto your subject, serving as a low-cost secondary light source in their own right. Large sheets of foamboard (which you can stand up and lean against things at the proper angle), poster board, Mylar sheets, or anything that reflects light can be used.

Soft Boxes

Soft boxes are similar in concept to photographic tents, which I discuss in Chapter 9. Both operate by using diffuse white material, such as cloth, to create a soft lighting effect. A tent is a white, usually cubical box that fits around the subject (usually for close-ups) and diffuses any light you apply to the outside. A soft box operates in a similar way, except it fits around the light source. Soft boxes can simulate window light and create a diffuse, flattering illumination suitable for photography of women, children, teens, and any adult men who aren't tenacious about preserving those craggy furrows they think of as facial character lines.

Gobos and Cookies

Gobos and cookies are the opposite of a reflector. They can be a black drape or sheet placed between a light source and the subject to block some light, and are handy when you have an unwanted light source, such as a window, that's spoiling the effect you want. These items are actually more of a tool for video and cinema photographers and for stage productions, because they can include cutouts that let some light through to produce an interesting combination of light and shadows, such as window frames, trees, or logos. However, still photographers should know about them and use them when appropriate.

Barndoors/Snoots

These are devices that limit where the light from a flash or lamp goes. A barndoor has two or four hinged flaps you can move into or out of the path of the light. Subtle adjustments can be made to "feather" the light on your subject. Snoots are conical devices that focus the light down to a narrow spot. They are excellent for creating a light that illuminates a small area, such as the hair of the subject.

You can easily make your own barndoors or snoots out of cardboard or tin (which is a better choice for accessories used near hot incandescent lamps). Spray paint them with black heat-resistant barbeque grill paint. Or, use purchased units, like those shown in Figure 6.5.

Figure 6.5 *Barndoors and snoots let you direct the light carefully.*

Umbrellas

A good set of umbrellas is the best investment you can make for portrait photography. Umbrellas soften the light in ways you can control and use for artistic effect. You can bounce light off an umbrella onto your subject, or, in the case of translucent white umbrellas, shine your illumination through the fabric for an especially diffuse effect. In either mode, a soft-white umbrella provides very diffuse illumination, but you can also purchase umbrellas with opaque shiny silver or gold interiors that provide a broad light source that still has snap and

contrast. Umbrellas produced for professional photographers are compatible with various lighting clamp systems that make them easy to set up and manipulate.

TIP FROM THE PROS: GOING FOR THE GOLD

Gold umbrellas, in particular, are prized for the warm illumination they provide. They are used extensively for fashion and glamour photography because of the flattering skin tones their light produces. Silver umbrellas have more contrast and snap than soft-white models. The edges of the illumination provided by silver umbrellas is more sharply defined, so you can angle the umbrella to "feather" the light on your subject (placing strong light on some parts, while fading to less light on others).

However, you can also use ordinary umbrellas of the type people take out into the rain. I found a source selling white umbrellas that collapse down to less than a foot in length for about $5.00 each. I really liked these when I was a traveling photojournalist who was unable to travel light (two or three cameras, five or six lenses, and two electronic flash units were my minimum kit), but tried to trim weight where ever I could. I picked up a dozen and found I could hold the umbrella and flash unit in my left hand and shoot with the camera held in my right hand). You can jury-rig clamps to hold them to light stands or other supports. Collapsible umbrellas usually have small diameters and must be used relatively close to get a soft, wrap-around lighting effect. Larger sizes are needed to provide illumination from greater distances (say, 10 to 12 feet).

Portrait Lighting Basics

Lighting is the palette you'll be using to paint your photographic portraits. The next two sections will introduce you to some basic techniques, using some diagrams I've put together that will help you set up professional-looking lighting on your first try. However, you don't need to stick to the setups I'm going to describe anymore than you'd want to paint using only one shade each of red, blue, green, yellow, orange, or other colors. Once you understand how various types of lighting affect your portrait, you'll want to expand on the basic techniques to achieve special looks of your own devising. This section covers some basics.

The Nature of Light

The character of the light you use is just as important as the direction it comes from. As a photographer, you probably already know that light can be hard and harsh, or soft and gentle. Neither end of the spectrum is "good" or "bad." Each type of light, and all the gradations in between, has their own advantages and disadvantages.

A spotlight or a lamp in a reflector, or an electronic flash pointed directly at a subject is highly directional and produces a hard effect. Hard light is harsh because all the light comes from a relatively small source. This kind of light can be good if you want to emphasize the texture of

a subject, and are looking for as much detail and sharpness as possible. In fact, many kinds of photographic projection and optical gear take advantage of point-source lighting to maximize sharpness. A photographic enlarger, for example, may be equipped with such a source to get the sharpest possible image from a piece of film. Of course, the point-source light emphasizes any scratches or dust on the film, so the technique works best with originals that are virtually perfect from a physical standpoint.

Direct light of this type is not as good a choice for portraiture. People rarely look their best under a direct light, because even a baby's skin is subject to imperfections that we don't see under home illumination (which is deliberately designed to be non-harsh). Only in direct sunlight are we likely to look our worst. Figure 6.6 shows how a direct light focuses a sharp beam on a human subject.

Most portraits are made using softer illumination, such as that produced by bouncing light off an umbrella. As the light strikes the umbrella (or other soft reflector), the light scatters. It bounces back towards the subject and appears to come from a much larger source—the umbrella itself rather than the bulb or flash unit that produced it. Figure 6.7 shows a much softer beam of light bounced onto the subject from an umbrella.

You can probably guess by now that the distance of the light source from the subject also has a bearing on the quality of light. In Figure 6.7, the umbrella is fairly far from the subject, so the light source seems to come from a relatively small area, even though it's bouncing off an umbrella. (Of course, some of the light is bouncing off in all directions, never reaching the subject, but that's irrelevant from the subject's perspective.) The effect is less harsh than direct light, of course, but still not as good as we can achieve.

Figure 6.6 *A direct light forms a sharp beam of high-contrast light on your subject.*

Figure 6.7 *Bouncing light from an umbrella produces a much softer light source.*

For Figure 6.8, I moved the umbrella in much closer to the subject. The apparent source of the light is now much larger, relatively, and correspondingly softer. You'll need to keep this characteristic in mind as you set up your lights for portraiture. If you need to move a light back farther from the subject, you'll also need to take into account the changing nature of the light. A larger umbrella may help keep the lighting soft and gentle. Or, you simply might want to have slightly "edgier" lighting for your subject. As long as you are aware of the effect, you can control it.

Balancing Light

As you'll see in the next section, you'll often be using multiple illumination sources to light your portraits. It's important to understand some of the principles that go into balancing light from several different sources in a single photograph. Here are some tenets to work by:

Figure 6.8 *Moving the light in closer provides an even broader, softer effect.*

The Inverse Square Law

Moving a light source twice as far away reduces the light by 4× (not 2×). In photographic terms, that translates into two f-stops, not one f-stop, to compensate. For example, an electronic flash placed 12 feet from your subject will provide one-quarter as much illumination as the same flash located just six feet from the subject. After moving the flash twice as far away, you'd have to open up two f-stops to keep the same exposure.

You can make the inverse square law work for you. If you find a source is too strong, either by itself or relative to other light sources you're using, simply moving it twice as far away will reduce its strength to one-quarter its previous value. Or, should you need more light, you can gain two f-stops by moving a light source twice as close. (Keep in mind that the softness of the light is affected by the movement, too.)

There are times when you won't want to adjust the light intensity entirely by moving the light because, as you've learned, the farther a light source is from the subject, the "harder" it becomes. In those cases, you'll want to change the actual intensity of the light. This can be done by using a lower power setting on your flash, switching from, say, a highly reflective aluminum umbrella to a soft white umbrella, or by other means.

Using Ratios

When lighting a subject, the most common way to balance light is to use ratios, which are easy to calculate by measuring the exposure of each light source alone (either with your camera's exposure meter or using an external flash meter). Once you have the light calculated for each source alone, you can figure the lighting ratio.

For example, suppose that the main light for a portrait provides enough illumination that you would use an f-stop of f11. The supplementary light you'll be using is less intense, is bounced into a more diffuse reflector, or is farther away (or any combination of these) and produces an exposure, all by itself, of f5.6. That translates into two f-stops' difference or, putting it another way, one light source is 4 times as intense as the other. You can express this absolute relationship as the ratio 4:1. Because the main light is used to illuminate the highlight portion of your image, while the secondary light is used to fill in the dark, shadow areas left by the main light, this ratio tells us a lot about the lighting contrast for the scene. (I'll explain more about main and fill lights shortly.)

In practice, a 4:1 lighting ratio (or higher) is quite dramatic, and can leave you with fairly dark shadows to contrast with your highlights. For portraiture, you probably will want to use 3:1 or 2:1 lighting ratios for a softer look that lets the shadows define the shape of your subject without cloaking parts in inky blackness.

If you use incandescent lighting or electronic flash equipped with modeling lights, you will rarely calculate lighting ratios while you shoot. Instead, you'll base your lighting setups on how the subject looks, making your shadows lighter or darker depending on the effect you want. If you use electronic flash without a modeling light, or flash with modeling lights that aren't proportional to the light emitted by the flash, you can calculate lighting ratios. If you do need to know the lighting ratio, it's easy to figure by measuring the exposure separately for each light and multiplying the number of f-stops difference by two. A two-stop difference means a 4:1 lighting ratio; two-and-a-half stops difference adds up to a 5:1 lighting ratio; three stops is 6:1 and so forth.

Figure 6.9 shows an example of 4:1, 3:1, and 2:1 lighting ratios.

Figure 6.9
Top: a 4:1 lighting ratio; middle: a 3:1 lighting ratio; bottom: a 2:1 lighting ratio.

Using Multiple Light Sources

As I warned you in the previous section, the best portrait lighting involves at least two, and often three or more light sources. The light sources don't always have to be incandescent lights or electronic flash. Figure 6.10, for example, was shot using window light (from the rear), light bounced from a flat reflector you can see at the right side of the image, and from another reflector at camera position (which you can't see). This section will introduce you to each type of light source, and the terminology used to describe it.

Figure 6.10 *Only window light and reflectors were used for this bridal portrait.*

Main Light

The main light, or key light, is the primary light source used to illuminate a portrait. It may, in fact, be the only light you use, or you may augment it with other light sources. The main light is most often placed in front of the subject and on one side of the camera or the other. Some kinds of lighting call for the main light to be placed relatively high, above the subject's eye-level, or lower at eye-level. You usually won't put a main light lower than that, unless you're looking for a monster/crypt-keeper effect.

Placed to the side, the main light becomes a sidelight that illuminates one side or the profile of a subject who is facing the light. Placed behind the subject, the main light can produce a silhouette effect if no other lights are used, or a backlit effect if additional lighting is used to illuminate the subject from the front. I'll show you how to create lighting effects using the main light shortly.

You'll usually position the main light at roughly a 45-degree angle from the axis of the camera and subject. The main light should be placed a little higher than the subject's head—the exact elevation determined by the type of lighting setup you're using. One thing to watch out for is the presence or absence of catch lights in the subject's eyes. You want one catch light in each eye, which gives the eye a slight sparkle. If you imagine the pupils of the eyes to be a clock face, you want the catch lights placed at either the 11 o'clock or 1 o'clock position. You might have to raise or lower the main light to get the catch light exactly right.

You most definitely do not want *two* catch lights (because you're using both main and fill lights) or no catch light at all. If you have two catch lights, the eyes will look extra sparkly, but strange. With no catch light, the eyes will have a dead look to them, as in Figure 6.11. Sometimes you can retouch out an extra catch light, or add one, with Photoshop, but the best practice is to place them correctly in the first place.

Figure 6.11 *Two catch lights (left), or no catch light at all (middle) look bad. One catch light (right) looks great.*

Fill Light

The fill light is usually the second-most powerful light used to illuminate a portrait. Fill light lightens the shadows cast by the main light. Fill lights are usually positioned on the opposite side of the camera from the main light.

The relationship between the main light and fill light determines, in part, the contrast of a scene, as you learned in the section on calculating lighting ratios. If the main and fill are almost equal, the picture will be relatively low in contrast. If the main light is much more powerful than the fill light, the shadows will be somewhat darker and the image will have higher contrast. Fill lights are most often placed at the camera position so they will fill the shadows that the camera "sees" from the main light. Figure 6.12 shows a main light and fill light in a typical lighting setup. I'll show you the effects of using main and fill lights in the sections that follow.

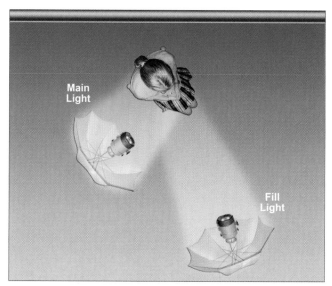

Figure 6.12 *Main and fill lights complement each other.*

Background Light

A light illuminating the background is another common light source used in portraits. Background lights are low-power lights that provide depth or separation in your image. Place the background light low on a short light stand about halfway between your subject and the background, so that the subject hides the actual light from view. This light can also provide interesting lighting effects on the background when used with colored gels or cookies. You can even turn the background light towards the back of the subject, producing a halo or backlight effect.

Hair Light

A hair light is usually a small light directed at the hair of the subject to provide an attractive highlight. Often, a snoot or barndoor is used to keep the hair light from spilling down on the subject's face. A hair light must be controlled carefully so it doesn't form an overexposed hot spot on the subject's head. A low-power light like the background light, the hair light also provides separation from the background, which can be very important if your subject has dark hair and is posed against a dark background. Place the hair light in a high position shining down on the subject's head, then move it forward until the light spills over slightly onto the subject's face. At that point, tilt the light back again until it is no longer illuminating the subject's face.

For Figure 6.13, I used a background light on the tiger-striped background as well as a touch of a hair light on the back of the young man's head to provide separation between his head and the background. I didn't overdo either one, because I wanted the focus of the picture to be on his face.

Figure 6.13 *Both a hair light and background light were used here to provide separation from the background.*

Lighting Techniques

Although I'll describe each of the most common lighting techniques, you'll want to set up some lights and see for yourself exactly how they work.

Short Lighting

Short lighting and broad lighting (discussed next) are two different sides of the same coin. Together, they are sometimes referred to as "three-quarter lighting," because in both cases the face is turned to one side so that three quarters of the face is turned toward the camera, and one quarter of the face is turned away from the camera.

Short lighting, also called narrow lighting, is produced when the main light illuminates the side of the face turned away from the camera, as shown in the bird's-eye view in Figure 6.14. Because three-quarters of the face is in some degree of shadow and only the "short" portion is illuminated, this type of lighting tends to emphasize facial contours. It's an excellent technique for highlighting those with "interesting" faces. It also tends to make faces look narrower, because the "fat" side of the face is shadowed, so those with plump or round faces will look better with short lighting. Use a weak fill light for men to create a masculine look.

This is a very common lighting technique that can be used with men and women, as well as children.

In Figure 6.15, our subject is looking over the photographer's right shoulder. The main light is at the right side of the setup, and the fill light is at the photographer's left. Because the fill light is about twice as far from the subject as the main light, if both lights are of the same power, the fill light will automatically be only one-quarter as intense as the main light (thanks to the inverse-square law). If the shadows are too dark, move the fill light closer, or move the main light back slightly.

Figure 6.14 *With short lighting, the main light source comes from the side of the face directed away from the camera.*

Figure 6.15 *A typical portrait illuminated using short lighting looks like this.*

Broad Lighting

In many ways, broad lighting, the other three-quarter lighting technique, is the opposite of short lighting. The main light illuminates the side of the face turned toward the camera. Because most of the face is flooded with soft light (assuming you're using an umbrella or other diffuse light source, as you should), it de-emphasizes facial textures (teenagers may love this effect) and widens narrow or thin faces. Figure 6.16 is the lighting diagram used to produce the image shown in Figure 6.17, which pictures the same subject as above, but with broad lighting instead. Broad lighting may not be the best setup for this teenager, because she has a broad face, but styling her hair so it covers both sides of her face reduces the effect. That let me use broad lighting and its feature-flattering soft light.

Figure 6.16 *This diagram shows how the lights are arranged for a typical broad lighting setup. Remember, you can also use a mirror image of this arrangement.*

Figure 6.17 *A portrait made using broad lighting de-emphasizes facial textures.*

Butterfly Lighting

Butterfly lighting was one of the original "glamour" lighting effects. The main light is placed directly in front of the face above eye-level and casts a shadow underneath the nose. This is a great lighting technique to use for women, because it accentuates the eyes and eyelashes, and emphasizes any hollowness in the cheeks, sometimes giving your model attractive cheekbones where none exist. Butterfly lighting de-emphasizes lines around the eyes, any wrinkles in the forehead, and unflattering shadows around the mouth. Women love this technique, for obvious reasons. Butterfly lighting also tends to emphasize the ears, making it a bad choice for men and women whose hairstyle features pulling the hair back and behind the ears.

Butterfly lighting is easy to achieve. Just place the main light at the camera position, and raise it high enough above eye-level to produce a shadow under the nose of the subject. Don't raise the light so high the shadow extends down to his or her mouth. The exact position will vary from person to person. If a subject has a short nose, raise the light to lengthen the shadow and increase the apparent length of the nose. If your victim has a long nose, or is smiling broadly (which reduces the distance between the bottom of the nose and the upper lip), lower the light to shorten the shadow.

You can use a fill light if you want, also placed close to the camera, but lower than the main light, and set at a much lower intensity, to reduce the inkiness of the shadows. Figure 6.18 is the diagram for applying butterfly lighting (without a fill light), while Figure 6.19 shows the final result. Notice that the ears aren't a problem with this portrait, because they are hidden behind the model's hair. Because this young woman has blonde hair, I've toned back on the use of hair light in all the photos.

Figure 6.19 *Butterfly lighting is a great glamour lighting setup.*

Figure 6.18 *This diagram shows the basic arrangement for butterfly lighting.*

Rembrandt Lighting

Rembrandt lighting is another flattering lighting technique that is better for men. It's a combination of short lighting (which you'll recall is good for men) and butterfly lighting (which you'll recall is glamorous, and therefore good for ugly men). The main light is placed high and favoring the side of the face turned away from the camera, as shown in Figure 6.20. The side of the face turned towards the camera will be partially in shadow, typically with a roughly triangular shadow under the eye on the side of the face that is closest to the camera,. For Rembrandt lighting, place the light facing the side of the face turned away from the camera, just as you did with short lighting, but move the light up above eye-level. If you do this, the side of the face closest to the camera will be in shadow. Move the light a little more towards the camera to reduce the amount of shadow, producing a more blended, subtle triangle effect, as shown in Figure 6.21. Eliminate or reduce the strength of the fill light for a dramatic effect, or soften the shadows further with fill light.

Side Lighting

Side lighting is illumination that comes primarily directly from one side, and is good for profile photos. You can use it for profiles or for "half-face" effects like the Fab Four on the much copied/parodied cover of *Meet the Beatles/With the Beatles*. The amount of fill light determines how dramatic this effect is. You can place the main light slightly behind the subject to minimize the amount of light that spills over onto the side of the face that's toward the camera. Figure 6.22 shows you how to set up lights for side lighting, and Figure 6.23 shows the results. Note that a subject with long hair that covers the cheeks may have most of their face obscured when sidelit in this way. Either comb the hair back or go for the mysterious look that my model requested in this case.

Figure 6.21 *Rembrandt lighting lends an Old Masters' touch to portraiture.*

Figure 6.20 *Arrange your main light high when working with a Rembrandt lighting effect.*

Figure 6.23 *Side lighting can create dramatic profile photos.*

Figure 6.22 *Side lighting is applied with most of the light coming from one side.*

Backlighting

With a backlit photo, most of the illumination comes from behind the subject and doesn't really light the subject as much as it defines its edges. Use additional fill light to provide for detail in the subject's front. You can use the background light for backlighting, and put your main and fill lights to work in a subordinate roll by reducing their intensity. Or, you can use the main light as the backlight, as shown in Figure 6.24 (place it below or above the camera's field of view), and fill in the shadows with your fill light. Figure 6.25 shows the final results. I didn't go for the wildly overlit, backlit glamour look in this case because the teenager in the photo is only 14 years old, and not quite ready for *femme fatale-dom*.

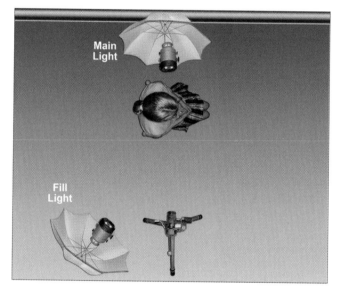

Figure 6.25 *Backlighting helps define the edges of a portrait subject.*

Figure 6.24 *Use your main light or background light to backlight your subject.*

Outdoor Lighting

You can apply virtually all the techniques you learned in the studio to your outdoors portraits. Once you've mastered short lighting, broad lighting, butterfly lighting, and the rest of the basic setups, you can use them outdoors by being flexible enough to work with the less controllable lighting you find there.

For example, you might have to position your subject to take advantage of the position of the sun as a "main" light, and use reflectors to create your fill. A search for some shady spot might be required to provide a soft enough light source. The sun might end up as your hair light or back light, as in Figure 6.26. Note that the backlighting is a little more blatant in this photo because the model is considerably older and more suited for the dramatic effect.

Figure 6.26 *Using sunlight, reflectors, and other aids, you can duplicate good studio lighting, such as this backlit portrait, outdoors.*

Posing and Shooting

Posing is another topic that's worth a book or two of its own. I'm going to provide a list of quick tips you can use in this section, but your best bet is to experiment with different poses and find some that you like. Work with those poses at first, try some variations, and add more poses as you become comfortable. Just keep in mind that your goal is not to use your subject as a mannequin that you can bend and twist any way you like. It's better to let the subject assume a pose that he or she is comfortable with. Then, you can make slight adjustments that reposition awkward limbs or produce better facial expressions.

TIP FROM THE PROS: CHOOSING POSES

There are an infinite number of good poses, but you're interested in starting with just a few. Your best bet is to clip photos from magazines with poses that you like, or purchase a posing guide with hundreds or thousands of different poses included. After you've worked with these canned poses for awhile, you'll be more comfortable working with your subject for poses on your own.

The important thing is that your victim(s) must be relaxed and comfortable. The days when portrait subjects had to be immobilized in head braces for their daguerreotypes are long past. Don't make them stand for anything other than a full-length portrait. Stools make a great seat because they discourage slouching. An individual can sit tall in a stool, alert and ready to take your direction. Because they have no backs, stools won't intrude upon your picture, either. But don't be afraid to use other kinds of resting places, or to incorporate them into the photo.

If you're photographing an individual, you can try different poses as you work. For group pictures, you'll probably want to try and arrange everyone in a pleasing away and take several sets of pictures with each pose before moving on. Use basic compositional rules to arrange your subjects. For example, in Figure 6.27, the three "gangsters'" faces are arranged in the upper third of the frame. Although all three heads are roughly on the same level, they actually form a curving line pointing to the upper-right corner, in the same direction the Tommy-gun held by the Big Boss is pointed. As a rule of thumb, if you're shooting photos of your subjects from the waist up, position the camera at chest- or eye-level.

Figure 6.27 *Avoid having all the heads in a "lineup" at exactly the same level.*

When shooting individuals, you can vary the camera's viewpoint slightly to portray your subject in a more flattering way. For example, raise the camera slightly above eye-level if you want to elongate a nose or narrow a chin, broaden a "weak" forehead or de-emphasize a prominent jaw line. If your subject has a wide forehead, long nose, or weak chin, lower the camera a little. If you encounter someone with a strong jaw and long nose, however, you're in a heap of trouble.

Nobody's perfect, and a portrait is a bad time to discover exactly where an individual's imperfections lie. Here are some general tips to keep in mind to minimize defects:

- The eyes are the most important component of any portrait, as they will always be the center of attention. They must be sharp and lively, even if you're going for a softer look in the rest of the portrait.

- The edges of hands are more attractive than the backs or palms of hands. The bottoms of feet are downright ugly, but you can sometimes get away with side views if the feet are young enough and there are other things to look at in the photo.

- Bald heads are pretty cool these days, but if your subject is sensitive about a bare pate, elevate your victim's chin and lower your camera slightly.

- For long, large, or angular noses, try having your subject face directly into the camera.

- To minimize prominent ears, try shooting your subject in profile, or use short lighting so the ear nearest the camera is in shadow.

- If you want to minimize wrinkles or facial defects such as scars or a bad complexion, use softer, more diffuse lighting; take a step backwards and photograph your subject from the waist up to reduce the relative size of the face; keep the main light at eye level so it doesn't cast shadows; consider using a diffusing filter (or add diffusion later in your image editor).

- If your subject is wearing glasses, be wary of reflections off the glass. Have him or her raise or lower his chin slightly, and make sure your flash is bouncing off the face at an angle, rather than straight on.

- Diffusion is a great way to add a soft, romantic look to a portrait. You can purchase diffusion filters, or make your own by smearing a little petroleum jelly around the edges of the plain glass skylight filter. Or, you can add diffusion within your image editor, as was done with Figure 6.28.

Figure 6.28 *Diffusion is a great technique, and you can apply it during the exposure or later, in your image editor, as was done here.*

You'll want to take lots of photos to capture various expressions and angles. Keep talking with your subject, and not just to provide them with instructions on where to place their arms and legs, or tilt their head. Mention how great they're doing; tell them how much they are going to like these photos.

Over time you'll develop a breezy line of patter that keeps your models relaxed. When working with amateurs, I use some funny stock phrases like, "Oh, I see you've done this before," or "Sorry, but we have to keep doing this until I get it right." You don't have to be that corny, but you'll soon collect a stockpile of jokes and phrases that will put your subjects at ease.

TIP FROM THE PROS: EYES WIDE SHUT

People may blink during a flash exposure, and you'll end up with a photo showing their eyelids instead of their eyes. The problem is particularly troublesome when shooting groups: the more people in the picture, the better the odds one of them will have their eyes closed. While you can review each shot on your LCD, a faster way is simply to ask your subjects to watch for the flash and then tell you whether it was red or white after the picture was taken. If the flash was red, they viewed it through closed eyelids and that particular picture, at least, is no good.

Project for Individual Study: Learn to Retouch

If you'll be taking many portraits, one thing you'll want to learn for sure is how to retouch your pictures digitally. Few people are so great looking that their photographs can be used as-is with no modification. Do you really think Sharon Stone or Keanu Reeves look like that when they get up in the morning? Unless your subjects have Hollywood make-up artists at their beck and call, it's likely you'll need to optimize some of their physical features when you take the photos (perhaps using the lighting techniques described in this chapter), or do some work on their images later on.

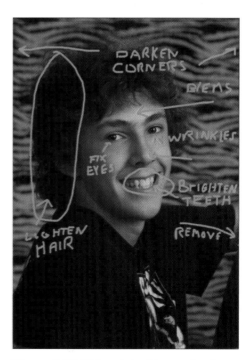

Retouching photographs in Photoshop or another image editor is a lot of fun, not too difficult, and is certainly easier than when I started in photography and retouching artists were just that: artisan specialists skilled with brush and knife, who knew a bit of photographic chemistry that came in handy when bleaching or restoring colors.

The finished portrait shown in Figure 6.13 earlier in this chapter didn't look like that originally. I performed quite a bit of fix up on the image, as you can see in the annotated version shown in Figure 6.29. It was actually quite common in the good old days to take a proof print and mark it up with a grease pencil, much like the representation in the figure. Today, we can mark up a digital copy and then go to work.

Figure 6.29 *This original image has lots of things that need fixing.*

Some things are easy to fix. In Figure 6.30, you can see the double catch lights in the young man's eyes. If you look close, you can make out the shape of the photographic umbrellas used to expose the picture. Removing the extra catch lights was relatively easy. Lightening the hair, improving the complexion, and making the teeth whiter were a bit more work. You can find everything you need to know about retouching in my book *Digital Retouching and Compositing: Photographers' Guide*, available from Muska & Lipman.

Figure 6.30 *Some of the fixes are simple, such as removing the extra catch lights in the eyes.*

If you'd like to get started, here's a list of the skills you'll need to sharpen:

- *Using selection tools.* Making selections is the best way to confine your corrections only to the parts of the image you actually want to modify. Image editors have a variety of selection tools that allow you to draw selections, select pixels based on their color or brightness, or even to "paint" a selection with a brush tool.

- *Working with layers.* Layers allow you to place different parts of the image on separate overlays so you can work with them individually. Need to correct the color of the eyes? It might be easiest to copy those features to a layer, make the changes you need, and then merge the eyes back when you're finished. With layers you can create several different versions of a change, make them visible or invisible, and use only the one you want.

- *Sizing, cropping, and changing orientation.* Many photos can be improved by resizing, cropping out extraneous material, or performing some rotation on all or part of the image.

- *Mastering painting/cloning tools.* Paint over bad complexions, replace part of a portrait with texture taken from elsewhere in the picture, and make other modifications using the painting and cloning tools.

- *Adjusting with tonal controls.* These allow you to change the brightness and contrast of an image, improving attributes you might not have been able to capture perfectly when the original photograph was taken.

- *Applying blurring and sharpening.* Blurring can de-emphasize parts of a picture, or make sharp portions appear even sharper. Sharpening tools can improve the contrast and apparent resolution of an image when you're not satisfied with the results you got in the original photograph.

- *Correcting color*. Automatic or even manual white-balance controls aren't perfect. Sometimes you need to adjust color in an image editor. Other times you might want to intentionally create an odd-ball color effect for artistic reasons. You'll often find this easier to do in an image editor than in your camera.

Next Up

Now that you've started down the road to proficiency with the most difficult of all subjects, let's take a stab at one of the easiest: Mother Nature. In the next chapter, you're going to learn how to capture scenic photos that you'll want to display on your wall and share with your friends. Whether you're surrounded by nature's beauty, or only go to visit it on vacations, you'll find the tips and techniques I've got for you to be quite useful.

7

Scenic Photography

The history of scenic photography is as old as photography itself. The first known permanent photograph, taken in 1826 by French chemist Nicéphore Niépce, is a view of the courtyard outside his laboratory. Because early photographs required exposures that were extremely long (Niépce's scenic required an eight-hour time exposure in full daylight), stationary subjects like trees and mountains were perfect pictorial fodder. When early photographers weren't strapping our ancestors into chairs for painfully tedious portraits, they were creating scenic photographs.

Of course, we've come a long way since then, both in the way photographs are taken, and the esteem in which they are held. That first photograph was made using a pewter plate coated with asphalt, and when Niépce submitted the "heliograph" to England's King George IV and the Royal Society, it was rejected. Today, the same photo could be exposed onto a solid-state sensor in 1/16,000th of a second (the fastest shutter speed on the latest digital cameras), and photographs are more highly valued. For example, a signed 16 × 20 print of Ansel Adams' "Monolith, Face of Half Dome" will set you back $37,000 at the Ansel Adams Gallery (www.anseladams.com, if you'd rather have the photograph than a new SUV).

Scenics are a great way to practice your digital photography skills. Vacations are a good time to investigate this type of photography. You're relaxed. You're out to have fun. You definitely have your digital camera along with you to document the sights and sites that you've paid thousands of dollars to visit. Even if you're on a whirlwind 14-city tour of Europe, you'll find that between each of those cities are scenes created by Mother Nature that deserve your artistic attention. This chapter focuses on several different varieties of scenics and offers some tips for getting some interesting shots of landscapes, sunsets/sunrises, fireworks, and other types of scenic images.

What You Need

Scenic photography isn't particularly equipment- or gadget-intensive. Your digital camera and its standard zoom lens will be fine in most cases. There are a few optional extras that you might want to consider, and I'll describe them in this section.

Your Scenic Camera

Scenic photos look gorgeous in large prints, and you might want to use your best shots from your travels as part of the décor of your home or office. For that reason, scenic photography is one digital pursuit that puts a premium on megapixels. The higher your camera's resolution, the better. You can take some good scenic photos with a 3 megapixel camera, but don't count on making prints much larger than 8 × 10 inches with the kind of detail you'll want to see. A 5- to 8-megapixel (or better) digital camera will provide the resolution you need to make 16 × 20 or even 20 × 30-inch prints.

If you're planning to include night photography in your scenic repertoire, particularly if you're going after fireworks pictures (discussed later in this chapter), you'll want a digital camera that can capture long exposures at boosted ISO ratings without introducing excessive noise into the picture. Some cameras have special noise reduction features that are able to separate actual image detail from random noise by comparing two separate photographs and then, in effect, deleting anything that doesn't look like picture information.

You'll want lots of memory cards for storing your images, too. By definition, when you're out shooting scenic photographs, you're often not near a computer (unless you tote a laptop along in your gadget bag), so those high-resolution 8 megapixel images will fill up your memory cards much quicker than you might expect. Carry plenty with you, and if your sojourn involves a lengthy, computerless vacation, think about a portable hard drive or some other means of offloading images from your digital film cards.

A main concern when selecting a camera for scenic photography will be the lens. A wide zoom range, extending from a true wide-angle perspective to a decent telephoto setting, gives you the flexibility you need to photograph wide-open spaces or focus in on a distant mountain. As you'll discover in Chapter 8, "Architectural Photography," many digital cameras do poorly from a wide-angle standpoint. Their zooms may have no better than a 35mm equivalent 35-37mm view at the wide-angle range, which is barely enough to be considered wide angle at all. You may be delighted to find your digital camera provides the equivalent of a 28mm lens, but film camera veterans are unlikely to be satisfied with anything longer than 24mm.

The situation doesn't brighten much for those owning digital SLRs with removable lenses, particularly if their DSLR's sensor is smaller than the 24 × 36mm film frame. The magnification factor inherent in these cameras happily makes telephoto lenses even longer, but conversely can instantly transform a 24mm wide angle into a 38mm "normal" lens at a typical 1.6× magnification factor. Some professional digital cameras already have full-frame sensors and don't suffer from this bonus/penalty magnification factor. The rest of us have to long for

truly wide-angle lenses for our digital cameras, or turn to add-on devices like the .75× accessory shown in Figure 7.1.

Similar add-ons are available to increase the focal length of your digital camera lens should you need a longer telephoto. Expect to pay $75 to $100 for these accessories, or even more if they come from companies like Nikon.

Choice of focal length is important when shooting scenics, because it's not always practical to drive a few miles closer to a mountain, and it may be impossible to back up any further for a wider view (thanks to a cliff, forest, ocean, or other impediment at your back). Telephotos can bring distant subjects closer, and de-emphasize things in the foreground that you don't want in the picture. Wide angles, in contrast, make distant objects look as if they are farther away while emphasizing the foreground. If you have a field full of flowers, like those in Figure 7.2, you'll want a wide-angle view.

Figure 7.1 *An add-on wide-angle attachment can be useful for your scenic panoramas.*

Figure 7.2 *To emphasize the foreground, use a wide-angle zoom setting.*

Lens Accessories

I've already mentioned add-on telephoto and wide-angle lens converters. Another kind of lens accessory you might want to consider is filters—not the kind that pop up inside your image editing program, but the kind that fit onto the front of your lens. Usually made of glass and mounted in a threaded metal ring, filters can be used to provide a variety of scene corrections or special effects. Among them:

■ *Color correction filters.* These filters have color casts of their own, which compensate for changing lighting conditions. They provide a warming effect that's helpful to brighten bleak snow scenes, or cool the excessively warm colors of early dusk. Your digital camera's built-in automatic or manually set white-balance controls take care of most of these situations, but you might want the stronger correction that an accessory filter can give you at times. In addition, some cameras have internal settings that correspond to additional filtration in colors like red, blue, green, yellow, or orange.

■ *Gradient color filters.* These provide an interesting special effect as they blend one color filter with another. For example, a common version blends a warm orange color on one half of the filter with a blue tone on the other. You can use them to give the sky portion of your image one tone, while applying a second tone to the foreground. You've seen this effect in advertising photography; now you can apply it yourself to get results like Figure 7.3.

■ *Attenuating filters.* These come in many varieties, including prism filters, star filters, and other filter types that warp and transform your image, for effects like those shown in Figure 7.4.

If you're serious about filters, you're probably already familiar with the versatile Cokin system, created by French professional photographer Jean Coquin. You'll find more information about the scores of different Cokin filters at www.cokin.com.

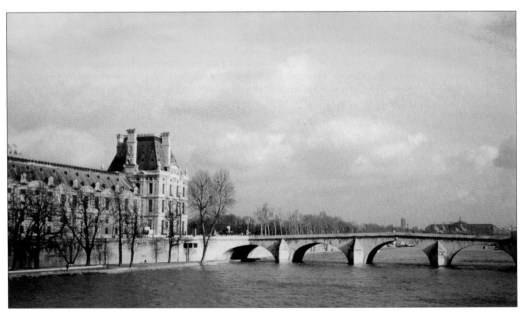

Figure 7.3 *Gradient filters can add two or more color effects to a single scene.*

Figure 7.4 *Prism filters break up your image into interesting shapes.*

Tripods

Tripods let you compose your photo carefully, or even, if you use your camera's self-timer, get into the picture yourself. They let you shoot sharper pictures in low-light levels, particularly at night, and are useful for panoramas, which I'll discuss shortly. You'll find more about tripods in Chapter 9, "Macro Photography."

Flash

You'll only need electronic flash for your scenic photographs under a limited number of conditions. One of these is when you want to illuminate a subject in the foreground while still capturing a dramatic sunset in the background. Or, you might want to "paint with light" (discussed in more detail in Chapter 8) to illuminate a large outdoor subject. You'll find more about flash in Chapter 5, "Action Photography."

Landscapes

If you think landscapes aren't hard-wired into our thinking, the next time you print a photograph, check out the name applied to the "wide" orientation in your printer's Setup dialog box. You may be printing an abstract image, a photo of a football game, or even a group portrait, but the name applied to a picture or document that's wider than it is tall is

landscape. Scenics have been a favorite subject for artists throughout history, from Da Vinci to Dali to Daguerre. In fact, you have to go back to the cave paintings of Lascaux to find artists who overwhelmingly preferred things like cattle to Mother Nature.

Seven Simple Rules for Composing Your Landscapes

Landscape photos, in particular, are an opportunity for you to create thoughtful and interesting compositions. Those mountains aren't going anywhere. You're free to move around a bit to get the best angle, and, unless you're including people in your pictures for scale, you don't have to worry about an impatient subject. If you can't pull all the elements of a scenic photograph together to create a pleasing composition, you're not trying hard enough.

In one sense, good composition is the most important aspect of landscape photography. Certainly an action photo or a portrait needs to be composed well for maximum effect, but if you've captured a once-in-a-lifetime moment in an important sports contest, no one is going to complain because the football needed to be a little more to the left. And, to be honest, do you really care about how well a close-up photo of Angelina Jolie or Brad Pitt is composed? Yet, mountains are everywhere, seashores look pretty much alike the world around, and nice-looking amber waves of grain are not especially distinctive. How you arrange the elements in photographs of these subjects can make all the difference.

There are seven simple rules for composing photos effectively. I'll review each of them in this section. In brief, they are as follows:

- *Simplicity.* This is the art of reducing your picture only to the elements that are needed to illustrate your idea. By avoiding extraneous subject matter, you can eliminate confusion and draw attention to the most important part of your picture.

- *Choosing a center.* Always have one main subject that captures the eye.

- *The Rule of Thirds.* Placing interesting objects at a position located about one-third from the top, bottom, or either side of your picture makes your images more interesting than ones that place the center of attention dead center (as most amateurs tend to do).

- *Lines.* Objects in your pictures can be arranged in straight or curving lines that lead the eye to the center of interest, often in appealing ways.

- *Balance.* We enjoy looking at photographs that are evenly balanced with interesting objects on both sides, rather than everything located on one side or another and nothing at all on the other side.

- *Framing.* In this sense, framing is not the boundaries of your picture but, rather, elements in a photograph that tend to create a frame-within-the-frame to highlight the center of interest.

- *Fusion/separation.* When creating photographs, it's important to ensure that two unrelated objects don't merge in a way you didn't intend, as in the classic example of the tree growing out of the top of someone's head.

Simplicity

Let nothing intrude into your photograph that doesn't belong there, and your viewer will automatically focus on the information you intended to convey. In scenics, extraneous subject matter can include busy backgrounds, utility wires, ugly buildings, or even stray people who interfere with the natural setting.

You probably won't have much choice in your background. The clouds, mountains, or ocean off in the distance aren't going to change their colors or move to suit you. However, you can make a background work for you by shooting on a day with a cloudless sky (if a plain-blue background suits your composition) or one with abundant fluffy clouds, if that's what you're looking for.

Crop out unimportant objects by moving closer, stepping back, or using your zoom lens. Remember that a wide-angle look emphasizes the foreground, adds sky area in outdoor pictures, and increases the feeling of depth and space. Moving closer adds a feeling of intimacy while emphasizing the texture and details of your subject. A step back might be a good move for a scenic photo; a step forward might be a good move for a scenic that includes a person.

Remember that with a digital camera, careful cropping when you take the picture means less trimming in your photo editor, and less resolution lost to unnecessary enlargement. Finally, when eliminating "unimportant" aspects of a subject, make sure you truly don't need the portion you're cropping. For example, if you're cropping part of a boulder, make sure the part that remains is recognizable as a boulder and not a lumpy glob that viewers will waste time trying to identify. And cutting off the heads of mountains can be just as bad as cutting off a person's head in a portrait!

Figure 7.5 is a photograph that is too cluttered. In fact, with the houses, powerlines, and the distracting boat at the left side of the photograph, it doesn't qualify as a "scenic" picture at all.

Figure 7.5 *Too much clutter spoils the scenic view in this photograph.*

Figure 7.6 is a similar photo taken a few minutes later, farther down the canal (you can see the original boat and barge under the bridge at the right side of the picture). However, a simple change of position has simplified the photo and transformed it into a pleasing scenic. The power lines are still showing, but they can be removed easily in Photoshop or another image editor.

Figure 7.6 *Simply moving a few yards down the canal yields a much better shot.*

Front and Center

Next, you should decide on a single center of interest, which, despite the name, needn't be in the center of your photo. Nor does it need to be located up front. No matter where your center of interest is located, a viewer's eye shouldn't have to wander through your picture trying to locate something to focus on. You can have several centers of interest to add richness and encourage exploration of your image, but there should be only one main center that immediately attracts the eye. Think of Da Vinci's *Last Supper*, and apply the technique used in that masterpiece to your scenic photography. There are four groups of Apostles that each form their own little tableaux, but the main focus is always on the gentleman seated at the center of the table. You may enjoy visiting Versailles or the Riviera when you travel to France, but Paris will always be your starting point. The same is true of scenic photos. One huge mountain with some subsidiary crests makes a much better starting point than a bunch of similarly sized peaks with no clear "winner."

The center of interest should be the most eye-catching object in the photograph; it may be the largest, the brightest, or most unusual item within your frame. Shoot a picture of a beautiful waterfall, but with a pink elephant in the picture, and the pachyderm is likely to get all of the attention. Replace the waterfall with some spewing lava, and the elephant may become secondary. Gaudy colors, bright objects, large masses, and unusual or unique subjects all fight for our attention, even if they are located in the background in a presumably secondary position. Your desired center of attention should have one of these eye-catching attributes, or, at least, shouldn't be competing with subject matter that does.

Avoid having more than one center of attention. You can certainly include other interesting things in your photograph, but they should be subordinate to the main subject. A person can be posed in your scenic photograph to provide scale, but if the person is dangling by a tree branch over a precipice, viewers may never notice the Grand Canyon in the background.

In most cases, the center of interest should not be placed in the exact center of the photograph. Instead, place it to one side of the center, as shown in Figure 7.7. We'll look at subject placement in a little more depth later in this chapter.

Figure 7.7 *The center of interest need not be in the center of the photograph.*

Landscape Portraits

The orientation you select for your picture affects your composition in many different ways, whether your landscape uses a landscape (horizontal) layout or a portrait (vertical) orientation. Beginners often shoot everything with the camera held horizontally. If you shoot a tall building in that mode, you'll end up with a lot of wasted image area at either side. Trees, tall mountains shot from the base, and images with tall creatures (such as giraffes) all look best in vertical mode.

Recognize that many landscapes call for a horizontal orientation, and use that bias as a creative tool by deliberately looking for scenic pictures that fit in the less-used vertical composition. Some photos even lend themselves to a square format (in which case you'll probably shoot a horizontal picture and crop the sides).

Figures 7.8-7.10 illustrate the kind of subject matter that can be captured in all three modes. Figure 7.8 looks best when composed horizontally, while Figure 7.9 is a natural vertical composition. Figure 7.10 fits naturally into a square format. Even though squares can be somewhat static, the curve of the tree and its roots gives this photo a more graceful look.

Figure 7.8 *Some scenes look best in a horizontal format, even if they contain vertical lines like the trees in this picture.*

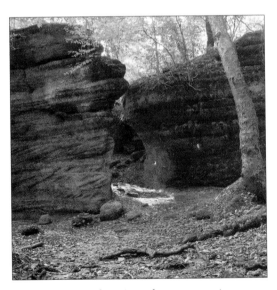

Figure 7.10 *Take care when composing square pictures to avoid a static look. The tree in this picture adds graceful movement to the shot.*

Figure 7.9 *Other photos are obviously vertically oriented.*

Rule of Thirds

You'll see the idea of dividing your images into thirds referred to as the Rule of Thirds quite a bit, and this is one case in which I'm not obsessive about avoiding hard-and-fast rules. It really is a good idea to arrange your pictures using this guideline much of the time, and when you depart from it, it's a great idea to know exactly why.

Earlier, I mentioned that placing subject matter off-center is usually a good idea. Things that are centered in the frame tend to look fixed and static, while objects located to one side or the other imply movement, because they have somewhere in the frame to go, so to speak.

The Rule of Thirds works like this: use your imagination to divide your picture area with two horizontal lines and two vertical lines, each placed one-third of the distance from the borders of the image, as shown in Figure 7.11. The intersections of these imaginary lines represent four different points where you might want to place your center of interest. The point you choose depends on your subject matter and how you want it portrayed. Secondary objects placed at any of the other three points will also be arranged in a pleasing way.

Figure 7.11 *The Rule of Thirds is a good starting place for creating a pleasing composition.*

Horizons, for example, are often best located at the upper third of the picture, unless you want to emphasize the sky by having it occupy the entire upper two-thirds of the image. Tall subjects may look best if they are assigned to the right or left thirds of a vertical composition. Figure 7.11 shows a scene arranged into thirds. Notice how the horizon is roughly a third of the way from the top, and the important structures of the castle all fall at the intersections of the imaginary lines.

One important thing to consider is that if your subject includes a person, an animal, a vehicle, or anything else with a definable "front end," it should be arranged in a horizontal composition so that the front is facing into the picture. If not, your viewer will wonder what your subject is looking at, or where the animal is going, and may not give your intended

subject the attention you intended. Add some extra space in front of potentially fast-moving objects so it doesn't appear as if the thing is just about to dash from view.

Oddly enough, it's not important to include this extra space in vertical compositions for anything that doesn't move. A tree can butt right up to the top of an image with no problems. We don't expect the object to be moving, therefore we don't feel the need for a lot of space above it. If your scenic was taken at Cape Kennedy and a booster rocket intrudes, it would be best positioned a bit lower in the frame.

Using Lines

Viewers find an image more enjoyable if there is an easy path for their eyes to follow to the center of interest. Strong vertical lines lead the eye up and down through an image. Robust horizontal lines cast our eyes from side to side. Repetitive lines form interesting patterns. Diagonal lines, like those shown in Figure 7.12, conduct our gaze along a more gentle path, and curved lines are the most pleasing of all. Lines in your photograph can be obvious, such as fences or the horizon, or more subtle, like a skyline or the curve of a flamingo's neck.

As you compose your images, you'll want to look for natural lines in your subject matter and take advantage of them. You can move around, change your viewpoint, or even relocate cooperative subjects somewhat to create the lines that will enhance your photos.

Lines can be arranged into simple geometric shapes to create better compositions. Figure 7.13 shows an image with a variety of lines. The strongest line is the curve of the road, which leads our gaze through the picture. The road's broad swath is crossed by the shadows of the trees. The vertical lines of the trees themselves lead our eyes toward the top of the photo. This is the sort of picture that engages the viewer's attention, luring them into spending more than a few seconds exploring everything it contains.

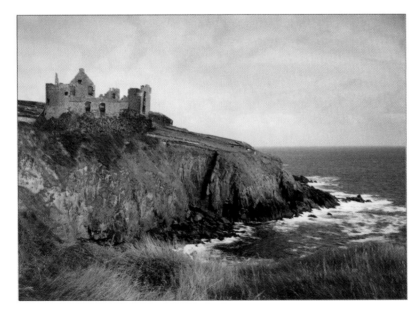

Figure 7.12 *The diagonal lines lead the eye from the ruins down to the sea, connecting the two.*

Figure 7.13 *The curved lines of the road interact with the horizontal shadows and the vertical lines of the trees.*

Balance

Balance is the arrangement of shapes, colors, brightness, and darkness so they complement each other, giving the photograph an even, rather than lopsided, look. Balance can be equal, or symmetrical, with equivalent subject matter on each side of the image, or asymmetrical, with a larger, brighter, or more colorful object on one side balanced by a smaller, less bright, or less colorful object on the other.

Figure 7.14 shows an image at top that on first glance has a balance of sorts. The light tones of the castle image at the far right are more or less offset by the darker foliage on the left side. However, because the castle is clearly intended to be the center of interest for this photo, the more you look at it, the more you get the feeling the picture is a bit lopsided.

By taking a step back, we can include more of the road and wall leading to the castle, and a bit more of the structure on the right side, as shown in the middle version. This cropping does several things. It balances the picture, while moving the center of interest closer to one of the "golden" intersections defined by the Rule of Thirds. The walls and road provide converging lines that attract our eye to the castle.

Even so, there's still something wrong with this picture. The tree branches at the right side aren't connected to anything. They appear to be growing out of the side of the picture frame. We can crop most of them out and improve the balance of the image even further, as you can see in the bottom version.

Figure 7.14 *Top: The large light and dark masses on the right and left sides of the picture don't really balance each other as they should. Middle: Cropping less tightly provides a better balanced picture with converging lines that draw our eyes to the castle. Bottom: Removing the tree branches improves the picture even further.*

Framing

Framing is a technique of using objects in the foreground to create an imaginary picture frame around the subject. A frame concentrates our gaze on the center of interest that it contains, plus adds a three-dimensional feeling. A frame can also be used to give you additional information about the subject, such as its surroundings or environment.

You'll need to use your creativity to look around to find areas that can be used to frame your subject. Windows, doorways, trees, surrounding buildings, and arches are obvious frames. Figure 7.15 shows a classic "environmental" frame, with the tree branches in the foreground framing the upper-half of the photo. A different example can be seen in Figure 7.16, in which the walkway of a centuries-old covered bridge is used to frame the river.

Figure 7.15 *Trees are a classic prop used to construct frames for scenic photographs.*

Figure 7.16 *The walkway of the covered bridge frames the river.*

Frames don't even have to be perfect or complete geometric shapes. Figure 7.17 shows how the bridge (above) and the walkway (below) provide a perfect frame for the seagull. Generally, your frame should be in the foreground, but with a bit of ingenuity you can get away with using a background object, such as the bridge, as a framing device.

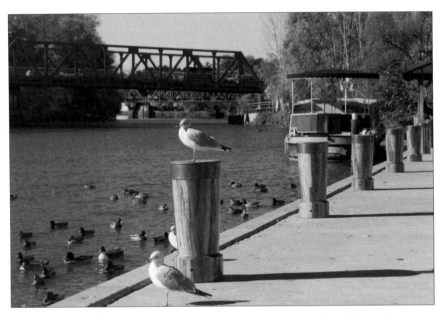

Figure 7.17 *Frames can be subtle, such as the bridge and walkway that frame this seagull.*

Fusion/Separation

Our vision is three-dimensional, but photographs are inherently flat, even though we do our best to give them a semblance of depth. So, while that tree didn't seem obtrusive to the eye, in your final picture, it looks like it's growing out of the roof of that barn in your otherwise carefully composed scenic photograph. Or, you cut off the top of part of an object, and now it appears to be attached directly to the top of the picture.

You always need to examine your subject through the viewfinder carefully to make sure you haven't fused two objects that shouldn't be merged, and have provided a comfortable amount of separation between them. When you encounter this problem, correct it by changing your viewpoint, moving your subject, or by using selective focus to blur that objectionable background.

Figure 7.18 is a good example of an undesired fusion. The windmills looked great in person, but when captured digitally, they appear to be crammed together. Using long lenses or zoom settings, which tend to compress the distance between objects, or standing very far away from a group of objects, can produce this effect. Your best defense is to be aware that it can happen, and to recognize and avoid mergers as you compose your images.

Figure 7.18 *Watch your compositions so that individual objects don't merge or fuse together.*

Key Types of Scenics

This section will provide you with a little advice on how to shoot the most common type of scenic photographs, including mountain scenery, sunsets, sea and water scenes, panoramas, and fireworks. All of them are easy to picture, but there are a few tricks you'll want to pick up to get the best shots.

Mountains

Although I label this category "Mountains," this kind of scenic photography really encompasses any broad expanses of nature unencumbered by large numbers of buildings. The same concepts apply whether you're in Idaho or Iowa.

Your main decision is a choice of lens or zoom setting. A wide-angle setting makes distant objects appear to be farther away, emphasizing the foreground of your photo. A longer telephoto setting brings far-away objects like mountains closer, but compresses everything in the foreground. For Figure 7.19, I settled on a focal length that's roughly in the middle, about 80mm, giving equal emphasis to the olive groves that dot the foothills of this mountain range.

A useful tool for photographing distant objects is a skylight or haze filter, which filters out some of the blue light that cloaks mountains and other objects located far from the camera. A haze filter was used to grab the photo shown in Figure 7.20. If you compare it with Figure 7.19, you can see that the most distant peaks are a bit more distinct.

Mountain scenes lend themselves to panorama photographs, which I'll explain in a separate section.

Figure 7.19 *Choose your zoom setting to emphasize the foreground or background, or neither.*

Figure 7.20 *A haze filter can cut through the blue mist that cloaks distant objects.*

Sunsets and Sunrises

Sunsets and sunrises are popular subjects because they're beautiful, colorful, and their images often look as if a lot of thought went into them, even if you just point the camera and fire away. Some photographers specialize in them. Although photographically they are almost identical, I prefer sunsets to sunrises for a couple technical reasons. First, I am not usually awake in time to see a sunrise, although I sometimes catch one when I go to bed late after an

all-night session browsing the Internet. Second, at the latitude where I live, for much of the year, it's a lot warmer at sundown than at sunset, and I don't particularly like cold weather. Finally, it's more difficult to scout out your location for a sunrise shot than it is for a sunset shot. Sunset follows a period of lightness (called "daytime") and you can spend hours looking for just the right spot, and use the waning daylight to decide exactly where to stand to capture the sunset as the sun dips below the horizon. Dawn, in sharp contrast, occurs after a really dark period, and you may have difficulty planning your shot in the relatively short interval just before sunrise.

Here are some tips for shooting photos of sunsets (or sunrises):

- If your camera has an automatic white-balance control that can be overridden, see if you have a Sunset/Sunrise white-balance setting as well as a Sunset/Sunrise programmed exposure mode. The former will let you avoid having the desired warm tones of the sunset neutralized by the white balance control, and the latter can allow you to get a correct exposure despite the backlighting provided by the sun. With sunset photos, you generally *want* a dark, silhouette effect punctuated by the bright orb of the sun.

- Don't stare at the sun, even through the viewfinder. I usually compose my sunset photos with the sun slightly out of the frame, then recompose just before taking the photo.

- Avoid splitting your photo in half with the horizon in the middle. Your picture will be more interesting if the horizon is about one-third up from the bottom (to emphasize the sky) or one third down from the top (to emphasize the foreground). Remember the Rule of Thirds.

- Sunsets don't have to be composed horizontally! Vertically oriented shots, like the one shown in Figure 7.21, can be interesting. In that photo, I broke several "rules" by using vertical orientation for a "landscape" photo, and didn't wait until the last moment to shoot. True sunset was actually about 30 minutes away when the picture was taken. I deliberately underexposed the photo to create a sunset image.

- Filters such as star filters, gradients, or other add-ons can enhance your sunset pictures. Figure 7.21 is actually a straight shot, with the star effect occurring naturally. However, if I'd used a star filter I could have picked up additional star-like reflections in the water and other highlights. Try it yourself.

Figure 7.21 *Break some rules: shoot vertical sunset shots, and don't wait until the sun reaches the horizon.*

■ Take advantage of the sun's backlighting to get some good silhouettes, whether the silhouette is a tree or two (as in my example), a church spire, or some other subject matter.

■ If you have a person or other object in the near foreground that you *don't* want in silhouette, try a few shots with your camera's flash turned on. The mixed lighting effect can be dramatic.

■ Plan carefully, and work fast. Once the sun starts to set, you might have only a few minutes to shoot your pictures, so be ready, have your camera settings locked in, and take many pictures. If some prove to be duds, you can always erase them.

■ Make sure your lens is focused at infinity. Sunsets can fool the autofocus mechanisms of some cameras. Use manual focus if you must.

■ Exposures can be longer than you might have expected when the sun dips behind the trees or below the horizon, so have a tripod handy.

Sea and Water Scenes

Whether you're at the ocean, by a lake, alongside a river, beneath a waterfall, or following the towpath of a canal, water makes for some great scenic photography, not only for the beauty of the water itself, but for the reflections and the excitement when the water is moving. Your images might take a languid approach, like that of Figure 7.22, or mix in a bit of kinetic energy from the ocean or a roiling stream or river, like that pictured in Figure 7.23.

Here are a few tips for photographing water:

■ Watch your exposures at the ocean. The bright sand can fool the exposure meter of your camera, giving you underexposed pictures. Review your first few shots on the LCD and dial in some EV corrections if necessary.

■ Incorporate the reflections in the water into your photographs. Many of the scenic photos in this chapter use water and reflections to good effect. Figure 7.24 is yet another one. The light bouncing off the surface of the water has a special look and you'll find the reflections add interest to your image.

■ Use a tripod and long exposures to capture waterfalls and streams. The water will blur, giving you the next best thing to laminar flow in a photograph. The tripod keeps the rest of the image rock solid and sharp. You might have to use a neutral density filter to achieve a long enough exposure in daylight, so streams and waterfalls in open shade are better than those in full sunlight.

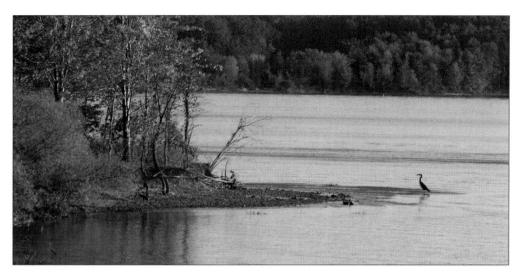

Figure 7.22 *Water scenes can be calm and cool...*

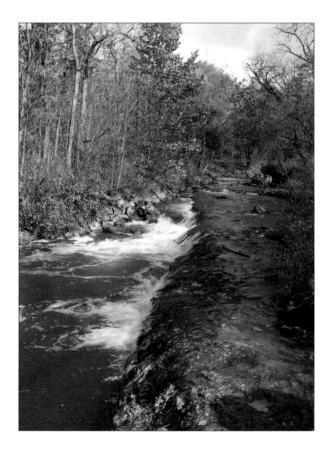

Figure 7.23 *...or water scenes can portray movement.*

Figure 7.24 *Use reflections to enhance your photograph of water.*

TIP FROM THE PROS: MULTI-COLORS

One of my favorite water effects for film cameras involves long exposures and a special gadget that's easy to make. I haven't tried this with a digital camera yet, but plan to do so for a future book. You can get a head start with this tip. All you need is a tripod, a neutral density filter with an 8× or 16× or more exposure factor, a stream or waterfall illuminated so you can make an exposure of about a second with your camera's lowest ISO setting, and a tri-color filter gadget. The "gadget," known to old-timers as the Harris Shutter, is a frame that fits in front of your lens in lens-hood fashion, and has a slot at the top or bottom. Take a strip of cardboard and place pieces of red, green, and blue gelatin filter material (available from any camera store) in suitable holes in the cardboard. Begin with the opaque portion of the cardboard covering the lens, as shown in Figure 7.25. With the camera on the tripod, open the shutter and then drop the cardboard so a time exposure is made consecutively through the red, green, and blue filters, until the lens is blocked again by the upper opaque tab.

Stationary subject matter (everything but the moving water) will be portrayed normally by the equal red, green, and blue exposures. However, because the water was moving, individual rivulets will be exposed by a different filter, producing a remarkable rainbow effect. Try it, and send me your results. I may have my own gadget built by then.

Figure 7.25 *This gadget, called the Harris Shutter, named after its inventor, Kodak whiz Bob Harris, can produce multicolored moving water effects*

Panoramas

Panoramas are another cool effect that gives you wide-screen views of very broad subjects. There are several ways to shoot panoramas. The simplest way is to simply crop the top and bottom of an ordinary photo so you end up with a panoramic shot like the one extracted from a full-frame picture in Figure 7.26.

Figure 7.26 *Crop a full-frame photo to produce a panorama.*

Another way to shoot a panorama is to stitch together several individual photos, which was done for the view of Toledo, Spain in Figure 7.27. Your digital camera might have a panorama mode, like that found in several Pentax Optio models. The most common mode doesn't actually shoot a panorama for you. You take the first picture and the camera shows you the edge of that picture in the LCD viewfinder, so you can use the semi-transparent review version to line up your second or third shot in the panorama series. Then, the individual pictures are stitched together using an image editor. Photoshop CS has a panorama-stitching feature, but you can accomplish the same thing with utilities like ACDSee (or an equivalent program for Macs).

Figure 7.27 *Panoramas can also be assembled by stitching together two or more individual photos.*

When shooting panoramas, you might find it useful to use a tripod so you can smoothly pan from one shot to the next overlapping picture. Strictly speaking, the pivot point should be under the center of the lens, rather than the usual tripod socket location on the digital camera, but you should still be able to stitch together your photos even if you don't take the picture series absolutely correctly from a technical standpoint.

Fireworks

Fireworks are fun to shoot, and it's easy to get spectacular results. Figures 7.28 and 7.29 show some fireworks I grabbed last Fourth of July. My big complaint is that I didn't get to see the fireworks! I was so busy fiddling with my digital camera and the tripod, and trying to push the shutter release at exactly the right time, that I really saw only glimpses of the show, and only then through the viewfinder of my camera. You can do better if you follow these tips:

- You must use a tripod. Fireworks exposures usually require a second or two to make, and nobody can handhold a camera for that long. Set up the tripod and point the camera at the part of the sky where you expect the fireworks to unfold, and be ready to trip the shutter.

- Watch as the skyrockets shoot up in the sky; you can usually time the start of the exposure for the moment just before they reach the top of their arc. With the camera set on time exposure, trip the shutter using a remove release (or a steady finger) and let the shutter remain open for all or part of the burst. Usually an exposure of one to four seconds works.

- Review your shots and adjust your f-stop so you won't overexpose the image. Washed-out fireworks are the pits. At ISO 100, you'll be working with an f-stop of about f/5.6 to f/11.

- Expect some noise in your photos. Most digital cameras produce noise during long exposures, especially if you boost the ISO rating to 200 or 400.

- Take along a penlight so you can check your camera settings and make manual adjustments. It's going to be dark!

- Try leaving your shutter open for several sets of displays. Cover the lens with your hand between displays to capture several in one exposure.

Figure 7.28 *Leave the shutter open for as long as four seconds to combine several bursts into one shot.*

Figure 7.29 *Be careful not to overexpose your fireworks scenes.*

TIP FROM THE PROS: DO-IT-YOURSELF NOISE REDUCTION

Newer cameras sometimes have noise-reduction features that combine a blank shot with an actual exposure, and then calculate the noise from the blank shot. You can do something similar in Photoshop by taking a blank frame with the lens cap on at the same exposure you use for the fireworks. Then combine this blank frame with an actual fireworks frame, and merge the two layers using the difference mode.

Snow Scenes

Photographing in snow is a lot like photographing at the beach: you have to watch out for glare and overexposures. Otherwise, snow scenics can be captured much like other landscape-type photographs. There are a few things to watch out for however. One of them is cold. Batteries of all types put out less juice in cold temperatures, and those in your digital camera are no exception. Keep your camera warm if you want it to perform as you expect.

Also, watch out for condensation on the camera, particularly on the lens. If your camera uses an optical viewfinder instead of an electronic viewfinder or SLR system, you may not notice water drops on your lens until it's too late. Consider using a skylight filter that you can clean off with a soft cloth as necessary. These filters are tougher than the glass of your lens, and cheaper to replace if they get scratched.

Figure 7.30 shows a typical snowy scene, one of the few I have on file, because nothing is going to get me to go out in that stuff voluntarily. After living for a few years in Rochester, NY (which has nine months of winter and three months of bad skiing), I moved elsewhere specifically to reduce my opportunities for photographing in snow.

Figure 7.30 *Be careful to avoid underexposure under the bright conditions found in snow scenes.*

Project for Individual Study: Infrared Photography

The special project for this chapter is one that can easily turn into a mania. If you have a digital camera that can handle it, infrared (IR) photography can be a lot of fun. By photographing an image primarily using the infrared light that bounces off your subject matter, you end up with eerie monochrome photographs featuring white foliage and dark skies, like the image shown in Figure 7.31. Because everyday objects reflect infrared in proportions that differ sharply than that of visible light, the tonal relationships are wildly unexpected.

Scenic photos lend themselves to the IR treatment for a number of reasons. People photographed by infrared light often look pale and ghastly. Landscapes, on the other hand, take on an other-worldly look that's fascinating. You'll need to do some work and buy some add-ons to get started with infrared photography, but this section should point you in the right direction.

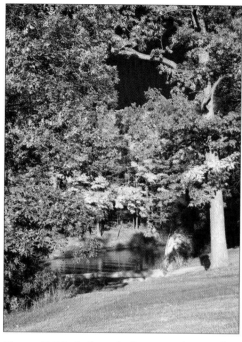

Figure 7.31 *Infrared photography produces weird black-and-white landscape photos.*

What You Need

To shoot infrared photos, you need several things. One of them is a digital camera that can capture pictures by infrared illumination, as well as a filter that blocks virtually all light except for near infrared (NIR) illumination.

The sensors found in digital cameras generally are very sensitive to infrared light in the range of 700-1200 nanometers, which is a good thing if you want to take infrared pictures, and not so good if you don't want infrared illumination to spoil your non-infrared photographs. Accordingly, many digital cameras now include a filter or "hot mirror" that specifically blocks IR light from the sensor. Some enterprising souls have opened their cameras and removed the filter so they could take IR photographs, replacing it with a piece of glass to preserve the camera's autofocus capabilities.

Other cameras remove the filter for you. For example, Sony digital cameras with NightShot capabilities move the IR filter when in NightShot mode, allowing the sensor to record both visible and IR light (this gives the camera the ability to take pictures in lower illumination at night, which is the purpose of NightShot). However, if you use Sony's NightShot capabilities in non-night situations, you may need to use a neutral density filter to cut the light levels down to what the NightShot expects, as this feature generally operates only with a wide-open lens and

low shutter speeds. (After all, it thinks it's taking a picture at night!) Sony deliberately disabled the NightShot feature for daylight photography for a simple reason: the bad publicity that resulted when certain photographers discovered that clothing is relatively transparent to IR in bright sunlight. (X-Ray Spex, indeed!)

This solution is complicated by the fact that many neutral density filters are transparent to IR light; they're not much better than a piece of clear glass in this situation! You might have better luck using a green or blue filter instead of an ND filter to cut down the light.

Many digital cameras have no IR-blocking filter or hot mirror at all, or have filters that block only part of the IR light, so you might be able to take infrared photos with your camera without needing to dismantle it and remove the IR filter manually. An easy way to check for IR capability is to photograph your television remote control. Point the remote at your camera, depress a button on the remote, and take a picture. If your camera can register IR light, a bright spot will appear on the photograph of the remote at the point where the IR light is emitted.

You'll also need an IR filter to block the visible light from your sensor. Find a Wratten #87 filter to fit your digital camera. You can also use a Wratten 87C, Hoya R72 (#87B), or try #88A and #89B filters. A simpatico camera store may let you try out several filters to see which one works best with your camera. These filters aren't necessarily cheap, easily costing $60 to $100, depending on the diameter. Some can be purchased for less than $30, however.

Taking IR Photos

Once you're equipped, you have to learn to contend with the quirks and limitations of IR photography. These include:

- *Light loss.* The IR filter blocks the visible illumination, leaving you with an unknown amount of infrared light to expose by. Typically, you'll lose five to seven f-stops, and will have to boost your exposure by that much to compensate. A tripod and long exposures, even outdoors, may be in your future.

- *Difficulty metering.* Exposure systems are set up to work with visible illumination. The amount of IR reflected by various subjects differs wildly, so two scenes that look similar visually can call for quite different exposures under IR.

- *Difficulty seeing.* Because the visual light is eliminated, you'll be in a heap of trouble trying to view an infrared scene through a digital SLR. The LCD view may be a little weird, too. If you have an optical viewing system, you're all set.

- *Focus problems.* Infrared light doesn't focus at the same point as visible light, so your autofocus system might or might not work properly. You may have to experiment to determine how to best focus your camera for infrared photos. If you're shooting landscapes, setting the lens to the infinity setting probably will work (even though *infrared infinity* is at a different point than visible light infinity).

- *Spotty images.* Some removable lenses include an anti-IR coating that produces central bright spots in IR images. A few Canon lenses fall into this category. Test your lens for this problem before blaming the artifacts on your filter or sensor.

- *Color mode.* Even though your pictures will be, for the most part, black and white, or, rather, monochrome (usually magenta tones or a color scheme described as "brick and cyan"), you still need to use your camera's color photography mode.

You'll find lots more information on the Internet about digital infrared photography, including the latest listings of which cameras do or do not work well in this mode. If you ever tire of conventional scenic photography, trying out digital IR can respark your interest and give you a whole new viewpoint.

Next Up

The next chapter, on architectural photography, shares many aspects with this one. Both kinds of photography depend on similar kinds of photographic techniques, and both may have scenic elements. A chief difference between them is that architectural photos generally contain structures of some sort, and structures present some challenges of their own. We'll look at those challenges next.

8

Architectural Photography

Architectural photography comes in two varieties: the sophisticated professional kind that's a highly specialized pursuit with complex rules and guidelines, and the informal type you can engage in just for fun. If you want to shoot architectural photographs professionally, whether it's for architectural firms, city planners, housing developers, or other colleagues, you don't need this chapter. You need a few months of study and thousands of hours of practice with sophisticated view cameras equipped with a pricey digital camera back. (Or, there's always film!) However, if you want to photograph structures as a creative outlet or for fun, you do need this chapter.

As you'll learn, professional architectural photography requires a medium- or large-format camera with sophisticated swings in tilts that can bring all the converging lines of a typical building into their proper perspective. Consumer-level digital cameras don't have the features required for the absolute control professional applications require. However, your digicam is easily capable of capturing some great pictures of architecture if you learn the ropes and know a few tricks. That's what I'll be providing you in this chapter.

Originally, I had planned to combine this chapter with Chapter 7, "Scenic Photography." That's because scenic and outdoor architectural photography share many of the same challenges and pitfalls and, in some cases, even the same subject matter. I decided to divide the topic in two: one chapter dealing with generally non-moving outdoors subjects that don't contain buildings or other structures, and this chapter, which deals with outdoor subjects that do contain buildings, with the addition of the topic of capturing interior views. The same techniques apply to a broad range of architectural subjects, whether you want to create photos for artistic purposes, for your real-estate listings, or to document the progress on a construction site.

225

What You Need

The equipment used for architectural photography is similar to that required for scenic photography, with a few differences. This section will explain the key requirements. There are a few optional add-ons you'll be interested in, too.

Your Architectural Camera and Lens

Just as with scenic photos, architectural subjects lend themselves to large prints, so you'll want to pack as many megapixels into your images as possible. Unless your photos are destined for web pages, a 3 MP camera is probably the minimum, and you'll be better served with a 5- to 8-megapixel model if you want to make large prints.

Some of the most dramatic architectural photos are taken at night, so you'll want a camera capable of long time exposures without excessive noise. A time-exposure setting, useful for the infamous "painting with light" technique (described later), is another important capability.

However, the most important consideration of all is your lens. You'll need a wide-angle lens and, up to a point, the wider the better. There are several reasons for needing a wide lens or zoom setting:

- For interior shots, you'll need a wide setting to capture most rooms or spaces. Unless you're shooting inside a domed stadium, cathedral, or other large open space, you'll find yourself with your back to the wall sooner or later. A wide-angle lens helps you picture more of a room in one image.

- Exterior photos often require a wide-angle setting for the same reason. The structure you're shooting is surrounded by other buildings, and you can back up only so far. A wide angle is required to grab an image from the best (or only available) vantage point.

- Wide angles help you include foreground details, such as landscaping, that are frequently an important part of an architectural shot.

Unfortunately, most digital cameras don't provide much in the way of a wide-angle view. The main problem is that the sensors are so small and the true focal length of the zoom lens is so short (frequently 7mm or shorter) that it's difficult to make a lens that's much wider. (Once you dip below a 5mm focal length, diminishing returns make a lens with a 4mm, 3mm, 2mm, or 1mm focal length a little ridiculous.) The 35mm equivalent of your digital camera's widest setting may be 37 to 39mm at worst, and no better than 28mm at best. Wide-angle attachments, like the one shown in Chapter 7, can help a little, but, like all lens add-ons, they rob you of a little resolution while introducing distortions and other image defects of their own.

As vendors create cameras with larger sensors, including so-called "full frame" sensors measuring 24×36 mm (the same as the 35mm film frame), wider lenses will become more common to digicam users. A digital SLR with a full-frame sensor can mount 24mm to 18mm true wide angles, as well as fish-eye effect lenses and other width expanders. The 4/3 (or Four-Thirds) system pioneered by Kodak and Olympus may eventually provide more flexibility in

lens choice for digital cameras, because the 4:3 aspect ratio can be used to design cameras (like the latest Olympus models) from the ground up so that sensor and lenses work together efficiently.

A lens with a wide f-stop is also desirable for nighttime and interior photos. Even if you want to use the smallest f-stop possible to increase depth-of-field, there will be times when you want to shoot wide open in very dim conditions. A "wide-open" setting of f2 is to be much preferred over one that's a paltry f3.5 to f4.8.

The final thing to watch out for is lens distortion. Some digital camera lenses produce lines that are slightly curved when they are supposed to be straight. For most types of photography, you might not even notice this distortion. Unfortunately, architectural design often depends on straight lines, even in structures that have curves, and any warps introduced by your lens stick out like a sore thumb. Figure 8.1 shows an image of an abandoned railway building taken with a lens that has, nominally, no distortion at all. Figure 8.2 displays typical lens distortion effects, exaggerated so you can see them clearly. At left, the photo shows *barrel distortion*, in which the straight lines are bowed outward toward the edges of the photo. At right, you can see *pincushioning*, with lines that curve inward toward the center.

Unless you're photographing barrels or pincushions, neither condition is desirable. Your lens may have one of these defects, although probably not dramatically, which would make it less than ideal for architectural photography. Test your lens by photographing a grid and then looking to see if the vertical and/or horizontal lines bow in or out. Andromeda makes a Photoshop-compatible plug-in called LensDoc that not only can correct for both kinds of distortion, but has built-in corrections for the tested distortion already found in some common Canon, Nikon, and Olympus digital camera lenses.

Figure 8.1 *This is a normal shot, with little or no distortion.*

Figure 8.2 *At left, the photo shows barrel distortion; at right, you can see the effects of pincushion distortion.*

Working with Tripods

A tripod is helpful for many kinds of architectural photographs. Certainly, indoor photos will often be taken using long exposures under the natural lighting present in the room or space, so a tripod is essential for holding the camera steady. Outdoors, a tripod makes a steady base for the camera so you can compose your shot carefully, and is also useful for making panoramic exposures. If you photograph a building at night, you'll want a tripod to hold the camera for exposures that can take a second or two.

The same kind of tripod you use for scenic photography, sports, or other imaging can be used for architectural work. Photographing structures frequently calls for a tripod with better than average height, because you'll sometimes want to position the camera at an elevated viewpoint either to shoot down on relatively short subjects or to bring the camera level with something other than the ground level of the subject.

Solving Architectural Photography Problems

I'm not going to run through different types of architectural photography in this chapter because, for the non-professional shooter, there isn't a lot of difference between them. Taking construction progress photos, real estate listing pictures, or shots intended for architectural firms all share a surprising number of characteristics when you examine their requirements closely.

What does differ are the problems you'll encounter. In fact, architectural photography is challenging precisely because each photograph you take is likely to involve several classical problems that are tricky to overcome the first time you encounter them. This section discusses some of the most common situations you're likely to run into, and offers advice on how to handle them.

Getting Permission

Your first challenge might be to discover whether you're allowed to shoot a picture of a particular subject in the first place. The good news is that most of the time you don't need permission to photograph the outside of a building or structure, especially those edifices that, on some level, exist expressly as a photographic opportunity. So, you don't have to ask if you can photograph the Pyramids of Egypt, the Eiffel Tower, or the Chrysler Building in New York City. The Pyramids are historical monuments; *la Tour Eiffel* has come to symbolize The City of Lights (and all of France); and the architecture of the Chrysler Building was deliberately designed to call attention to the success of the automotive company.

Groups of buildings, such as city skylines like the one shown in Figure 8.3, require no permission. Nor do you usually need permission to photograph ordinary office buildings or even private homes, as long as they are on what is called "permanent public display" and can be photographed from public places. If you have to make a photograph while standing on private property, you may need the permission of the property owner. Interior photos of non-public buildings may require permission, as well. Shooting photographs inside public buildings can be restricted, or there may be some limitations on whether you can use a tripod or electronic flash.

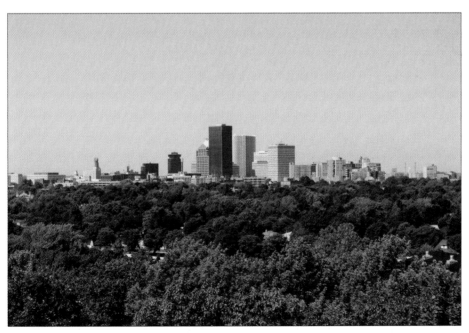

Figure 8.3 *City skylines can be photographed and used any way you want.*

Museums may limit flash photography. Towns may prohibit use of tripods in the public buildings or parks. Security forces at many manufacturing plants will offer to take custody of your cameras while you're on site. Secure facilities such as federal buildings, military installations, financial institutions, or airports may have guards who will automatically be suspicious of anyone attempting to take pictures. I was innocently taking family photographs of my kids at Heathrow Airport in London a while back, when I was approached by a British policeman who informed me in the most apologetic way that what I was doing was prohibited. I'm glad I didn't try to whip out a tripod and set up for a more formal shot!

Use of the photographs you create is another matter entirely. Private and editorial use, as in books like this one, generally requires no special permission. However, if you want to use a photograph of someone's home in an advertisement or other marketing application, you'll want to get the owner's permission.

Choosing Your Shot

Like scenic photos, architectural photographs require a bit of planning so you'll be standing in the right spot, with the right lighting, at the right time. If you're just passing through, you might want to walk around the site and choose the best location on the spot. If you're aiming for a more formal image, you might scout the area, take a few test shots, and then come back at a time you select. For example, a building in a busy city might be best photographed on a Sunday morning when automobile and foot traffic is light. A Spanish castle might look best at sunset, from a particular angle.

Explore all the angles, try to visualize the lighting at different times of day, and look for the best location for your picture. Decide whether you want an overall view, or would prefer to capture just one façade. Do you want to emphasize the lines of the building, or the texture of its components? Your ruminations may reward you with an unusual photograph of a familiar architectural landmark. Later in this chapter, you'll see a photo I took at a national monument in Spain. I've seen hundreds of different photographs of the overall scene at the Valle de los Caidos (Valley of the Fallen), but not one from the angle I chose. You'll discover the approach I used in the section "Shooting Details."

Use light and shade to give the structure a three-dimensional look, as in Figure 8.4. Avoid long lenses, which compress all the details together and produce a decidedly 2D appearance.

Perspective Control

Most non-architectural photographs are taken head-on, with the camera held level and pointed directly at the subject. The back of the camera is roughly parallel to the plane of the subject. The lines of the subject itself are generally at right angles or parallel to the ground. So, key elements of the subject, top to bottom, and side to side, are roughly the same distance from the camera's digital sensor. This perspective gives you an undistorted viewpoint.

The problems start as soon as you tilt the camera up or down to photograph a tall building or other vertical structure. Tilting the camera lets you take in the top of the structure, but the subject appears to be falling back, as you can see in Figure 8.5. (The same thing happens when

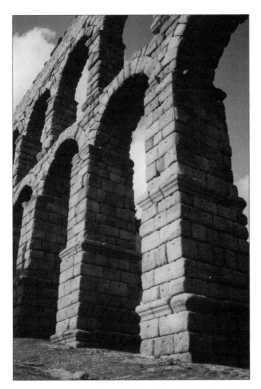

Figure 8.4 *Light and shade add a third dimension to photographs.*

Figure 8.5 *Tilting the camera to take in the top of a structure causes the subject to appear to be falling backwards.*

you angle the camera to either side to grab a picture of a receding object, such as a stone wall, but the results aren't as apparent or, usually, as objectionable.)

The most obvious solution, to step backwards far enough to take the picture with a longer lens or zoom setting while keeping the camera level, isn't always available. You may find yourself with your back up against an adjacent building, or standing on the edge of a cliff. The cathedral shown in Figure 8.5 happens to face a large plaza, and it is possible to back up 10 or 20 yards and take the picture from a more distant vantage point. Unfortunately, decorative trees planted in the plaza intervene, obstructing the view. You'll find many natural obstacles of this sort, making your architectural photography more complicated.

Switch to a wide-angle setting and you'll get more of your subject in the frame, but the top of the structure probably still won't be in view, as you can see in Figure 8.6. You can see from the illustration that the back of the camera is parallel to the plane of the monument. There's no distortion, but both the top and bottom of the monument are clipped off.

If you then tilt the camera to include the entire subject, you get the distorted photo shown in Figure 8.7. As in Figure 8.5, the subject appears to be falling back, and the base appears proportionally larger than the top, because it's somewhat closer to the camera. You can see from the illustration that the camera back/sensor and subject are no longer parallel.

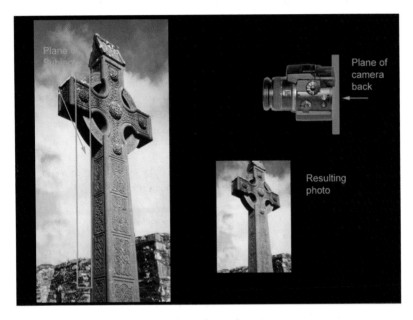

Figure 8.6 *When the camera back is parallel to the plane of the subject, the top and bottom of the monument are clipped off.*

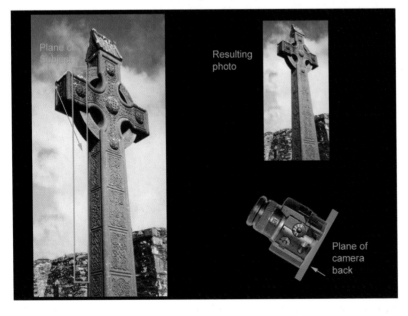

Figure 8.7 *When the camera is tilted to take in the top of the monument, a distorted view results.*

The traditional workaround to this dilemma is one that's generally available only to those who do a great deal of architectural photography. The solution for 35mm photographers is to use something called a perspective control lens, an expensive accessory that lets you raise and lower the view of the lens (or move it from side to side; perspective control can involve wide subjects as well as tall) while keeping the camera back in the same plane as your subject. I happen to own one of these quirky lenses, and haven't found it particularly useful. The amount of raising and lowering that can be applied isn't really enough for most situations.

A more sophisticated (and expensive) solution requires a professional camera called a view camera, a device that uses 4×5 inch (or larger) film, and has lens and film holders that can be adjusted to any desired combination of angles. Such cameras are capable of compensating for any reasonable amount of perspective distortion, but their use requires training and practice. Moreover, those who can't afford such gadgets, or who own digital cameras without interchangeable lenses, appear to be left out in the cold.

Fortunately, there are several solutions available. One can be applied on-site, if you're very, very lucky. Look around and locate a viewpoint that's about half the height of the structure you want to photograph. It might be a neighboring building or a bluff overlooking the site, or some other elevation. Ideally, there should be no trees or other undesirable subject matter to interfere with your shot. Then, shoot the picture from that position, using the widest lens setting you have available. You should be able to keep the back of the camera parallel with the structure, and both the top and base of the building will be roughly the same distance away from the camera. You'll get a much more natural-looking picture.

Another solution is hidden in your digital darkroom. You can use Photoshop to make some reasonable adjustments to the perspective of an image. Often, the manipulations are enough to fully or partially correct for perspective distortion. Photoshop's built-in tools are enough, but there are some specialized plug-ins, such as Andromeda's Perspective filter, shown in Figure 8.8, which make correcting distortion fast and easy.

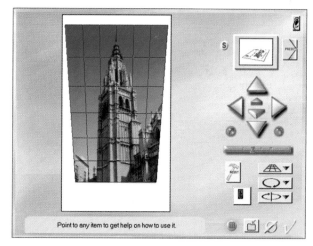

Figure 8.8 *Andromeda's Perspective plug-in can help you correct perspective distortion.*

I used the Andromeda plug-in to produce a corrected image of the rural church shown in Figure 8.9. This picture shows the kind of problems you can encounter. I spotted the church while driving down a country road, but discovered that the best, least-distorted viewpoint was from a position at the edge of the street. Unfortunately, utility poles and power lines intruded on the picture.

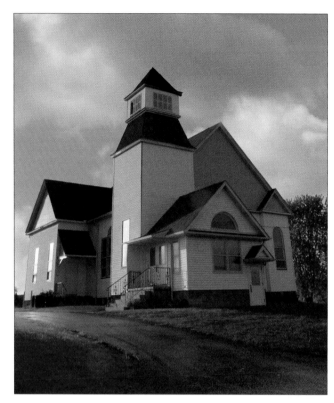

Figure 8.9 *Converging lines make this shot look like it was taken in a fun-house mirror.*

So, I had to get a lot closer. Using the digital camera's widest 28mm setting, the vertical lines of the church show pronounced tilt. It doesn't help that the shooting position at the end of the driveway was down slope from the church itself.

Using Andromeda's Perspective filter, I was able to visually correct most of the tilt (as shown in Figure 8.10). The triangle-shaped buttons at the center-right of the dialog box let you zoom in and out and rotate the image vertically or horizontally around the center point, as well as clockwise or counterclockwise. Preset camera positions are available to choose from, and any settings you apply can be stored for re-use later.

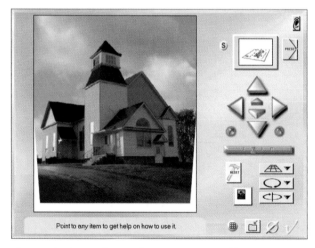

Figure 8.10 *Andromeda's Perspective filter can correct the bad tilt.*

The corrected image, shown in Figure 8.11, looks much less "tilty" and a bit more realistic. Compare the image to the original in Figure 8.9, or check out how closely vertical and horizontal guidelines in Figure 8.12 conform to the actual lines of the church.

Figure 8.11 *The final image looks much more realistic.*

Figure 8.12 *You can see how the guidelines correspond more closely to the actual lines of the structure.*

Shooting Details

Sometimes, the best way to picture a building is to capture individual snippets of its design. Indeed, parts of some buildings may be more interesting than the structure as a whole. Doorways, entrances, roofs, and decorations all make interesting photographs. Best of all, you can often use a telephoto or normal lens to capture details, avoiding the problems of perspective distortion entirely.

A case in point is the huge 500 foot stone cross that tops the underground cathedral, which the (still-dead) Generalissimo Francisco Franco had carved into the side of a mountain at the Valley of the Fallen outside Madrid. The cross is huge and can be seen from 30 miles away, so photographing it is not much of a problem, if you're satisfied with a mundane photograph like Figure 8.13.

If you look closely at the photograph, you can see the enormous stone sculptures of heroic figures clustered around the base of the cross, representing the four Evangelists. To get a better representation of the colossal sculptures (each more than 50 feet high), I ascended to the peak of the mountain and captured the photo of St. Matthew, shown in Figure 8.14. The perspective

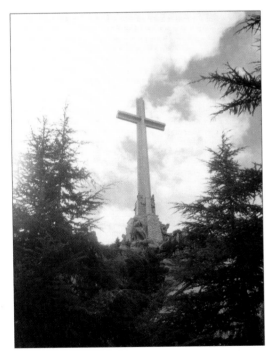

Figure 8.13 *This important monument to Fascist theatricality can be easily photographed in the traditional way.*

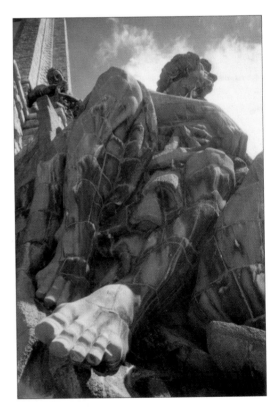

Figure 8.14 *Oddly enough, distortion isn't objectionable in this unusual perspective of a colossal sculpture.*

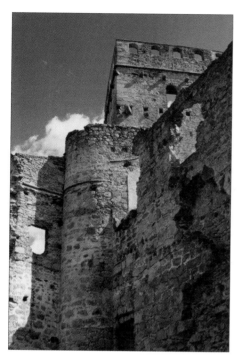

is all wrong: the feet look much larger than the head, for example. But, in this case, the distortion just serves to emphasize exactly how huge the sculpture really is. It seems to recede off into the distance as the huge stone figure rises toward the heavens.

In other situations, a detail may tell a little story about the structure you're photographing. Figure 8.15 shows the wall of a ruined castle. The gaping holes and crumbling stones weave a tale of assaults, sieges, and medieval warfare, even if the destruction happens to have been caused by natural erosion rather than combat. Cobblestones worn by the incessant pounding of human feet, weathered siding on an old barn, as shown in Figure 8.16, or even the shiny perfection of a slick new glass office tower can express ideas better than any caption.

Figure 8.15 *The ruins of a medieval castle are best captured in details, like this section of wall.*

Figure 8.16 *Weathered siding on this barn helps paint a picture of pastoral simplicity.*

Contending with Distracting Elements

I was able to photograph the rural church shown earlier in this chapter by getting a little closer to the structure and correcting the inevitable perspective distortion in Photoshop. In other cases, you won't be able to get close enough, because the distracting elements themselves abut your subject or are part of it. Figure 8.17 illustrates the problems you can run into.

Figure 8.17 *Air conditioners, shadows, an ugly sign, and power lines are only a few of the distracting elements in this photo.*

I wanted to photograph the school building for publication in its yearbook. Unfortunately, there were *a lot* of distracting elements, including two trees smack in front of the building, an ugly sign, some fencing, a plethora of utility lines, and even unsightly air conditioners perched in the windows. If you look closely at the original photo, you'll see a cola can on the lawn, shadows of trees, utility poles, and even the photographer himself intruding on the picture. This is one of those cases when there's not a lot you can do onsite, and you must rely on your image editor to repair the damage.

Here's what I did to capture the final image:

■ First, I carefully chose the day and time for the photograph to minimize potential problems. I waited until early Fall, when the two trees in front of the school had already shed their leaves, yet there was plenty of foliage on the other trees in the picture. I had the lawn raked and mowed so no trace of the leaves remained. Then, I selected a late afternoon time when the shadows on the building itself would be flattering and dramatic.

■ I took the photograph shown in Figure 8.17, ignoring the shadows cast on the lawn. I knew I would be fixing them later in Photoshop. Note that because of the distance I was able to stand from the school, there is very little perspective distortion.

■ In my image editor, I cropped most of the distracting subject matter out of the photograph, as you can see in Figure 8.18.

■ I copied sections from one part of the picture and pasted them over other parts that I didn't want. This surgery included putting a new window over the most distracting air conditioner at the upper left of the photo, and copying part of the left end of the building to eliminate the fence and storage shed.

■ Using the Clone/Rubber Stamp tool, I erased shadows, the ugly sign, and many of the utility lines extending to the building. The finished photo is shown in Figure 8.19.

Figure 8.18 *Crop out most of the distracting subject matter.*

Figure 8.19 *The finished photo looks a lot cleaner and more attractive.*

If you want to learn more about mending and enhancing photos using Photoshop, I recommend my book *Digital Retouching and Compositing: Photographers' Guide*, published by Muska & Lipman. It's full of projects like this one, with easy solutions to many digital photography problems.

Solving Interior Lighting Problems

Shooting indoors is one of the most difficult kinds of architectural photography you can face. Unless the interior is huge, your widest wide-angle setting may not provide enough of a view, and there certainly is no way you can back off further (although I've sometimes resorted to stepping outside and shooting through an open window). In addition, the lighting is likely to be problematic, presenting one or more of the following predicaments:

- ■ *Insufficient light.* The illumination is so dim you're forced to make a long exposure with the camera mounted on a tripod.

- ■ *Uneven illumination.* The light may be strong in one area of the interior, and dim in another, making it difficult to evenly expose the entire image.

- ■ *Harsh illumination.* Glaring lighting can give an image excessive contrast.

- ■ *Mixed illumination.* You may have daylight streaming in the windows, mixing its blue light with the orangish incandescent illumination of the room.

- ■ *Off-color illumination.* The light in the interior may be distributed evenly, diffuse and pleasant, and entirely the wrong color, thanks to fluorescent lighting or, worse, colored illumination. Your digital camera's white-balance controls might or might not be able to correct for this problem.

Insufficient illumination can sometimes be countered by using a tripod-mounted camera and a long exposure. If the light is evenly distributed and otherwise pleasing, a longer exposure may do the trick, as long as your camera isn't subject to excessive noise during long and time exposures. Sometimes using a lower ISO setting helps reduce noise, although at the cost of even longer exposures. Figure 8.20 shows a photograph captured in the very, very dim interior of a cathedral using a tripod. Many public buildings don't allow tripods, but you might be able to get special permission to shoot at a certain time.

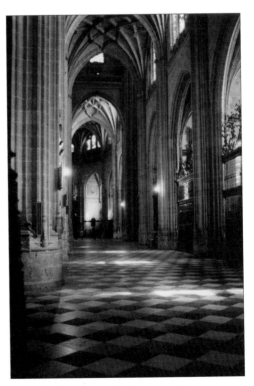

Figure 8.20 *Dim lighting conditions can be overcome with the use of a tripod.*

Uneven and harsh illumination can be fixed by additional lighting, softening existing light, or, perhaps by using reflectors to spread the illumination around. Figure 8.21 shows the interior of the world's most successful unknown digital photography author's office, illuminated entirely by the light from a pair of windows. I softened the light by closing the blinds, used a couple large white reflectors at the camera position to spread a little light to the foreground, and then decided to allow the windows themselves to become overexposed. The only reason I was able to get back far enough (this office measures only 24 × 16 feet) was that I stood in the next room and shot through the open doorway.

Figure 8.21 *The windows that provide the illumination were allowed to be overexposed so that detail could be preserved in the rest of the photograph.*

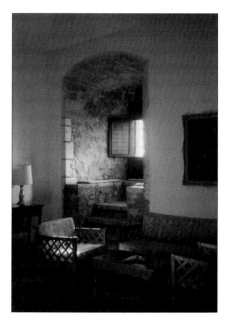

If you encounter mixed illumination and don't want to use it as a special effect, your best bet is to settle on one source or another, and stick with that. If you want to use the blue daylight coming through a window, you'll have to dim the room's incandescent illumination and, perhaps, substitute soft, diffuse electronic flash (say, bounced off a piece of white cardboard). Or, cut the room lights entirely and use reflectors, as was done for the photograph in Figure 8.22.

Figure 8.22 *Solve mixed lighting problems by eliminating one of the light sources. In this case, window illumination was used instead of the room's incandescent lighting.*

This room in a converted castle tower in Villaba, Spain, had walls that were five feet thick. The light streaming in from the open window was used to illuminate the whole room. I let the furniture and other foreground details go dark in order to preserve the medieval mood of this photograph.

TIP FROM THE PROS: CUSTOM WHITE BALANCE

Off-color illumination is best fixed by using your camera's custom white-balance controls. Many digital cameras have a custom setting. All you need to do is point the camera at something that *should* appear to be white, and create the custom setting from that. You'll find that most of the time this will fix off-color lighting conditions. Some specific kinds of fluorescent lights can be corrected using a fluorescent filter (such as an FL-D), available from your photo retailer. Another remedy is to include a neutral gray card in the shot (or a similar one) and use that to make color corrections in Photoshop.

At times, it's better not to fool around with the lighting at all, and let the existing lighting set a mood, as is the case with Figure 8.23. The picture was exposed for the medium shadows, and the arches and furniture given over to a little washing out to provide a glowing, sunlit look to the image.

Figure 8.23 *Sometimes it's best to set the mood using the existing lighting, with no extra lighting or modifications.*

Weather or Not

Weather can be your friend or foe, depending on the situation and the kind of photograph you're trying to take. For example, a blanket of snow, like the one in Figure 8.24, can disguise many faults, such as an unkempt lawn, or roof in need of repair (both of which apply to this particular home). A picture like this can grace a holiday card, or be used as an illustration for a real-estate ad.

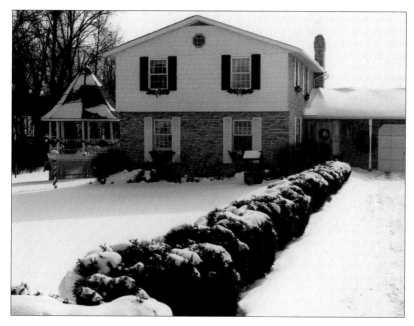

Figure 8.24 *Snowy weather needn't deter you from photographing architecture. The snow can add to your composition.*

When shooting in snow, make sure you use your camera's snow/beach exposure setting to avoid seriously underexposing the picture. Or, use your manual spot metering exposure option to expose for important shadow detail, like the front of the home in Figure 8.24. Because nobody expects to see much detail in snow anyway, in this case it was okay to overexpose the snow in the foreground in order to keep the detail in the home.

Rainy weather with a dull, lifeless sky can kill a photograph unless you figure a way to incorporate slick streets and reflections into the picture. You also might have problems setting up and taking a photograph in inclement weather. That doesn't mean, of course, that you need perfect weather for your photos. Bright, mid-day sunlight is often too harsh, so I often opt for late afternoon or early evenings. Slight overcast can soften the light and provide more even illumination, too.

If you must shoot at mid-day, try to make those shadows work for you. In Figure 8.25, the dramatic shadows accentuate the shape of the lighthouse, and help reinforce the strong, vibrant colors of the photo (accentuated by slightly underexposing everything except the white of the lighthouse itself).

Figure 8.25 *Strong shadows can help your picture if you make them part of the composition.*

Humor and Drama

Because architectural photographs concentrate on static buildings and other structures, you might find that a little humor or drama can improve the quality of your photograph. Look for some incongruous element, such as a street sign that makes an unintentionally ironic statement about the building, or a juxtaposition of several shapes that cause an unusual arrangement.

Figure 8.26 provides a little humor, and perhaps some social commentary, as two clusters of birds—white seagulls and dark gray pigeons—all cluster for warmth on the roof of a home during a slight winter thaw. The unexpected sight of dozens of avian refugees on the roof, all lined up by species, gives a lighter touch to the photograph.

More dramatic is Figure 8.27, which uses the vivid colors of a sunset to add some interest to a mundane shot of some suburban backyards. Many sunsets are worthy of being photographic subjects in their own right (as you'll recall from the last chapter), but you can also use them to enhance other subject matter.

Documentation

Construction photography is one type of architectural imaging that presents a special problem. You not only need to find the best angle (or angles) to shoot your subject matter, you need to be able to use that position repeatedly, at intervals ranging from a few days to a few weeks. If you want to document the construction of a building, you'll need to do your planning up front. You'll have to find a position that will remain accessible throughout the construction, and

Figure 8.26 *A little humor can brighten a mundane photograph.*

Figure 8.27 *A little drama doesn't hurt, either.*

mark it so you can set up at that spot in the future. Another structure that isn't going anywhere is a good choice, particularly if you can get permission to mark the position with tape or paint. Set up your tripod, mark the position of each leg, adjust the height of the tripod post, and record the angle of the camera. Note the zoom position you used, too. Then, when you return, you can take another photo from virtually the same position.

Perhaps your goal is not to document the entire construction process. When I built the addition that became my office, the construction crew got a late start in October and hadn't finished when an early winter hit, so they planned to hold off finishing the work until Spring. I took the picture shown in Figure 8.28 to document what needed to be done (which included painting of the deck railings). Then, when the structure was finished, I took additional photos that showed places that had been missed, such as the painting that needed done above the steps in Figure 8.29. Because I had everything photographed, it was easy to show the contractor what was required.

Your construction photographs can come in handy for insurance purposes, too. I cobbled together the playground shown in Figure 8.30 without using any plans or formal designs, so when one of the trees in the background fell during a windstorm and reduced it to kindling and cracked plastic, the picture came in handy in helping the insurance company come up with an estimate of the replacement cost. If disaster strikes, you might be glad you went around the interior and exterior of your home documenting each room and part of the structure.

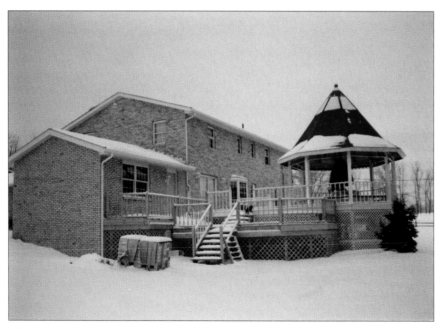

Figure 8.28 *Document your construction project to show what needs to be done.*

Figure 8.29 *Take a photo of the finished project to demonstrate that it's been completed satisfactorily.*

Figure 8.30 *This construction photo came in handy when the playground was destroyed by a falling tree.*

Project for Individual Study: Painting with Light

I think you'll find this project a lot of fun, because there are lots of different effects you can achieve. Painting with light is just that: using a light source to daub illumination over a dark subject during a time exposure. You can use this technique to provide good lighting for architectural subjects that are too large or too dark even for a long exposure with your camera mounted on a tripod.

Here's a quick description of how to paint with light:

1. Choose a subject that has insufficient illumination, or which is illuminated unevenly. If possible, select an environment that has few, if any, strong lights pointed directly at the camera. External security lights on the building, for example, should be doused if they're pointing toward the lens. Some light sources, such as city lights in the background, won't hurt anything and may even add interest.

2. Mount your camera on a tripod and compose the photograph.

3. Set the camera for a time exposure. (Make sure your camera has this capability!) You may have to experiment with the right f-stop, but you'll want a fairly long exposure in order to give you time to do your painting. Ten to 20 seconds, to a minute or two is the exposure to shoot for. Setting your camera to a lower ISO rating (ISO 64 to 100) will let you use longer exposures but, of course, will reduce the amount of exposure from your external flash units.

4. Start the time exposure.

5. Move into the scene, and keep moving as you paint so your body won't show up in the picture. You'll find that with a two-minute time exposure, a rapidly moving person won't register at all as long as you keep spill light from your electronic flash from hitting you.

6. Keeping your body between the camera and your external electronic flash, trip the flash to expose one part of the building. Move around and expose other parts with additional flash exposures. Because your camera's lens is open, it will register each of these exposures.

7. Go back to the camera and close the shutter, ending the time exposure.

8. Check your results on your camera's LCD screen, and repeat the process, making appropriate changes to improve your photo. You might want to use a longer exposure, more flashes, or work harder to keep yourself from showing up in the picture.

There are many variations on this theme. Here are a few to play with:

■ Alternate flashes using multi-colored gels over your unit, painting your building with a rainbow of different colored lights.

■ Paint only part of the structure, allowing the rest to remain in shadow. This is a good way of disguising the less-photogenic portions of a building.

■ Instead of an electronic flash pointed *away* from the camera, use a flashlight pointed *towards* the camera, and "write" with it. Small beams, such as those provided by penlights, work best. Trace the outline of a portion of the building, draw a human figure, or create any other kind of light writing you want.

Next Up

We'll conclude this book with a chapter on shooting up close and personal, using macro photography to capture images of everyday objects from an unusual perspective. Whether you're grabbing images of your collection of pewter soldiers, or just want to see what a tree frog looks like photographed from an inch away, I think you'll enjoy exploring the contemplative world of close-up photography.

Macro Photography

Every type of photography presents its own challenges and unique rewards, and macro, or close-up, photography is no exception. Some types of close-up pictures involve inanimate objects that will remain stolidly in front of your camera for hours while you arrange lighting and choose the perfect angle. Other macro photographs picture flighty living creatures that can scarcely be coaxed to remain in the frame long enough for an exposure or two. You can take leisurely close-up pictures indoors in a mini-studio of your devising, or take your work outdoors and suffer the vagaries of the environment. Macro photographs can picture the familiar in new ways, or result in images that are abstract and thought provoking.

In short, if you're jaded by portraiture, no longer turned on by taking scenic photographs, and have had enough of action photography for a while, macro photography is a whole new ballgame. The rules are easy to learn, and you probably already have all the skills you need to knock one out of the metaphorical park. Getting up-close and personal can spark your creative energies and prove to be a rewarding outlet.

This chapter should provide you with everything you need to know to get great close-up pictures.

Made for Each Other

If it seems as if shutter lag and other features of digital cameras were designed to make action photography difficult, the reverse is true for the macro-photographic realm. Many features built into every digital camera make these image grabbers ideal for taking close-up pictures. If

you've been doing macro photography with film cameras, a few sessions with a digital camera will convince you that digital technology is exactly what you've been waiting for.

For example, digital cameras have an LCD display that makes it easy to frame your photo precisely. Conventional film cameras of the non-SLR variety do a very poor job of showing you what the image will look like at close distances. Cutting off the tops of subjects, unwanted trimming at the sides, and other blunders are common. Yet, even the least expensive digital point-and-shoot camera can show you virtually the same image that will be captured, using the color LCD screen on the back of the camera. That's important for framing the image, but equally useful when it comes to lighting your subject.

Focusing a close-up image can be tricky with a traditional non-SLR camera, too. It's easier to focus with the display of a digital camera (assuming you can shield the LCD screen from extraneous light and can see it clearly) if you need to, but the autofocus mechanisms of these cameras generally do a good job of locking focus in for you. Moreover, digital cameras have much more depth-of-field at a particular magnification, so you'll find that more of your subject is in focus. The majority of digital cameras have close-focusing capabilities, too, whereas many film cameras are able to focus no closer than a foot or two.

When film cameras ruled, it was common for professional photographers to shoot instant photographs of any sort of complicated studio setup (close-up or otherwise) to confirm that the lighting, composition, and other factors were perfect. After all, by the time the film was processed, the close-up setup might have been torn down to make room for a different photo shoot. Reproducing a setup is expensive and time-consuming. Your digital camera is better than a Polaroid-style instant camera, because you can review the *exact* photograph that was taken, moments after the exposure. You can keep taking pictures until you're satisfied that you have the precise image you were looking for.

Most digital cameras focus a lot closer than their non-SLR film camera counterparts, making them much more suitable for close-ups. Digital camera lenses are more compact, which means that engineering close-focus capabilities is a lot easier for the designer. Moreover, it doesn't make a lot of sense to have macro capabilities in a point-and-shoot camera that do not accurately frame the image at close range anyway.

Macro photography is convenient. You don't have to jump into your car or travel by plane to photograph something that's out of the ordinary. That weird crystal saltshaker you found at a garage sale might be a perfect subject when you zoom in close to capture its angles and texture.

Close-up photographs can work hand-in-hand with your other hobbies, too. Coin and stamp collections are such obvious subjects that I'm almost ashamed to mention them. What about those works of art you painted on single grains of rice? A close-up photograph may be the only way to appreciate them. Do you work with ephemeral subjects, like flowers that bloom only for a short time, or study the intricacies of spider webs? A digital photo can live on long after your original subject no longer exists. If model train layouts are your thing, close-up photos can bring them to life. You might be surprised at how much macro photography can add to your favorite avocation.

Close-ups Up Close

Whether you call it macro photography or close-up photography, the meaning is the same: taking photographs of objects, usually from 12 inches or less (frequently *much* less). Macro photography is *not* microphotography (that's the production of little tiny photos, such as microfilm images); nor is it photomicrography (taking pictures though a microscope). Macro photography is nothing more than up-close pictures of everyday things caught in the act of being themselves. Because the intimate viewpoint is unique, the results can be fascinating.

There are several ways to achieve a close-up view with a digital camera. One way is to step back from a subject and zoom in with a long lens to provide a tight view using the telephoto/zoom's magnification. Another way is to get in very, very close and use proximity as a way of getting the look you want. A combination of the two methods is also possible, if you have a telephoto lens/zoom setting that allows you to focus close, too. There are several important considerations to deal with in close-up photography, and I'll address all of them in this chapter.

Magnification

The newcomer to macro photography invariably wants to know "how close can I get?" That's a logical question. If you're used to taking pictures of subjects that are located from six feet to infinity, the desire to get close, preferably as close as possible, takes on special significance. However, if you think about it, the distance between your lens and the subject isn't the most important thing. You want a bigger view of your subject, so the size of the subject on your sensor (or film) is the key factor. Instead of focusing on distance, think *magnification*.

It's easy to see why, through a simple thought experiment. You don't even have to whip out your camera. Imagine taking a photograph of a coin from your coin collection from eight inches away, with your camera set to its widest zoom setting, say, the equivalent of a 35mm lens. Now, move the camera back so it's 12 inches away from the coin, but zoom in to your camera's maximum telephoto setting, say, 200mm. (Not all cameras can focus close at all zoom settings, but, fortunately, this is a thought experiment.) Which photograph will have the larger image? Which will be a more satisfactory close-up of your coin?

Figure 9.1 shows an aloe vera plant photographed from about two feet away using the equivalent of a 28mm wide-angle lens. For Figure 9.2, I moved back to about 5½ feet and shot at the 80mm zoom setting. Note that the magnification of each image is exactly the same (at least, in terms of the flowerpot), even though one photo was taken at a distance that's nearly three times as far.

There are other differences in the photos, which I'll point out in the "Perspective" section.

In macro photography, it's not how close you can focus, but the final size, or magnification, of the image that is important. A lens that focuses very close only at the wide-angle setting will not produce the same results as one that focused close at both wide-angle and telephoto settings. Indeed, there are situations in which you'd want to use one or the other, because both

Figure 9.1 *This photo was taken using a 28mm zoom setting from about two feet away.*

Figure 9.2 *This picture was taken using the 80mm zoom setting from 5½ feet away.*

wide-angle and telephoto settings can produce distortions in your final image, depending on the subject matter and how close you are to it. (You'll find a recap on perspective distortion later in this chapter.)

Because final image size depends on the lens setting and distance to the subject, magnification is the most useful way of expressing how an image is captured with macro photography. If your magnification is 1×, the object will appear the same size on the sensor (or film) as it does in real life, completely filling the frame. At 2× magnification, it will be twice as big, and you'll only be able to fit half of it in the frame. At .5×, the subject will be half life-size and will occupy only half the width or height of the frame. These magnifications are most commonly referred to as ratios: 1× is 1:1, 2× is 2:1, .5× is 1:2, and so forth. As you work with close-up photography, you'll find using magnifications more useful than focusing distances.

Perspective

Another important factor in macro photography is the perspective of the camera. Earlier in this section, I mentioned that close-up pictures could be taken from a relative distance (even if that distance is only a few feet away) with a telephoto lens or long zoom setting. The same magnification can also be achieved by moving in close with a shorter lens. The same apparent perspective distortion that results from using a wide-angle lens close to a subject, and the distance compression effects of a telephoto, apply to macro photography (see Chapter 6, "People Photography," for more on these effects).

So, if you have a choice of tele/wide-angle modes for macro photography, you'll want to choose your method carefully. Relatively flat subjects without a great deal of depth and those that can't be approached closely can be successfully photographed using a telephoto/macro setting. Subjects with a moderate amount of depth can be captured in wide-angle mode. If you find that a wide setting tends to introduce distortion, settle for a focal length somewhere in between wide and telephoto.

The most important types of subjects affected by perspective concerns are tabletop setups such as architectural models and model railroad layouts. Use the right perspective, and your model may look like a full-scale subject. With the wrong perspective, the model looks exactly like what it is, a tiny mock-up.

You can see the difference perspective makes by comparing Figures 9.1 and 9.2. Objects that are closer to the camera appear proportionately larger in the wide-angle shot, compared to the version shot with the longer zoom setting. It's most noticeable if you compare the stool seat the plant is resting on. In Figure 9.1, the stool seat looks larger and "wider," whereas in Figure 9.2, the seat is more compressed (which is what telephoto lenses do). For a given magnification, you'll want to choose the focal length of your lens carefully to provide the kind of perspective that you're looking for.

Lighting

Lighting is an important aspect of all types of photography, of course, but it becomes more difficult when dealing with close-up subjects. Here are some of the challenges involved:

- The camera may be so close to the subject that there isn't room to light the front of the subject.

- Your camera's built-in flash is probably aimed "over" the subject and either won't illuminate it at all, or will only partially illuminate it.

- Built-in flash may be too powerful for close-up photos, or be unable to reduce power enough to compensate for the close distance.

- Your camera's lens itself may cast a shadow on the subject.

- Your light source may be visible in the frame, or cause glare.

There is a variety of solutions to these lighting problems, and I'll address them as we move along. Special lighting gear, such as ringlights that fit around the lens, or light-softening setups, such as lighting "tents," can help.

Depth-of-Field

The depth of sharp focus with three-dimensional subjects can be a critical component in macro photography. You'll find that depth-of-field is significantly reduced when you're focusing close. Although the relatively short focal length of the lenses attached to many digital cameras provides extra depth-of-field at a given magnification, it still might not be enough. You'll need to learn to use smaller apertures and other techniques to increase the amount of sharp subject matter, if you have problems like the one shown in Figures 9.3. and 9.4. If you focus on the cup in front, the jug in the background might be out of focus. Focus on the jug, and the cup might be out of focus.

Figure 9.3 *At a wide-open aperture, focusing on the background means that only the jug is in focus.*

Figure 9.4 *Focusing on the cup brings it into sharp focus, but makes the jug appear blurry*

Composition

Good composition is as important with macro photography as with any other type of picture taking. The challenge is to achieve a pleasing composition when even small changes in camera position can drastically modify the arrangement of your subjects. If you're taking pictures of inanimate objects, you might be able to arrange the subjects any way you like. If you're attempting to capture a ladybug or other living creature, you might not have that luxury.

What You Need

Close-up photography can be equipment-intensive if you want to get fancy, although in most cases you can get by with the basic capabilities of your digital camera. Once you become immersed in macro photography, however, you'll probably want to add a few accessories. This section will tell you exactly what you need to have to shoot good close-ups.

Your Camera

You'll need a digital camera with close-focusing capabilities, and a way to frame your images accurately. Fortunately, those two features are common to just about every digital camera made. Even low-end fixed focus digital cameras with no zoom may have a "macro" setting for close-up pictures.

The minimum distance your camera can focus will vary with the focal length and other physical properties of the lens. One way close focus is achieved is to move the lens farther away from the sensor. A 7mm (actual focal length) digital camera lens moved 14mm from the sensor can focus at half the distance of the same lens at 7mm from the sensor. Because the

actual focal length of most digital camera lenses is so short, it's relatively easy to design a camera that can move the lens a moderate distance from the sensor, achieving a relatively close minimum focus distance.

Cameras with larger sensors (and therefore longer focal length lenses for a particular magnification) require greater distances between the center of the lens and the sensor. This is particularly true with digital SLRs. Fortunately, these cameras can be equipped with extension tubes and other aids (discussed later) that provide the necessary distance.

The second requirement is a viewfinder that lets you compose your image accurately. Digital cameras that use an optical viewfinder actually provide a slightly different view of the subject than the one the sensor sees. If the optical "window" is directly above the taking lens, you'll see more at the top of the frame at close distances than the sensor sees. If the window is to one side, you'll see more of that side than the lens. Should the viewing window be placed both above and to one side, your actual image will be "clipped" in two directions. This viewing phenomenon is called "parallax error."

You won't have this problem if you have a digital SLR that allows viewing through the same lens used to take the picture, or if your camera is equipped with an electronic viewfinder, an internal LCD that displays the image from the camera's sensor. Nor will you have parallax problems viewing the image on the LCD display on the back of the camera. Some find the camera-back LCD clumsy to use and difficult to view in bright light (unless you use an add-on light shield), but when composing a close-up image, it's preferable to relying on an optical viewfinder alone.

Some digital cameras have a composite video out connector that allows displaying the sensor's image on a TV screen or monitor (use the yellow composite video in connector of your TV/monitor). This option may be the best of all for non-SLR users for at-home shooting, as it is big and bright and easy to focus.

Close-up Lenses

Close-up lenses come in two types. One kind is an actual lens designed for close-up photography and used with cameras that have removable optics. However, these are usually referred to as *macro lenses*. When we talk about close-up lenses, we're usually talking about screw-on, filter-like accessories that attach to the front of your camera's prime lens.

These add-ons are useful when you want to get even closer than your camera's design allows. Many digital cameras focus down to an inch or less. That's usually as close as you'll want to go, because if you get much closer than that, a three-dimensional object will be very difficult to light. There simply wouldn't be enough room between the lens and subject to allow decent lighting. An exception would be if you were photographing a transparent or translucent item, such as a transparency, but in most cases, being able to focus a few inches away is close enough.

However, some vendors have a looser definition of close focusing, so you might happen to own a digital camera that allows getting no closer than a foot or two. Or, perhaps you own a fixed focus digital camera that offers acceptable sharpness for everything from a few feet to infinity.

You, too, can take close-up pictures if you know the secret. You might have to choose your camera's macro setting, and then set focus distance manually using a dial, but you'll still be able to take close-ups.

TIP FROM THE PROS: A CAP STRAP RULER

Is your lens cap tethered to your camera by a chain or strap to keep it from getting lost? Consider putting markings on the strap with nail polish so you can use it as an impromptu measuring tape when you need to gauge distance manually.

Close-up lenses, like the one shown in Figure 9.5, are generally labeled with their relative "strength" or magnification using a measure of optical strength called *diopter*. A lens labeled "No. 1" would be a relatively mild close-up attachment; those labeled "No. 2" or "No. 3" would be relatively stronger. Close-up lenses are commonly available in magnifications from +1 diopter to +10 diopters.

The actual way close-up magnification is calculated is entirely too complicated for the average photographer (unless formulas like Magnification at Infinity=Camera Focal Length/(1000/diopter strength) are your cup of tea) and not particularly useful. That's because the close-focusing distance varies with the focal length of the lens and its unenhanced close-focusing capabilities.

Figure 9.5 *A close-up lens can bring you even closer than your camera's minimum focusing distance.*

However, as a rule of thumb, if your lens normally focuses to one meter (39.37 inches; a little more than three feet), a +1 diopter will let you focus down to one-half meter (about 20 inches); a +2 diopter to one-third meter (around 13 inches); a +3 diopter to one-quarter meter (about 9.8 inches); and so forth. A +10 diopter will take you all the way down to about 2 inches—and that's with the lens focused at infinity. If your digital camera's lens normally focuses closer than one meter, you'll be able to narrow the gap between you and your subject even more.

In the real world, the practical solution is to purchase several close-up lenses (they cost roughly $20 each and can often be purchased in a set) so you'll have the right one for any particular photographic chore. You can combine several close-up lenses to get even closer (using, say, a +2 lens with a +3 lens to end up with +5), but avoid using more than two close-up lenses together. The toll on your sharpness will be too great with all those layers of glass. Plus, three lenses can easily be thick enough to vignette the corners of your image.

Bellows and Extension Tubes

Those who own digital SLRs have all manner of accessories they can purchase to focus even closer. These all function by moving the lens farther away from the sensor, allowing you to reduce the distance between the subject and the lens. Bellows, like the one shown in Figure 9.6, are accordion-like attachments that move along a sliding rail to vary the distance between lens and camera continuously over a particular range. Extension tubes are fixed-length tubes with a male lens mount on one end (to fasten to your camera) and a female lens mount on the other (to accept your camera lens). They provide a fixed amount of magnification, but are commonly available in several different thicknesses.

These extenders can produce sharper results than you get with close-up lenses, particularly when used with specialized macro lenses.

The downside is that these attachments are expensive (as much as $100 or more) and reduce the light reaching your sensor by a factor of 2× to 4× or more (depending on the amount of extension). You'll probably have to make exposure readings in manual mode, too. Unless you're taking a great many close-up photos, you probably don't need them.

Figure 9.6 *Digital SLRs can be equipped with sophisticated bellows attachments like this one.*

Supporting Players

Although it's possible to shoot close-up photographs on the fly, macro photography is really easiest and most effective when done carefully, with deliberation, and a lot of forethought. That usually means you'll want to place your camera on a tripod so it stays put while you're arranging your subject matter, and doesn't jiggle during the exposure. If you're using auxiliary light sources, or a background of some sort, you'll want to have supports for them, too.

Tripods

A good tripod is almost essential. It not only frees you from needing to have three or four different hands, but it makes it easier to focus and frame an image through a digital camera's LCD screen. A tripod is also a consistent and repeatable support, so if you're taking photographs of your model-train collection, the camera can remain the same distance from your rolling stock picture to picture and session to session.

You'll quickly discover that not just any tripod is suitable for close-up photography. Some models are little better than camera stands and the worst of them wobble more than you do. Digital cameras are so small (many weighing only a few ounces) that you might be tempted to

go with an equally petite tripod. Don't succumb to the temptation! Although you might not need a heavy-duty studio tripod like the one I use, you still need something that's rigid enough not to sway while you compose your image, and heavy enough to remain rock-solid during a long exposure. There are smaller tripods available that don't flex under tiny amounts of pressure and resist swaying with every gust of wind or other minor environmental shakes.

Camera supports come in a variety of sizes and shapes, from single-leg unipods, best suited for sports photography, to tiny tabletop tripods and full-sized studio units. A small, but solid tripod is a good choice if size alone makes the difference between whether you'll carry the tripod with you or not. A tabletop tripod or clamp-style camera mount is generally best used in the same way as that first aid kit in your trunk: you hope you never need to use it, but carry it with you everywhere, just in case.

Here are some things to look for in a tripod used for close-up photography:

■ Legs that adjust easily so you can change the height of the tripod quickly. You'll need to make some altitude adjustments while taking pictures, of course. However, you'll find that you frequently need to set up a tripod on uneven surfaces, from stairs (indoors) to a sloping hill (outdoors). Legs that adjust quickly make it easy to set each leg at a different appropriate length for a steady mount on a less-than-flat surface.

■ Sure-grip "feet." Rubberized feet at the end of each leg are good for gripping slippery surfaces. Some tripods have feet that can be adjusted to use spiky tips that can dig into dirt, grass, or other iffy surfaces.

■ An adjustable center column. You'll need one that's long enough to let you move the camera up or down by a foot or two without the need to adjust the legs.

■ A center column that's reversible. This feature comes in handy when you need to point the camera directly down at the floor for some close-ups.

■ A tilt-and-swing head that flips in horizontal and vertical directions, or a ball head that swivels in all directions, so you can quickly change the camera angle. With some professional tripods, the tilt-and-ball heads are a component that's purchased separately.

■ Cross-bracing that holds the legs of a light-weight tripod rigid even when extended fully. Sturdier tripods, like the one shown in Figure 9.7, might not need any cross-bracing.

■ Locks that let you tightly fix the legs, center column, and tilt head at precisely the position you want.

Figure 9.7 *A sturdy tripod can last you a lifetime.*

If you take pictures of small, flat objects (such as stamps, coins, photographs, or needlepoint), you might want to consider a special kind of camera support called a *copystand*. These are simple stands with a flat copyboard and a vertical (or slanted) column on which you fasten the camera. The camera can be slid up or down the column to adjust the camera-subject distance. A slanted column is best, because it ensures that the camera remains centered over a larger subject area as you move the camera up. Copystands provide a much more convenient working angle for this type of photography, particularly if your digital camera allows swiveling the lens and viewfinder in different directions.

TIP FROM THE PROS: DON'T CARRY THAT WEIGHT

When you're shooting in the field, take along one of those mesh bags that oranges come in. You can fill it up with rocks onsite, tie it to the center support of your tripod, and use it to add extra hill-hugging weight to a light-weight camera support.

Other Supports

If you're shooting indoors, you'll want supports for your background and lighting equipment, if you plan to use them. Like a tripod, these are all once-in-a-lifetime expenditures. Go ahead and splurge, because tripods and stands are not the sort of equipment that quickly becomes outmoded by advancing technology. I'm still using the same light stands and tripod I purchased while in college, and amortized over the time that's elapsed since, they've cost me roughly $10 a year. Of course, that doesn't mean you need to spend a fortune. You can even make some of the supports yourself.

Light stands, for example, are basically simple telescoping aluminum tripod-like affairs, like the one shown in Figure 9.8 that can hold any auxiliary lighting you plan to use, whether it's incandescent or electronic. You can buy 7-foot light stands, but I sprung for the 9-foot tall variety because they have a larger, steadier base and a little extra height so they can be used as a background support.

Background supports themselves can be light stands, or something you make yourself, depending on what kind of background you're using. Cloth backgrounds are light in weight and can be supported by just about anything you care to set up, including duct tape applied to nearby

Figure 9.8 *Light stands can support backgrounds, lighting equipment, and other things.*

furniture. (I've taped backgrounds to the bookcases and fireplaces from time to time.) If you're tearing down your "studio" often, you might want to use light stands. You can set one stand on either side of your shooting area, place a wood dowel between them as a horizontal support, and drape your cloth over that.

Paper rolls are more challenging, because they can weigh 20 to 30 pounds each. Good-quality light stands may be able to support them if you use a metal pipe or thick wood closet pole as your horizontal support. Or, build something out of 2 × 4 lumber if you're handy. When I've had a permanent studio, I usually nailed multiple homemade supports to the ceiling rafters so I could have five or six rolls of paper in different colors all hung at the same time.

Lighting Equipment

As I mentioned earlier, the lighting used for close-ups can make the difference between a successful picture and a so-so effort. You can choose from the existing light (modified with reflectors if need be), electronic flash units (or incandescent illumination such as photoflood lights), high-intensity lamps, or other auxiliary lighting. If you want to be pedantic, you can also shoot close-ups with light emitted by the subject itself, so if you have some lighted candles or lightning bugs to capture, knock yourself out.

Working with Existing Light

The existing light that already illuminates your subject may be the most realistic and easy to use option for close-up photos, as long as you're prepared to manipulate the light a bit to achieve the best effect. That's particularly true when you're shooting on location or outdoors. Making the most of the existing light means not having to set up special light sources or possibly locating a source of electrical power (not always an option outdoors).

Available light can be contrasty, providing enough illumination for the highlights of your subject, but with not enough light to open up the shadows. It might also be too dim overall, or too bright. You can usually fix these failings with a variety of reflectors and light blockers. You can buy these tools if you like, but it's often just as easy to make your own in the exact shape and size that you need. As a bonus, you can use reflectors and light attenuating accessories with your electronic flash units, too.

The next sections detail some recommended tools and what you can do with them.

White Cardboard

The best and most versatile light tool is a piece of white cardboard. It's cheap, disposable, and you can do dozens of things with it. Here are a few ideas on using white cardboard:

- Fold it up into quarters to make it more compact. Having a few creases won't hinder your cardboard's utility as a reflector in the least. You can unfold only as much as you need for your photograph.

- Use white shades, but mix in some colors. Most of the time you'll want a neutral white board, but you can carry orange and light-blue versions to warm up or cool down the

shadows of your picture. You might find, for example, that the highlights of an object are illuminated by diffuse sunlight, but the shadows are filled in by reflections off a bluish object. An orange reflector can balance the color quickly.

■ Use the cardboard to block light, too. While you'll generally use the cardboard to reflect light onto your subject, you'll find you can use it to block direct sunlight and create soft shadows where none existed before.

■ Cut holes in the cardboard for special effects. Motion-picture lighting often uses "cookies" to create special lighting shapes and effects. What? You thought those shadows on the wall were cast by *real* Venetian blinds? Use your imagination and cut some holes in your cardboard to create a halo around your subject or some other effect. Move the cardboard closer to the subject to make the highlight harder, and farther away to soften it.

Foamboard

Foamboard can make a great soft-light reflector, especially when you're shooting in your home studio. Those ultra-light boards of plastic foam sandwiched between paper or plastic sheets are commonly used to mount photos or to construct exhibits. They make great reflectors, too, especially if you need larger sizes that are rigid but also light in weight. They don't fold easily, and are probably more useful for portraits and group pictures, but if you have a small hunk of foamboard, keep it handy.

Aluminum Foil

Aluminum foil provides a bright, contrasty reflection that can sharpen up soft lighting (if that's what you need). Tape aluminum foil to a piece of white cardboard (use the reverse side of your main cardboard reflector if you want). If you need lighting with a little less snap, just reverse the cardboard to expose the non-aluminum side. Be sure to crinkle the aluminum foil so it will reflect the light evenly; you don't want shiny hot spots.

Mylar Sheets

Those space blankets can do more than keep you warm at your campsite or in an emergency. They can be used as a handy high-contrast reflector, yet still folded up and carried in a pocket of your gadget bag. Every photographer should get two: one for the emergency kit in the trunk of your car, and another for photographic purposes.

Umbrellas

Photographic umbrellas used in the studio, available in white, gold, or silver surfaces, are compact enough to carry with you on outside close-up shooting expeditions. However, I favor white purse-sized rain umbrellas, like the one shown in Figure 9.9, that telescope down to six or eight inches in length, yet

Figure 9.9 *Purse- or pocket-sized umbrellas are perfect for macro shooting in the field.*

unfold to a respectable size. You can use these as a reflector to bounce light onto your subject, or as a translucent diffuser to soften the light that passes through them (perfect for use in bright sunlight when you can't find any open shade). And if it rains, you won't get wet!

Tents

If you're photographing a very shiny object, a light tent may be the best tool to even out your lighting. Photographic tents are usually made of a translucent material and are placed right over the object you're photographing. I'll show you how to make your own later in this chapter.

Black Cardboard or Cloth

Sometimes you need to block light from a glaring source to produce softer illumination. A sheet of black poster board works, although even black board reflects some light. For extra light absorption, consider a small piece of black velour. If you're trying to take photos of seashells in their natural habitat, a black cloth will help.

Electronic Flash

The electronic flash built into your digital camera may work fine for quick and dirty pictures, but usually it will provide illumination that is too bright, too harsh, and might not cover your subject completely. This is because built-in flash are typically "aimed" to light subjects that are at least a few feet away from the camera. It's more difficult to visualize how electronic flash illumination will look in the finished picture. While available light provides an automatic "preview," with electronic flash, what you get may be a total surprise. On the plus side, the short duration of electronic flash will freeze any moving subject this side of a hummingbird.

Electronic flash is most applicable to macro work indoors, especially if you plan to work with several lights and set them up on stands. Outdoors, you might be limited to one or two battery-operated flash units. Here are you choices for electronic flash used for close-up photography:

- *Built-in flash*. This is the flash unit built into your digital camera. You'll find that in extreme close-ups, the light it produces will look unnatural and may not illuminate your subject evenly. You probably can't aim the built-in flash in any meaningful way, and may find that the lens casts a shadow on your close-up subject.

- *External flash units*. Many digital cameras have a connector for attaching an external flash unit. These can be inexpensive flash units designed for conventional film cameras, or more elaborate (and more costly) devices with modeling lights, which are extra incandescent lamps that mimic the light that will be emitted by the flash.

- *Slave flash*. These are electronic flash units with light-detecting circuitry that automatically trigger them when another flash goes off. You can also purchase add-on slave detectors that set off any flash. Slaves are useful when you want to use two or more electronic flash. Keep in mind that you may need to disable your main flash's preflash feature to avoid tripping the slave too early.

■ *Ringlights.* These are specialized electronic flash units made especially for close-up photography. They have circular tubes that fit around the outside of a camera lens, providing very even lighting for close-ups. Ringlights are generally a professional tool used by those who take many close-ups, particularly with interchangeable lens cameras. If you can afford an SLR digital camera, and do enough close-up work to justify a ringlight, they make a great accessory.

TIP FROM THE PROS: REFLECTORS

If you're forced to use your camera's built-in flash, you still may be able to achieve acceptable lighting. Try placing a reflector or two just outside the picture area at the back and sides of the subject. A piece of white cardboard or even a handkerchief might be enough. The reflector bounces light from the camera's flash back onto the subject, providing a more even, softer light than you'd get with the main flash alone, as you can see in Figure 9.10.

Figure 9.10 *No special lights required for this shot. The camera's built-in flash and some white reflectors did the trick.*

Incandescent Lights

Good old-fashioned incandescent lights are usually your best tool for lighting indoor close-ups of things that don't hop around or wiggle. While not as intense as electronic flash, that's not usually a problem with your camera locked down on a tripod and with longer exposures. Most of the close-up illustrations in this chapter were taken with incandescent lighting. Their main advantage is that you see exactly what your lighting effect will be (indeed, studio flash units usually have an incandescent light, too, not for illumination but as a "modeling light").

Incandescent lights are cheap, too, so you can use several to achieve the exact lighting effect you want. The most important thing to remember when using them is to set your white balance manually, or make sure your camera's automatic white-balance control is turned on. These lights are much more reddish than daylight or electronic flash.

Any gooseneck high-intensity lamp or table lamp, like the one shown in Figure 9.11, that you can twist and turn to adjust its angle will work great as illumination for close-up pictures. Other types of lamps can also be used, but will be less flexible, so to speak, when it comes to positioning. High-intensity bulbs may have too much contrast, especially for shiny objects. You can use reflectors to soften their light, or investigate adjustable neck lamps that can use conventional "soft-white" light bulbs. Watch out for the heat generated by your incandescent lamps! They are a poor choice for photographing ice sculptures or chocolate candies, but a good choice for illuminating burgers and fries you want to be toasty warm after the shoot is over.

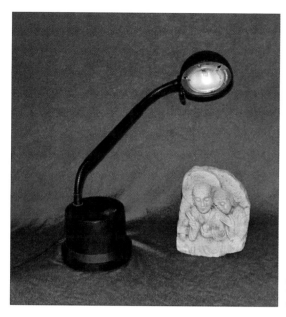

Figure 9.11 *An ordinary desk lamp can be used for close-up photography.*

Background Information

For most kinds of close-up pictures, the background you use is very important. In all cases, the background should complement the main subject and not distract the viewer's attention from it, just as with any carefully composed photograph.

For models, insects, or other subjects that have a distinctive environment, you might want to create a background that pictures or simulates that environment realistically. The best way to do that is to actually use the true environment in your photo, which may be possible if you're shooting on location. You'll probably want to clean up the surroundings a bit, removing stray rocks and twigs from a floral photograph, for example. Trim dead leaves or foliage with cuts and tears. Your goal should be to preserve the natural background without having it look unattractive or cluttered.

Other types of pictures call for plain backgrounds with no detail at all, so the viewer's attention is totally focused on your subject matter. Seamless white backgrounds, black backdrops, or backgrounds with a small amount of texture might be what you're looking for. Just remember that an unobtrusive background does not have to be a black hole of nothingness (or white hole, for that matter). Something as simple as a soft shadow on the background can bring your subject to three-dimensional life and keep it from appearing to be a flat cutout.

For close-up photography in a studio, backgrounds should generally be plain, so they won't detract from the object being photographed. One popular type of background is the so-called seamless backdrop, which combines the surface that the subject rests on and the vertical background behind it, with a smooth, often invisible transition between them. Seamless backgrounds are extremely flexible, because you can go for the "seamless" look or use lighting

to provide different amounts of illumination on the foreground and background, producing a degree of separation that is still smooth and non-distracting.

The next sections will detail some types of backgrounds you might want to work with.

Cloth

Buying a few yards of cloth in plain colors can be the smartest investment you make for macro photography. There are so many things you can do with cloth. It can be stretched and curved to form a seamless backdrop, or draped artfully to give an image a more classical look. You can use a light color that complements the color of your subject, or a black velour fabric that soaks up every drop of extraneous light, forming a true drop-out background.

I buy velour cloth in widths of about 54 inches and lengths up to eight or nine feet so they can be used for objects of any size, or even for portraits. Velour fabric is doubly useful because you can work with the fuzzy velour side or flip it over and use the smooth reverse side that has a little bit of shine. You can add folds and wrinkles or drape the cloth over objects to create an abstract background "stage" for your subject. Eventually, your cloth will become soiled, and you can just toss it in the laundry.

Cloth is so cheap that you can purchase lengths in a variety of colors, from muted pastels to brighter hues. If you only buy a few pieces of cloth, go with blues and browns that go well with many different subjects. Get a black drape as well. Once you've accumulated a collection of plain colors, add a few patterned cloth pieces. Cloth with small red and white checks can be useful when you want a "country" or "diner" look. Striped patterns can be useful, but plaids and other strong patterns tend to overpower your close-up subject. In Figure 9.12, I wanted to emphasize the diagonal lines in the jug, so I experimented with some equally strong lines in the serape I used as a background.

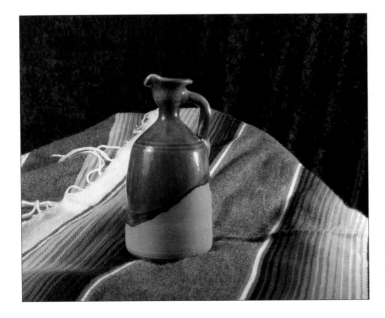

Figure 9.12 *Use patterned backgrounds with caution to avoid overpowering your subject.*

Seamless Paper

Seamless paper has long been a key tool of professional photographers, but it didn't really become famous to the public at large until those shenanigans on the seamless backdrops in the mid-60's cult film *Blowup*. I used them to photograph models when I taught photo posing at an agency, managed to squeeze an entire rock group onto a 12-foot wide swathe of brown paper, and struggled to make a truck clutch look as "glamorous" as the client specified on a dark paper background. Seamless paper is just as useful for close-up photography, albeit on a smaller scale.

You can buy rolls of seamless paper at most camera stores that cater to professional photographers. The big problem is that the most easily obtainable paper rolls are a bit large for close-up work. While some narrower rolls may be available, the standard sizes are 9 feet and 12 feet wide. Even a 9-foot by 36-foot roll (which costs about $40) is a little unwieldy for a mini-studio. You can sometimes find 53-inch × 12-yard half rolls that are a better size for macro photography.

However, you can make your own half rolls. A few minutes with a hacksaw will earn you a couple 4½ foot rolls that are more easily wrestled into submission. The paper eventually gets soiled or torn (it will last longer when used for close-up photography because you won't have people walking all over it) so getting two narrower rolls for the price of one is good economy. If you're not planning to use the paper for portraits or other types of photography, a better choice may be to split the cost with a friend who also needs narrower seamless rolls. That way, you can each have a roll of a particular color and double the number of colors you have in stock.

One of the very cool things about seamless paper is that you can change its very character based on how you light it. Pour a lot of light on the background, and it takes on a lighter appearance. Less light on the background, and it appears to be darker. A single roll of medium gray paper can appear to be any shade, from light gray to almost black, depending on how you light it. Extend the seamless paper a few feet back from your subject before curling it upwards, and you can light the paper to provide a gradient-tone background—very light by your subject and gradually fading to a much darker shade in the back. You can achieve some of these effects with cloth, but the smooth texture of seamless paper makes for smooth light transitions, too.

I originally took the image shown in Figure 9.13 to use with another chapter as an illustration of the add-on wide-angle lenses that are available for digital cameras like the HP Photosmart model pictured. I spent so much time adjusting the lights so that both the camera and lens were illuminated properly that I decided to use it as an example for this macro photography chapter instead. For this shot, the

Figure 9.13 *A seamless background is used in many product photos.*

seamless paper extended about four feet behind the camera, and I feathered the lights so that the vertical portion of the paper was barely lit. This is a typical effect you'll find in many product-type photographs, but you can use it to make your porcelain figurine collection look more glamorous, too.

Poster Board

That poster board you purchased as a reflector can also double as a seamless background. Posterboard is not quite as good as rolls of seamless paper, because the sheets aren't really large enough if your close-ups will involve anything that's more than a few inches on a side. You'll find that the background or foreground (or both) aren't large enough to let you choose different angles (nothing beats a long roll of paper that's four feet wide or more in such cases). Posterboard is also more difficult to manage: it's rigid and may not stay where you want it without taping or propping up. However, posterboard is cheap, cheap, cheap, so you can have lots of colors.

Getting Down to Business

I've told you just about everything you need to know to prepare for shooting close-up photographs. This section will concentrate on the steps you need to follow to make your macro dreams a reality. Most of this information applies broadly to just about any kind of close-up photography, but as we go along, I'll offer tips on getting the best results in specific kinds of situations.

The first thing to do is to choose a venue. If you want to photograph small animals, flowers, or small geological formations (I think of them as "rocks"), you'll need to go out into the field, and tote your gear with you. Be prepared with tripod, reflectors, and any other ancillary equipment you might need. In some cases, that might include a trowel or shovel you can use to rearrange the landscape to your liking, perhaps a cage or jar to temporarily house a subject that might otherwise hop away, or sturdy gloves to let you clear away the underbrush.

Other kinds of close-up work, particularly hobby photography, will probably take place in your own home or in a makeshift home studio, so you won't need to worry about remembering to take all your gear with you. Instead, you'll need to find a place where you can work undisturbed, such as a kitchen table or the shelves that showcase your pewter soldier collection.

As I mentioned earlier, many inanimate objects may look much better when removed from their habitat and photographed against a plain background. A simple background is less distracting and concentrates interest on your intended subject. A simple background is repeatable, too. I photograph my wife's collection of Lladró porcelain on the same backdrop using similar lighting every time, so the resulting pictures look like they were photographed at the same time even though months may have elapsed, as you can see in Figure 9.14. It can be difficult to achieve the same consistency on location, where lighting and backgrounds can vary much more.

Figure 9.14 *Use a consistent setup and you can get repeatable results over time.*

Setting Up Your Subject and Background

The first step is to arrange your subject and its background. If you're shooting in a mini-studio, set up the background on a table or other surface with enough space in front of the setup to let you get close with your camera and tripod (if you're using a tripod). Arrange your subject at the angle you want, making sure it won't tip over or move unexpectedly. Bits of modeling clay can be used to fix many items to the shooting surface (remember that some kinds of clay may contain oils that will stain cloth or paper). Sometimes I prop up items with bits of wood placed so it won't show up in the photo. Figure 9.15 shows an inexpensive clamp that can be used to hold objects being photographed.

Figure 9.15 *This 33-cent clamp makes a good holder for keeping an object steady while you zoom in.*

If you're shooting on location, police the area and remove any dead branches, leaves, rocks, extraneous fauna, or anything else you don't want to appear in your photo. Now is the time to simplify your background. Look closely for dirt that can be cleaned away to improve your photo.

Setting Up Your Camera

If you're using a tripod, adjust the length of the legs so they provide most of the elevation you need. The center pole should be used to fine-tune the height of the camera; if you set the legs too short and have to crank the center column way up, the tripod will top-heavy and less stable. Arrange the tripod and camera so you can use the tripod's swivel head to get the angles you want. If you have trouble getting close enough because the tripod's legs get in the way, don't be afraid to reverse the center pole and shoot down on your subject (if your tripod has that feature).

Setting Up Your Lights

If you're shooting in a mini-studio, you'll probably want to use at least two lights to illuminate your subject from both sides. Shine the lights directly onto your subject, or bounce the light off a reflector like those described earlier in this chapter. Make sure there is some light on the background to separate your subject from its surroundings.

You may have to get creative with lighting on location. If you're not using external lights, take advantage of reflectors to bounce additional light into the shadows, and light-blocking objects to create softer shadows from direct sunlight or illumination, as shown in Figure 9.16, in which a white reflector was used off to the right side of the photo to brighten up the cat's eyes.

As you light your scene, remember that depth-of-field is always limited when taking close-ups, so anything you can do to increase the amount of light available will make it possible to shoot at a smaller aperture, which in turn increases depth-of-field.

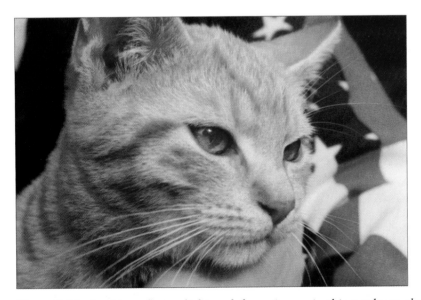

Figure 9.16 *A white reflector lightened the cat's eyes in this outdoors close-up.*

If you happen to be using your camera's built-in flash, lack of light will rarely be a problem. In fact, you may find yourself with too much light even at your lens's smallest f-stop, and end up with a washed-out picture. Here are several possible solutions:

■ Step back a little and use a tighter zoom setting to produce the same size image. The flash will be that much farther from your subject and less likely to wash out the picture. Remember that electronic flash obeys the inverse-square law: a light source that is 12 inches away from your subject produces only one-quarter as much illumination as it does when it's six inches away.

■ Use your camera's exposure value (EV) control to deliberately "under" expose the picture, thus fooling your image grabber's automatic exposure mechanism.

■ Consider covering your flash with a layer or two of tissue paper or other neutral translucent covering. You'll cut down on the light, and soften it a bit at the same time.

Watch for glare reflecting off shiny objects. If you're not using a tent (discussed at the end of this chapter), you may have to arrange your lights carefully to prevent reflections from ruining your shot. My first attempt at photographing a Pentax Optio digital camera looks like Figure 9.17. The lighting is soft and not too bad, and I managed to avoid most glare problems. Unfortunately, this particular angle emphasizes the most boring view of the front of the camera. All the "business" features, like the lens and flash, are located on the other side. So, I decided to rotate the camera for the version you can see in Figure 9.18.

Figure 9.17 *This version approaches the camera from the wrong angle. This is not the Optio's "best" side.*

Figure 9.18 *A better angle on the camera, but now we've got glare!*

Ordinarily, mixing color sources is a bad idea, but using multiple colored light sources for product photography can be cool. In Figure 9.17, I used a magenta colored reflector from the left side of the camera to provide a warm color cast. However, I placed the camera itself on a light green seamless backdrop, and used a green reflector on the right side. The mixed colors provide an interesting contrast.

Using even softer light reduced the glare, and carefully directing the lights provided some illumination for the lens surface, producing the final version shown in Figure 9.19. Sometimes it takes a while to manipulate your lights, but it's worth it. You can see where incandescent illumination may be preferable to flash when you need to make tiny modifications in how your subject is lit.

Setting Up Your Shot

Choose an appropriate zoom setting (focal length) for your picture. Some digital cameras offer close focusing only at particular focal lengths (that is, they focus closely at medium to telephoto settings, but not at the wide-angle setting), so your choice may be limited. Remember that wide-angle settings can add apparent distortion to your image, making things that are closer to the lens appear much larger than they normally look. This effect is most pronounced with close-ups. A normal or short telephoto zoom setting may produce a more natural look.

Frame your picture to exclude extraneous subject matter. Get in tight to produce a photo that will require a minimum of enlargement and will be as sharp as possible. Close-up pictures are often an exception to the rule about arranging your subjects off-center. Many good macro photos have the main subject smack in the middle of the frame, or only slightly off-center, as shown in Figure 9.20.

Make sure your camera has been set to close-up or macro mode (usually represented by a flower icon on your status display LCD).

Focus very carefully. Some cameras allow switching autofocus to a center-oriented mode. Use that if your subject matter is

Figure 9.19 *Softer light and some careful placement yield this final result.*

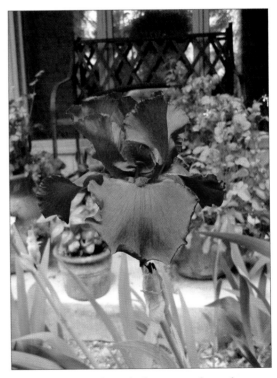

Figure 9.20 *Although that's not the only way to compose a close-up, macro photos often have the main subject centered.*

indeed in the middle of the picture. Switch to manual focus if your camera offers it. You might want to use aperture-priority mode, if available, and select the smallest f-stop available to increase the depth-of-field. And keep in mind what you learned about how depth-of-field is arranged: two thirds is allocated to the area in front of the plane of sharpest focus, and only one-third is allocated to the area behind it.

Check to make sure the back of the camera (where the sensor is located) is parallel to the plane in which your main subject lies. That's the plane you'll be focusing on, and where the maximum amount of sharpness lies. If the camera is tilted in relation to the plane of the main subject, only part of the subject will be in sharp focus. Unless you're shooting for a special effect, you want as much sharpness as you can get. In Figure 6.21, the strawberries and knife are all located in relatively the same plane so that all of them are in sharp focus.

Figure 9.21 *All the subjects are in roughly the same plane, so all are in focus.*

Watch your camera's focus indicator, which may be an LED light near the viewfinder that glows green (or some other color) when the image is in focus.

Use your camera's LCD display to evaluate your framing, composition, and focus. The optical viewfinder of your digital camera won't show you exactly what you are going to get, and may indeed cut off part of the picture area.

Smile!

The big moment has arrived. It's time to take your first close-up. Here are some last-second tips for you.

- Your digital camera may have several automatic focus lock methods. My own camera, for example, can be set to continuous autofocus (changing focus at all times up until the moment of exposure) or to "lock" at a particular focus when the shutter release is partially depressed. If you're taking photos without a tripod, you may want to use continuous autofocus to compensate for slight movements you make as you frame the photo. Locking focus at a particular point is best when you are confident that the focus you have when you press the shutter release is the focus you want for the final picture.

- If your subject is inanimate and you're using a tripod, consider using your digital camera's self-timer to trip the shutter after a delay of a few seconds. Even if you press the shutter release carefully, you might shake the camera a little. Under incandescent illumination with a small f-stop, your camera will probably be using a slow shutter speed that's susceptible to blurring with even a little camera shake. The self-timer will let the camera and tripod come to rest.

- Some digital cameras also have a socket for a remote shutter release. These can also let you keep your hands off the camera when taking a picture, and have the added advantage of tripping the shutter at the exact moment you want (just before the frog takes off, for example), rather than after a delay of indeterminate length.

- Wait a few seconds after you hear the camera's shutter click (whether real or simulated) before doing anything, until you are sure your camera is not making a lengthy exposure or time exposure. That click might have been the shutter opening, and the camera might still be capturing the picture.

- Review your photo immediately on your camera's LCD display (or that big TV you set up) to check for unwanted reflections (especially those produced by flash) and other problems.

TIP FROM THE PROS: AVOIDING PARALLAX ERRORS

There will be times when you simply must use your camera's optical viewfinder to take a close-up photo. Perhaps you're outdoors and the sunlight washes out your camera's LCD screen. Or, maybe you're taking a grab shot on the spur of the moment: it's either bring the camera to your eye and snap, or lose the picture entirely. Some photos don't require deep thought and planning before you take them, too. Most of the close-ups I take for eBay auctions are of the quick-and-dirty variety, using my camera's optical viewfinder.

In all these situations, you need to keep possible parallax errors in mind. Parallax causes problems because what you see through the optical viewfinder is not the same as what is seen by the camera's sensor through the taking lens. At differences of more than a few feet, this difference is minor, but as your subject gets closer to the camera, the variance becomes significant. At distances of a foot or less, a quarter to a third or more of what you think you see through the viewfinder isn't shown in the actual picture, as you can see in Figure 9.22.

Figure 9.22 *At left, what you see through your camera's optical viewfinder. At right, what the sensor sees.*

The amount of image area affected is determined by the distance between the taking lens and the viewfinder, as well as the distance to your subject. If the viewfinder is directly above the camera's lens, you'll lose a little of what appears at the top of the viewfinder in your actual photo. If the viewfinder is off to the left, some of the left of your image may be cut off. With many digital cameras, the viewfinder window is both above and to the left of the taking lens, affording the opportunity of accidentally cropping your photo in two directions at once. The default danger zones apply only when your camera is being held horizontally; if you're taking a vertical photo, the area subject to parallax errors migrates along with your viewfinder.

More expensive cameras might have some compensation built into the optical viewfinder; it might tilt slightly to compensate for parallax error. It's more common, though, to simply place guidelines in the viewfinder that show where the "safe" area is, and expect the photographer to keep the subject matter lined up properly. If you keep in mind that the correction marks in the viewfinder are only an approximation of what your camera really sees, you can usually avoid the worst parallax transgressions. Adjust on the safe side by including a little extra area around your main subject and you'll do fine.

Also remember that your camera's built-in electronic flash suffers from parallax error, too. At very close distances, the flash will probably not illuminate the lower part of your subject. I am often able to fix this by placing a small white card out of the picture area, but located to bounce some of the flash illumination down onto the subject.

Close-ups for Online Auctions

Judging from the flood of questions I've received from readers wanting to know how to take pictures for their eBay auctions, this brand of close-up photography has to be one of the fastest-growing segments of the macro universe. My whole family has the auction bug, too, so I've been called on to solve photographic problems for them a few hundred times also. Most of

the time the solutions are easy (until I was recently asked to photograph a totally transparent plastic two-piece "ghost" candy mold in a realistic and exciting way), so I'll pass along some tips here.

The most common question I receive about auction photography is what resolution is required for good product close-ups. My stock answer is that because your auction pictures are unlikely to be displayed at anything larger than about 600 × 400 pixels, it's tempting to consider buying a relatively low-resolution digital camera for eBay close-ups. That's false economy for a number of reasons:

- If you start with a 3 MP or better image, you can crop it mercilessly and still end up with a good 600 × 400 pixel close-up picture. Indeed, capturing a larger image means you don't even have to get as close to your subject as you would with a lower resolution camera, as you can see in Figure 9.23, which was taken with a 3 MP camera, and then cropped and reduced in size for display on eBay. Even the low-resolution version you see here is good enough for the web.

- Higher-resolution photos can be edited more easily in Photoshop or another image editor. Even with my astounding photographic skills, I usually find it necessary to retouch images a bit (or a lot) before posting them in auctions.

- I've discovered that many of the people who have no interest in a digital camera other than as a tool for grabbing images for eBay soon discover just how much fun digital photography is. That's when they wish they'd sprung for a better camera with some extra features that are suitable for general-purpose photography.

Figure 9.23 *Taken with a 3-megapixel camera, these images were cropped and reduced in size for web page display.*

Although this is a digital photography book, I should mention that for some kinds of auction close-ups, a *scanner* is actually a better tool than a digital camera. If you're selling flat items such as old magazines, stamps, coins, books, or similar goods, a scanner can be a fast and efficient way of grabbing macro views. Figure 9.24 shows a coin captured with a digital camera (at left) and with a scanner (at right). The scanner version took much less time to capture.

When I sold off some of my surplus Robert A. Heinlein science-fiction collection, I did lay out some of the materials on a seamless background and took a digital photo of the lot. However, with some of the rarer stuff, such as 1950s first editions, the condition of the covers was very important. So, I scanned each book individually, created a small thumbnail image that could be displayed on the auction page, and added an HTML link to a full-sized digital image that showed every flaw

Figure 9.24 *The digital camera version (left) took a lot longer to create than the scanned version (right).*

and crease in the cover. The scanner proved to be a better tool for that sort of image. You'll find more about scanning in my book, *Mastering Digital Scanning with Slides, Film, and Transparencies*, published by Muska & Lipman.

Here are some other tips for shooting close-ups for online auctions:

■ Find a permanent nook or cranny in your home that you can set up as a semi-permanent home studio for your close-ups. Family members constantly, and without warning, approach me with cake pans or candy molds or other items they want captured *right now*. A small corner supplied with a few lights and a plain cloth background can be used repeatedly with little fuss.

■ Be prepared to include some common object in the photo, such as a ruler, to show the scale of the object. That helps avoid questions from potential bidders (who may not read the auction description carefully) who want to know if your two-piece Dia de los Muertos skull candy mold is two inches or four inches wide. For Figure 9.25, I included a laptop computer in the photo for scale, even though the computer wasn't being sold along with the widget.

Figure 9.25 *Include another object in the photo, if necessary, to show its relative size.*

■ Husband your time. I've spent 20 minutes photographing an item that might bring $100 in an eBay auction and considered it time well-spent. I've also spent that much time shooting a commodity item that sells for $8.95, because I had 100 of the little devils to peddle and would re-use the photograph over and over. However, it's not smart to spend a lot of time on a one-of-a-kind object that won't bring big bucks. If it's a $5.00 item, I hand my kids a spare digital camera and tell them to photograph it themselves on the living room rug.

- Watch those colors. Buyers can be miffed if the item they purchase isn't quite the color they expected. While there's nothing you can do to calibrate their monitor to match your own, you can still take care in setting white balance and color correcting your final image to make it as accurate as possible.

- Optimize your depth-of-field. Selective focus may be cool artistically, but when you're shooting a close-up of an item for eBay, you'll want it to have as much overall sharpness as possible.

- Let your photo tell a story and/or provide as much information as possible. One of the gadgets I sell is a cable that plugs into the S-Video socket of a laptop computer and converts the output to the composite signal required by older TVs (www.dbusch.com/svideo/). I used to get e-mails from potential bidders asking whether the S-Video cable had four pins or seven pins, and just what the other end of the cable looked like. I contrived the illustration shown in Figure 9.26, which does a pretty good job of answering both questions.

- Eliminate extraneous information. I shot Figure 9.26 against a seamless white background, then boosted the brightness of the background in Photoshop so it dropped out completely, leaving the "floating" image you see. Because the eBay web pages have a white background, my image blends cleanly in with its surroundings, so there is no distracting border.

Figure 9.26 *Let your photograph provide as much information about the item as possible.*

Project for Individual Study: Pitching a Tent

This chapter's special project is one that will benefit nearly anyone interested in close-up photography. Building your own lighting tent can be the best move you ever made if you regularly photograph shiny things that pose seemingly insurmountable reflection problems when captured using conventional lighting techniques. This section will help you get started.

Lighting tents are closely related to those photographic "soft boxes" you've seen in photographers' studios. A soft box is, as you might guess, a large box-like affair holding a light source and having a large diffusing surface on the front to soften the light. They're widely used to provide flattering lighting for portraits and for product photography where glare might be a problem. You can build your own soft box, too, but I think a tent might be more useful for close-ups.

An easy way to create a small tent is to use a translucent, diffusing object that can fit around the subject you're photographing. An ordinary one-gallon plastic milk container, like the one shown in Figure 9.27, can do a good job. You'll want the kind that is white and translucent. Clean the jug carefully and cut off the bottom so you can place it over your subject. Enlarge the opening in the top so your camera lens will fit through. You can light the jug from all sides to provide a soft, even lighting, while photographing the subject through the top.

This makeshift kind of tent isn't especially versatile. Only small objects fit inside, and your camera-to-subject distance may be constrained by the size of the jug. A better choice is to build a full-fledged tent framework out of lumber, using 2 × 2 or 2 × 4 studs to create an open cube. Then staple or fasten sheets of muslin, white plastic trash bags, or other translucent white material to each face of the cube. Attach the diffusing material only at the top of the frame.

Flip up the material on any side to insert your macro subject matter on an appropriate stand or backdrop. You can cut flaps in the material on all four sides, plus the top, so you can insert the camera lens as required, or close the flap and move to another side for a different angle. I like to set the tent apparatus on a tall barstool so I can get close from any angle and move around for the best perspective.

A cubical tent of this sort offers all kinds of flexibility in terms of use and how you light it. For example, you can place stronger lights on one side and slightly weaker lights on the other to provide a soft modeling effect. Or hit all the sides with bright lights for flat, low-contrast illumination. Figure 9.28 shows a photograph of a coin made inside a tent. There was enough directional quality to the light so that the raised features of the coin can still be seen easily. Yet, nearly all the glare that a direct light source would produce has been eliminated. It may not be the best coin photograph in the world, but you can see how the soft lighting has no glare to interfere with viewing the coin's features, but there is still enough contrast to see the texture of the coin.

Figure 9.28 *Tent lighting can be directional, yet soft and without glare.*

Figure 9.27 *A translucent plastic milk bottle can be pressed into service as a makeshift tent.*

Some Final Tips

I'll close out this chapter with a few final tips that might come in handy for specific types of close-up photography.

- *Chill out.* Some nature photographers looking to increase the patience of their insectoid subjects put the little creatures in an icebox for a few moments before posing them carefully back in more natural surroundings. Chilled butterflies, for example, will remain in one spot long enough for an interesting series of pictures. A brief visit to colder climes (a totable ice chest may work fine in the field) doesn't harm them in the least.

- *Have a spritz bottle handy.* Flowers, vegetables, fruit, and spiderwebs often look better when dusted with a light mist, as you can see in Figure 9.29. Don't over-dew (hehehe) the moisture and your photos can be enhanced.

- *Make creative use of reflections.* I spent a lot of time in this chapter telling you how to *avoid* reflections, but this is one rule that deserves to be shattered from time to time. Some interesting close-up photos have been produced when the photographer accidentally or intentionally included a reflection of something in the shiny surface of the subject being photographed. It might have been a photographic umbrella or even the photographer. When photographing spoons, chromium bumpers, or anything imprinted with an "Objects are closer than they appear" warning, see what you can do creatively with the reflection. Check out Figure 9.30 for an example.

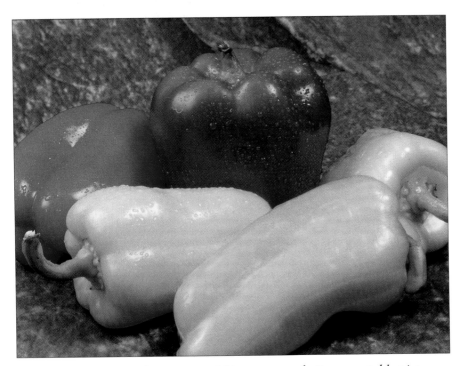

Figure 9.29 *A spritz of water can add interest to a fruit or vegetable picture.*

Figure 9.30 *A close-up photo of a mirror yields a non-close-up view of a roller-coaster.*

Next Up

That's all, folks! The next step is up to you. I hope I've filled you with enough information about digital photography and picture taking to equip you to handle just about any situation that comes up, and enough excitement to fire your imagination with new ideas.

I've tried to pass along some of the tricks I've picked up over the years as I explored the fascinating field of photography. Still, we've only scratched the surface. Analog (film) photography hasn't yet been fully explored in its 165 plus years of existence, so you can be certain that digital photography has many surprises in store for all of us. As long as cameras keep getting better and their capabilities grow, the boundaries of digital photography will never be approached. My hopes are that this book will encourage you to explore photography further, and that the chapters have held lots of nuggets and idea starters that will help you come up with the kind of images that evoke those, "Wow! How was that photo created?" comments we all secretly yearn for.

Illustrated Glossary

Photographic jargon isn't really a foreign language! However, there are a lot of words and terms that have special meanings in the world of picture taking and image editing. This glossary is your English/photospeak "dictionary," defining the tough words in this book, as well as a few dozen other words and phrases you'll encounter when taking and manipulating photos. I'm including illustrations to help clarify some concepts. You'll also find illustrations throughout the book which illustrate other photography and imaging ideas. You can read through this glossary for fun, to build up a mighty imaging vocabulary to impress your boss, or to stump that know-it-all colleague.

additive primary colors Red, green, and blue, used alone or in combinations to create all other colors you capture with a digital camera, view on a computer monitor, or work within an image-editing program like Photoshop. See also *CMYK*.

airbrush Originally developed as an artist's tool that sprays a fine mist of paint, the computer version of an airbrush is used both for illustration and retouching in most image-editing programs.

ambient lighting Diffuse nondirectional lighting that doesn't appear to come from a specific source but, rather, bounces off walls, ceilings, and other objects in the scene when a picture is taken.

angle of view The area of a scene that a lens can capture, determined by the focal length of the lens. Lenses with a shorter focal length have a wider angle of view than lenses with a longer focal length.

Figure A.1 *The additive primary colors, red, green, and blue, combine to make other colors, plus white.*

anti-alias A process in image editing that smoothes the rough edges in images (called jaggies or staircasing) by creating partially transparent pixels along the boundaries, making them appear smoother. See also *jaggies*.

aperture-preferred A camera setting that allows you to specify the lens opening or f-stop that you want to use, with the camera selecting the required shutter speed automatically based on its light-meter reading. See also *shutter-preferred*.

artifact A type of noise in an image, or an unintentional image component produced in error by a digital camera or scanner during processing.

Figure A.2 *A diagonal line that has been anti-aliased (left) and a "jaggy" line that displays the staircasing effect (right).*

aspect ratio The proportions of an image as printed, displayed on a monitor, or captured by a digital camera. An 8 × 10-inch or 16 × 20-inch photo each has a 4:5 aspect ratio. Your monitor set to 800 × 600, 1024 × 768, or 1600 × 1200 pixels has a 4:3 aspect ratio. When you change the aspect ratio of an image, you must crop out part of the image area, or create some blank space at the top or sides.

autofocus A camera setting that allows the camera to choose the correct focus distance for you, usually based on the contrast of an image (the image will be at maximum contrast when in sharp focus) or a mechanism such as an infrared sensor that measures the actual distance to the subject.

averaging meter A light-measuring device that calculates exposure based on the overall brightness of the entire image area. Averaging tends to produce the best exposure when a scene is evenly lit or contains equal amounts of bright and dark areas that contain detail.

background In photography, the background is the area behind your main subject of interest.

backlighting A lighting effect produced when the main light source is located behind the subject. Backlighting can be used to create a silhouette effect. See also *ambient lighting*, *fill lighting*, and *frontlighting*.

balance An image that has equal elements on all sides.

bilevel image An image that stores only black-and-white information, with no gray tones.

Figure A.3 *Backlighting can create interest in a photo by illuminating and emphasizing the outer edges of a subject.*

bit A binary digit—either a 1 or a 0—used to measure the color depth (number of different colors) in an image. For example, a grayscale 8-bit scan may contain up to 256 different tones (2^8), whereas a 24-bit scan can contain 16.8 million different colors (2^{24}).

bitmap In Photoshop parlance, a bitmap is a bilevel black/white-only image. The term is also widely used to mean any image that represents each pixel as a number in a row and column format.

black The color formed by the absence of reflected or transmitted light.

black point The tonal level of an image where blacks begin to provide important image information, usually measured by using a histogram. When correcting an image with a digital camera that has an on-screen histogram, or within an image editor, you'll usually want to set the histogram's black point at the place where these tones exist.

Figure A.4 *The black triangle (in the middle portion of the dialog box) should be set to the point on the histogram where black pixels begin in the image, shown at left in this dialog box.*

blend To create a more realistic transition between image areas, as when retouching or compositing in image editing.

blowup An enlargement, usually a print, made from a negative, transparency, or digital file.

blur In photography, to soften an image or part of an image by throwing it out of focus, or by allowing it to become soft due to subject or camera motion. In image editing, blurring is the softening of an area by reducing the contrast between pixels that form the edges.

bounce lighting Light bounced off a reflector, including ceiling and walls, to provide a soft, natural-looking light.

bracketing Taking a series of photographs of the same subject at different settings to help ensure that one setting will be the correct one. Many digital cameras will automatically snap off a series of bracketed exposures for you. Other settings, such as color balance, can also be "bracketed" with some models.

brightness The amount of light and dark shades in an image, usually represented as a percentage from 0 percent (black) to 100 percent (white).

burn A darkroom technique, mimicked in image editing, which involves exposing part of a print for a longer period, making it darker than it would be with a straight exposure.

calibration A process used to correct for the differences in the output of a printer or monitor when compared to the original image. Once you've calibrated your scanner, monitor, and/or your image editor, the images you see on the screen more closely represent what you'll get from your printer, even though calibration is never perfect.

camera shake Movement of the camera, aggravated by slower shutter speeds, which produces a blurred image.

candid pictures Unposed photographs, often taken at a wedding or other event at which (often) formal, posed images are also taken.

cast An undesirable tinge of color in an image.

CCD Charge-coupled device. A type of solid-state sensor, used in scanners and digital cameras, that captures the image.

center-weighted meter A light-measuring device that emphasizes the area in the middle of the frame when calculating the correct exposure for an image.

chroma Color or hue.

chromatic aberration An image defect, often seen as green or purple fringing around the edges of an object, caused by a lens failing to focus all colors of a light source at the same point.

Figure A.5 *A color print that has faded over the years can display a distinct magenta cast like this one.*

chromatic color A color with at least one hue and a visible level of color saturation.

chrome An informal photographic term used as a generic for any kind of color transparency, including Kodachrome, Ektachrome, or Fujichrome.

CIE (Commission Internationale de l'Eclairage) An international organization of scientists who work with matters relating to color and lighting. The organization is also called the International Commission on Illumination.

close-up lens A lens add-on that allows you to take pictures a distance that is less than the closest-focusing distance of the lens alone.

CMY(K) color model A way of defining all possible colors in percentages of cyan, magenta, and yellow, and frequently, black. Black is added to improve rendition of shadow detail. CMYK is commonly used for printing (both on press and with your inkjet or laser color printer). Photoshop can work with images using the CMYK model, but converts any images in that mode back to RGB for display on your computer monitor.

Figure A.6 *Cyan, magenta, yellow colors combine to form the other colors, plus black.*

color correction Changing the relative amounts of color in an image to produce a desired effect, typically a more accurate representation of those colors. Color correction can fix faulty color balance in the original image, or compensate for the deficiencies of the inks used to reproduce the image.

comp A preview that combines type, graphics, and photographic material in a layout.

composite In photography, an image composed of two or more parts of an image, taken either from a single photo or multiple photos. Usually composites are created so that the elements blend smoothly together.

composition The pleasing or artistic arrangement of the main subject, other objects in a scene, as well as the foreground and background.

compression Reducing the size of a file by encoding using fewer bits of information to represent the original. Some compression schemes, such as JPEG, operate by discarding some image information, while others, such as TIFF, preserve all the detail in the original, discarding only redundant data. See also *GIF, JPEG,* and *TIFF.*

continuous tone Images that contain tones from the darkest to the lightest, with a theoretically infinite range of variations in between.

contrast The range between the lightest and darkest tones in an image. A high-contrast image is one in which the shades fall at the extremes of the range between white and black. In a low-contrast image, the tones are closer together.

contrasty Having higher than optimal contrast.

crop To trim an image or page by adjusting its boundaries.

dedicated flash An electronic flash unit designed to work with the automatic exposure features of a specific camera.

Figure A.7 *High-contrast image (left); low-contrast image (right).*

densitometer An electronic device used to measure the amount of light reflected by or transmitted through a piece of artwork, used to determine accurate exposure when making copies or color separations.

density The ability of an object to stop or absorb light. The less light reflected or transmitted by an object, the higher its density.

depth-of-field A distance range in a photograph in which all included portions of an image are at least acceptably sharp.

depth-of-focus The range that the image capturing surface (such as a sensor or film) could be moved while maintaining acceptable focus.

desaturate To reduce the purity or vividness of a color, making a color appear to be washed out or diluted.

diaphragm An adjustable component, similar to the iris in the human eye, which can open and close to provide specific-sized lens openings, or f-stops.

diffuse lighting Soft, low-contrast lighting.

diffusing Softening detail in an image.

Figure A.8 *Depth-of-field determines how much of an image, such as the dog in this photo, is in sharp focus, and what parts, such as the background, are out of focus.*

diffusion The random distribution of gray tones in an area of an image, producing a fuzzy effect.

dither A method of distributing pixels to extend the number of colors or tones that can be represented. For example, two pixels of different colors can be arranged in such a way that the eye visually merges them into a third color.

dodging A darkroom term for blocking part of an image as it is exposed, lightening its tones. Image editors can mimic this effect by lightening portions of an image using a brush-like tool.

dot A unit used to represent a portion of an image, often groups of pixels collected to produce larger printer dots of varying sizes to represent gray or a specific color.

dot gain The tendency of a printing dot to grow from the original size to its final printed size on paper. This effect is most pronounced on offset presses using poor-quality papers, which allow ink to absorb and spread, reducing the quality of the printed output, particularly in the case of photos that use halftone dots.

Figure A.9 *Our eyes merge halftone dots together to provide continuous tones and colors.*

dots per inch (dpi) The resolution of a printed image, expressed in the number of printer dots in an inch. You'll often see dpi used to refer to monitor screen resolution, or the resolution of scanners. However, neither of these use dots. The correct term for a monitor is pixels per inch (ppi), whereas a scanner captures a particular number of samples per inch (spi).

dummy A rough approximation of a publication, used to evaluate the layout.

dye sublimation A printing technique in which solid inks are heated and transferred to a polyester substrate to form an image. Because the amount of color applied can be varied by the degree of heat (and up to 256 different hues for each color), dye-sublimation devices can print as many as 16.8 million different colors.

emulsion The light-sensitive coating on a piece of film, paper, or printing plate. When making prints or copies, it's important to know which side is the emulsion side so the image can be exposed in the correct orientation (not reversed). Photoshop includes "emulsion side up" and "emulsion side down" options in its print-preview feature.

EXIF Exchangeable Image File Format. Developed to standardize the exchange of image data between hardware devices and software. A variation on JPEG, EXIF is used by most digital cameras, and includes information such as the date and time a photo was taken, the camera settings, resolution, amount of compression, and other data.

existing light In photography, the illumination that is already present in a scene. Existing light can include daylight or the artificial lighting currently being used, but not electronic flash or additional lamps set up by the photographer.

export To transfer text or images from a document to another format.

exposure The amount of light allowed to reach the film or sensor, determined by the intensity of the light, the amount admitted by the iris of the lens, and the length of time determined by the shutter speed.

exposure program An automatic setting in a digital camera that provides the optimum combination of shutter speed and f-stop at a given level of illumination. For example a "sports" exposure program would use a faster, action-stopping shutter speed and larger lens opening instead of the smaller, depth-of-field-enhancing lens opening and slower shutter speed that might be favored by a "close-up" program at exactly the same light level.

eyedropper An image-editing tool used to sample color from one part of an image, so it can be used to paint, draw, or fill elsewhere in the image. Within some features, the eyedropper can be used to define the actual black points and white points in an image.

feather To fade out the borders of an image element, so it will blend in more smoothly with another layer.

fill lighting In photography, lighting used to illuminate shadows.

filter In photography, a device that fits over the lens, changing the light in some way. In image editing, a feature that changes the pixels in an image to produce blurring, sharpening, and other special effects.

FireWire (IEEE-1394) A fast serial interface used by scanners, digital cameras, printers, and other devices.

Figure A.10 *A feathered edge, so to speak.*

flat An image with low contrast.

flatbed scanner A type of scanner that reads a line of an image at a time, recording it as a series of samples, or pixels.

focal length The distance between the film and the optical center of the lens when the lens is focused on infinity, usually measured in millimeters.

focus To adjust the lens to produce a sharp image.

focus lock A camera feature that lets you freeze the automatic focus of the lens at a certain point, when the subject you want to capture is in sharp focus.

focus range The minimum and maximum distances within which a camera is able to produce a sharp image, such as two inches to infinity.

focus tracking The ability of the automatic-focus feature of a camera to change focus as the distance between the subject and the camera changes.

four-color printing Another term for process color, in which cyan, magenta, yellow, and black inks are used to reproduce all the colors in the original image.

framing In photography, composing your image in the viewfinder. In composition, using elements of an image to form a sort of picture frame around an important subject.

frequency The number of lines per inch in a halftone screen.

frontlighting Illumination that comes from the direction of the camera. See also *backlighting* and *sidelighting*.

f-stop The relative size of the lens aperture, which helps determine both exposure and depth-of-field. The larger the f-stop number, the smaller the f-stop itself. It helps to think of f-stops as denominators of fractions, so that f2 is larger than f4, which is larger than f8, just as 1/2, 1/4, and 1/8 represent ever-smaller fractions. In photography, a given f-stop number is multiplied by 1.4 to arrive at the next number that admits exactly half as much light. So, f1.4 is twice as large as f2.0 (1.4 × 1.4), which is twice as large as f2.8 (2 × 1.4), which is twice as large as f4 (2.8 × 1.4). The f-stops which follow are f5.6, f8, f11, f16, f22, f32, and so on.

Figure A.11 *f-stop.*

full-color image An image that uses 24-bit color with 16.8 million possible hues. Images are sometimes captured in a scanner with more colors, but the colors are reduced to the best 16.8 million shades for manipulation in image editing.

gamma A numerical way of representing the contrast of an image. Devices such as monitors typically don't reproduce the tones in an image in straight-line fashion (all colors represented in exactly the same way as they appear in the original). Instead, some tones may be favored over others, and gamma provides a method of tonal correction that takes the human eye's perception of neighboring values into account. Gamma values range from 1.0 to about 2.5. The Macintosh has traditionally used a gamma of 1.8, which is relatively flat compared to television. Windows PCs use a 2.2 gamma value, which has more contrast and is more saturated.

gamma correction A method for changing the brightness, contrast, or color balance of an image by assigning new values to the gray or color tones of an image to more closely represent the original shades. Gamma correction can be either linear or nonlinear. Linear correction applies the same amount of change to all the tones. Nonlinear correction varies the changes tone-by-tone, or in highlight, midtone, and shadow areas separately to produce a more accurate or improved appearance.

gamut The range of viewable and printable colors for a particular color model, such as RGB (used for monitors) or CMYK (used for printing).

Gaussian blur A method of diffusing an image using a bell-shaped curve to calculate the pixels which will be blurred, rather than blurring all pixels, producing a more random, less "processed" look.

GIF An image file format, limited to 256 different colors, that compresses the information by combining similar colors and discarding the rest. Condensing a 16.8-million-color photographic image to only 256 different hues often produces a poor-quality image, but GIF is useful for images that don't have a great many colors, such as charts or graphs. The GIF format also includes transparency options, and can include multiple images to produce animations that may be viewed on a web page or other application. See also *JPEG* and *TIFF.*

grain The metallic silver in film which forms the photographic image. The term is often applied to the seemingly random noise in an image (both conventional and digital) that provides an overall texture.

gray card A piece of cardboard or other material with a standardized 18 percent reflectance. Gray cards can be used as a reference for determining correct exposure.

grayscale image An image represented using 256 shades of gray. Scanners often capture grayscale images with 1024 or more tones, but reduce them to 256 grays for manipulation by Photoshop.

halftone A method used to reproduce continuous-tone images, representing the image as a series of dots.

high contrast A wide range of density in a print, negative, or other image.

highlights The brightest parts of an image containing detail.

hue The color of light that is reflected from an opaque object or transmitted through a transparent one.

hyperfocal distance A point of focus where everything from half that distance to infinity appears to be acceptably sharp. For example, if your lens has a hyperfocal distance of four feet, everything from two feet to infinity would be sharp. The hyperfocal distance varies by the lens and the aperture in use. If you know you'll be making a "grab" shot without warning, sometimes it is useful to turn off your camera's automatic focus, and set the lens to infinity, or, better yet, the hyperfocal distance.. Then, you can snap off a quick picture without having to wait for the lag that occurs with most digital cameras as their autofocus locks in.

incident light Light falling on a surface.

indexed color image An image with 256 different colors, as opposed to a grayscale image, which has 256 different shades of the tones between black and white.

infinity A distance so great that any object at that distance will be reproduced sharply if the lens is focused at the infinity position.

interchangeable lens Lens designed to be readily attached to and detached from a camera—a feature found in more sophisticated digital cameras.

interpolation A technique digital cameras, scanners, and image editors use to create new pixels required whenever you resize or change the resolution of an image, based on the values of surrounding pixels. Devices such as scanners and digital cameras can also use interpolation to create pixels in addition to those actually captured, thereby increasing the apparent resolution or color information in an image.

invert In image editing, to change an image into its negative; black becomes white, white becomes black, dark gray becomes light gray, and so forth. Colors are also changed to the complementary color; green becomes magenta, blue turns to yellow, and red is changed to cyan.

iris A set of thin, overlapping metal leaves in a camera lens which pivot outward to form a circular opening of variable size to control the amount of light that can pass through a lens.

ISO (International Standards Organization) A governing body that provides standards used to represent film speed, or the equivalent sensitivity of a digital camera's sensor.

Figure A.12 An iris opening and closing.

jaggies Staircasing effect of lines that are not perfectly horizontal or vertical, caused by pixels that are too large to represent the line accurately. See also *anti-alias*.

JPEG (Joint Photographic Experts Group) A file format that supports 24-bit color and reduces file sizes by selectively discarding image data. Digital cameras generally use JPEG compression to pack more images onto memory cards. You can select how much compression is used (and therefore how much information is thrown away) by selecting from among the Standard, Fine, Super Fine, or other quality settings offered by your camera. See also *GIF* and *TIFF*.

landscape The orientation of a page in which the longest dimension is horizontal, also called wide orientation.

latitude The range of camera exposures that produce acceptable images with a particular digital sensor or film.

lens One or more elements of optical glass or similar material designed to collect and focus rays of light to form a sharp image on the film, paper, sensor, or a screen.

lens aperture The lens opening, or iris, that admits light to the film or sensor. The size of the lens aperture is usually measured in f-stops. See also *f-stop* and *iris*.

lens flare A feature of conventional photography that is both bane and a creative outlet. It is an effect produced by the reflection of light internally among elements of an optical lens. Bright light sources within or just outside the field of view cause lens flare. Flare can be reduced by the use of coatings on the lens elements or with the use of lens hoods. Photographers sometimes use the effect as a creative technique, and Photoshop includes a filter that lets you add lens flare at your whim.

Figure A.13 *Lens flare.*

lens hood A device that shades the lens, protecting it from extraneous light outside the actual picture area, which can reduce the contrast of the image, or allow lens flare.

lens shade A hood at the front of a lens that keeps stray light from striking the lens and causing image flare.

lens speed The largest lens opening (smallest f-number) at which a lens can be set. A fast lens transmits more light and has a larger opening than a slow lens. Determined by the maximum aperture of the lens in relation to its focal length, the "speed" of a lens is relative: A 400 mm lens with a maximum aperture of f/3.5 is considered extremely fast, while a 28mm f/3.5 lens is thought to be relatively slow.

lighten A Photoshop function that is the equivalent of the photographic darkroom technique of dodging. Tones in a given area of an image are gradually changed to lighter values.

lighting ratio The proportional relationship between the amount of light falling on the subject from the main light and other lights, expressed in a ratio, such as 3:1.

line art Usually, images that consist only of white pixels and one color, represented in Photoshop as a bitmap.

line screen The resolution or frequency of a halftone screen, expressed in lines per inch.

lithography Another name for offset printing.

lossless compression An image-compression scheme, such as TIFF, that preserves all image detail. When the image is decompressed, it is identical to the original version.

lossy compression An image-compression scheme, such as JPEG, that creates smaller files by discarding image information, which can affect image quality.

luminance The brightness or intensity of an image, determined by the amount of gray in a hue.

LZW compression A method of compacting TIFF files using the Lempel-Ziv Welch compression algorithm, an optional compression scheme offered by some digital cameras.

macro lens A lens that provides continuous focusing, from infinity to extreme close-ups, often to a reproduction ratio of 1:2 (half life-size) or 1:1 (life-size).

Figure A.14 *When carried to the extreme, lossy compression methods can have a serious impact on image quality.*

macro photography The process of taking photographs of small objects at magnifications of 1× or more.

magnification ratio A relationship that represents the amount of enlargement provided by the macro setting of the zoom lenses, macro lens, or with other close-up devices.

matrix metering system An exposure metering system using a multi-segment sensor and programming so various parts of a scene can be emphasized when calculating the correct exposure.

maximum aperture The largest lens opening or f-stop available with a particular lens, or with a zoom lens at a particular magnification.

mechanical Camera-ready copy with text and art already in position for photographing.

midtones Parts of an image with tones of an intermediate value, usually in the 25 to 75 percent range. Many image-editing features allow you to manipulate midtones independently from the highlights and shadows.

moiré An objectionable pattern caused by the interference of halftone screens, frequently generated by rescanning an image that has already been halftoned. An image editor can frequently minimize these effects by blurring the patterns.

monochrome Having a single color, plus white. Grayscale images are monochrome (shades of gray and white only).

negative A representation of an image in which the tones are reversed: blacks as white, and vice versa.

neutral color In image editing's RGB mode, a color in which red, green, and blue are present in equal amounts, producing a gray.

noise In an image, pixels with randomly distributed color values. Noise in digital photographs tends to be the product of low-light conditions, particularly when you have set your camera to a higher ISO rating than normal.

normal lens A lens that makes the image in a photograph appear in a perspective that is like that of the original scene, typically with a field of view of roughly 45 degrees. A quick way to calculate the focal length of a normal lens is to measure the diagonal of the sensor or film frame used to capture the image, usually ranging from around 7mm to 45mm.

orthochromatic Sensitive primarily to blue and green light.

overexposure A condition in which too much light reaches the film or sensor, producing a dense negative or a very bright/light print, slide, or digital image.

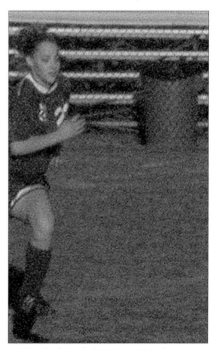

Figure A.15 *Boosting the sensitivity of your camera so you can freeze action may just fill your images with noise.*

panning Moving the camera so that the image of a moving object remains in the same relative position in the viewfinder as you take a picture. The eventual effect creates a strong sense of movement.

panorama A broad view, usually scenic.

parallax compensation An adjustment made by the camera or photographer to account for the difference in views between the taking lens and the viewfinder.

perspective The rendition of apparent space in a photograph, such as how far the foreground and background appear to be separated from each other. Perspective is determined by the distance of the camera to the subject. Objects that are close appear large, whereas distant objects appear to be small.

perspective control lens A special lens that allows correcting distortion resulting from high or low camera angle.

pixel The smallest element of a screen display that can be assigned a color. The term is a contraction of "picture element."

pixels per inch (ppi) The number of pixels that can be displayed per inch, usually used to refer to pixel resolution from a scanned image or on a monitor.

plug-in A module such as a filter that can be accessed from within an image editor to provide special functions.

point Approximately 1/72 of an inch outside the Macintosh world, exactly 1/72 of an inch within it.

portrait The orientation of a page in which the longest dimension is vertical, also called tall orientation. In photography, a formal picture of an individual or, sometimes, a group.

positive The opposite of a negative, an image with the same tonal relationships as those in the original scenes—for example, a finished print or a slide.

prepress The stages of the reproduction process that precede printing, when halftones, color separations, and printing plates are created.

process color The four color pigments used in color printing: cyan, magenta, yellow, and black (CMYK).

RAW An image file format offered by many digital cameras that includes all the unprocessed information captured by the camera. RAW files are very large, and must be processed by a special program after being downloaded from the camera.

red eye An effect from flash photography that appears to make a person's or animal's eyes glow red. It's caused by light bouncing from the retina of the eye, and is most pronounced in dim illumination (when the irises are wide open) and when the electronic flash is close to the lens and therefore prone to reflect directly back. Image editors can fix red eye through cloning other pixels over the offending red or orange ones.

red-eye reduction A way of reducing or eliminating the red-eye phenomenon. Some cameras offer a red-eye reduction mode that uses a preflash that causes the irises of the subjects' eyes to close down just prior to a second, stronger flash used to take the picture.

reflection copy Original artwork that is viewed by light reflected from its surface, rather than transmitted through it.

Figure A.16 *Digital cameras usually have several features for avoiding the demon red-eye look.*

reflector Any device used to reflect light onto a subject to improve balance of exposure (contrast). Another way is to use fill-in flash.

register To align images.

registration mark A mark that appears on a printed image, generally for color separations, to help in aligning the printing plates. Photoshop can add registration marks to your images when they are printed.

reproduction ratio Used in macro photography to indicate the magnification of a subject.

resample To change the size or resolution of an image. Resampling down discards pixel information in an image; resampling up adds pixel information through interpolation.

resolution In image editing, the number of pixels per inch, used to determine the size of the image when printed. That is, an 8 × 10 inch image that is saved with 300 pixels per inch resolution will print in an 8 × 10-inch size on a 300 dpi printer, or 4 × 5-inches on a 600 dpi printer. In digital photography, resolution is the number of pixels a camera or scanner can capture.

retouch To edit an image, most often to remove flaws or to create a new effect.

RGB color mode A color mode that represents the three colors—red, green, and blue—used by devices such as scanners or monitors to reproduce color. Photoshop works in RGB mode by default, and even displays CMYK images by converting them to RGB.

saturation The purity of color; the amount by which a pure color is diluted with white or gray.

scale To change the size of a piece of an image.

scanner A device that captures an image of a piece of artwork and converts it to a digitized image or bitmap that the computer can handle.

SecureData memory card A flash memory card format that is gaining acceptance for use in digital cameras and other applications.

Figure A.17 *Fully saturated (left) and desaturated (right).*

selection In image editing, an area of an image chosen for manipulation, usually surrounded by a moving series of dots called a selection border.

selective focus Choosing a lens opening that produces a shallow depth-of-field. Usually this is used to isolate a subject by causing most other elements in the scene to be blurred.

self-timer Mechanism delaying the opening of the shutter for some seconds after the release has been operated. Also known as delayed action.

sensitivity A measure of the degree of response of a film or sensor to light.

sensor array The grid-like arrangement of the red, green, and blue-sensitive elements of a digital camera's solid-state capture device.

shadow The darkest part of an image, represented on a digital image by pixels with low numeric values, or on a halftone by the smallest or absence of dots.

sharpening Increasing the apparent sharpness of an image by boosting the contrast between adjacent pixels that form an edge.

Figure A.18 *CCD sensors have alternating rows of green/red- and green/blue-sensitive elements.*

shutter In a conventional film camera, the shutter is a mechanism consisting of blades, a curtain, plate, or some other movable cover that controls the time during which light reaches the film. Digital cameras can use actual shutters, or simulate the action of a shutter electronically. Many include a reassuring shutter "sound" that mimics the noise a mechanical camera makes.

shutter-preferred An exposure mode in which you set the shutter speed and, based on that information, the camera determines the appropriate f-stop. See also *aperture-preferred*.

sidelighting Light striking the subject from the side relative to the position of the camera; produces shadows and highlights to create modeling on the subject.

single-lens-reflex (SLR) camera A type of camera that allows you to see through the camera's lens as you look in the camera's viewfinder. Other camera functions, such as light metering and flash control, also operate through the camera's lens.

slave unit An accessory flash unit that supplements the main flash, usually triggered electronically when the slave senses the light output by the main unit.

slide A photographic transparency mounted for projection.

SLR (single lens reflex) camera A camera in which the viewfinder sees the same image as the film or sensor.

SmartMedia A type of memory card storage for digital cameras and other computer devices.

smoothing To blur the boundaries between edges of an image, often to reduce a rough or jagged appearance.

soft focus Produced by use of a special lens that creates soft outlines. Filters are more popular than lenses, because they are more economical and flexible.

soft lighting Lighting that is low or moderate in contrast, such as on an overcast day.

solarization In photography, an effect produced by exposing film to light partially through the developing process. Some of the tones are reversed, generating an interesting effect. In image editing, the same effect is produced by combining some positive areas of the image with some negative areas. Also called the Sabattier effect, to distinguish it from a different phenomenon called overexposure solarization, which is produced by exposing film to many, many times more light than is required to produce the image. With overexposure solarization, some of the very brightest tones, such as the sun, are reversed.

Figure A.19 *Digital photographers can manipulate the color curves of an image to simulate one kind of solarization.*

specular highlight Bright spots in an image caused by reflection of light sources.

spot color Ink used in a print job in addition to black or process colors.

subtractive primary colors Cyan, magenta, and yellow, which are the printing inks that theoretically absorb all color and produce black. In practice, however, they generate a muddy brown, so black is added to preserve detail (especially in shadows). The combination of the three colors and black is referred to as CMYK. (K represents black, to differentiate it from blue in the RGB model).

telephoto A lens or lens setting that magnifies an image.

thermal wax transfer A printing technology in which dots of wax from a ribbon are applied to paper when heated by thousands of tiny elements in a printhead.

threshold A predefined level used by a device to determine whether a pixel will be represented as black or white.

thumbnail A miniature copy of a page or image that provides a preview of the original. Photoshop uses thumbnails in its Layer and Channels palettes, for example.

TIFF (Tagged Image File Format) A standard graphics file format that can be used to store grayscale and color images plus selection masks.

time exposure A picture taken by leaving the lens open for a long period, usually more than one second. The camera is generally locked down with a tripod to prevent blur during the long exposure.

tint A color with white added to it. In graphic arts, often refers to the percentage of one color added to another.

tolerance The range of color or tonal values that will be selected, with a tool like the Photoshop's Magic Wand, or filled with paint, when using a tool like the Paint Bucket.

transparency A positive photographic image on film, viewed or projected by light shining through film.

transparency scanner A type of scanner that captures color slides or negatives.

tripod A three-legged supporting stand used to hold the camera steady. Especially useful when using slow shutter speeds and/or telephoto lenses. See also *unipod*.

tungsten light Light from ordinary room lamps and ceiling fixtures, as opposed to fluorescent illumination.

underexposure A condition in which too little light reaches the film or sensor, producing a thin negative, a dark slide, a muddy-looking print, or a dark digital image

unipod A one-legged support, or monopod, used to steady the camera. See also *tripod*.

unsharp masking The process for increasing the contrast between adjacent pixels in an image, increasing sharpness, especially around edges.

USB A high-speed serial communication method commonly used to connect digital cameras and other devices to a computer.

viewfinder The device in a camera used to frame the image. With an SLR camera, the viewfinder is also used to focus the image if focusing manually. You can also focus an image with the LCD display of a digital camera, which is a type of viewfinder.

vignette Dark corners of an image, often produced by using a lens hood that is too small for the field of view, or generated artificially using image-editing techniques.

white The color formed by combining all the colors of light (in the additive color model) or by removing all colors (in the subtractive model).

white balance The adjustment of a digital camera to the color temperature of the light source. Interior illumination is relatively red; outdoors light is relatively blue. Digital cameras often set correct white balance automatically, or let you set it through menus. Image editors can often do some color correction of images that were exposed using the wrong white-balance setting.

white point In image editing, the lightest pixel in the highlighted area of an image.

wide-angle lens A lens that has a shorter focal length and a wider field of view than a normal lens for a particular film or digital image format.

zoom In image editing, to enlarge or reduce the size of an image on your monitor. In photography, to enlarge or reduce the size of an image using the magnification settings of a lens.

Index